PRINTS AND DRAWINGS

prints & drawings

a pictorial history

Gottfried Lindemann

Translated by Gerald Onn

Phaidon E.P. Dutton
Oxford New York

Phaidon Press Limited
Littlegate House, St Ebbe's Street, Oxford
Published in the United States of America by
E. P. Dutton & Co., Inc.

First published in Great Britain 1970 by
Pall Mall Press Limited. Second impression 1976

© 1970 by Georg Westermann Verlag, Brunswick, Germany
English translation © 1970 by Pall Mall Press Limited

ISBN 0 7148 1760 0

Library of Congress Catalog Card Number : 71-111074
Printed in Germany by Georg Westermann Druckerei
Brunswick

CONTENTS

INTRODUCTION

Graphic art has always been overshadowed by the painted picture. With its small format, its economical use of colour and its delicate techniques it is a fundamentally less spectacular art form and consequently is known only to the small group of connoisseurs who visit the collections of prints and drawings or are themselves collectors. But although it has not been easy for the general public to gain access to this special branch of the fine arts, its importance as an independent medium has long been established. After all, the great European graphic collections were started as early as the sixteenth century. This, however, is only of incidental interest. What really matters is the fact that line drawing—which lies at the heart of graphic art—actually forms the basis of all artistic activity. Children's drawings, the incised drawings of the prehistoric cave dwellers, and the Greek vase paintings all testify in their different ways to the primacy of linear composition over colour. Moreover, when an artist chooses to portray reality in linear terms he takes the crucial step which leads away from nature and towards abstraction. Colour, on the other hand, has constantly induced artists to emulate nature.

It would be wrong to think that, by restricting himself to a linear technique, the artist also restricts his power of expression. Drawings alone offer immense scope. There is the delicate silver point, the pencil—which is capable of producing a whole series of greys—chalk, charcoal and the reed pen, whose harsh line stands in marked contrast to the smooth stroke of the ink brush. But, quite apart from drawings, we also have the various graphic media, which permit of infinite variations extending from the black and white contrast of the linoleum cut to the painterly nuances of the etching. With this wide selection at his disposal the graphic artist is extremely well equipped. And, like every other artist, he can use colour to heighten his effects.

But however highly we may feel inclined to rate prints and drawings as a genre, we should not overlook the fact that in the course of their development they have led a decidedly chequered existence. In certain historical periods the only drawings produced were those used as sketches or studies while in others drawings were regarded as an autonomous branch of art and included a number of really great works. The copper engravings and woodcuts of the Dürer period were conceived in purely artistic terms, whereas in the eighteenth and nineteenth centuries these techniques were used largely as a means of mechanical reproduction. In general we may say that linear composition reached its peak whenever it was pursued independently of painting and, conversely, that it reached its nadir whenever it became subservient to painting. And so in this enquiry, in which we hope to trace the historical development of prints and drawings, we shall be assessing the importance of the graphic art of various periods with reference to painting and the other artistic activities.

The illustrations include a number of less well known but none the less important prints, which it is hoped will now reach a wider public.

THE LATE MIDDLE AGES

Master of Bologna
(c. 1400),
HUNTING ADVENTURE.

The earliest graphic works to have survived date from the time when Western painters finally succeeded in emancipating themselves from their subservience to Byzantine art. This happened at the end of the fourteenth century when the new, human view of the world, first established by Giotto almost a century before, found general acceptance and the strictly hierarchical structures of Italo-Byzantine art with their stereotyped, unworldly figures were at last forced to yield to a gentler and more realistic type of composition. It was no accident that graphic art should have made its début in Western Europe at that time, for with their greater naturalness and humanity the paintings of the period had gained a wide appeal, which was reflected in an increased demand. In the late fourteenth century, when the numerous side altars of the Late Gothic churches were decorated with altarpieces, the monasteries—which until

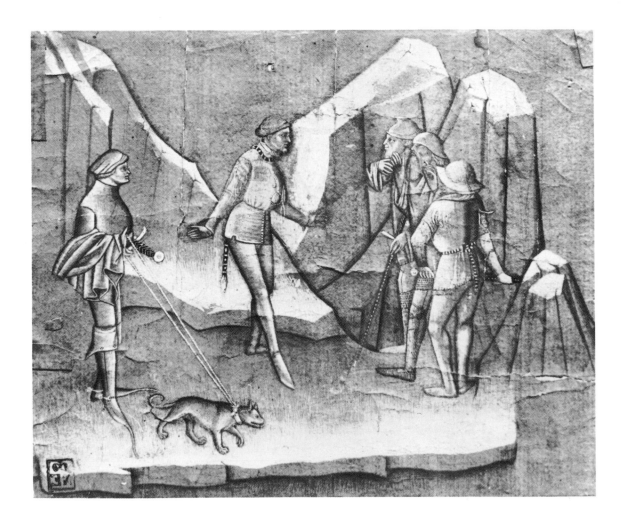

8

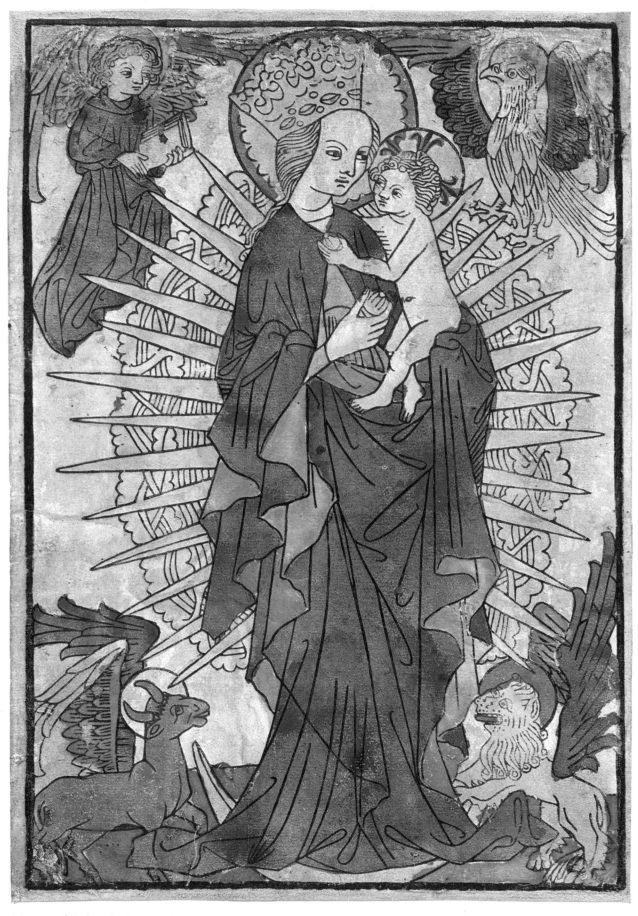

Master of Bohemia (c. 1430), MADONNA IN HER GLORY.

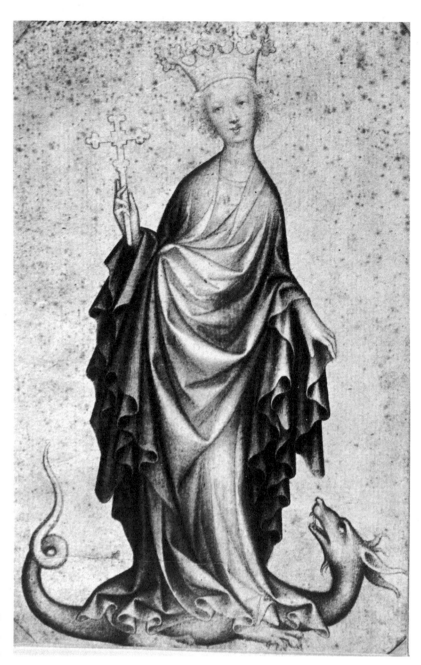

Master of Cologne
(c. 1400),
ST. MARGARET.

then had enjoyed a virtual monopoly both as patrons and as producers of art—lost their position of pre-eminence in the sphere of painting to the work-shops, which had meanwhile been organized into guilds. Previously these work-shops had been run along purely artistic lines, but now they became subject to economic considerations as well. Although the Church continued to determine both the subject-matter and the style of the pictures which it commissioned, it was no longer the only patron in the field. Private individuals, who donated works to the Church or commissioned them on their own account, were also able to command attention. The secularization of painting which took place in the early fifteenth century was due not least to the growing influence of the rich merchants and the guilds on the whole structure of public life and consequently on the Church.

But the increased demand for pictures could not be met by traditional methods of production. There was only a small number of paintings available, which

were too expensive for the great majority of private clients. And so prints were introduced to answer this new need. The first technique to be used was the woodcut, which enabled local craftsmen to reproduce any desired motif in a highly simplified form. Because of this simplification these early woodcuts have no intrinsic artistic value: the linear composition was really no more than a guide line and the flat colouring simply reflected the strong local colours used in contemporary painting. The Madonna of the Master of Bohemia of about 1430 reproduced the gracious image of the Virgin which was then in vogue. The nimbus motif and the four evangelists have been traced back to the four teenth century in Bohemia and southern Germany, while the calligraphic line of the drapery is characteristic of the late phase of the Soft Style. The gentle and lyrical expression on this Madonna's face is also found in the woodcut of St. Dorothy, which dates from the same period. The use of only a few colours, the flat handling, and the economy of the inner shading give this saint something of the immediacy that is one of the attractions of later folk art. No doubt hundreds of prints were made from this block, for works of this kind were displayed in even the most humble fifteenth-century rooms as holy pictures. The ornamental border portraying the arms of Bavaria, Austria, and the Palatinate was printed from a second block, which would also have been used for other woodcuts. The little stars, which form the backcloth, were added subsequently, probably by the colourist. The Madonna of the German Master of the Lower Rhine is artistically of a much higher order, for although the linear

Master of Bohemia,
Madonna in her Glory,
page 9

Anonymous Master,
St. Dorothy,
page 12

German Master of the
Lower Rhine,
Madonna and Child,
page 13

Below:
Master W. A. (c. 1475),
SWISS TROOPS
PLUNDERING THE TENT
OF CHARLES THE BOLD
AFTER HIS DEFEAT
AT GRANDSON.

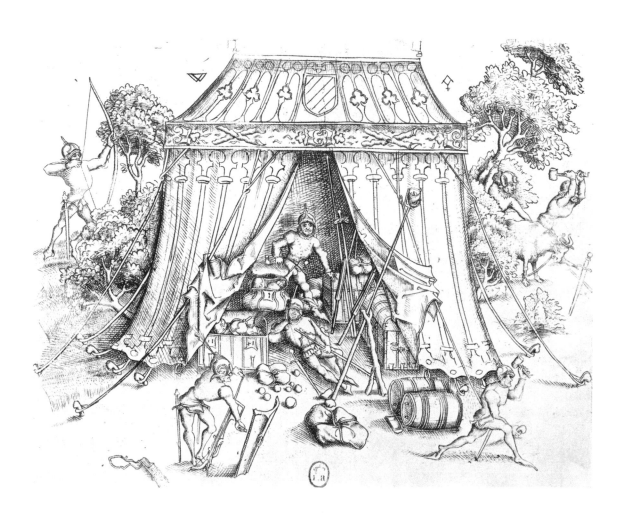

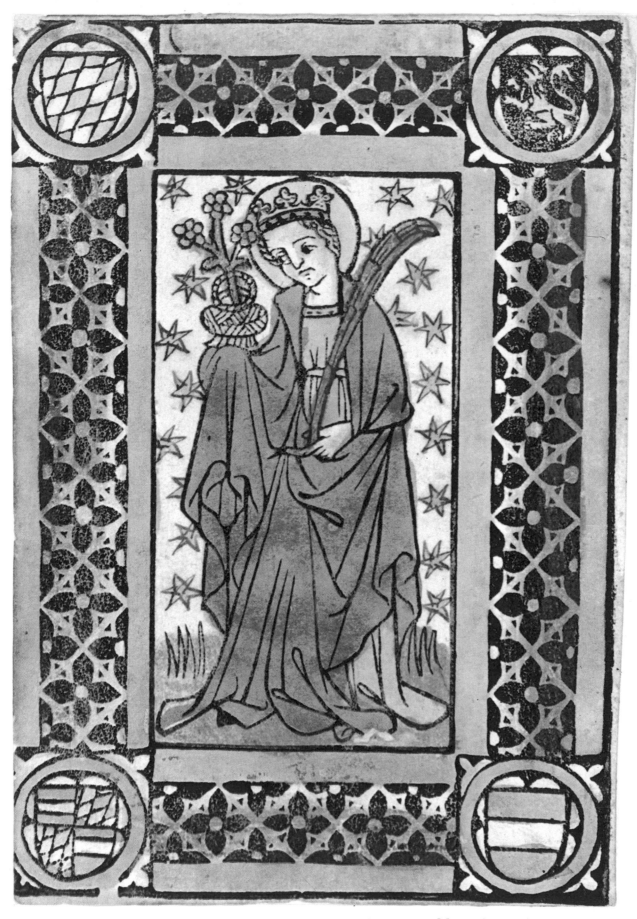

Anonymous Master (c. 1430), ST. DOROTHY.

Anonymous German Master of the Lower Rhine (c. 1430), MADONNA AND CHILD. 13

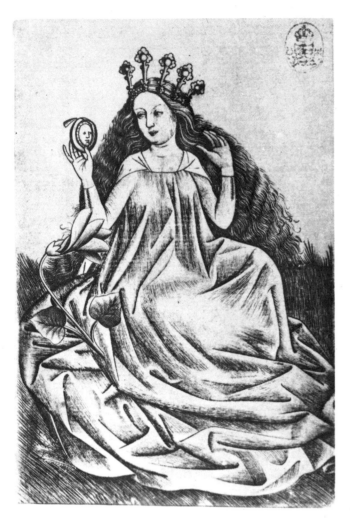

composition conforms to the normal standards of the day the colouring is very rich and reveals a degree of care in the handling which is lacking in the other two prints. The delicate shading creates an illusion of plasticity, not only in the folds of the drapery, but also in the reddish areas of the skin.

The impression of plasticity which this Rhenish master created with his colour was produced a good fifty years later by the Master of Paris with a linear technique. In his Madonna hatching is used to indicate indentations—especially on the drapery—whilst the line of the floor tiles and the receding timbers of the balustrade create an illusion of three-dimensional space that is further enhanced by the distant landscape. Perspective had long been in use at that time and was employed with complete mastery by this Parisian artist. His colouring on the other hand, was decidedly slipshod: the orange of the balustrade, for example, has been allowed to run over onto the angels' wings and the drapery. The discrepancy between the masterly carving technique and the careless colouring would

Master of the Playing Cards (c. 1450), FLOWER QUEEN.

indicate that this particular woodcut was run off in very large numbers. These prints, incidentally, were referred to as 'casket cuts' because their owners kept them in tiny caskets as amulets.

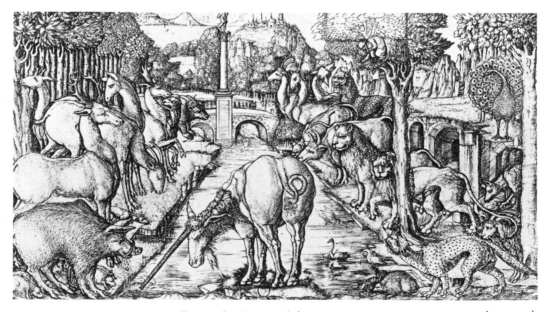

Jean Duvet (1485—1561), UNICORN PURIFYING A STREAM (C. 1547).

In about 1536 an anonymous French master produced a print which anticipated the modern poster. In that year Francis I promulgated an edict requiring his subjects to use 'affiches', i. e. posters, for all royal proclamations, and this print seems to have been designed to announce the forthcoming marriage between the king and Eleonore of Austria. In this woodcut the union, which is symbolized by the exchange of a heart and a rose, is blessed by the Virgin and Child, who are seated on a cloud beneath a baldachin supported by hovering angels. This moving scene is portrayed in the plain language of poster art, which was immediately intelligible to the king's subjects. There were no subtle effects, for none were needed.

This is a point to remember for, although these naïve prints with their simple line and their flat and, in many cases, monochrome colouring may seem particularly charming and impressive to the modern viewer (who has been conditioned by the simplification of twentieth-century painting), in point of fact these early woodcuts were not intended as works of art. On the contrary they were consumer articles, which were aimed at the widest possible public and had nothing to do with the burning artistic questions of the day. European painters had just begun to explore external reality and to depict it in plastic terms by the use of perspective. But the early woodcut was unable to express these new ideas. It offered too little opportunity for differentiation, for gradations of light and shade, and for the detailed treatment of objects. Graphic artists were not able to influence the development of artistic style

Parisian Master,
Madonna in her Glory,
page 16

French Master,
*Francis I offers his
Heart to Eleonore of
Austria*,
page 17

Below:
Master E. S.
(active in the Upper
Rhineland 1440—67),
A PAIR OF LOVERS
ON A GRASSY SEAT.

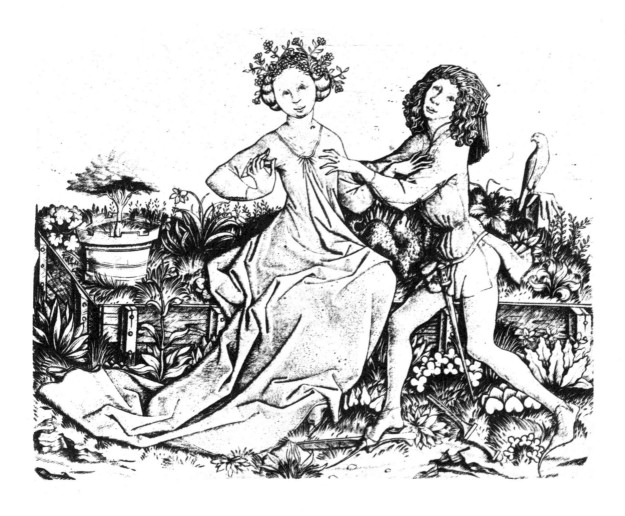

15

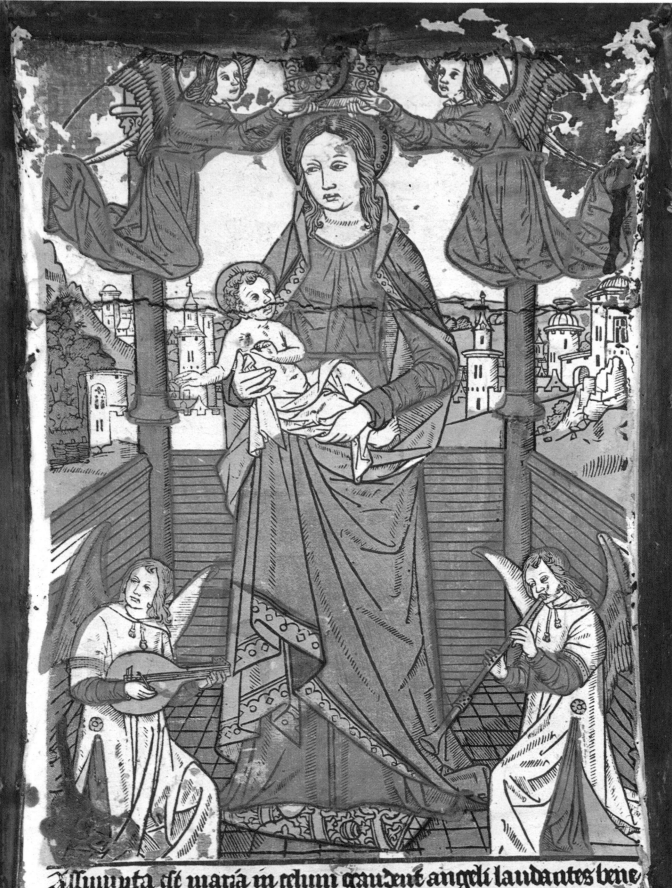

Aſſumpta eſt maria in cclum gaudent angeli laudantes bene
dicunt dm̄. In omnibz requiem queſiui: τ in hereditate dm̄
alor huic precepit et diat michi creator omnir oui creauit

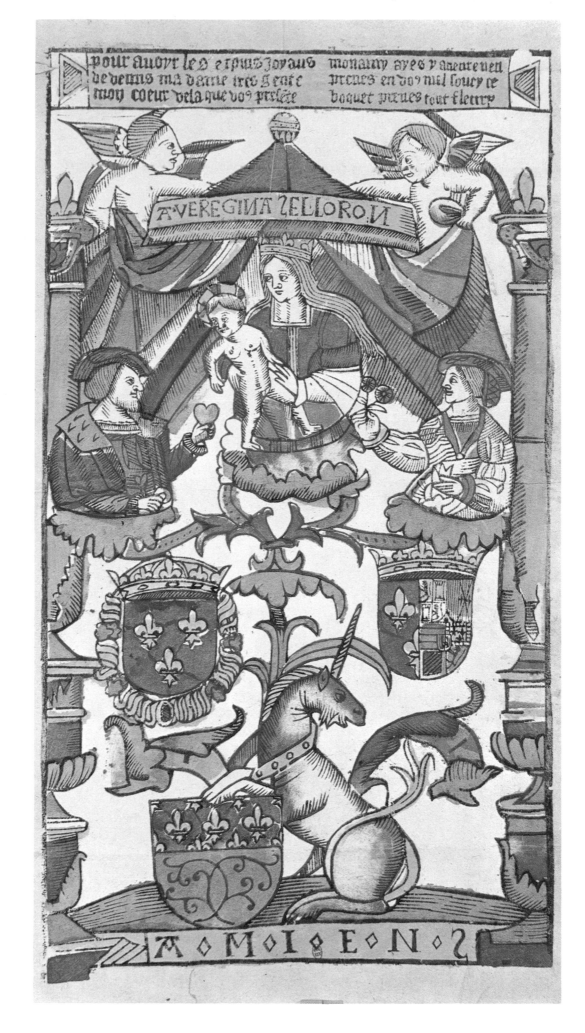

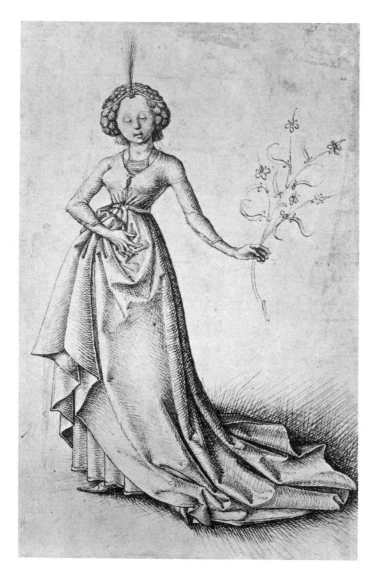

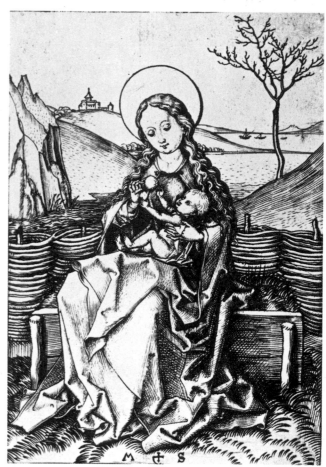

Martin Schongauer (1425/45—91),
MADONNA ON A GRASSY SEAT.

Left: Master E. S. (active 1440—67),
GIRL WITH A BRANCH OF BLOSSOM.

Master of the Playing
Cards,
Flower Queen,
page 14

until a new graphic technique was discovered, which was capable of
producing illusionist effects. This technique was the line engraving.

When a master of the Upper Rhine produced his charming line engraving
of playing cards between 1430 and 1450, this technique had almost certainly
been known for several decades. But he was the first artist to appreciate its
real potential. The light flowing drapery of his *Flower Queen* is the result
of extremely delicate hatching, which constituted an entirely new departure
from the deep incisions of earlier woodcuts. The individual lines in this
hatching are quite insignificant as such, but together they create an impression
of plasticity. Like so many of the engravers of the period the 'Master of the
Playing Cards' would doubtless have started out as a goldsmith. After gaining
experience in this difficult field he would presumably have turned to painting
and applied himself to contemporary problems of artistic form. He would
then have used his skill as an engraver to reproduce his paintings and so
popularize his ideas.

Another German master, a pupil of the 'Master of the Playing Cards', with
the initials 'E. S.', carried the art of line engraving to new heights. Using
a highly specialized linear technique he reproduced flowers and plants with
great virtuosity. In one of his prints, in which he portrayed a lady sporting
with her gallant on a grassy seat, this artist produced a vibrant chiaroscuro

design on the folds of the drapery, which greatly enhances the poetic mood of the scene. The finely formed figures and the tight angular folds of the drapery are traditional Gothic features, but the great wealth of natural detail is a sure indication that E. S. was in fact a 'modern' artist. Moreover, by depicting his courtly lovers on a grassy seat instead of in the Garden of Eden—the setting favoured by Late Medieval artists for such couples—he was following the general trend of the day, which reflected the growing movement away from the old religious commitment.

The third of the graphic artists working in the Upper Rhineland during this transitional period is known to us by name. He is Martin Schongauer. This man must have evolved a completely new attitude to graphic art, for he signed his prints individually. For him the art print would appear to have been more than a means of reproducing original drawings or pictures. In fact he seems to have regarded it as an independent discipline capable of opening up entirely new areas of art, for which other techniques were unsuitable. His style was essentially linear. Unlike E. S., moreover, he did not try to reproduce the effect of an original drawing by making shallow incisions. On the contrary, he exploited the natural quality of the burin, thus producing deep incisions and correspondingly powerful lines. These are clearly demonstrated in his *Madonna on a Grassy Seat*, where they combine with lines of infinite softness to form a linear composition that is quite perfect in itself. In this engraving the two-dimensional surfaces are transformed into living structures by the clarity and austerity of the linear composition: the thick dark lines were all the artist needed in order to portray his pictorial objects—the bare tree in the background, for example, or the plaited osiers immediately behind the seat— whilst the carefully modulated cross-hatching enabled him to reproduce any degree of light and shade. With Schongauer line engraving became an artistic discipline in its own right and with its own inner laws. This was due partly to his systematic simplification of traditional techniques and partly to his new method of incising, which did full justice to the new material.

If we compare these fifteenth-century line engravings with the few surviving Late Medieval drawings it is immediately apparent that, in its earliest form, copper engraving was evolved simply as a means of reproducing the kind of effects created in line drawing. The deep drapery folds, which the Master of Cologne used for his *St. Margaret* in about 1400, are repeated both by the 'Master of the Playing Cards' in his *Flower Queen* and by Master E. S. in his *Girl with a Branch of Blossom*. With its almost sculptural plasticity this St. Margaret is reminiscent of the 'Beautiful Madonnas' on the altarpiece and reredoses in fourteenth-century chapels.

Master E. S.,
A Pair of Lovers on a Grassy Seat,
page 15

Schongauer,
Madonna on a Grassy Seat,
page 18

Master of Cologne,
St. Margaret,
page 10

Master of the Playing Cards,
Flower Queen,
page 14

Master E. S.,
Girl with a Branch of Blossom,
page 18

Anonymous Florentine Master (14th century), THE VIRGIN MARY VISITING ST. ELISABETH.

THE EARLY RENAISSANCE IN ITALY

'And God said to man: I have placed you in the world that you may more readily see what you are. I have made you neither an earthly nor a heavenly, neither a mortal nor an immortal being, in order that you, as your own sculptor, may carve features for yourself. You may degenerate into an animal; but by using your free will you may also be reborn as a god-like being.' Towards the end of the *Quattrocento*, which ushered in our modern period, the Florentine philosopher Pico della Mirandola was able to make this statement in his famous speech on human dignity without being decried as an opponent of the medieval world order or being accused of overweaning pride. He was, after all, merely postulating what the intellectual *élite* of Italy had long regarded as an absolute right: freedom of thought and action. By then not even the Church was opposed to this quest for freedom. On the contrary, many of her representatives were actively engaged in promoting it. The fact of the matter was that, far from contradicting Church doctrine, the Renaissance movement allowed its followers to continue in their old religious adherence. The only thing on which it insisted was that it should be allowed to pursue what Jakob Burckhardt subsequently called 'the discovery of the world and of man'. In this respect of course it constituted a completely new departure from the corrupt practices and the intellectual dishonesty of the Late Medieval social order. This break with tradition was first recorded by artists and only subsequently by writers because—in the early days of the new movement—it was possible to express in paintings concepts which nobody dared to state in plain language. Giotto had already turned away from established pictorial forms at the beginning of the fourteenth century, when he removed his sacred figures from their former habitat, namely the heavens, and allowed them to wander the earth as human beings. He even humanized the heavens themselves by painting them blue instead of gold. And it was Giotto who emancipated the human figure from the rigid schema of Italo-Byzantine art, depicting it—for the first time since antiquity—as a solid, physical form. He also painted trees, plants and animals in a style which, although technically somewhat clumsy, is quite uninhibited and faithfully reflects the workings of his artistic phantasy. Giotto was of course honoured in his own lifetime and, although very few of his contemporaries had the courage to follow the example which he had set, his vital and realistic conception of art was not to be denied. Some seventy years after his death it was revitalized. By then the time was ripe for men to throw off the shackles of the old order: the natural scientists were beginning to evolve a new, rational view of the world; the traditional pre-eminence of the Church and the royal houses was being undermined by the wealth of the *bourgeoisie;* the map of the world was slowly being expanded by intrepid merchants; and scholars were refusing to countenance the edited versions of antique authors sanctioned by the Church, preferring to study the original texts instead. The

THE BIRTH OF CHRIST
(middle of 15th century).

Antonio Pisanello
(c. 1395—1455),
LUXURIA.

Renaissance, which has so often been described by unthinking critics as the rebirth of antiquity, was really a rebirth of the human spirit, which was no longer prepared to accept guidance and preferred the risk of independence.

Quattrocento art bears the unmistakable imprint of this new quest for freedom while at the same time revealing the basic anxiety attendant on any such step into the unknown. The painters of this period often attached so much importance to questions of form that their works lacked spontaneity. They painted enormous canvases, simply to demonstrate their mastery of perspective, and large biblical scenes, which were really only studies in movement. They featured nude figures, not only in their mythological, but also in their religious works, because this enabled them to show the human figure in its natural state. In the circumstances it is scarcely surprising that the *Quattrocento* artists should have set great store by studies and sketches. Their medieval predecessors had had no need for such aids, for the subject-matter of their paintings was normally determined by their patrons whereas the form was based on established designs, the finished picture consisting of a mosaic of component

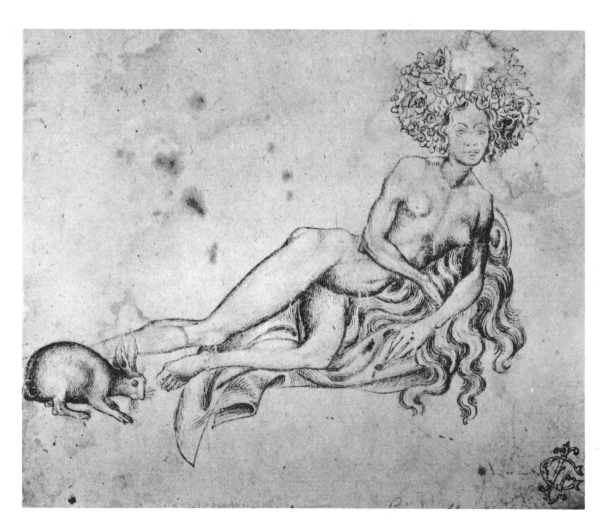

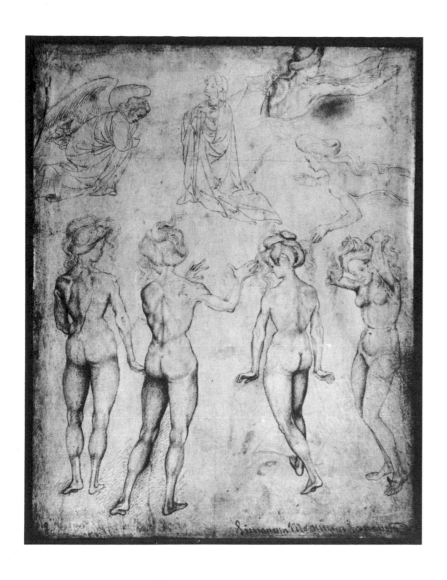

Antonio Pisanello
(c. 1395—1455),
STUDY.

Antonio Pollaiuolo
(c. 1432—98),
BATTLE OF THE
NUDE GODS.

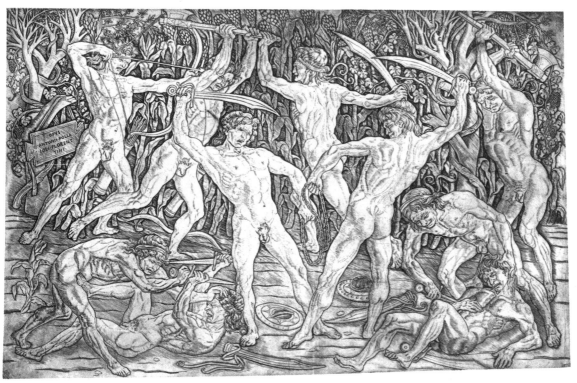

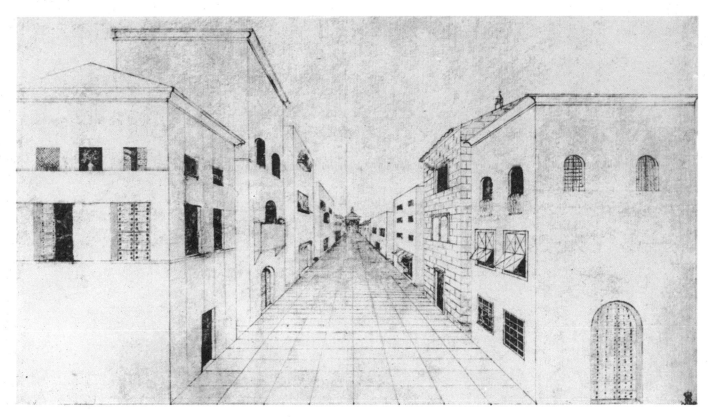

Piero della Francesca (1410/20—92), PERSPECTIVE DRAWING.

Opposite:
Paolo Uccello (1396/7—1475), STUDY FOR AN EQUESTRIAN WALL PAINTING
DEPICTING GIOVANNI ACUTO.

details, which were added one after the other. But the fifteenth-century artist
was expected to be original. Consequently he had to work out the complete
layout of his picture in advance, making sure that the various details fitted
in with the general composition and conformed to the requirements of the
new system of perspective. He also had to pay far more attention to the
representation of detail. The growing interest in nature, which was one of
the features of the Renaissance, had made people more aware even of ap-
parently trivial objects. As a result artists began to concern themselves with
the precise reproduction of materials and metals, plants and flowers, gesture
and movement, light and shade, and in order to do so had constant recourse
to their sketchbooks, many of which have survived. Very few of these sketches
were developed into full-scale drawings and this particular medium is only
sparsely represented in collections of *Quattrocento* art. The vast majority
were used either as rough drafts, as guide lines for workshop apprentices,
or as a means of demonstrating new ideas to patrons.

The extremely important Florentine pen-and-ink drawing of *The Virgin Mary
Visiting St. Elisabeth* was long thought to be Giotto. This view is no longer
held today, although it seems certain that the work was produced during
Giotto's lifetime and was influenced by him. It may even have been a copy
of one of his frescoes executed by a pupil. At all events, it proves that Italian
draughtsmanship had reached a very high standard at the beginning of the
fourteenth century. The extremely economical background composition, which

Florentine Master,
*Virgin Mary visiting
St. Elisabeth,*
page 20

25

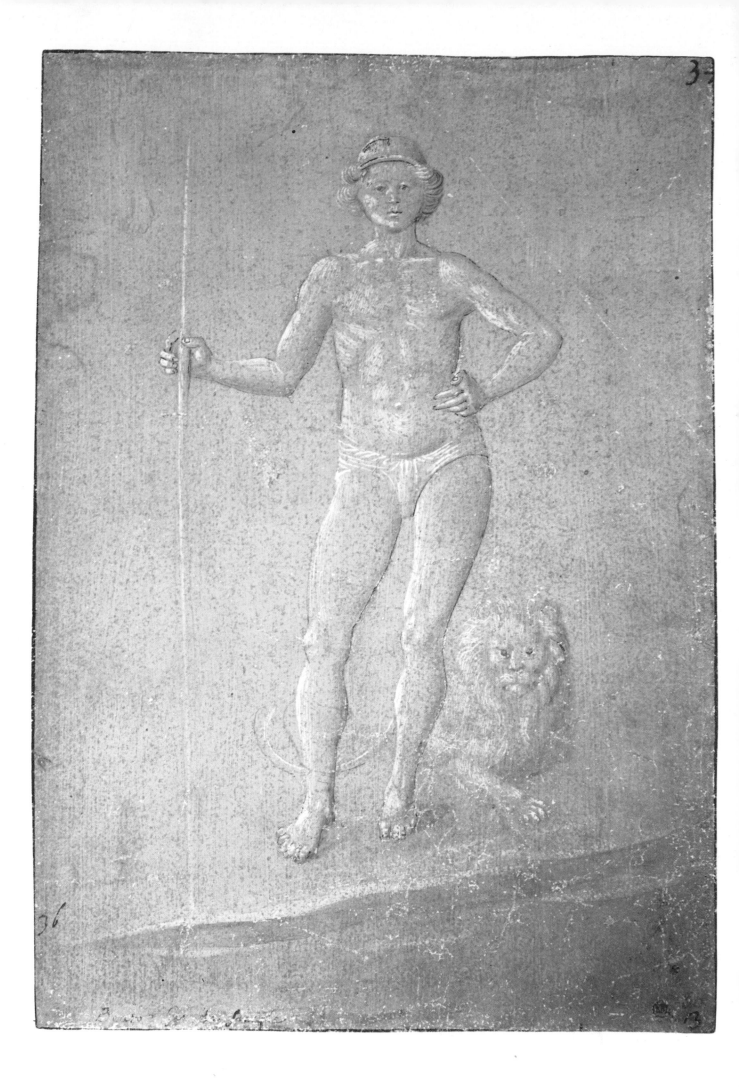

Page 26:
Benozzo Gozzoli
(c. 1421—97),
NAKED YOUTH
AND LION.

Page 27:
Antonio Pollaiuolo
(c. 1432—98),
EVE SPINNING.

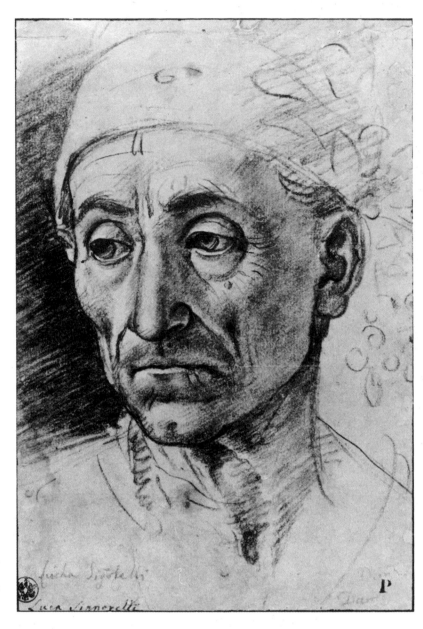

Luca Signorelli
(c. 1441/50—1523),
PORTRAIT OF AN
OLD MAN.

conveys the impression of an open expanse of country by just a few strokes of the pen, contrasts with the immensely detailed draughtsmanship employed on the figures. The solidity of the bodies and the great plasticity of the drapery folds are achieved simply by the use of line. The figures are arranged in groups—a typical Giotto device—with the result that, despite the restricted foreground setting, the viewer does not receive the impression of a serried row, which was still a typical feature of composition in those times. The meeting between the two women is entirely free from pathos and Gothic graciousness. It is a profoundly human event, one that is taking place on this earth and in which the spirit of the modern period is unmistakably present.

The drawings of Antonio Pisanello are an important source of information for the transitional period between the *Trecento* and the *Quattrocento* in Italy. Pisanello, who was an exponent of international Gothic, incorporated many traditional features into his work. The narrow, angular limbs of his *Luxuria* provide a typical example of his involvement with traditional values. But the same work also reveals a distinctly progressive trend for, instead of

Pisanello,
Luxuria,
page 22

28

dressing this figure in costly garments in the time-honoured manner, Pisanello protrayed it as a nude. His interest in nude subjects, which appears to have been quite pronounced, is also demonstrated by a study (now in Rotterdam) which shows three rear views of female nudes and one side view. The realism of these figures is so marked that it is generally thought that Pisanello must have drawn them from life. Numerous of the artist's drawings were collected in the Codex Valladri in the Louvre. This collection of the artist's graphic work shows how carefully he must have studied the people, plants, animals, buildings, tools and utensils which he reproduced with such fidelity and such sensual power.

Pisanello,
Study,
page 23

'Unlike the masters who preceded him Antonio painted naked figures more after the new manner, he dissected many human bodies so that he might acquire a precise knowledge of their forms, and he was the first painter to try to investigate the course of the muscles so as to portray them in his paintings in accordance with their actual structure and disposition.' These

Ercole de' Roberti
(c. 1448/55—96),
PORTRAIT STUDIES.

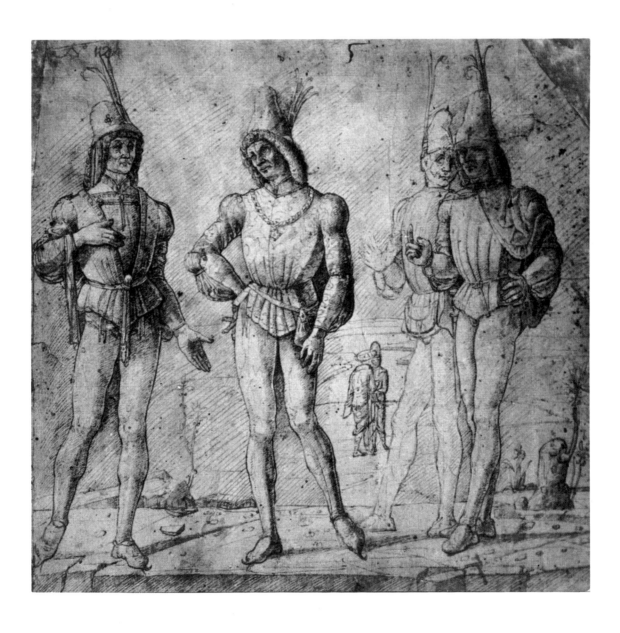

Pollaiuolo,
*Battle of the
Nude Gods,*
page 23

words were written by Giorgio Vasari—in his biography of Italian architects, painters and sculptors—about Antonio del Pollaiuolo, one of the late fifteenth-century scientific artists who tried to establish the functional principles of the human body by means of anatomical studies. His celebrated *Battle of the Nude Gods* was a direct result of these enquiries. The subject-matter of this work is not important in itself, for what really interested Pollaiuolo was the movement of the human body. But although he certainly succeeded in portraying the muscular system with amazing precision, the general sense of physical movement is somehow unconvincing. These gods of his look more like actors executing carefully rehearsed moves.

None the less this print of Pollaiuolo's is one of the few Italian line engravings from the *Quattrocento* which can lay claim to original artistic merit. In northern Europe at that time the copper engraving had already been established as an artistic discipline in its own right, but in Italy, prior to Pollaiuolo, it had been treated simply as a cheap and convenient method of reproducing popular motifs. Needless to say such replicas possessed no intrinsic merit. The only branch of engraving to become really popular in fifteenth-

Below:
School of
Filippino Lippi
(1457/8—1504),
THREE YOUNG MEN
DRESSED IN LOOSE
ROBES.

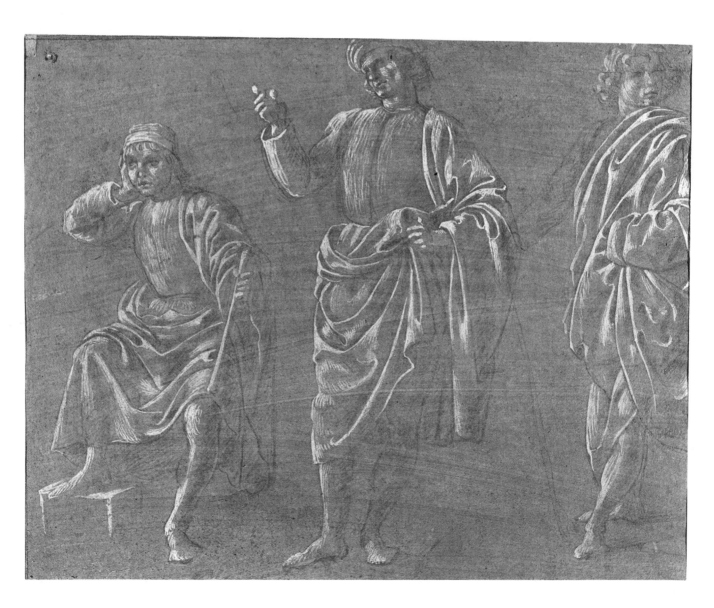

Francesco di Stefano, also called Pesellino (c. 1422—57), ALLEGORY OF ROME.

century Italy was *niello* work, which may be regarded as an early form of line engraving. A *niello* is a small plate of metal with a pattern engraved on it, the pattern being filled with a black composition which is also called niello. According to Vasari the first prints made from such plates were the result of an accident: a washerwoman is supposed to have accidentally laid a damp cloth on a newly engraved plate, which had just received its niello filling, thus producing the first niello print. Although this derivation, like so many of the amusing stories recounted by this great historiographer, must be regarded as dubious, the mere fact that the discovery of the niello printing process was ascribed to an accident would suggest that graphic art was not taken at all seriously in Italy at that time. As for line engraving, this was not really established as a genuine art form until it was taken up by Pollaiuolo and Mantegna.

Like Pisanello, Pollaiuolo was very interested in the nude figure. In his splendid drawing of *Eve spinning* he employed a subject that was very popular in his day, this Old Testament figure being the one nude motif that contemporary artists might portray with impunity. The outline of Eve's body was executed in ink with great skill; the head and limbs were then modelled with bistre and the background shading was executed in chalk. Although this work was almost certainly conceived as a sketch it none the less testifies to Pollaiuolo's great gifts as a draughtsman: the extremely economical composition and the general sense of improvisation create a graceful and highly pictorial effect.

As the people of the Early Renaissance became aware of their growing importance as individuals they began to identify themselves with the bold and arrogant *condottieri,* the unscrupulous mercenary leaders of the day, who sold their services to the highest bidder. These soldiers, to whom the medieval concept of fealty was completely alien, were hero-worshipped as the perfect embodiment of Renaissance man. The city of Padua commissioned the Florentine sculptor Donatello to produce an enormous bronze monument of the *condottiere* Gattamelata, which shows his lust for power and his fierce determination. The painter Uccello also portrayed the profession of arms in picturesque and heroic terms. In 1436 he was commissioned by the city of Florence to paint a fresco in imitation of an equestrian statue in the cathedral of Santa Maria del Fiore portraying the English mercenary Sir John Hawk-wood, who was known in Italy as Giovanni Acuto and had led the Florentine troops to victory at the Battle of Cascina. The sketch reproduced in this book

was one of the first which Uccello made for the fresco. In it he consciously set out to create the impression of a silhouette and it will be noted that, although the detail has been executed with great care and delicacy, it has not been allowed to encroach on to the firm outlines. The foreshortening of the plinth produces an illusion of three-dimensional space and also heightens the monumentality of the subject. Uccello was one of the great realists of the Early Renaissance. He made an intensive study of the laws of perspective and became so enamoured of this new technique that he once said he loved it more than he loved his wife. His realism extended not only to plants and flowers, but also to every aspect of landscape. It is also demonstrated by his pictures of battle-scenes in which the precise technical detail of the arms, armour, and harness is a source of constant fascination.

But although Uccello was undoubtedly a systematic artist, in this particular respect he was far outdone by his younger contemporary Piero della Francesca, the Umbrian painter and mathematician. The perspective and geo-

Sandro Botticelli (c. 1445—1510), NATIVITY.

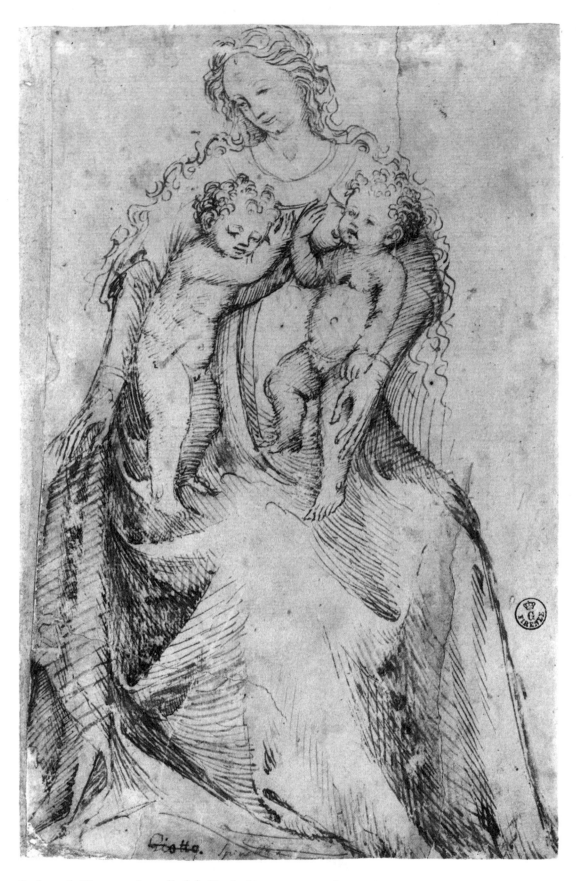

Stefano da Verona, also called da Zevio (c. 1375—1451), CARITAS.

Opposite: Andrea Mantegna (c. 1431—1506), JUDITH WITH THE HEAD OF HOLOFERNES.

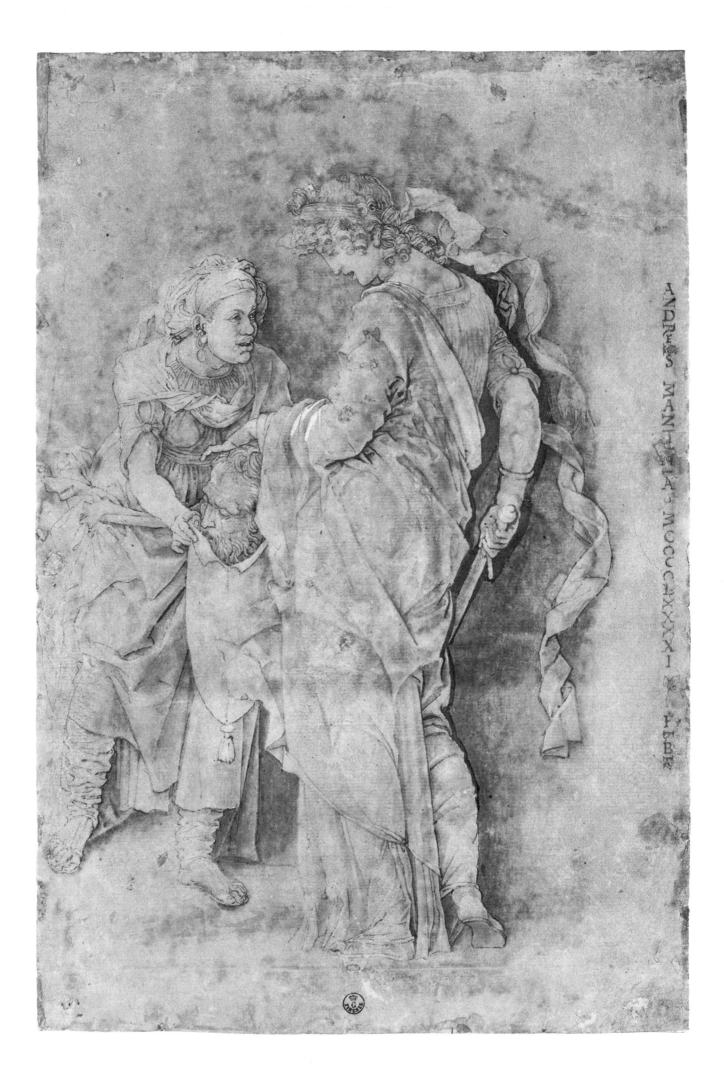

metrical drawings which fill Piero's sketchbooks paved the way for the perfect forms and precise structures of his later works. He exerted a powerful influence on Vittore Carpaccio, the Venetian master of the Early Renaissance, who was introduced to his style by Antonello da Messina. Carpaccio's drawing of *St. George Showing the Slain Dragon to the People* is executed in full perspective, a technique rarely used by Venetian artists at that time and which Carpaccio can only have learnt from the draughtsmen of central Italy. The strict symmetry of the composition is reminiscent of Perugino's *Christ Giving the Keys to Peter* in the Sistine Chapel and of the *Lo Sposalizio (The Betrothal of the Virgin)*, an early work by Perugino's great pupil Raphael. In all other respects, however, Carpaccio's drawing is specifically Venetian. Using short, closely aligned strokes he created a composite design of ink and red chalk, in which great clarity is combined with a magical and poetic atmosphere. The exotic figures, who are massed together in the two large groups on either side of the picture, may well have been drawn from life, for such people will no doubt have been commonplace in Carpaccio's native Venice. In this city, which was then a meeting-place between East and West, oriental splendour and a cosmopolitan populace were part and parcel of the daily scene. The buildings in the background of the drawing also reveal oriental motifs and the large building in the centre is probably based on the Church of the Holy Sepulchre in Jerusalem. But for all its pulsating life, this drawing has an underlying quality of calm that stems partly from the symmetrical composition and partly from the juxtaposition of densely packed and completely bare surfaces.

Carpaccio, *St. George Showing the Slain Dragon to the People*, page 40

The establishment of new artistic techniques following the discovery of perspective and the introduction of realism was accompanied by a complete reappraisal of artistic themes. The old religious motif, which had reigned supreme in medieval art, was completely humanized. Botticelli's poetic version of the *Nativity* contains no hint of mystical pathos. On the contrary, it is virtually a family scene, whose intimacy is well preserved by this close-knit group. A few decades earlier Botticelli's master Fra Filippo Lippi had painted a similar picture, the *Adoration in the Forest*. This work, which was intended as an altarpiece for the Medici Chapel and is now in Berlin, must have been in Botticelli's mind when he produced his drawing, for there is an undeniable resemblance between the two Virgins, both in their looks and in their posture. But Botticelli went much further than Fra Filippo in his quest for emancipation. Not that the master's madonna resembled the heavenly Mother of God of ecclesiastical tradition! On the contrary, she is an extremely handsome young woman. Moreover his saviour is a perfectly normal baby whilst his St. John may have been a child from the streets of Florence. But this cheerful family scene is set in a forest grove and illumined by rays of divine light with God the Father and God the Holy Ghost appearing in the heavens above, a device which necessarily removes Fra Filippo's nativity from the natural world. In Botticelli's case, however, the miracle of Christ's incarnation is presented without heavenly visions, for he has made the transition to the modern period.

Botticelli, *Nativity*, page 33

Botticelli was the great 'court painter' of the Medici family. He glorified secular pleasures in his allegorical pictures *Primavera* and *The Birth of Venus* in the days of the great Lorenzo and portrayed the leading representatives of this epoch in his great group portrait *The Adoration of the Kings*. He was also one of the *Quattrocento* masters who worked in the Sistine Chapel in

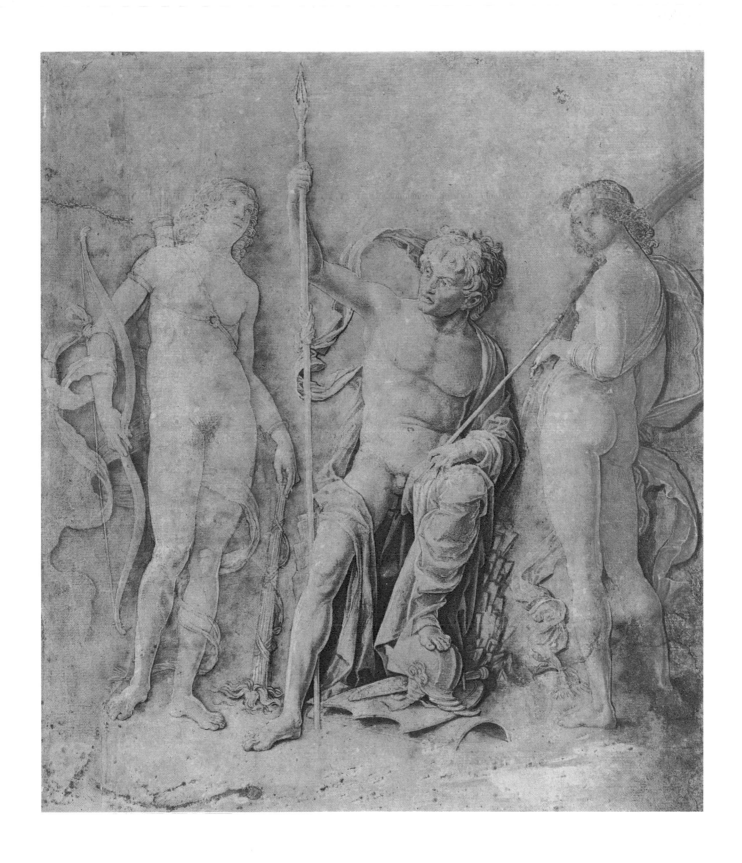

Andrea Mantegna (c. 1431—1506), MARS, VENUS (?) AND DIANA. 37

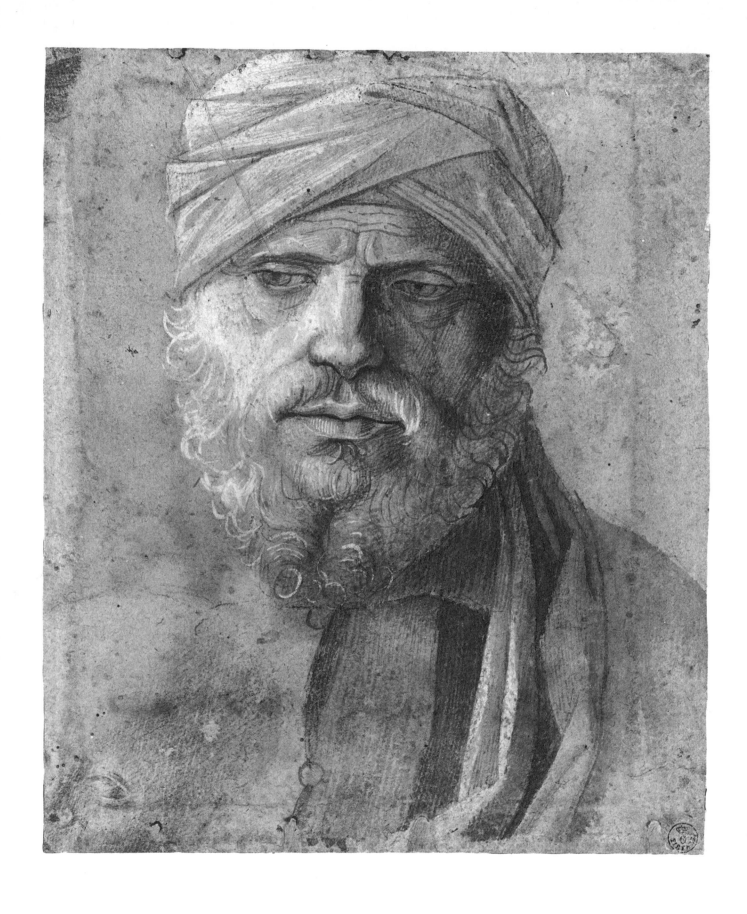

38 Giovanni Bellini (c. 1430—1516), PORTRAIT OF A MAN WITH A TURBAN.

Rome, whilst in his late period he became an ardent follower of Savonarola. He then turned his back on the hedonism of the Renaissance world and even burnt a number of his youthful works. He was far less interested than many of his contemporaries in the purely formal problems of painting because he was essentially an artist and not an art theorist. This is clearly demonstrated by his drawing of the Nativity which is, above all else, the work of a master craftsman. In this drawing the contours simply serve to reinforce the modelled forms, which Botticelli created with coloured chalk. With this material he was able to produce the finest gradations of tone on the drapery folds and the infant's limbs, thus giving an impression of depth. Where others had recourse to linear perspective he relied on his skill as a draughtsman.

Botticelli's fellow countryman Benozzo Gozzoli also used religious themes as a pretext for glorifying earthly beauty. The Florentine nobles, led by the Medici, whom he portrayed in his celebrated *Medici Family as the Magi*, are certainly not intent on paying homage to the infant in the crib. On the contrary, their sole object is to present themselves to the world in all their splendour. In his drawing of a youth and a lion Gozzoli was ostensibly treating the subject of Daniel in the lion's den, but from the graceful way in which the youth has been portrayed it seems quite clear that he was actually paying tribute to the antique ideal of physical beauty. Since no nude studies were being made at that time, it must be assumed that Gozzoli—like his younger contemporaries Botticelli and Michelangelo—obtained his knowledge of the human body from a study of antique statues. The greenish coloured chalk ground of this drawing—which Gozzoli actually used in order to stiffen the surface of the paper—is most unusual but extremely effective.

Gozzoli, *Naked Youth and Lion*, page 26

Andrea Mantegna was another *Quattrocento* artist who revealed a predilection for antique forms. In his drawing of *Judith with the Head of Holofernes* Judith is depicted as a beautiful, courageous, and self-confident woman, who looks more like an Athenian goddess than an Old Testament figure, especially by comparison with the wild-eyed servant. The dramatic tension of the scene is heightened by the chiaroscuro effects produced with bistre and chalk, which also raise the figure of Judith to monumental proportions. Despite the extensive use of chiaroscuro, however, the contours remain perfectly clear; and, although this drawing is obviously intended to produce a painterly effect, it none the less hints at Mantegna's great virtuosity as a line engraver. His mythological drawing of *Mars, Venus (?) and Diana* is even more striking. Two of these figures—Mars and Venus—are brightly lit and appear as fully modelled forms while the third—Diana—stands in the shadow, where she is seen in bas-relief, almost as a silhouette. The vibrant colouring covers a wide range of tonal values extending from the bright patch of light at the bottom right of the drawing to the dark areas in the centre. But despite this emphasis on colour, close attention is still paid to the structural detail: the muscles, the calves of the legs, and the folds of flesh are interpreted anatomically, and the movement of the drapery is worked out with great care, though without impeding the general flow of the composition. This drawing is a completely autonomous graphic work, which owes nothing to the art of painting, for the style is created by the linear composition alone, the colour merely serving to heighten the graphic effect.

Mantegna, *Judith with the Head of Holofernes*, page 35

Mantegna, *Mars, Venus (?) and Diana*, page 37

Mantegna grew up in the university city of Padua, which was then a great international centre. He was encouraged to study the works of antique artists by a group of enlightened humanists and found within the borders of Venetia

Vittore Carpaccio (c. 1460/5—1523/6), ST. GEORGE SHOWING THE SLAIN DRAGON TO THE PEOPLE.

numerous Roman remains, drawings of monuments, coins, cameos and reliefs, which provided him with the necessary material with which to do so. He was introduced to the progressive ideas of central Italy when he saw works by such Florentine masters as Uccello, Fra Filippo Lippi and the sculptor Donatello, who all visited northern Italy. But he did not become a mere imitator, either of Florentine realism or of antiquity. On the contrary, he went his own way. In Mantegna's art an unerring sense of reality is combined with a perfect appreciation of beauty.

As was only to be expected, the renaissance of antique art was accompanied by a predilection for allegory. In 1471, shortly after the printing press had been introduced into Italy, Silius Italicus's *Punica* was printed and this work, which revived the myth of the goddess Roma as the ruler of Rome and the world, probably influenced the Florentine painter Francesco di Stefano when he came to paint his highly colourful miniature on vellum. Di Stefano was greatly admired as a painter of *cassone* panels, the decorative panels on the special coffers used by Italian brides as marriage chests. And in point of fact this miniature of his, which shows a young girl with orb and sceptre against a stylized landscape, is also remarkable for its decorative colouring, which is combined with an extremely graceful line. By comparison, Stefano da Verona's *Caritas* allegory seems positively old-fashioned. True, the type of the Late Gothic madonna is presented here as a courtly lady and not as a heavenly figure, but the great wealth of tiny folds in the drapery and the tender inclination of the head reveal her origins in the traditional art of northern Europe. This rather charming mixed style of Stefano's may well have been due to Verona's geographical position, for this town was a meeting place between North and South.

Another important subject to make its artistic début in the Early Italian Renaissance was the human portrait, which enabled the *Quattrocento* artists to depict human beings as individuals. Not surprisingly, the early works in this new genre reveal a lack of expertise, which could only be made good by practice in drawing. Only a few decades after Roberti had executed his full-length portraits of the Duke of Ferrara and his son and brother, Giovanni Bellini produced his *Portrait of a Man with a Turban*, in which he concentrated on the physiognomy of his anonymous sitter, thus creating a character study of immense power. This portrait epitomizes fifteenth-century man who, having forced himself to reject the comfortable attitudes of traditional thought, was prepared to look the world in the face and accept the reality of his situation.

Francesco di Stefano, *Allegory of Rome*, page 31

Stefano da Verona, *Caritas*, page 34

Ercole d'Roberti, *Portrait Studies*, page 29

Giovanni Bellini, *Portrait of a Man with a Turban*, page 38

THE HIGH RENAISSANCE IN ITALY

The Renaissance was first established in Florence. Ever since the days of Dante and Giotto it was the men of this city who preached the new doctrine of humanism and, by doing so, brought freedom of thought to mankind. It was they who shaped the new period and it is their names which now epitomize it: Filippo Brunelleschi, painter, sculptor, architect and mathematician, who designed the cupola for the cathedral church of Santa Maria del Fiore in Florence and discovered the system of simple perspective; Masaccio, the founder of realistic painting; Lorenzo Ghiberti, who created the *Porta del Paradiso*, a revolutionary work of sculpture; Ghiberti's pupil Donatello, the first great realistic sculptor; Mirandola, Poliziano and Ficino, the great humanists; Lorenzo de' Medici, the banker and art patron; Niccolò Macchiavelli, the politician and political theorist; and, finally, Leonardo da Vinci and Michelangelo Buonarroti. But when the *Quattrocento* came to an end the fortunes of Florence began to decline. The economy of the city had been undermined by political disturbances; its Republican liberties were lost when Alessandro de' Medici had himself appointed Duke of Florence and its reputation as a centre of the arts was destroyed when its leading artists left the city in search of a more congenial atmosphere. From then onwards Rome and Venice gradually established themselves as the focal points of artistic life in Italy.

During the major part of the *Quattrocento* the eternal city had played only a subordinate role in the sphere of art and it was not until Sixtus IV entered upon his pontificate, which lasted from 1471 to 1484, that she began to assert herself as the artistic centre of Europe. This ambitious and ostentatious prince of the Church soon succeeded in persuading many leading Italian artists to come to Rome by offering them splendid commissions. For the decoration of the Sistine Chapel he obtained the services of the Florentine and Umbrian *élite:* Botticelli, Ghirlandaio, Perugino, Signorelli, Pinturicchio, Rosselli and Piero di Cosimo. In 1496—after Sixtus's death—the young Michelangelo arrived in Rome, where he created his first major work, the St. Peter's *Pietà*. Between 1508 and 1512, during a subsequent stay in Rome, Michelangelo painted the ceiling of the Sistine Chapel, arguably the most important work of the High Renaissance. In 1508 Raphael also left Florence for Rome, where he produced a series of works incorporating all the characteristics of High Renaissance art. They include the Vatican frescoes, the Madonnas, the portraits and the cycle of frescoes of Amor and Psyche in the Villa Farnesina. In these paintings antiquity was triumphantly revived, re-emerging in a new type of composition, where it joined with the spirit of a new age.

Throughout the whole of the first half of the *Quattrocento* Venice had adopted a reserved attitude to the Renaissance movement, largely because the influence of Byzantine art had continued to make itself felt over a far longer period of time in this seafaring Republic than in other parts of Italy. But

Donato Bramante
(1444—1516),
ST. CHRISTOPHER
AND THE
CHRIST CHILD.

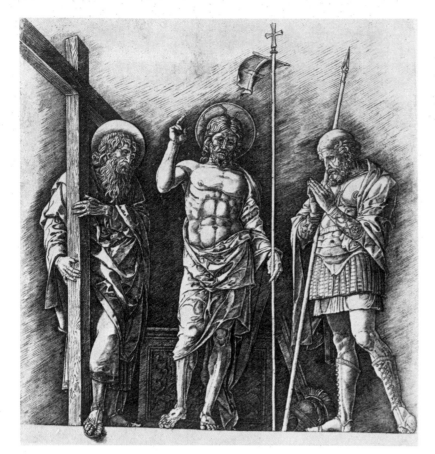

Andrea Mantegna
(c. 1431—1506),
THE RISEN CHRIST BETWEEN
ST. ANDREAS AND ST. LONGINUS.

when the Turks took Constantinople in 1453 Venice lost her Eastern market
and was obliged to enter into more extensive trading agreements with the
hinterland. This in its turn led to a more active exchange of cultural ideas
so that towards the end of the century—by which time Florence had already
ceded her position of pre-eminence to Rome—the new age also dawned in
Venice, where it produced a degree of splendour and passion quite unknown
in either Florence or Rome. The wealthy city of Venice attracted artists from
every part of Italy: Gentile and Giovanni Bellini came from Padua, Giorgione
from Castelfranco, Antonello da Messina from southern Italy and Titian
from the Dolomites. In Venice the sensual quality of Renaissance art was to
find its most perfect expression.

This change of scene coincided with the end of the secular phase of Renaissance
art. During the *Quattrocento* not only had Church architecture abandoned
the medieval conception of space as a mystical element by incorporating
antique structures, but secular architecture had been established as a com-
pletely independent discipline. The painters and graphic artists of the period
had developed the basic techniques of realism: the third dimension had been
opened up by the discovery of linear perspective and the intensive study of
nature undertaken in the fifteenth century had led to the development of
new pictorial forms capable of portraying natural objects with greater
fidelity. Over and above this, man had been incorporated into pictorial art
as an individual in his own right.

The numerous extant sketchbooks give us a very clear idea of the extremely
methodical way in which the *Quattrocento* artists tried to solve the problems
posed by this new naturalistic approach. It is therefore hardly surprising that
their works are often academic or that the artistic aspects of composition were
often sacrificed to the requirements of structural precision.

Jacopo da Empoli
(c. 1551—1640),
HEAD OF A VEILED WOMAN.

Fra Bartolommeo
(c. 1474—1517),
THE PIAZZA DELLA SANTISSIMA
ANNUNZIATA IN FLORENCE.

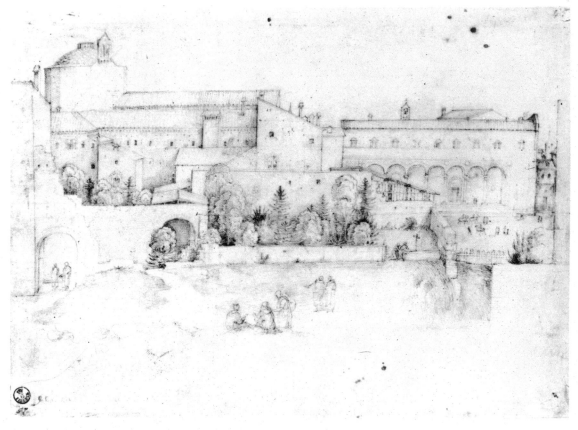

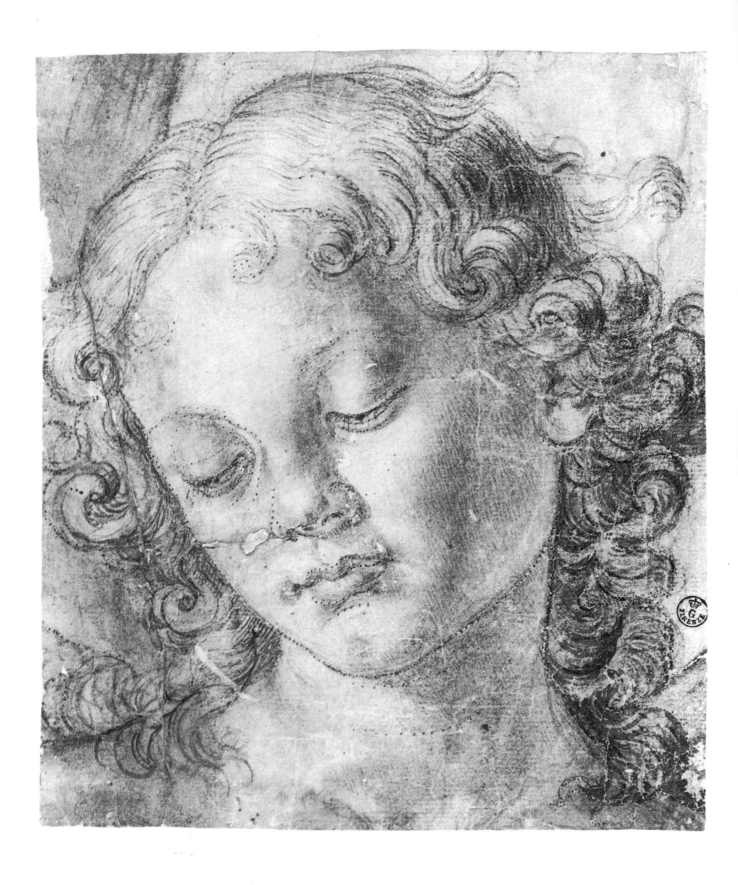

46 Andrea del Verrocchio (c. 1435—88), HEAD OF AN ANGEL.

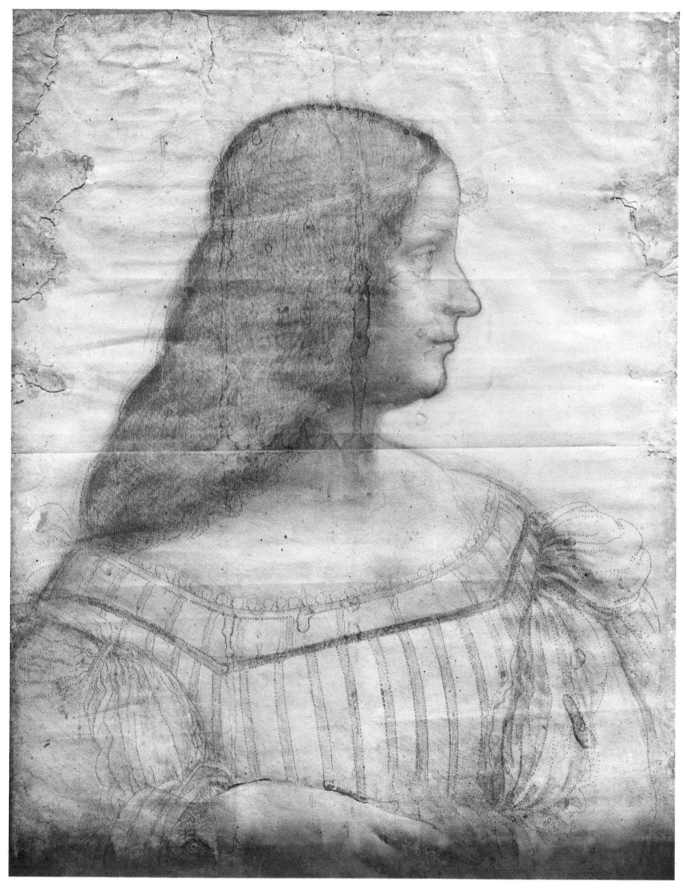

Leonardo da Vinci (1452—1519), PORTRAIT OF ISABELLA D'ESTE, DUCHESS OF MANTUA.

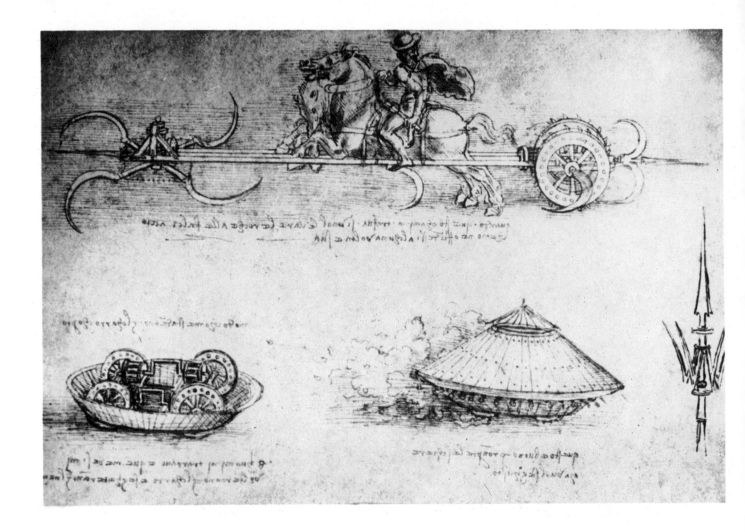

It was the artists of the High Renaissance who benefited from these endeavours, for they were able to place the knowledge gathered by their predecessors in the service of a new conception, thus raising pictorial reality to the higher level of a classical and universal ideal. And so we see that the Realism of the Early Renaissance reached its apogee when it was fused with the Idealism of the High Renaissance.

Michelangelo's development provides a good example of this general trend. He was born in 1475 and lived through the peak of the Early Renaissance in Florence as a young man. When he was thirteen years old he was apprenticed to Ghirlandaio but soon broke away from his master. Lorenzo de' Medici then took the boy under his wing and placed him in the school for young artists which he had set up in the Medici gardens and where the pupils made drawings or marble replicas of antique statues. And so from the day he entered this school Michelangelo gave up the study of nature and began learning from antique models instead. Whilst other artists of his day continued to investigate the human body by drawing from life he proceeded to evolve his ideal image of man from his own imagination. His first important sculpture, the St. Peters' *Pietà,* shows very clearly what he was aiming at. His Virgin is not a grief-stricken old woman but an extremely beautiful young girl, far too young in fact to be the mother of a thirty-three-year-old son. Michelangelo gave his own explanation of this unusual interpretation: he is supposed to have told a friend that women who are chaste keep their looks far better than women who are not and that consequently

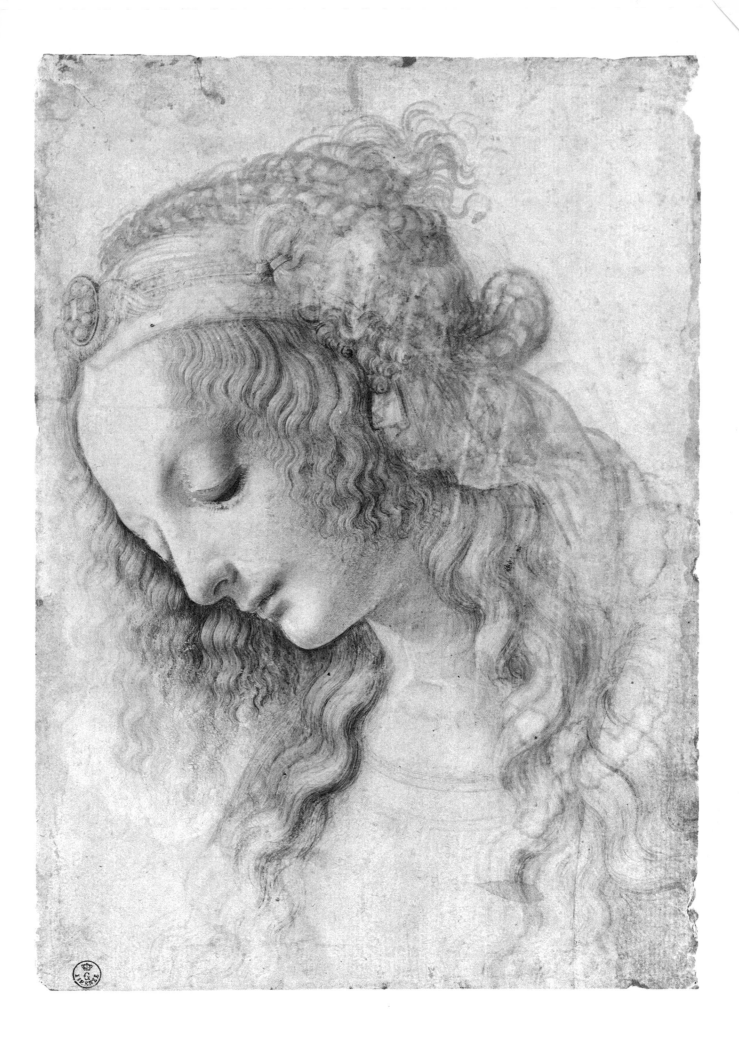

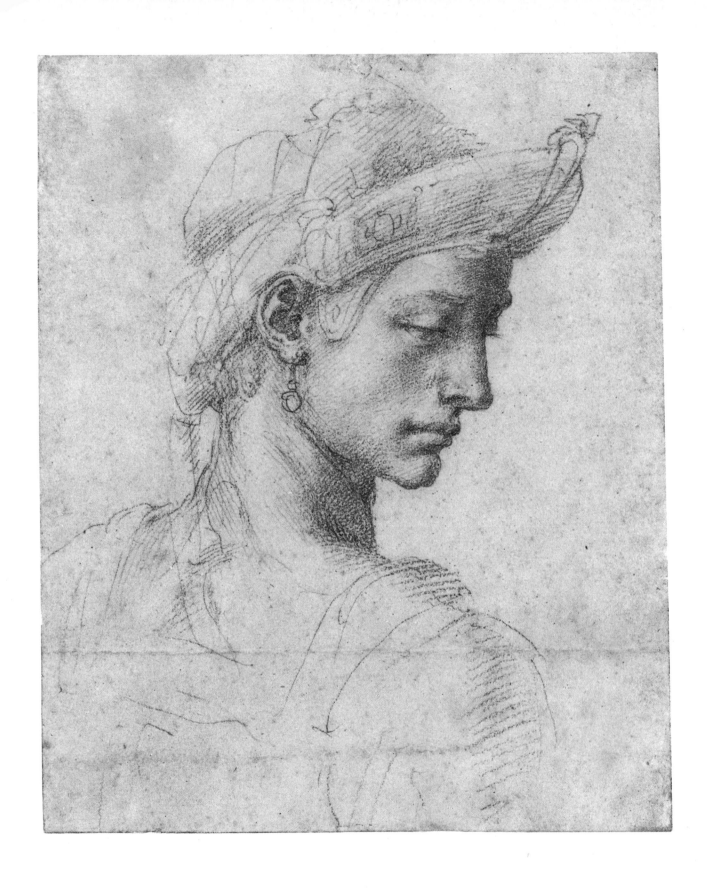

50 Michelangelo (1475—1564), IDEAL HEAD.

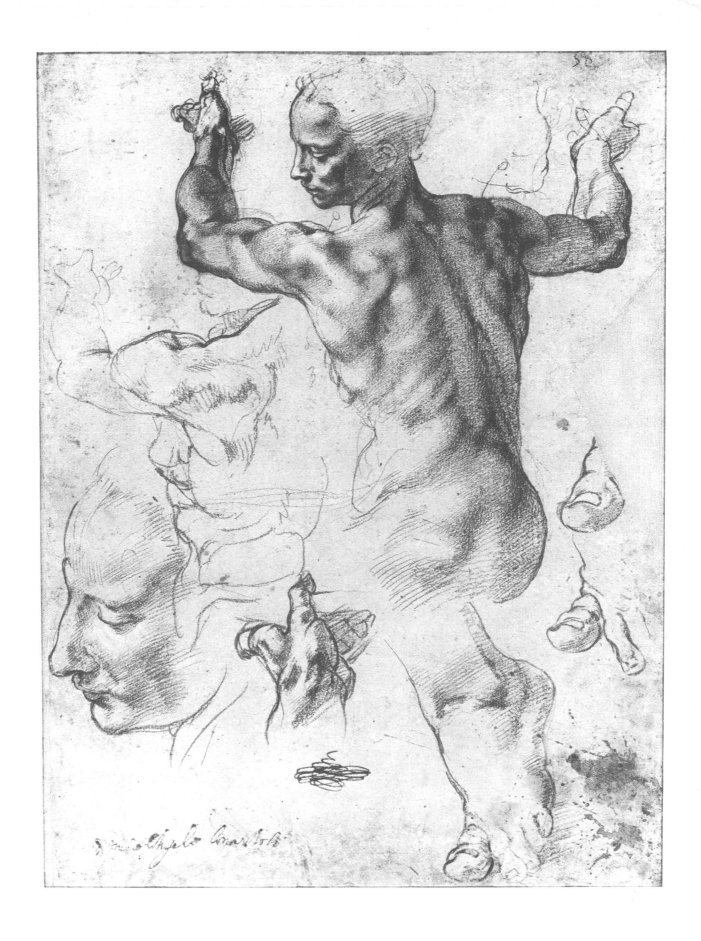

Michelangelo (1475—1564), STUDIES FOR THE LIBYAN SIBYL. 51

the Virgin Mary—who had never conceived a single sinful desire—would naturally look much younger than her years, especially since she had received divine grace in order that the imperishable purity of the Mother of God might be made manifest to the world. This approach is clearly far removed from the absolute realism to which the *Quattrocento* artists had aspired. Michelangelo's attitude constituted an attempt to realize in a work of art an ideal form that would have universal application.

It is understandable that in the High Renaissance, when men were striving to achieve a total art, in which form and content would blend in perfect harmony, little importance was attached to drawing, for the draughtsman is essentially an improviser. Even the *Quattrocento* draughtsmen had restricted themselves largely to sketches and studies, which they executed either for practice or as rough drafts for projected paintings. In the High Renaissance this was even more the case. And yet the sketches and studies which we possess from this period are of inestimable value to us, for they are a constant reminder of the fierce struggle which preceded the production of these great works of art, a fact which we are all too liable to forget when confronted with their perfection. But the very perfection of these finished works had a marked effect on the draughtmanship of the period. It too had to be perfect: improvisation was banned from the start. Consequently the drawings of the High Renaissance were not just casual notations but a conscious attempt to evolve a new artistic form. Michelangelo's studies for the *Libyan Sibyl* provide a striking example of this process.

Michelangelo,
Studies for the Libyan Sibyl,
page 51

The problem of creating an illusion of three-dimensional space in the paintings on the ceiling of the Sistine Chapel was particularly difficult and one that Michelangelo was obliged to ponder at some length. His *Quattrocento* predecessors, of course, had achieved their spatial effects primarily by means of linear perspective. But although the walls of the chapel were decorated with frescoes by leading artists of this period—including Botticelli, Perugino and Ghirlandaio—Michelangelo made no attempt to draw on their ideas. Instead he developed his own highly individual conception of space. By means of painted architecture—splendid formerets, pilasters, brickwork and arches—he created a series of large and small panels which seem to be open to the sky and have no apparent connection with the actual vaulted ceiling on which they are painted. This highly sophisticated device enabled him to create the illusion of two clearly defined pictorial spheres: the earthly sphere represented by the painted architecture and the heavenly sphere of the panels. The Prophets and Sibyls are situated at the base of the ceiling, where the curve of the vault is most pronounced, and since the Libyan Sibyl has turned sharply away from the scene, the movement of her body is diametrically opposed to the movement of the rising vault. This particular spatial effect is extremely bold and in order to be quite certain that it would be convincing, Michelangelo made a detailed study of this figure. In his study, which was executed in red chalk, the Sibyl is shown in the nude, although the finished figure on the chapel ceiling is dressed in a robe. The reason for this is quite simple: if he was to extract the maximum movement from this motif Michelangelo had to exploit the full potential of the human body. The general study enabled him to examine the tension of the muscles and skin and the shape of the bones in their relationship to one another, while further studies helped him to establish the position of the head (which was thrown back to balance the body), the foreshortening of the hand and the spread of the toes.

Giovanni Battista Rosso, also called 'Rosso Fiorentino' (1494—1540), A GROUP OF NAKED FIGURES.

The hand of the sculptor is discernible in the plasticity of this figure: the smooth, shining texture of the body is reminiscent of Michelangelo's marble surfaces and the impression created by the hatching is comparable to that produced by his sensitive chisel work. Like many Italian artists of his generation Michelangelo used red chalk for his drawings in order to give them colour. But he never succumbed to the temptation of producing his plastic effects by blurring the line, a technique that is all too easy with this soft material. On the contrary, his drawings are notable for their marked linear quality, which makes even this unpretentious study a work of art in its own right.

But quite apart from his studies, Michelangelo also produced a number of finished drawings, which were intended as presents for his friends. It is in these works, which were not undertaken as formal exercises, that he really demonstrated his outstanding powers as a draughtsman. In his *Ideal Head* a delicate outline combines with extremely fine shading—which gives a subtle plasticity to the face—and with just a hint of detail on the headgear to produce an enigmatic portrait, whose mysterious charm is heightened by its hermaphrodite appearance, for it is not really possible to tell whether this head is male or female.

Raphael, who was eight years younger than his great rival Michelangelo, was one of the most important draughtsmen of the High Renaissance. This artist, whose paintings came to epitomize the new ideal of harmony evolved in this period, also established new criteria for linear composition. Raphael the draughtsman used quite a different technique from Raphael the painter. This is immediately apparent from his pen and ink drawing of *St. George Fighting with the Dragon* for although this served as a preliminary sketch for his painting of the same name, it is a strictly graphic work. By emphasizing the outlines in this drawing Raphael fused the three component figures—rider, horse and dragon—into a corporate entity. The plasticity, which is produced by strong hatching and cross-hatching, is kept to a minimum, thus giving greater prominence to the dynamic motifs—the sinuous forms of the dragon's body, the rider's flowing cloak and the diagonal movement of the general composition. Another drawing of Raphael's, one that is quite as forceful and quite as severe, is his *Study for a Male Nude.* In this work, which may well have been the first draft for a deposition, the powerful linear composition expresses what was evidently a spontaneous idea. The artist has not lingered over detail, although this is not to say that the drawing lacks precision. Our third Raphael reproduction—his *Study for Two Goddesses*—has clearly been worked out with far greater care. Yet here too the dominant features are still linear. The plasticity of the nude body in the foreground is produced by the powerful contour and not by the rather scant shading, which plays only a minor role. This study, incidentally, formed part of the preliminary work for the frescoes in the Villa Farnesina in Rome.

Of the many artists whom Raphael copied during his stay in Florence (1504-1508) the most important was Fra Bartolommeo, the founder of the school of San Marco. The quiet solemnity of Fra Bartolommeo's religious pictures was very different from the harsh realism of the Tuscan masters of the *Quattrocento.* His classicist approach and his harmonious compositions exerted a considerable influence on his contemporaries. Fra Bartolommeo's ability to transmute ordinary everyday scenes into a poetic vision of reality is well illustrated by his pen and ink drawing of the *Piazza della Santissima*

Opposite:
Gaudenzio Ferrari
(1471/81—1546),
ANGEL OF THE
ANNUNCIATION.

Michelangelo,
Ideal Head,
page 50

Raphael,
*St. George Fighting
with the Dragon,*
page 58

Raphael,
Study for a Male Nude,
page 59

Raphael,
*Study for Two
Goddesses,*
page 60

55

Andrea del Sarto (1486—1530), HEAD OF A MAN WITH DISHEVELLED HAIR.

Sebastiano del Piombo
(c. 1485—1547),
MADONNA AND CHILD
WITH ST. JOHN

Annunziata in Florence. It was in the monastery portrayed in this drawing that Andrea del Sarto subsequently painted his frescoes of scenes from the life of St. Filippo Benizzi, which constituted one of the peaks of Florentine 'Classicism' and brought the twenty-six-year-old artist an international reputation. As a result Francis I invited him to spend a year in France and Pope Leo X commissioned him to paint a fresco for the Medici villa at Poggio a Caiano near Florence. Andrea's two drawings of a man's head were made as a study for one of the figures on this fresco. For those who know only the

Fra Bartolommeo,
*Piazza della Santissima
Annunziata in Florence,*
page 45

57

Raphael (1483—1520), ST. GEORGE FIGHTING WITH THE DRAGON.

Opposite: Raphael (1483—1520), STUDY FOR A MALE NUDE.

Andrea del Sarto, *Head of a Man with Dishevelled Hair*, page 56

smooth perfection of his painting, the forceful, almost expressionistic composition of this study is likely to come as a surprise. The carefree line reflects the wildness and the melancholy of the subject, which means that the artist consciously used his graphic technique as a means of heightening the expression.

Of all the artists whose formative years were spent in Florence but who eventually perfected their art elsewhere, the most important was doubtless Leonardo da Vinci. When he was fourteen years old Leonardo was appren-

Raphael (1483—1520),
STUDY FOR TWO GODDESSES.

Verrocchio,
Head of an Angel,
page 46

ticed to the painter, sculptor and goldsmith Andrea Verrocchio. The little angel's head is typical of what Vasari aptly described as Verrocchio's 'rather dry and hard manner'. This drawing was probably a study for the angel painted together with the young Leonardo in Verrocchio's *Baptism*, which was executed between 1470 and 1476. It is no surprise to find, therefore, that Leonardo's first independent work—*The Annunciation*—was strongly influenced by Verrocchio's realist approach, which is clearly discernible in the plasticity of the drapery and décor and the precision of the perspective. After offering his services to the Duke of Milan as a military technician and engineer, Leonardo joined the Court of the Sforza in 1481 and, when war threatened with France, showed himself to be a competent fortress engineer and invented some useful military machines. While in Milan he also worked on two of his major projects: the equestrian monument to Francesco Sforza, the father of the then Duke, and the *Last Supper*. The monument, which was to have been cast in bronze, was never completed, although a number of

Titian (c. 1487/90—1576),
DOLOMITE LANDSCAPE.

Titian (c. 1487/90—1576),
ST. SEBASTIAN.

61

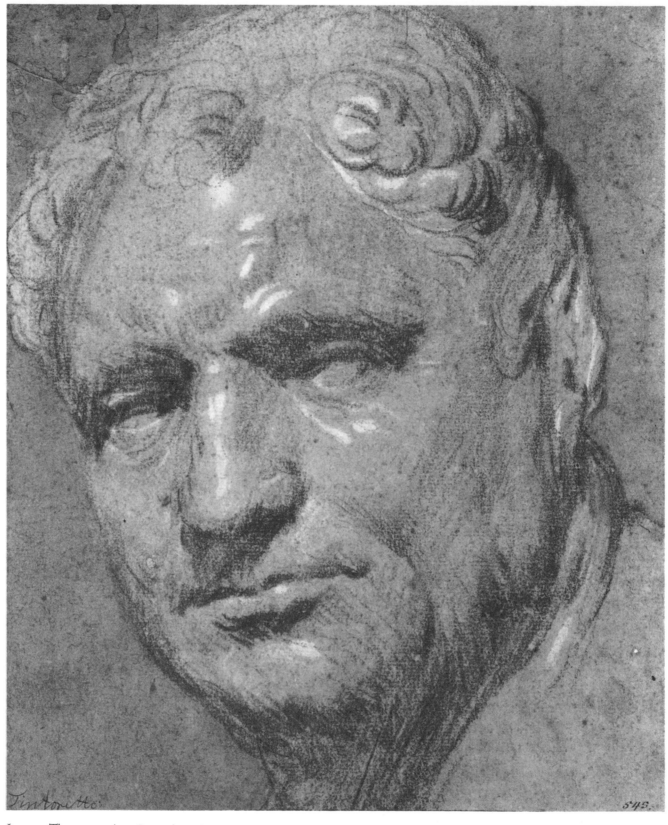

Jacopo Tintoretto (1518—94), EMPEROR VITELLIUS.

Opposite: Jacopo Pontormo (1494—1556), STUDY FOR A FEMALE FIGURE.

Above: Paolo Veronese (c. 1528—88), FESTIVE SCENE.

preparatory drawings of horses for it have been preserved, whilst the *Last Supper*—a wall painting which Leonardo executed in oils instead of fresco—quickly deteriorated. Very few of Leonardo's major paintings have survived in their original form: many were never completed, others were altered by his pupils. In fact we have learnt very little about Leonardo from his few extant paintings. His drawings, on the other hand, tell us a great deal about this 'universal man', who astounded the world not only as an artist but also as a scientist and technician.

As a natural scientist and engineer Leonardo used drawings in order to check and elucidate his ideas and also as a means of acquiring fresh knowledge. He recorded all his designs, experiments, observations of natural phenomena and scale models in diaries, which he kept in perfect—almost pedantic—order. Like the laboratory reports of a modern scientist these diary records cover every phase of his working life, a methodical approach and one that is quite indispensable for any form of systematic research. Leonardo left no less than thirteen folio and quarto volumes, which contain thousands of drawings. The technical sketch which we have reproduced shows a design (top) for a military chariot with sickles at the leading end of the shafts which are rotated by means of a gear driven from the back axle. The other design (bottom) is for an armoured car that was to be propelled by internal drive rods and was actually a prototype of the modern tank.

But apart from these technical diagrams, we also possess a very large number of drawings, in which Leonardo dealt with purely artistic problems. The profile portrait of a female head, which was executed as a study for the head of the Virgin in the small *Annunciation* (Louvre), is an example of his early work. This is readily apparent from the detail, which has been executed with

Leonardo, *War Machines,* page 48

Leonardo, *Profile of a Female Head,* page 49

loving care. The main contours, on the other hand, are extremely soft and clearly anticipate the *sfumato* technique, for which Leonardo later showed such a marked preference and which enabled him to 'dematerialize' his pictorial forms. Some fourteen years after he had completed this study—by which time he had completely freed himself from the influence of the Tuscan realists—Leonardo was in Mantua, where he made a drawing of Isabella d'Este, Duchess of Mantua. This image of an enigmatic and majestic female figure was one with which Leonardo was much pre-occupied: five years later it was to find its most perfect expression in his *Mona Lisa*.

Leonardo's painterly draughtsmanship, which followed the dictates of his artistic fantasy, won few disciples in the Renaissance. But then it was very rarely that the graphic arts were taken at all seriously during that period. This state of affairs was to undergo a marked change, however, when artists stopped idealizing reality and began to produce schematic work based on conceptual systems of thought, in other words when Mannerism was introduced. This new style constituted a complete rejection of the secular art of the Renaissance for it came to reflect the thinking of the Counter-Reformation, which was launched by the Council of Trent between 1543 and 1563. It was during the Mannerist period that Italian graphic art reached its first great peak as an independent discipline.

Jacopo Pontormo, the leading representative of the Florentine Mannerists, demonstrated his preference for narrow, elongated forms in his *Study for a*

Leonardo, *Isabella d'Este,* page 47

Page 66: Federico Barocci (c. 1535—1612), HEAD OF A MAN.

Page 67: Leandro Bassano (1557—1622), PORTRAIT OF A MAN.

Below: Francesco Parmigianino (1503—40), CIRCE ENCHANTING ODYSSEUS'S COMPANIONS.

Baroche

Female Figure, a work charged with emotional energy. In this study the figure, which was executed with very little attention to details, is surrounded by mysterious areas of shading, which impart a dull, pale gleam to the flesh. The overall impression is of a creature struggling for deliverance from the dark confines of terrestrial life. Rosso Fiorentino's *Group of Naked Figures* is another extremely macabre drawing. A cold light shines on these figures, rendering large areas of their bodies insubstantial and reducing their faces to masks with sunken, almost hollow eyes. In this work Fiorentino cleverly exploits the soft quality of the red chalk, which is admirably suited to his subject. In his chalk drawing of the *Madonna and Child with St. John* Sebastiano del Piombo, a pupil of Michelangelo, portrayed a madonna with a face that is reminiscent of the faces of his master's ideal figures. But Sebastiano's crumbling forms and dissolving contours fully justify his classification as a Mannerist. The elongated and over-refined forms of the bodies, which are matched by the elongated picture format, show quite clearly that Sebastiano was determined to move away from the Renaissance ideal of natural beauty. Jacopo da Empoli was another Mannerist artist who tried to achieve heightened emotional effects with a frugal use of line. His pencil drawing of the *Head of a Veiled Woman* is built up from contrasting graphic elements in an extremely conscious manner. The soft hatching combines with firm outlines and dark areas to produce a composition of considerable power.

Enamoured as they were of colour, the Venetians had never shown much understanding for the linear composition of the Florentines and initially they adopted an entirely negative attitude to the graphic arts. Titian's charming mountain landscape was almost certainly conceived simply as a fond reminder of his native Dolomites and it was not until Leonardo had demonstrated the painterly potential of the drawing that the Venetians had occasional recourse to the new medium. Even then, however, their approach was far from graphic, for they tended to use their pencil or chalk to produce new tonal effects. For his *Portrait of a Man* Leandro Bassano worked on coarse-grained blue paper, using coloured chalks, whose powdery texture allowed the blue ground to shine through and merge with the picture surface. Federico Barocci, a native of Urbino, was undoubtedly inspired by this virtuoso technique when he came to draw his masterly *Head of a Man*. Like Bassano he used a combination of red, white and black chalks on a blue ground. As a Mannerist, however, he preferred colder tones, which he blended with great subtlety.

But although the Venetians had lagged behind the rest of Italy in their acceptance of drawing, by the time Mannerism had been established they too regarded it as a new and unique branch of art. When asked how a man could best train himself to be an artist, Tintoretto, the most important of the Venetian Mannerists, is said to have replied that he should 'draw, draw and draw again'. He himself followed this advice to the letter: he drew from life, from little figures which he himself had modelled and from antique and contemporary sculptures. For him drawing was more than just a technical device for making rapid notations; he used it as a means of coming to terms with his subject.

And so, at the end of the Renaissance, line drawing broke away from its centuries-old subservience to painting and achieved the status of an independent discipline.

THE DÜRER PERIOD IN GERMANY

There was no parallel development in Germany to the Italian Renaissance. Any attempt to link the artistic activities of northern Europe in the fifteenth and even the sixteenth centuries with the events then taking place in Italy is doomed to failure because the sources from which the German and Italian artists drew their inspiration had scarcely anything in common. A revival of antique art forms was not feasible in the north for the simple reason that there was no Classical past on which to draw.

The *Quattrocento,* the century of the Early Renaissance in Italy, corresponded to the Late Gothic period in Germany, which brought a final resurgence of medieval art. This was not a period in which traditional and progressive factions were engaged in bitter strife. On the contrary, the fusion of the old and the new in fifteenth-century German art was effected without rancour. There was no radical, revolutionary element in Germany at that time: no Masaccio, no Donatello and no Brunelleschi. Whilst the young Masaccio was painting his Carmine frescoes, which paved the way for realist art in Italy, Master Francke was working on his *St. Thomas à Becket Altar* in Hamburg. In 1488, seven years after Verrocchio had created his equestrian monument to the *condottiere* Bartolommeo Colleone in Venice, Bernt Notke carved his precious memorial statue of *St. George Killing the Dragon* in Hamburg, Tilman Riemenschneider finished his *Lady Altar* in Creglingen—one of the major works of medieval woodcarving—in 1506, one year after Michelangelo had completed his *David* in Florence. And while Michelangelo was painting the Sistine Chapel ceiling Grünewald created his *Isenheim Altar.* In Italy the Renaissance came in with the full force of a revolution, which nobody dared seriously to oppose. In the end princes, popes and burghers actually vied with one another in their desire to glorify their century and to savour worldly pleasures. Fired by the new spirit of artistic, moral and social liberty, they completely rejected the worn-out forms of the Middle Ages and, taking antiquity as their guide, evolved a new *Lebensgefühl,* which found its highest expression in Renaissance art.

German humanism of the pre-Reformation period was a far more sober affair. It lacked the spontaneity and youthful vigour of its Italian counterpart, for the breakdown of the medieval world order had left the Germans more in a state of fear and trembling than of hopeful expectancy. They knew that they must build a new stable order by reforming the Church, the Empire and the social and economic life of the community; and their approach to this great task was both circumspect and thorough. Scholarship, education and knowledge were the weapons chosen for the renewal of the faith and they were wielded to great effect by competent representatives of the Church in combating superstition and credulity; but they were not allowed to undermine ecclesiastical dogma. However, an important factor in this new educational work was the German printing industry, which was then far and away the

69

most advanced in Europe. And along with countless editions of the Vulgate and the Bible, numerous texts by classical authors were also printed and propagated in book form. This was a significant development, for it was the publication of classical literature that provided the principal inlet for Renaissance ideas in Germany. Even more significant, however, was the fact that the printed book created new tasks for German artists: the painted miniature of the medieval manuscript was superseded by the woodcut and the line engraving. And although fifteenth-century German painting continued to vacillate between the medieval and the modern, the graphic work of this period reveals a marked trend towards the new secular art. It was in this sphere that German humanism found what is probably its most telling pictorial expression.

From the 1450s onwards the development of German painting had been hindered by reactionary forces. Many German artists were well disposed towards the secular art which had emerged in Italy, news of which had reached them long before. But there was a lack of progressive patrons prepared to lend their support. The German Church, unlike its Italian counterpart, was adamantly opposed to the new movement and its reactionary outlook was shared by the guilds, which regarded the growing individualization of art as a threat to their existence. Since the Church was still the most important patron for contemporary painters and since it placed its commissions through the guilds, between them these two institutions were able to ensure that German painting remained firmly entrenched in its craft tradition. Even in Dürer's day German artists were appreciated abroad primarily as craftsmen. 'If somebody wants an outstanding piece of work executed in stone, bronze or wood,' an Italian correspondent wrote in 1484, 'he gives the commission to a German. I have seen German goldsmiths, jewellers, masons and coach-builders produce wonderful things. They exceed even the Greeks and the Italians in their artistry.'

But, unlike paintings, drawings and prints were not subject to such restrictions. Line engravings and woodcuts—which depended for their success on the sort of craftsmanship for which, as we have just seen, the Germans were internationally renowned—were especially suitable for experimental purposes, partly because they were cheap, partly because they were produced for private individuals who made no reactionary demands. On the contrary, many of those who supported the early development of the graphic arts in Germany were humanists. Another factor which contributed to the popularization of this medium was its versatility, for both the copperplates and the wood blocks could be used for illustrating books. The young Dürer, for example, started his career in Basle by producing woodcuts as illustrations to Terence, the romance of the Ritter von Thurn and the 'Narrenschiff' of Christian Brandt. Dürer's admiration for Schongauer, incidentally, was prompted not by his paintings but by his line engravings. But to return to the print. Because it was possible to reproduce pictures in large numbers and at low cost by the graphic process the new pictorial concepts, which had entered Germany from Italy, were propagated primarily in this way. And so in fifteenth-century Germany we find ourselves confronted by the strange situation, in which the graphic arts acted as pace-maker for the other visual arts and actually helped to establish a new artistic style. This in itself explains their immense importance and also demonstrates their complete independence of painting. Woodcuts and copper engravings produced in Germany during the Dürer period

Holbein the Elder, *Death of the Virgin*, page 71

Hans Holbein the Elder (c. 1465—1524), DEATH OF THE VIRGIN.

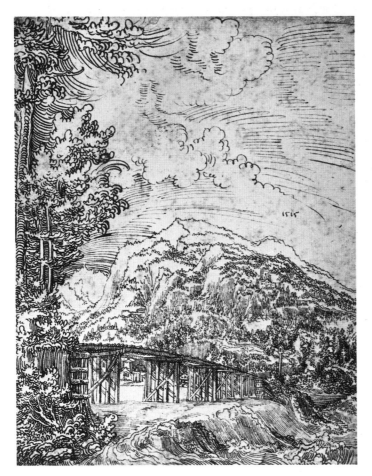

Wolf Huber (c. 1490—1553), BRIDGE LANDSCAPE.

constitute one of the peaks of graphic art in the Western world. The use of bold outlines to demarcate specific areas of colour was in complete harmony with the basic conceptions of Late Gothic painting in northern Europe. Hans Holbein's *Death of the Virgin* shows just how important the linear structure in a painting really was. This pen and ink drawing with its fascinating watercolour effects appears to have been executed in Augsburg, either by the master himself or by one of his workshop assistants. At the time it was by no means customary for an artist to subordinate painting to drawing. But in this particular case the hand of the draughtsman is indubitably the dominant factor: the colour is entirely subservient to the linear composition and was not intended to create a painterly effect. In fact the impression would be essentially the same if it were reproduced in a black and white version. And so despite the Late Gothic angularity of the figures and drapery, the drawing is none the less

Albrecht Altdorfer (c. 1480—1538), SARMINGSTEIN ON THE DANUBE.

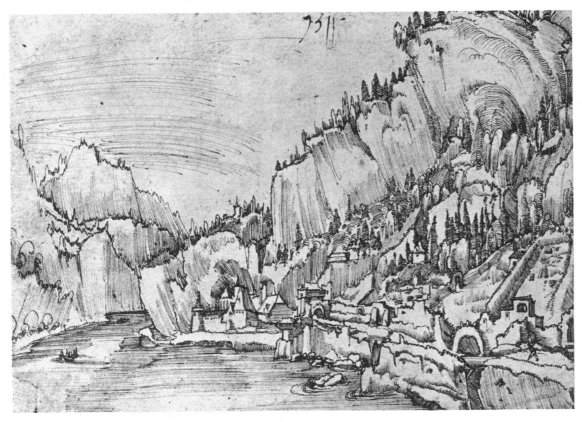

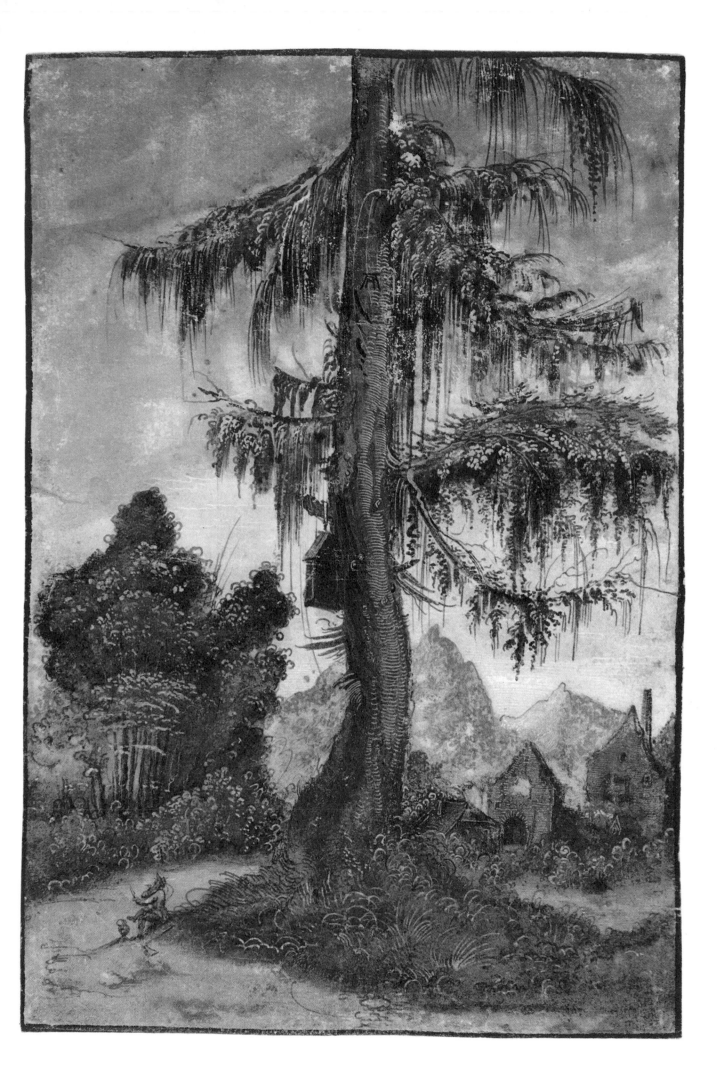

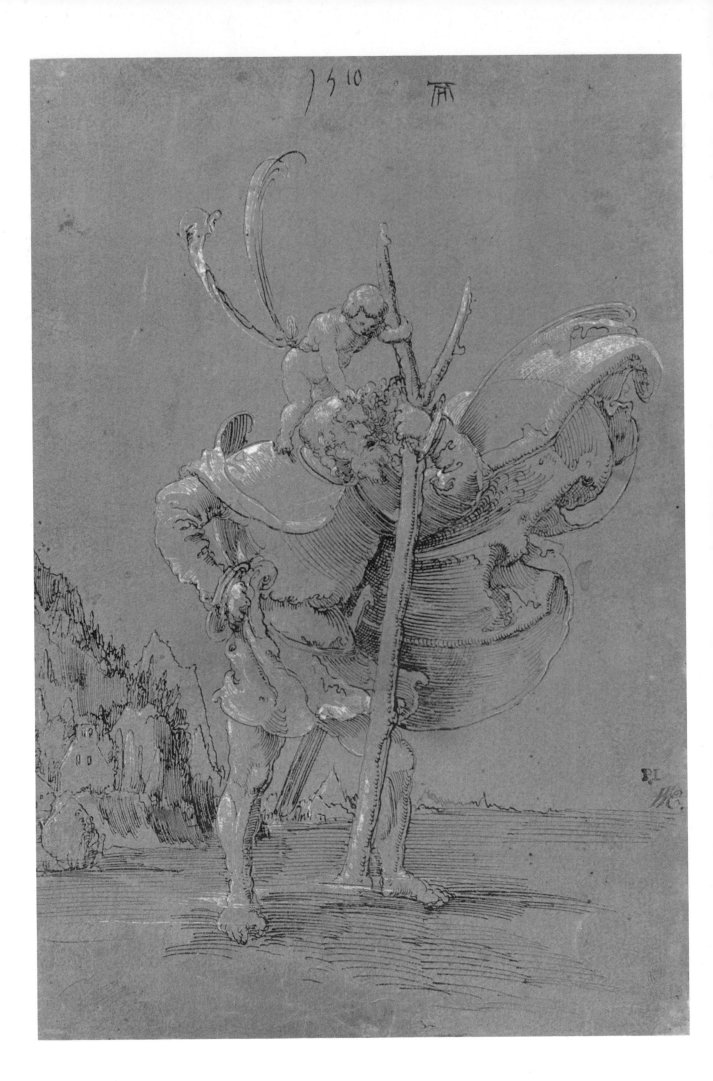

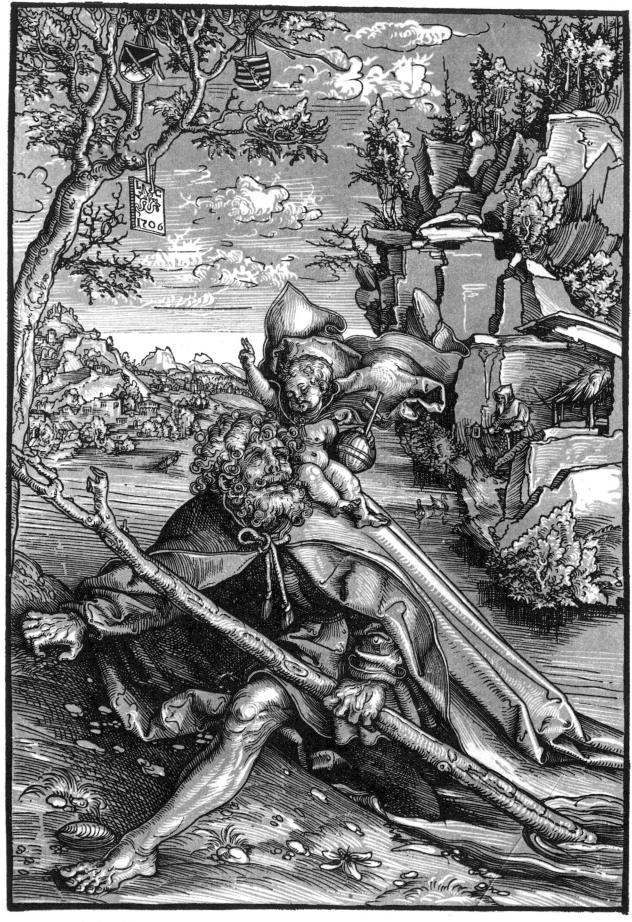

Lucas Cranach the Elder (1472—1553), ST. CHRISTOPHER.

Opposite: Albrecht Altdorfer (c. 1480—1538), ST. CHRISTOPHER.

Page 73: Albrecht Altdorfer (c. 1480—1538), THE LARCH.

'modern' by virtue of its structural simplification, in which the plasticity of the pictorial forms is reduced to an essentially graphic *schema*, a feature that is characteristic of all graphic art in the Dürer period.

Holbein the Elder was a native of southern Germany, which steadily asserted its supremacy over the established art centres of Bohemia, Cologne and northern Germany during his lifetime. The physical proximity of Italy contributed to this process, for the close trading relations between the two territories encouraged intellectual and artistic contacts. With the growing wealth of the south German cities local artists also began to receive big private commissions, which made them more and more independent of their traditional employers, the Church and the guilds. And so they acquired personal prestige and respect, where previously they had been engulfed in the great mass of anonymous masters. As a result their names were recorded in documents and they also began to sign their works. Lucas Moser of Ulm, Konrad Witz of Rottweil, Hans Holbein of Basle, Hans Burgkmaier of Augsburg, Albrecht Altdorfer of Regensburg, Wolf Huber of Feldkirch and Martin Schongauer of Colmar were all working in south Germany in the fifteenth or early sixteenth centuries. We would look in vain for equally illustrious names in north Germany during the same period.

The landscape was introduced into Italian painting in about 1400 and into German painting some fifty years later. It was quickly found to be indispensable, since it provided an all purpose backcloth with which to extend pictorial space, and it was used from then onwards, not only in religious scenes, but also in histories and, occasionally, portraits. Initially of course such landscapes were highly idealized and bore no resemblance to external reality. In fact they were intended to reflect and enhance the transcendental action taking place in the foreground. And so, during its early phase in Western art, the landscape was simply an indeterminate scene, a backcloth, a means of indicating distance. Strangely enough the landscape proper—the representation of a natural scene for its own sake—was not discovered by a painter but by a draughtsman. It was in 1494 that the twenty-three-year-old Albrecht Dürer walked outside the west gate of his native town of Nuremberg and made sketches of the *Wire-drawing Mill* in the picturesque setting formed by the river, the green meadows and the undulating hills. At home in his studio he used these sketches to paint his celebrated watercolour, which was the first genuine landscape in European art. The sketches, which have since been lost, must have been extremely accurate for, although the mill no longer exists, it has been possible to establish its precise location from the watercolour. In the top left of the picture we see the Spitteler Tor, which was the west gate of the city, the small church in the centre immediately behind the meadows is St. Leonhard, and the meadows themselves—which still exist today—are the Hallerwiesen. Despite slight errors of perspective in the timber-framed houses, the path and the low wall, the picture creates an impression of great immediacy: the sunless sky common in our latitudes provides a light which gives no hint of pathos and which, while subduing the colours and precluding artificial shadow effects, none the less affords a clear view of the distant scene. It is a completely natural description without conceptual overtones. Four years later, after his visit to Italy, Dürer painted his *Mill by the Willow*. The distinctly painterly quality of this landscape bears out Panofsky's observation to the effect that 'after his return he saw his native land with different eyes'. The iridescent colouring of the evening sky, the gentle re-

Dürer,
The Wire-drawing Mill,
page 90

Opposite:
Lucas Cranach the
Elder (1472—1553),
FOUR DEAD PARTRIDGES.

Dürer,
Mill by the Willow,
page 91

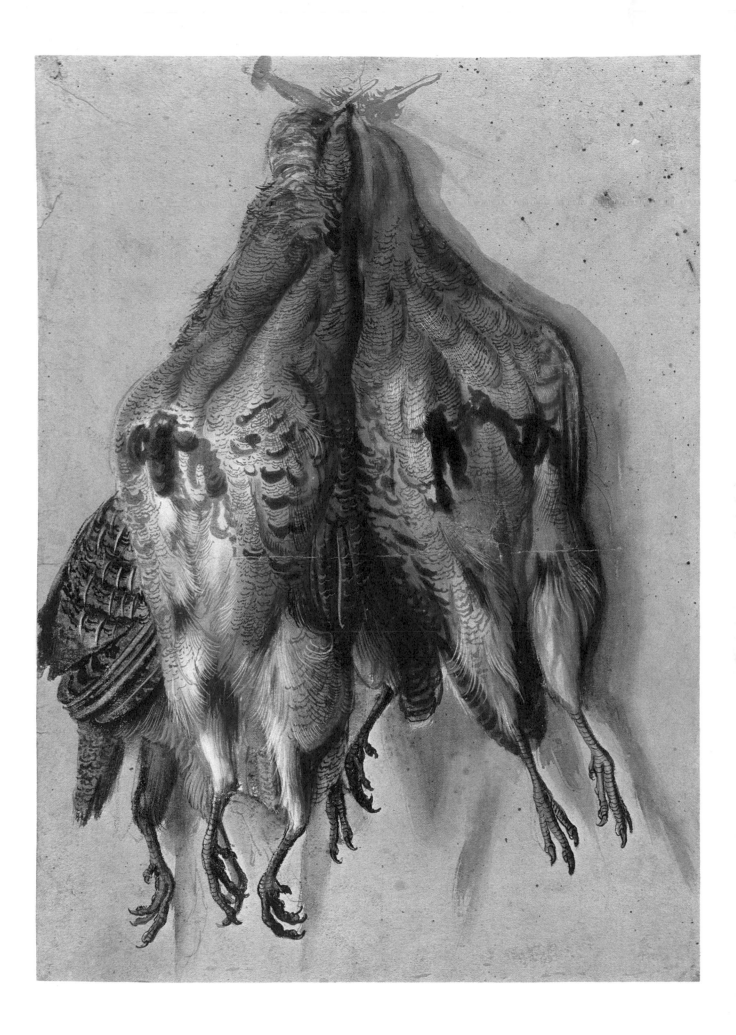

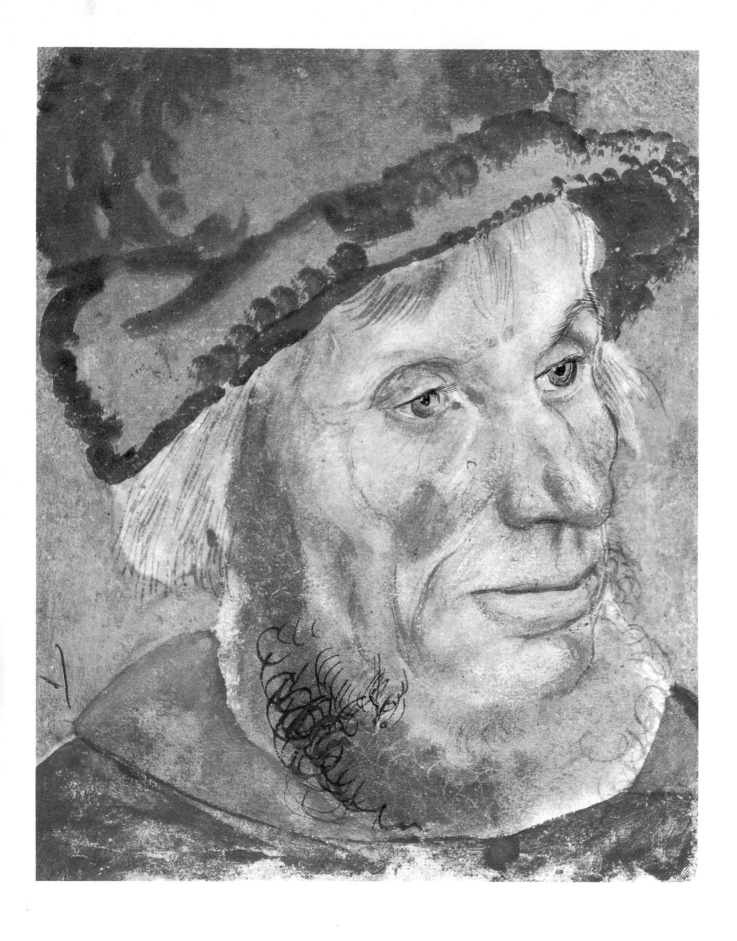

Lucas Cranach the Elder (1472—1553), HEAD OF A HUNTER.

flections in the water, the silver glow on the roofs and trees and the overall brightness of the palette show just how freely Dürer was now prepared to indulge his artistic fantasy in his landscapes.

But the highly poetic quality of the watercolours and gouaches which Dürer produced from the turn of the century onwards was eclipsed by the masters of the Danube School, whose romantic landscapes were virtually acts of devotion. In these works thought and observation, nature and fantasy go hand in hand. In his small brush drawing *The Larch*, Albrecht Altdorfer, the principal representative of this school, created the sort of scene that any walker might encounter when he emerges from a forest and suddenly finds himself faced with a panoramic view of the surrounding country: a bright, high sky, distant mountains tinted blue by the mist, and wide open spaces. But although at first sight this picture seems to be no more than an artist's spontaneous impression of a natural scene, in fact it is much more than this. It demonstrates the essential vanity of human existence and human endeavour. By comparison with the enormous larchtree, which rises up beyond the picture frame and appears to be ascending into infinity, the woodcutter seems like a midget. The two mountains in the background match the two houses in the foreground, both in layout and in shape. But whereas the mountains rise up in solemn grandeur, the houses stand in ruins, a perfect symbol of man's insignificance and mortality. And from the branches of the larchtree hang long rushy strands, which seem to underline this melancholy view of the world. Altdorfer's pen and ink drawing of *Sarmingstein on the Danube* is not a straightforward landscape either. It has nothing in common with Dürer's realistic portrayal of the *Wire-drawing Mill*. On the contrary, it is a transmuted landscape, one that owes as much to the artist's imagination as to the original scene on which it is based. This is immediately apparent from

Altdorfer,
The Larch,
page 73

Altdorfer,
Sarmingstein on the Danube,
page 72

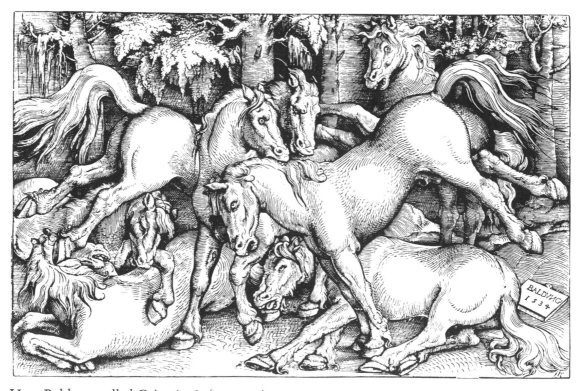

Hans Baldung, called Grien (1484/5 — 1545), FIGHTING STALLIONS.

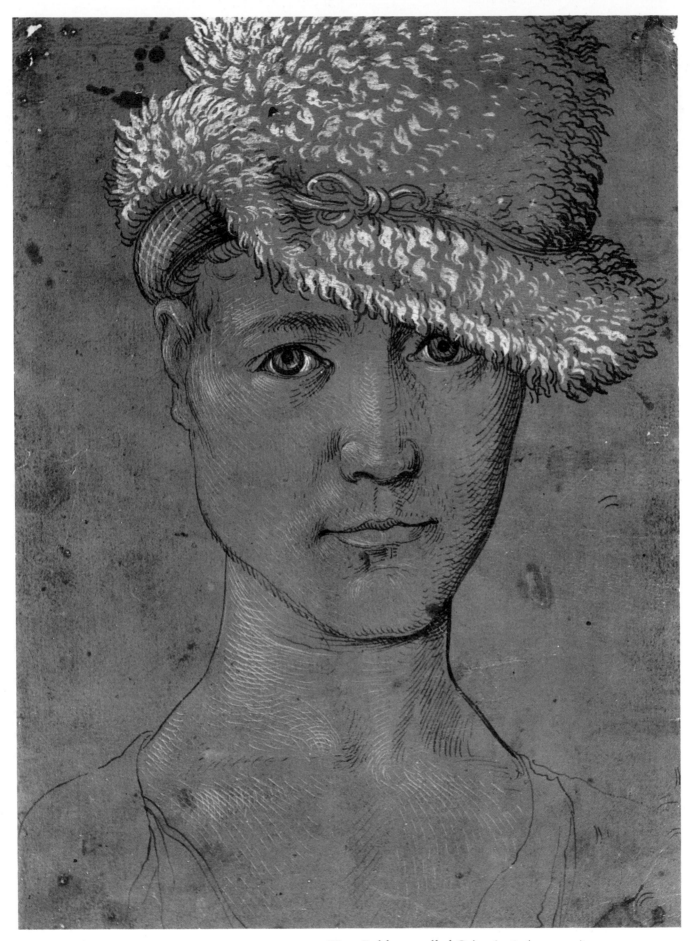

Hans Baldung, called Grien (1484/5—1545), SELF-PORTRAIT.

Hans Leu the Younger (c. 1490—1531), MOUNTAIN LAKE.

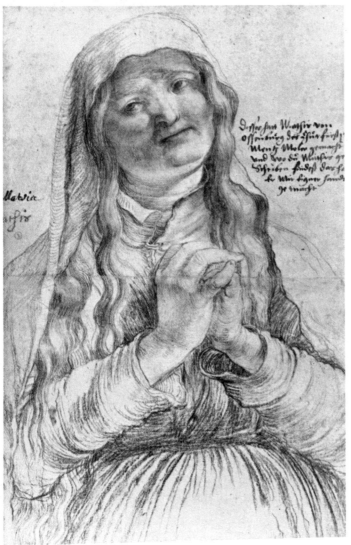

Grünewald (c. 1470/80—1528), MIDDLE-AGED WOMAN
WITH CLASPED HANDS.

the angle of the drawing, for the vantage point actually lies on the river. The vertical line of the rocks and trees in this work creates an impression of monumentality so that here too the human figure is dwarfed by natural forms. But in other works of Altdorfer's—for instance, his *St. Christopher*—nature is itself dwarfed by a superhuman figure. In this particular drawing the mighty earth spirit towers above the natural scene and is subject only to the directions of the infant Jesus, who stands on his shoulders. The fantastic quality of the scene is achieved by extremely impressive graphic techniques. The uniform turquoise ground provided by the tinted paper sets the mood and also subdues the bold outlines of the pen-and-ink composition. The gleaming white highlights impart a sense of macabre excitement. But the principal movement stems from the horizontal lines, which run from the Saint's body to the outer edge of his billowing cloak, where they enter into the strangest convolutions. This activity is further reinforced by the dynamism of the arabesques, which loop upwards from the waist of the infant Jesus and whose open-ended structure is reflected in the forked prongs of the Saint's staff. A com-

Altdorfer,
St. Christopher,
page 74

Bramante,
St. Christopher,
page 43

Huber,
Bridge Landscape,
page 72

parison between this *St. Christopher* and the silver-point drawing of the same subject executed by Bramante, an older Italian contemporary of Altdorfer's, illustrates the fundamental difference between the German and the Italian approach. In the Bramante we find a complete demystification of the supernatural element, which stems from the plasticity and realism of the figures, whereas in the Altdorfer specifically graphic techniques are used to produce a poetic transfiguration of this mythical subject.

But not all of the members of the Danube School were as poetic. The landscape drawings of Wolf Huber, one of the lesser masters working in this style, are comparatively realistic. Although he was well aware of the strange effects that could be produced by the use of transparent graphic structures, he tended to devote far more attention to detail. Whereas Altdorfer would depict the sky with just a few casual strokes, Huber filled it with row upon row of fleecy clouds, as in his *Bridge Landscape*. In this drawing every detail of the trees—even of those in the background—is clearly discernible, a feature that is never found in Altdorfer's work, where the whole emphasis is on simplification. Hans Leu the Younger, who was a native of Zürich, introduced

Grünewald (c. 1470/80—1528),
ST. DOROTHY.

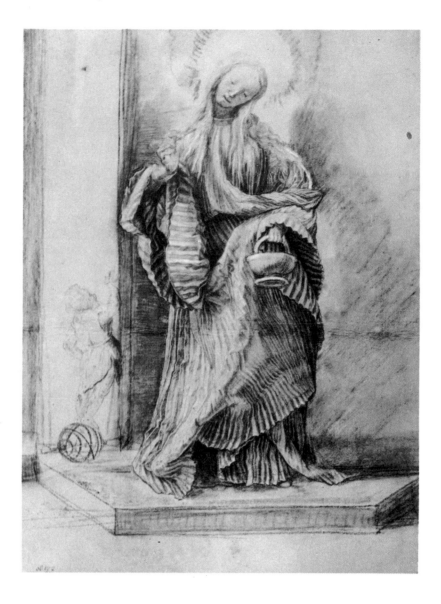

positively demonic motifs into his *vedute*. The macabre mood of his *Mountain Lake* derives above all from the combination of a deep olive ground and the liberal application of body colour. He used an ink wash for the strange grotto-like rock structure in the foreground, whose vague uncertain forms contribute to the general air of magic. Leu, who had a predilection for this kind of chiaroscuro drawing, is now thought to have spent his early years in Hans Baldung's workshop, which would explain his mystical leanings. He would also have been acquainted with Altdorfer's landscape drawings and Dürer's woodcuts.

Leu the Younger, *Mountain Lake*, page 81

Hans Baldung, a native of south-west Germany, was probably employed in Dürer's workshop as a young man, where he may well have acquired the nickname 'Grien', which was given to him because of his marked preference for the colour green. His *Self-Portrait* casts considerable light both on his personality and on his art. The bold self-assurance with which he looks the viewer full in the face is heightened by the economical but vivacious handling. The reflected light adds to the expressiveness, as do the shadows on his left cheek and the tongues of fur on the hat, whose colour changes abruptly from white to black. The animated, youthful face is as challenging as the masterly use of line. In this drawing we are confronted with a new type of man, one who was prepared to shape the world to his own ends and held no

Baldung, *Self-Portrait*, page 80

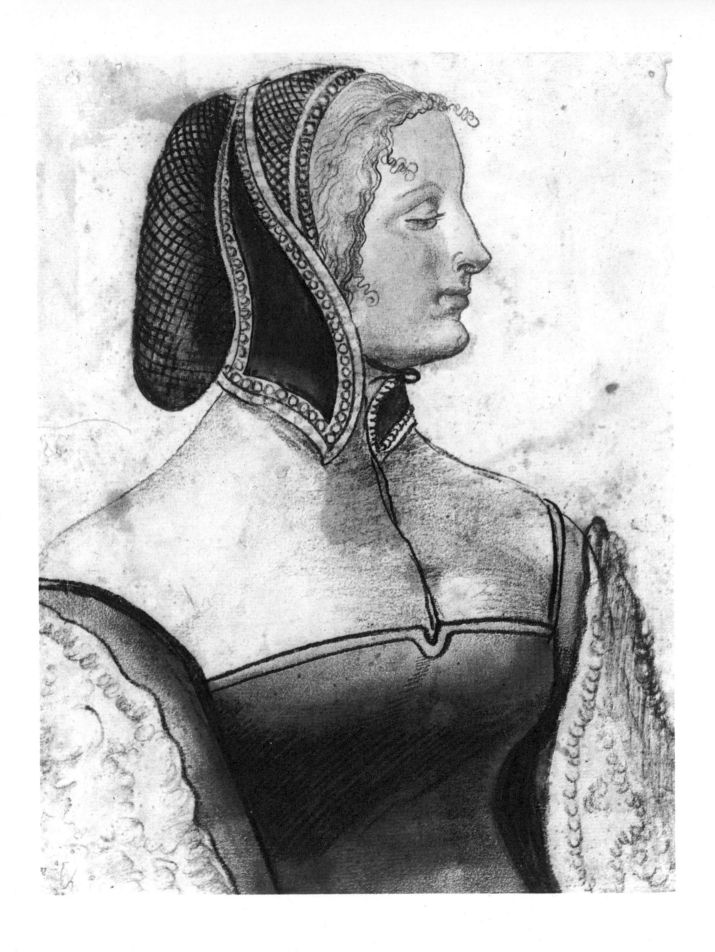

Niklaus Manuel Deutsch (c. 1484—1530), PROFILE PORTRAIT OF A (BERNESE) WOMAN.

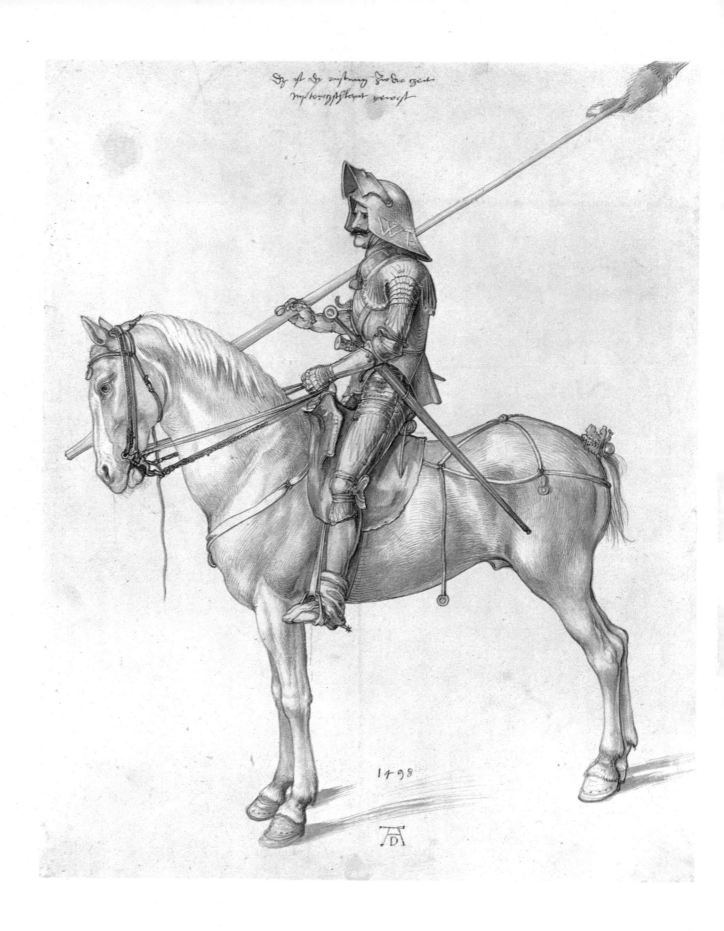

Albrecht Dürer (1471—1528), THE RIDER.

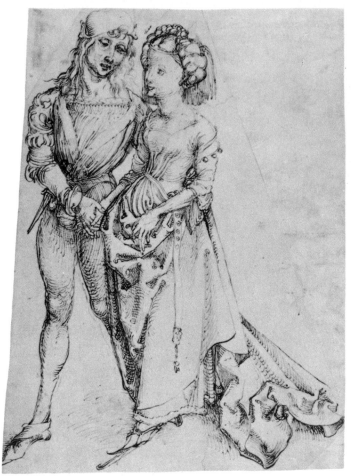

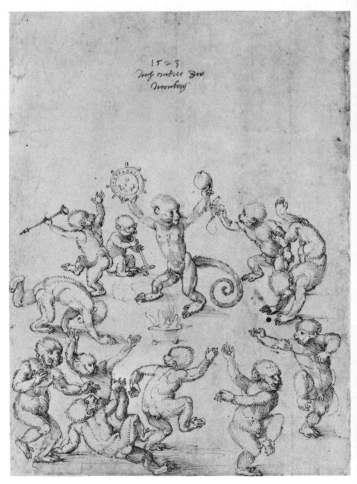

Albrecht Dürer (1471—1528),
PAIR OF LOVERS.

Albrecht Dürer (1471—1528),
MONKEYS' DANCE.

brief for the stagnant forms of a worn-out tradition. And, in point of fact, Baldung refused to subject his work to any restrictions whatsoever, either formal or thematic. He paid tribute to the sensual beauty of the nude female body in numerous allegorical paintings, portraying it with the sort of attention to anatomical detail that we might expect from a pupil of Dürer's but without incorporating the slightly pedantic realism of his great mentor. In his religious painting Baldung had constant recourse to secular motifs while in his portraiture he revealed searching powers of observation. In making the transition to the modern period Baldung was doubtless helped by his upbringing, for he was the first German artist to come from a humanist family with academic leanings.

Like Hans Leu, Niklaus Manuel Deutsch was one of the south German artists influenced by Baldung. Deutsch was a native of Berne and, although as a graphic artist he does not even begin to compare with Baldung, he had an undeniable talent for characterizing the human face. The dress and posture of his *Bernese Woman* are a model of decorum, but there is an expression of pride and self-will in the face, which is as dangerous as it is attractive. This type of woman featured in many of Manuel's paintings and drawings, for example, as Lucretia and as the woman tempting St. Anthony.

Lucas Cranach was another of the undogmatic artists of this period who was well versed in the ways of the world. He never placed his art in the service of a particular idea. On the contrary, he had a completely catholic taste, to which he gave full rein. If an idea moved him, then no matter where it came from, he would seize on it without hesitation and work on it until it

Manuel Deutsch,
Bernese Woman,
page 84

answered his artistic purpose. Because he was so open to the world it has often been suggested that he lacked integrity, because he was so productive he has been accused of personal greed, and because his repertoire was so wide it has been said that he had a superficial mind. In actual fact, he was simply a very fast painter, as is evident from his two watercolours of partridges and the head of a hunter. This head was almost certainly dashed off on the spur of the moment, for the paint was clearly applied in haste—albeit with great skill—and, where necessary, Cranach went over the work with his pen to bring out the form. But any carelessness in the handling is more than made up for by the vivacity of the expression. As for the still life, here Cranach displayed a degree of virtuosity unusual in his day. After marking out the bodies of the dead partridges in bold outlines he painted in the plumage, creating an extremely convincing overall effect but without attempting to reproduce the detail in precise and realistic terms. All that interested him was that the general impression should be convincing, and in this he undoubtedly succeeded. In this watercolour Cranach almost anticipates the Baroque still life.

Cranach the Elder, *Head of a Hunter,* page 78

Cranach the Elder, *Four Dead Partridges,* page 77

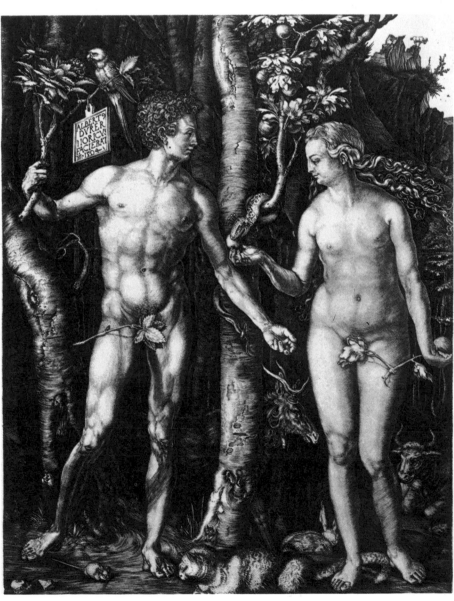

Albrecht Dürer
(1471—1528),
ADAM AND EVE.

Albrecht Dürer (1471—1528), TALL GRASS.

Albrecht Dürer (1471—1528),
PORTRAIT OF THE ARTIST'S
MOTHER.

German graphic art reached its peak in the work of Albrecht Dürer. He established new criteria for the woodcut, the copper engraving, the water-colour and the line drawing. The line was Dürer's weapon and none of his contemporaries equalled him in its use. Even the proud Italians were aston-ished by his *bravura* whilst Erasmus of Rotterdam was almost fulsome in his praise: 'You ask what Dürer, this man who is so admirable in every way, is able to express with his black lines? He makes precise observations of the symmetries and harmonies. And for this reason he is able to paint things which cannot really be painted: fire, rays, thunder, lightning, the senses, all the moods, in fact the whole of man's soul lighting up in the vestment of his body. It would take very little and he would paint the human voice. He presents his work in such a fortunate manner, all in black lines, that it would be a sacrilege if anyone were to try to colour it.'

Dürer began his artistic career as a goldsmith in his father's workshop. There he learnt to draw with pencil, pen and charcoal and also became expert in handling the burin. Before long these skills were to prove extremely valuable, for on his travels Dürer visited Basle—then a centre of humanism—where he was commissioned to execute various woodcuts. Although he was only nineteen years old at the time Dürer had already evolved a virtuoso technique which enabled him to dispense with the hard, angular line of the Late Gothic

Albrecht Dürer (1471—1528), THE WIRE-DRAWING MILL.

Albrecht Dürer (1471—1528), MILL BY THE WILLOW.

Albrecht Dürer
(1471—1528),
THE APOCALYPSE.

Dürer,
The Apocalypse,
page 92

92

woodcut and to replace it by a more natural style capable of satisfying the new popular demand for realistic compositions. But the secular book illustrations which he executed in Basle were only the beginning of Dürer's career as a woodcut artist. It was when he realized that the woodcut lent itself to the portrayal of the supernatural that he produced his really mature works in this medium. In the fifth print of the *Apocalypse* (the opening of the sixth seal) the visionary quality of the scene derived from the explosive dynamism of the abstract linear *schema*; here Dürer was able to use the unreal quality of the graphic line as the meaningful element in the composition.

When he wanted to portray secular themes Dürer usually had recourse to copper engravings. With their greater delicacy they were better suited to the presentation of detail and the creation of modelled forms. And yet in his engravings Dürer did not violate the essentially linear structure of the composition, as is apparent from his *Adam and Eve*. Here the whole design remains transparently clear and beautifully ordered, even where the lines are closely packed. At the same time the variation of texture is quite fascinating: the soft, smooth glow of the naked flesh is offset by the hard, cracked bark of the trees while the skins of the animals and the snake and the plumage of the bird, which Dürer reproduced with complete fidelity, provide a whole range of contrasting surfaces. The precise observation of nature, which is subordinated in this print to the ideal representation of a perfect man and woman, becomes a theme in its own right in Dürer's *Tall Grass*. Here a German artist set out to discover and recreate the world in the true spirit of the Renaissance. A tiny piece of nature, chosen at random, has been transformed into a work of art. The lower section of the composition is tightly

Dürer,
Adam and Eve,
page 87

Dürer,
Tall Grass,
page 88

Albrecht Dürer
(1471—1528),
PORTRAIT OF A
YOUNG GIRL.

Hans Holbein the Younger (1497/8—1543), CHARLES DE SOLIER, SIEUR DE MORETTE.

Lucas Cranach the Younger (1515—86), PORTRAIT OF PRINCESS ELISABETH OF SAXONY.

packed and gives an impression of nature in its wild state. But the individual stalks and blades of grass that rise up from this dense undergrowth stand out in relief against the luminous backcloth of the sky, forming a delicate pattern in which clarity and order prevail. Because of the 'frog's-eye view' that is imposed on the viewer, what would normally have been an insignificant motif, gains in stature, enabling us to experience the wonder of nature in its original complexity and order, both as an intellectual and as a sensual phenomenon.

The immediacy of man's experience of nature, which Dürer depicted both in his large-scale landscape of the *Wire-drawing Mill* and in this small-scale view of *Tall Grass*, found its ultimate expression in his treatment of the human face. In his *Portrait of a Young Girl* he made no attempt to introduce any external trappings: the girl's habit is completely restrained and so too is the graphic technique (black chalk on a tinted ground), a combination which greatly enhances the expression of shyness and introversion. But of all Dürer's drawings the one of his mother which he made just a few weeks before her death, is far and away the most impressive. It seems quite incredible that he should have been able to impart such radiance to such an old and twisted face. But the words in which Dürer invoked his mother's memory cast some light on his enigma: 'She never knew good health following my father's death [1502] . . . and I cannot adequately praise her good works, or the charity which she extended to one and all, or her good name. This mother of mine bore and bred eighteen children, she often had the plague and many other strange illnesses, she suffered great poverty, mockery, derision, scornful words, terrors and great tribulations, yet she was never vindictive . . . In death she looked far more lovely than she had looked in life.' There is no other portrait of this period in which the human quality makes such an immediate impact. After five hundred years Dürer's drawing of his mother is still capable of moving the viewer with all its original force.

Only a few decades after Dürer had made these portrait drawings Hans Holbein the Younger took over his spiritual conception of man and proceeded to carry German portraiture to its highest peak. Holbein observed his models with seemingly detached objectivity, painting or drawing them in their characteristic environment, usually in a three-quarters view. His portrait of Sieur de Morette was painted during Holbein's second visit to England. This study shows (as does the later painting) an extremely careful portrayal of the various aspects of Morette's countenance. Morette, who was French ambassador to England, was as famous for his intelligence as he had been for his bravery in war as a young man. Holbein recognized in him the traits of goodness and warmth while doing justice to the dignity of his appointment as Francis I's envoy through the severe frontal view and noble bearing.

Dürer, *Portrait of a Young Girl,* page 93

Dürer, *The Artist's Mother,* page 89

Holbein the Younger, *Charles Solier, Sieur de Morette,* page 94

THE GREAT PERIOD
OF NETHERLANDISH ART

Lucas van Leyden's charming little line engraving of the *Milkmaid* was made in 1510, almost a hundred years before the artists of the Netherlands began to specialize in genre scenes. In this engraving van Leyden created a rustic idyll without any of the false pathos or ideological overtones that were so characteristic of contemporary Netherlandish art. He was undoubtedly influenced by Dürer, whose new engraving technique had aroused great interest, not only in Germany, but in Italy and the Netherlands as well.

We have already seen that the development of the new graphic art forms was one of the factors which contributed to the dissemination of new ideas and techniques. Because line engravings and woodcuts were so cheap, artists and collectors alike could now afford to buy prints from the various European art centres, which meant that northern artists were able to learn from the Italians and vice versa. There were of course other ways in which this extremely benefical exchange was carried on. For example, educational visits to Italy became fashionable, and those artists who undertook them not only acquired new ideas from their host country but were also instrumental in

Lucas van Leyden
(1494?—1533),
THE MILKMAID.

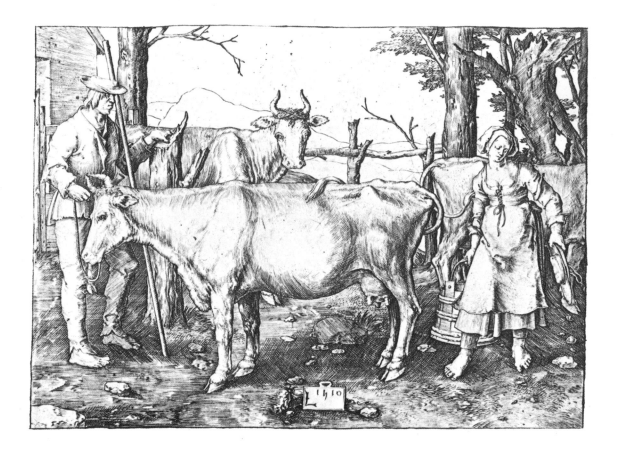

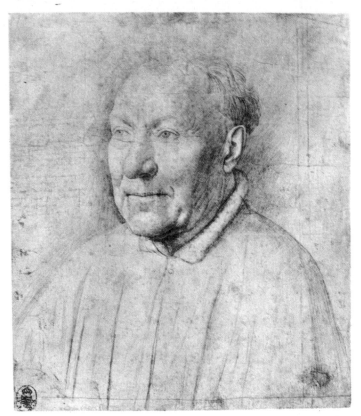

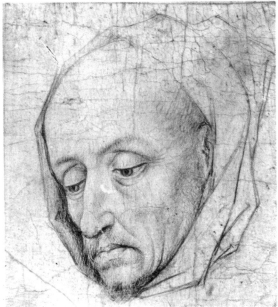

Rogier van der Weyden (1399/1400—64),
HEAD OF AN OLD MAN.

Left: Jan van Eyck (c. 1390—1441),
PORTRAIT OF CARDINAL NICCOLO ALBERGATI.

introducing northern ideas into Italy. Not infrequently they left works behind them which influenced the native artists. Returning Italian merchants and diplomats also brought paintings or prints home with them, many of which were greatly admired. One such was the altarpiece painted by the Flemish artist Hugo van der Goes. This work had been commissioned by Tommaso Portinari, the Medici's representative in Bruges, and when it was installed in Florence it created a minor sensation. Ghirlandaio, the great *Quattrocento* master who had taught Michelangelo, used it as a model. And then there was the *Madonna of the Rose Garlands* which Dürer painted for the German merchants in Venice in 1506 and which so impressed the Venetians that they offered him a fixed income if he would agree to make his home in Venice. At the turn of the fifteenth and sixteenth centuries the artistic life of central Europe was distinctly cosmopolitan. Rarely had cultural exchanges been so unimpeded by national frontiers.

This freedom was particularly beneficial for a small country like Holland, which depended on economic and cultural exchanges for its very survival. Netherlandish artists had always been extremely susceptible to outside ideas. It was at the court of the Duke of Burgundy that the van Eyck brothers were introduced to the French illuminated manuscripts. They immediately recognized the significance of the secular miniatures and since there was no contemporary French artist capable of exploiting this field and applying the discoveries of the medieval miniaturists to the larger medium of panel painting, it was left to the Netherlander Jan van Eyck to do so. He succeeded in creating a uniform style based on the wide range of pictorial forms used by the miniaturists and so became the founder of realistic painting in northern Europe. Thanks to him the Netherlands assumed the position previously held by France. But van Eyck's realism had nothing in common with the kind of realism evolved by the Italian masters of the early Renaissance. This is quite clear from his silver-point drawing of *Cardinal Niccolo Albergati*, which antedates

van Eyck,
*Cardinal Niccolo
Albergati,*
page 98

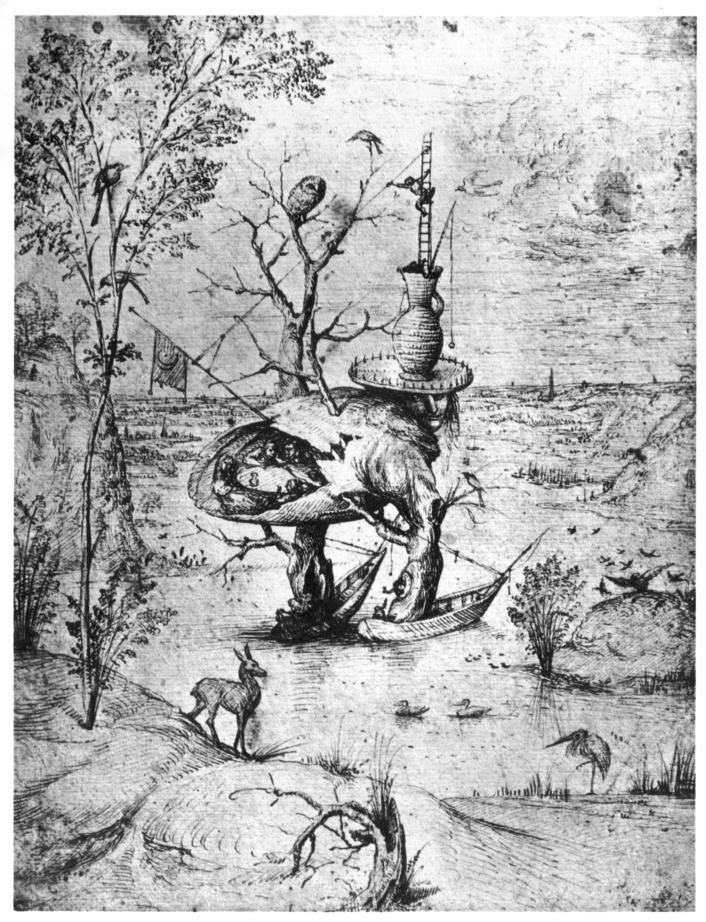

Hieronymus Bosch (c. 1450—1516), THE HUMAN TREE.

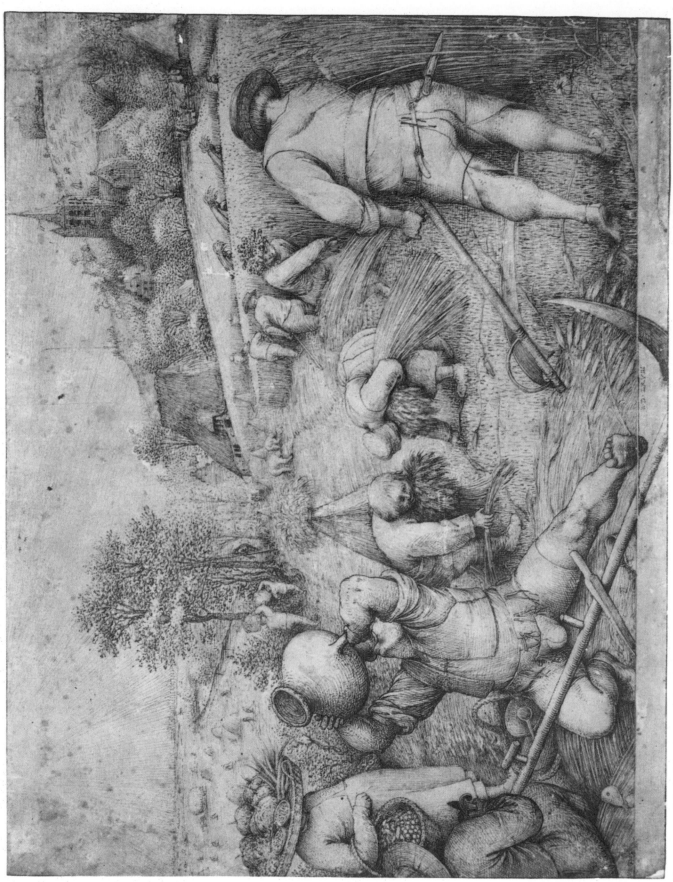

Pieter Bruegel the Elder (c. 1525/30—69), SUMMER.

Pisanello's first portrait by at least two years. Pisanello's work, which marks the beginning of portraiture in Italy, was executed in a flat, cameo style. Van Eyck, on the other hand, portrayed his Cardinal in half profile and without the slightest trace of idealization. On the contrary, he went into great detail, omitting nothing that would help establish the individuality of his sitter. No attempt was made to gloss over the Cardinal's less attractive features, as is clear from the notes which van Eyck jotted down at the side of his drawing and which were intended as guidelines for a later painting: '... nose blood red, pale light in the hair, purple warts ... the lips very white ...' The painting, which he based on this drawing, is now in the Kunsthistorisches Museum in Vienna.

The new realistic style was quickly taken up by van Eyck's compatriots, who were far more willing to sever their ties with the late medieval tradition than were their counterparts in Germany. Numerous schools were formed, whose members produced a large body of new and highly varied works. Artists like Rogier van der Weyden, the Master of Flémalle, Dirk Bouts, Aelbert van Ouwater, Hugo van der Goes and Hans Memling all contributed to the development of north European painting, which was soon celebrated throughout the Continent and, by the end of the century, had even eclipsed the fame of the Italian *Quattrocento* artists.

van der Weyden,
Head of an Old Man
page 98

In the early sixteenth century, however, this trend was reversed. With the birth of the High Renaissance and the emergence of such masters as Michelangelo, Raphael, Leonardo, Titian and Giorgione, the Italians regained their former pre-eminence. By then German painting had also acquired an international reputation, due to the prestige of artists like Dürer, Cranach and Holbein. By contrast, the Netherlandish schools had lost their early impetus. Once their leading artists—men like van Eyck and Rogier van der Weyden—had left the scene, it soon became apparent that there was nobody of comparable stature to take their place. Instead of continuing in the native tradition, therefore, the Netherlandish artists began to exploit the close relations which Holland had always maintained both with her immediate neighbours and with Italy. After having given so much to the world they were now able to take from the world and although Netherlandish art lost some of its distinctive quality, it remained productive and highly inventive.

The pull of the South now began to make itself felt. The great majority of Netherlandish artists visited Italy as part of their artistic education and some—like Jan van Scorel and Jan Gossaert—stayed there for good. At home numerous 'romanizing' associations were formed, whose members sought to combine the pictorial quality of early Netherlandish art with the structures of the Italian Renaissance. Many of these experiments—for instance, Lucas van Leyden's allegories and divine figures in the classical Italian manner—are almost touching in their simplicity and gaucherie. Van Leyden of course could also be an extremely original artist, when he dispensed with the Italianizing fashion of his day and treated native motifs, as is quite evident from his *Milkmaid*.

Only very few sixteenth-century Netherlandish artists succeeded in holding themselves entirely aloof from Italian influence. Of these the most important were Hieronymus Bosch and Pieter Bruegel, whose work was often diametrically opposed to the popular trend but which for that very reason furnished one of the most important links between the fifteenth and the seventeenth centuries. The fact that both of these men produced their most convincing

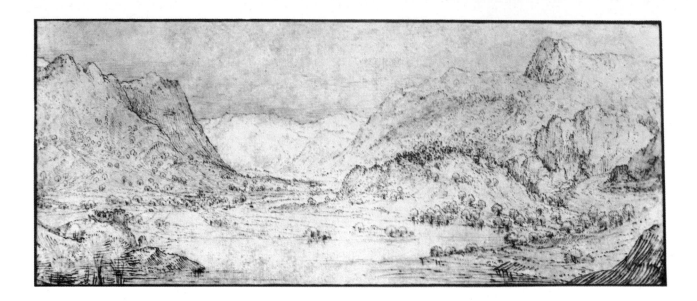

Above: Pieter Bruegel
the Elder
(c. 1525/30—69),
RIVER LANDSCAPE.

Below: Pieter Bruegel
the Elder
(c. 1525/30—69),
THE TEMPTATION
OF ST. ANTHONY.

work in the graphic sphere is hardly an accident, for there they were better able to resist the seductive power of classical art.

Hieronymus Bosch was one of the great outsiders in the history of Western art. The symbolism of many of his pictures has yet to be fully established by modern scholars, and it is perhaps for this very reason that his macabre figures have lost none of their fascination for the twentieth-century viewer. At first sight Bosch's fantastic creatures and his dark vision seem to have very little in common with the late fifteenth and early sixteenth centuries. It was after all during this period that the High Renaissance celebrated its initial triumphs in Italy and northern humanism dispelled the dark clouds of medieval dogma, thus enabling artists and thinkers to glorify worldly pleasures and to establish a new world order, in which man occupied the

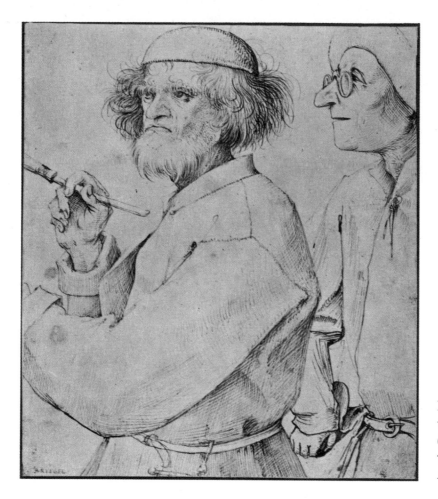

Pieter Bruegel
the Elder
(c. 1525/30—69),
THE PAINTER
AND THE PATRON.

central position. But in point of fact, what Bosch did was to show just how shaky were the foundations on which this new world order rested: in his work man's newly acquired self-assurance is depicted as a hollow façade, behind which the old fear of hell-fire continued to operate with all its potency.

In their attempts to explain the ideas underlying Bosch's enigmatic fantasy world, modern scholars have been greatly hindered by the fact that so little is known about the artist's personal life. His name first appears in contemporary documents in connection with his marriage to Aleid van Meervenne, the daughter of an aristocratic family in Hertogenbosch, which was the artist's own native town. There, in 1486, Bosch joined a religious fraternity called the 'Hieronymians', whose members had withdrawn from the world in order to attain to a more spiritual conception of God. This sect had been in existence since the beginning of the fifteenth century, which means of course that it had its origins in the pre-Reformation, and it is to be assumed that Bosch drew much of his inspiration from this conservative brotherhood. The anti-clerical trend, which was then in vogue, must have been espoused by the Hieronymians, for in Bosch's works we constantly find monks and nuns in extremely compromising situations. Besotted, womanizing clerics, nuns having intercourse with the devil and veiled or becowled pigs are recurring motifs. This defamation of the clergy, incidentally, did not prevent Bosch from executing commissions for the Church.

But it was not only his predilection for weird motifs that stamped Bosch as an outsider. His highly personal graphic style also set him apart from the main stream of Netherlandish artists, for instead of using the soft silver-point technique, which was customary in his day, he preferred the generally harder

Jan Bruegel the Elder (1568—1625), HIGHWAY NEAR A WOOD.

Jacques de Gheyn II (1565—1629), STUDIES OF FIELDMICE.

D: Geyn fe

Bosch,
The Human Tree,
page 99

and more expressive line of pen and ink. In his *Human Tree* the entire ground is built up from delicate horizontal lines while the objects and figures, which form the composition, have been executed with bold, vertical strokes of the pen. The great power of this work derives partly from the contrasting texture of the graphic structure and partly from the subject-matter. The cavity in the body of the human tree is like some inner hell, a last miserable refuge for drunkards and rakes. The feet of this fabulous creature are planted in tiny little boats which threaten to capsize and sink in the bottomless pit whilst its face is a self-portrait, an indication of Bosch's awareness that he too was threatened by divine wrath. By comparison with this monstrous creature the distant scene, whose realistic treatment anticipates the seventeenth-century landscape, seems strangely harmonious and peaceful.

Bosch had no disciples in his lifetime, but a few decades after his death his memory was evoked by Pieter Bruegel. The demons and the scurrilous human creatures in Bruegel's pen drawing of the *Temptation of St. Anthony* are direct descendants of Bosch's fantastic figures while the idea for the hollow skull, fish and tree can only have come from the *Human Tree*, which Bruegel must have known from Bosch's triptych *The Garden of Delights*.

Pieter Bruegel
the Elder,
*The Temptation of
St. Anthony,* page 102

Little is known about Pieter Bruegel's early years and although it has been assumed that he was born in the Dutch village of Brueghel, there is no documentary evidence to this effect. He trained under the painter and architect Coecke van Aelst and the engraver Hieronymus Cock, for whom he made various drawings including the *Temptation of St. Anthony*. After becoming a master of the Lukas guild in Antwerp he made the customary journey to Italy, where he visited Venice, Rome, Naples and Sicily. A number of landscape etchings and townscapes, which he produced on this journey, have survived, but there are no extant paintings from this period. It is not

Below:
Pieter Bruegel the Elder
(c. 1525/30—69),
THE ALCHEMIST.

easy to discover any links with contemporary Italian art in the small landscape which Bruegel drew on his return journey across the Alps in 1554. This peaceful view is entirely characteristic of the South Tyrolean countryside and it seems more likely that the artist was trying to excute a precise study of a natural scene than produce a landscape in the Italian mode. Bruegel's draughtsmanship is demonstrated in his early work by the variation in the intensity of his line, which becomes progressively fainter towards the background, thus creating an impression of three-dimensional space. In 1555 Bruegel arrived back in Antwerp. In 1562 he moved to Brussels, where he subsequently married the daughter of his former teacher Pieter Coecke van Aelst.

There was, therefore, nothing unusual about Bruegel's training and early development. What was unusual, however, was his great expressive power, which marked him out as a unique artist in what was otherwise an extremely conventional period of Netherlandish art. Whilst others copied Italian models he remained impervious to their charms and so retained his direct relationship to the world of reality. His entire œuvre—paintings and graphic works alike—is based on experience and precise observation and as such is both refreshingly original and vital. But this is not to say that Bruegel was simply the 'peasant Bruegel'—a genre artist, full of dry humour and satire, with a special gift for describing the cheerful, simple life. Although he analysed the unaffected, unspoilt Dutch peasant with far greater insight than most artists of his day, he did not feel a natural affinity with him. What fascinated him as an artist was the picturesque quality of the country scene, its great vitality and colour; and even this was really only a pretext for his underlying didactic and moral message. For at their deepest level Bruegel's peasant scenes are a caustic comment on human inadequacy: he used the peasant to symbolize a perverted world. This device, which is used quite openly in his great paintings (*Picture of Proverbs, Children's Games* and *Peasant Dance*), is also implicit in his graphic works, for instance his *Summer*. At first sight this drawing—which forms part of an uncompleted

Above:
Jan Bruegel the Elder
(1568—1625),
STORMY SEA.

Pieter Bruegel
the Elder,
River Landscape,
page 102

Hendrik Goltzius (1558—1617), HEAD OF A DOG.

Hendrik Goltzius (1558—1617), PORTRAIT OF THE SCULPTOR GIOVANNI DA BOLOGNA. 109

Pieter Bruegel
the Elder,
Summer,
page 100

series on the four seasons—appears to be a straightforward representation of a harvest: on the right the scything of the wheat, in the left foreground vegetables, and in the background the gathering of the hay, the whole scene stretching away into the distance and illumined by a glittering light. But if we look closer we find that there is no real sense of harmony here. On the contrary, these grim peasants create an atmosphere of restlessness; they are truly 'faceless' creatures for—whether they are eating, drinking or working— the impression they give is one of complete physical coarseness, which clashes violently with the natural setting that Bruegel has depicted so poetically. In this scene nature is being stripped bare: the harvest serves as a symbol of human rapacity. Peasant greed and stupidity also provided the theme for

Pieter Bruegel
the Elder,
The Alchemist,
page 106

Bruegel's pen drawing of *The Alchemist.* This is not a picture of learned men practising the magical art in the interests of knowledge but of idiotic peasants obsessed with the idea of instant wealth. Their laboratory was once a kitchen, which the woman of the house has allowed to go to rack and ruin: her children are neglected and one, which has a cooking-pot wedged on its head, can neither see nor hear. Meanwhile a fool fans the fire. The only person who realizes the futility of this frenzied activity is the doctor seated behind the folio volume. His finger is pointing to the title of the section open before him, which reads 'Alghe-Mist', a play on the words 'Alchemist' and 'Alles Mist' [all nonsense].

Bruegel's first biographer, Karel van Mander (1548-1606), maintained that nature had been this artist's only mentor. It is a bold assertion and one that

Hendrik Goltzius (1558—1617),
THE HOLY FAMILY.

must be treated with considerable reserve. As an artist Bruegel was often a typical Mannerist whilst as a thinker he was essentially a moralist. His bistre drawing of *The Painter and the Patron*, for example, dealt with a moral problem that was very close to his own heart. In this work the painter is seen struggling grimly with his canvas whilst 'the expert' peers over his shoulder with a self-satisfied look on his face and an open purse in his hand. The patron's right to interfere in this way had been a sore point with artists ever since their emergence from the anonymity of the medieval workshops and has remained one to this day. Bruegel's treatment of the theme is splendidly caustic and apposite. One would have thought, incidentally, that his artist was based on a self-portrait but in point of fact this appears not to have been the case. Modern scholars take the view—one that is borne out by a contemporary inscription—that the subject of this drawing was Hieronymus Bosch, the artist whom Bruegel so greatly admired. Undoubtedly there was

Pieter Bruegel
the Elder,
Painter and Patron,
page 103

111

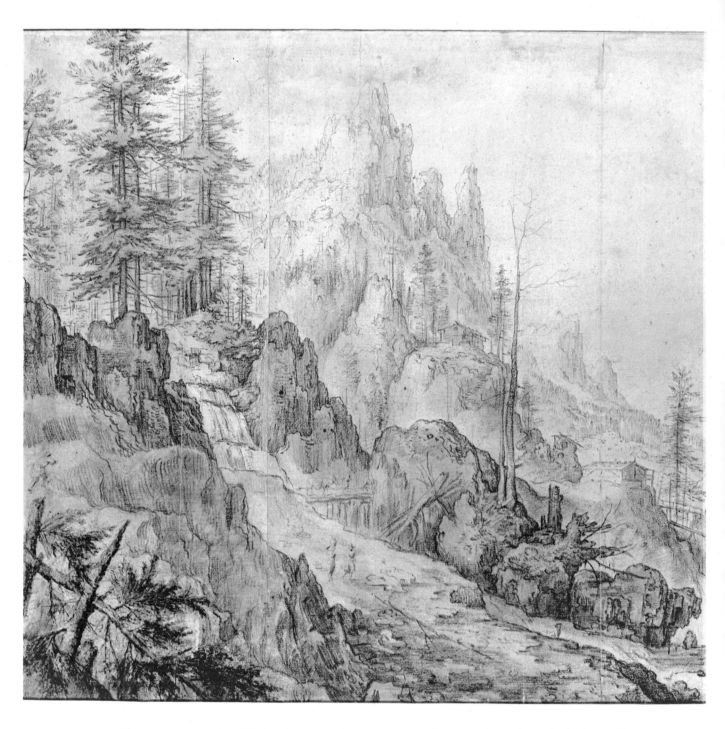

a certain affinity between these two men that is reflected in the high quality of their graphic work, whose technical and artistic originality could hardly be matched by any other Dutch artist of their day.

Jan Bruegel, better known as 'Velvet Bruegel' to his contemporaries, does not even begin to compare with his father Pieter as a draughtsman. Jan was primarily a painter and in his drawings he invariably tried to produce painterly effects by his virtuoso use of colour. Not surprisingly, the most impressive aspect of his *Highway near a Wood* is not the group of figures in the foreground, which he drew with great attention to detail, but the distant scene, in which the detail is blurred by the mist. The transition from the foreground to the background is effected with great skill by means of a blue watercolour wash. The gradations of tone begin at the little river and then build up until they cover the whole panorama. Another work, his *Stormy*

Pieter Stevens (c. 1540—1620), LANDSCAPE WITH RUINS.

Hendrik Avercamp (1585—1634), STORM ON THE COAST.

Sea, is almost an Impressionist work for even the figures in the foreground merge into the general scene: they too are in the grip of the storm, like the boats pitching about on the troubled sea. Stylistically this masterly drawing belongs to the Flemish Baroque. Its date—1614—would also place it in this category.

Hendrik Goltzius, an important draughtsman, engraver and etcher, was one of the artists who influenced the course of Netherlandish art during the transitional period at the turn of the fifteenth and sixteenth centuries by incorporating German and Italian motifs, which he blended with his native Dutch realism. After seeing works by Dürer and Holbein, Goltzius began to paint large portraits, a branch of art which had aroused little interest in the Netherlands until then. During his extensive tour of Italy he produced a series of portraits of well-known Italian artists, which impress us by their great vitality and technical brilliance. His painting of the head of his dog was also executed as a portrait. Goltzius's technique—a combination of ink wash and coloured chalks—enabled him to reproduce detail with great precision but without destroying the general air of improvisation. He also developed a special engraving technique, creating a new kind of shading which produced an impression of great plasticity and was taken up with enthusiasm by the many craftsmen-engravers then engaged in copying famous paintings because it was particularly suitable for the graphic reproduction of painted models.

Goltzius,
The Sculptor Giovanni da Bologna,
page 109

Head of a Dog,
page 108

The Holy Family,
page 110

The political events which took place in the Netherlands from 1550 onwards were to have serious repercussions on the development of Netherlandish art. Although the secession of 1579 brought the northern provinces their independence it also split the original territory, for the southern province of Flanders (now Belgium) remained under Spanish rule. This political division of the Netherlands into the Republican and Protestant state of Holland on the one hand and the Spanish monarchical colony of Flanders on the other was accompanied by the division of Netherlandish art into a Dutch and a Flemish school. While the Flemish joined the mainstream of the Catholic Baroque movement, the Dutch developed their own Baroque style, which reveals specifically bourgeois traits. In the north the Calvinist doctrine had fallen on particularly fertile ground and the anti-Catholic and anti-Roman attitude of large sections of the community had been a major factor in the build-up of popular resentment against the Spanish regent. The Dutch first took to arms as early as 1566. Although basically religious their revolution had definite economic and political overtones: the Dutch leaders spoke of religious freedom, but they were also hoping for the restitution of their ancient liberties; they fought for independence from Rome but they were well aware that secession from the Spanish crown would bring them great economic advantages. In the event all their hopes were fulfilled.

In 1609, when Philip III ceded complete autonomy and freedom of religion to the Dutch, they entered upon a period of great economic expansion with the result that by the mid-seventeenth century Holland controlled two thirds of all international trade. With their new-found wealth the Dutch merchants and burghers were able to play a new cultural role as patrons of the fine arts. Very soon they came to dominate this sphere for now that the Dutch Church had turned Protestant, it was opposed to images of any kind and placed no further commissions for paintings or statues. And so seventeenth-century

Hendrik Avercamp (1585—1634), FUN ON THE ICE NEAR A FARMYARD.

Opposite: Hendrik Avercamp (1585—1634), WINTER LANDSCAPE WITH OTTER HUNTERS.

Paulus van Vianen (c. 1570—1613), LANDSCAPE WITH A RIVER AND RAFTSMEN.

Aert van der Neer (1603/4—77), CANAL LANDSCAPE BY MOONLIGHT.

painting entered the service of the middle class. Whilst the Dutch churches remained bleak and bare the walls of private houses were lined with exquisite pictures, which were executed in a new and smaller format in keeping with this intimate setting, where they testified to the affluence and good taste of their owners. But there was another reason why the Dutch burghers patronized the arts. In seventeenth-century Holland paintings were already regarded as an investment; they possessed a hard market value and were not infrequently bought up by speculators. As was only to be expected, the artists themselves also benefited from the general boom. In fact, their status rose to such an extent that many burghers with good professional positions gave up their careers to become full-time artists. Any Dutch painter of average ability could confidently expect not only to improve his social standing, but also to augment his income, provided he satisfied the requirements of his middle-class patrons. To do so he had to portray the burghers themselves and the world in which they lived: their native landscape, their cities, their neat domesticity, the life of their villages, their taverns and their streets. But he also had to portray the common people of this small but self-assured country, the peasants and maids, the young girls and ugly old women, the hard determined men and the tired old beggars. These new patrons were not interested in potentates, prelates or princes. Consequently the Baroque art of Holland was concerned primarily with the more intimate aspects of both middle-class and working-class life.

Nearly all seventeenth-century Dutch painters produced a large number of graphic works—drawings, watercolours, line engravings and etchings. The artists liked this medium because it lent itself to the representation of ordinary, everyday events whilst the more knowledgeable collectors appreciated its greater immediacy, its ability to reflect external reality in more direct terms than was possible in painting.

Hendrik Avercamp was one of the first Dutch landscapists to turn away from Italian motifs and paint scenes from his native Holland. He revealed a marked preference for winter landscapes, which he usually filled with figures pursuing the pleasures of winter sports on the ice. The people he depicted were evidently comfortably off and seem just a trifle smug and self-satisfied. In fact, with their brightly coloured clothes they look rather like Bruegelian peasants who have come up in the world. But the iridescent glow of Avercamp's wintry skies never fails to fascinate. Normally this artist portrayed peaceful scenes, in which people are seen enjoying themselves. But one of his drawings—the seascape *Storm on the Coast*—is quite different. Here the low hanging clouds, the rising sea, and the sailors fighting the storm combine in a highly dramatic action, in which the detail is unimportant as such, since everything is subordinated to the central motif. The watery haze and the threatening light, which Avercamp produced with a masterly combination of watercolour and body colour, are the dominant features of this composition. If we compare Avercamp's work with the imaginary landscapes of his older contemporaries Savery and Stevens, we see just how great was the gap which separated this early exponent of the realistic Dutch landscape from the 'Idealists' who had preceded him.

Paulus van Vianen was an extremely sensitive draughtsman. In his *Landscape with a River and Raftsmen* he created a carefully calculated painterly effect by contrasting the brown pen and ink area in the foreground with the blue wash of the background. Although—like Savery and Stevens—van Vianen

wesen dic geteyckent den 29 in 30 Juny 1644.

are thoren der Stadt Rheenen
Coninx van Bohemen sijn Hoff &c.

Pieter Jansz Saenredam (1597—1665), THE TOWER OF THE CUNERA CHURCH AND THE CASTLE
OF THE KING OF BOHEMIA IN RHENEN.

Willem van de Velde the Younger (1633—1707), WARSHIPS IN QUIET WATERS.

Opposite: Frans Hals (1581/5—1666), THE CAVALIER.

Adriaen van de Velde (1636—72), SUMMER LANDSCAPE WITH CORNFIELDS.

Adriaen van Ostade (1610—84), PEASANT TAVERN.

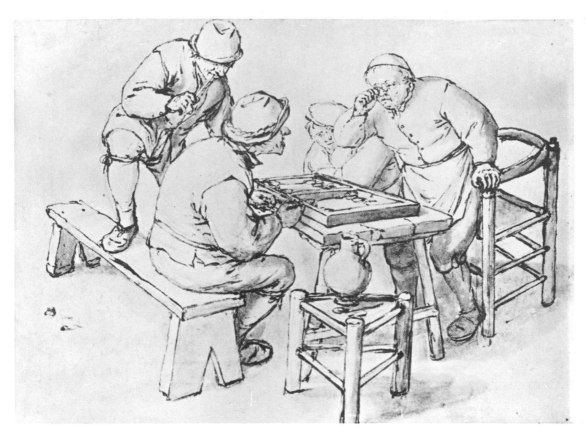

Adriaen van Ostade (1610—84), BACKGAMMON PLAYERS.

Jan van Goyen (1596—1656), RIVER LANDSCAPE WITH A FERRY.

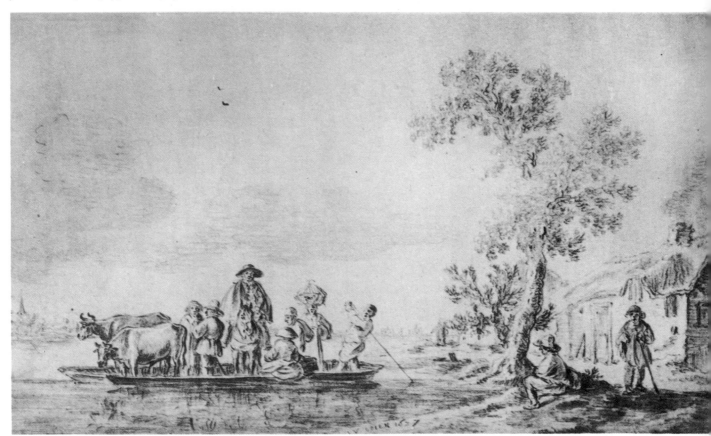

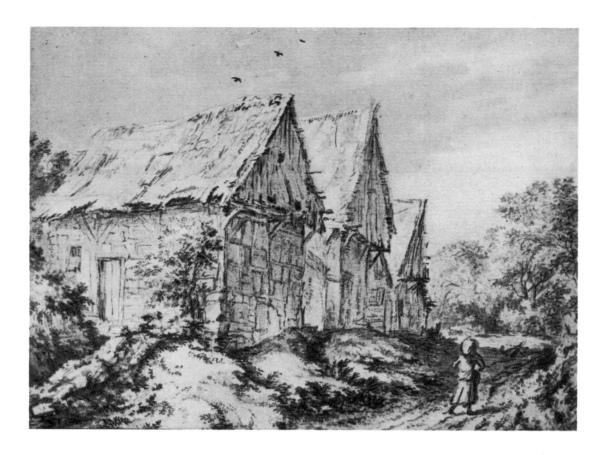

indulged his highly poetic vision of nature in his general composition, he was often extremely faithful to nature in his treatment of detail, as is evident from the group of trees in the foreground of this landscape, which he drew with infinite care. The work dates from 1603, the year in which van Vianen left Salzburg to join the court of Rudolph II in Prague, which was then a centre of northern Mannerism. The new realist movement, which was emerging in Holland, made no impact on him.

Aert van der Neer, a very much younger contemporary of van Vianen, was a romantic artist of quite a different kind. He saw no incompatability between poetry and reality. But then his kind of reality was extremely unreal, for he specialized in moonlight scenes. In his paintings this unreal element was expressed purely in terms of colour, but in his graphic work he achieved a similar effect by blurring the contours with an ink brush and making them merge with the uncanny light. In his *Canal Landscape by Moonlight* the objects appear strangely transparent; even the two figures in the foreground are no more than vague silhouettes, which blend into the total composition. Here a landscape was reproduced, just as it had appeared to the artist in real life.

Hercules Seghers's *Moss-clad Larch* is almost a surrealist work. The larch itself in this etching simply served as a starting-point for what is virtually an abstract linear structure; the weird ramification appears to be a purely artistic conception, for it has no counterpart in nature. In his own day Seghers's fantastic landscapes were not appreciated. Today we know that he was ahead of his time, nor is it an accident that the Expressionists and Surrealists should have been among those responsible for his rediscovery in the twentieth century.

The realistic Dutch landscape reached its apogee in the work of Jan van Goyen, who was born in Leyden in 1596. Our whole conception of this genre

Above:
Jacob van Ruisdael
(1628/9—82),
PEASANT HUTS.

van der Neer,
*Canal Landscape
by Moonlight,*
page 119

Seghers,
The Moss-clad Larch,
page 111

127

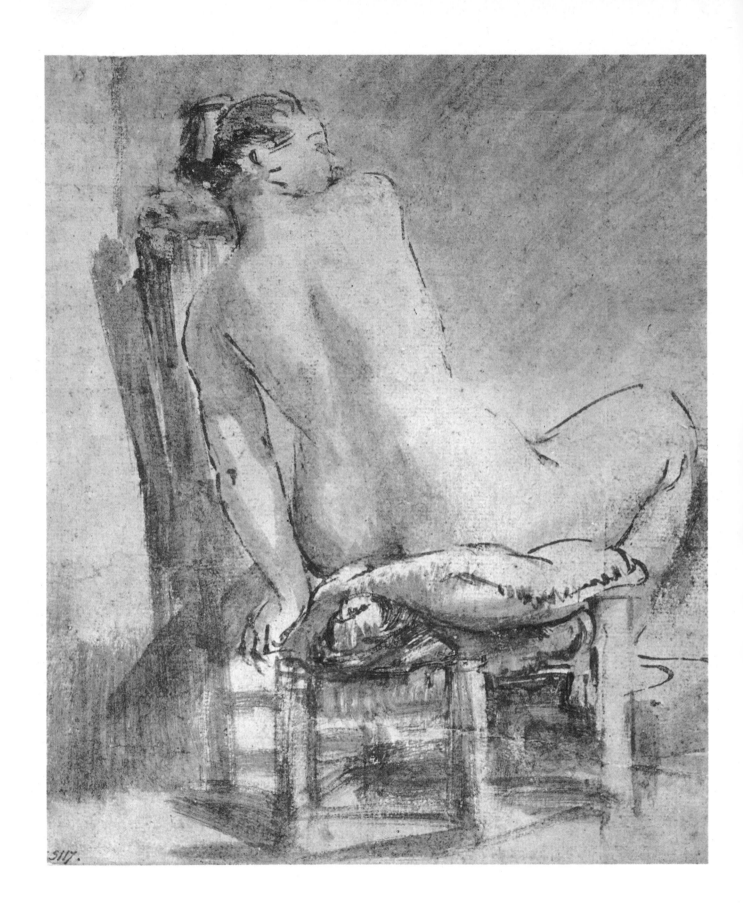

128 Rembrandt (1606—69), FEMALE NUDE SEEN FROM THE BACK.

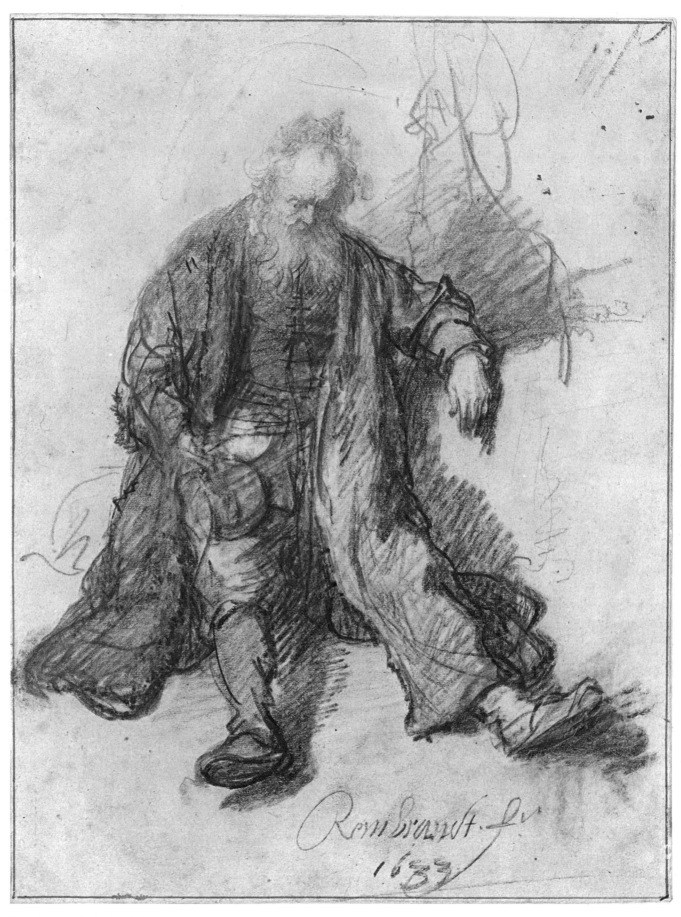

Rembrandt (1606—69), DRUNKEN LOT.

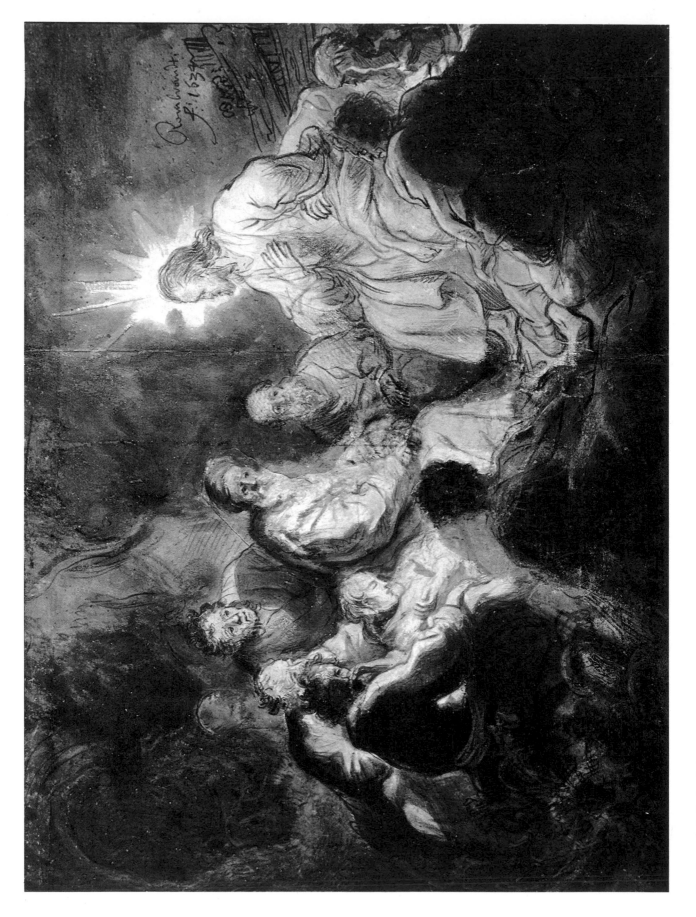

Rembrandt (1606—69), JESUS AND HIS DISCIPLES.

is intimately tied up with his pictures, for no other Dutch artist of the times succeeded in portraying his native country with such a perfect combination of fidelity and poetry. In his early period van Goyen filled his landscapes with a wide variety of extremely colourful figures and objects after the manner of Avercamp. But in about 1630 he simplified his style and replaced the strong luminous colours which he had used up till then with blended colours of reduced intensity. He also changed the position of the horizon, which had run across the middle of the picture in his earlier landscapes, bringing it right down into the bottom quarter and so giving the sky an entirely novel preponderance. At about this time he produced a series of drawings in which he used no colour at all. This had the effect of heightening the mood of languor, which is the principal feature of these works and is well exemplified by the *River Landscape with a Ferry*. Here only the figures in the foreground are defined, with everything else submerged in the soft light and the mist.

van Goyen, *River Landscape with a Ferry,* page 126

Jacob van Ruisdael also portrayed the beauty of the rural scene with all its romantic allure and all its deficiencies. Like Goyen, he filled his pictures with atmospheric light, which transformed the flat landscape of his native Holland into a thing of splendour. In his works the human element is always prominent. His *Peasant Huts*, for example, is dominated by a group of ramshackle dwellings, whose very dilapidation creates an impression of dignity and beauty.

van Ruisdael, *Peasant Huts,* page 127

With its translucent colouring Adriaen van de Velde's *Summer Landscape with Cornfields* is almost an Impressionist work. In it the artist exploits the full potential of the watercolour medium: the sky and the fields form large open areas, the gradations of tone increase towards the background, where they finally blend in a bright uniform glow, whilst the white paper backing is allowed to shine through the thinly painted and highly luminous ground. Against this ground the trees, the stocks, the animals and the solitary figure of the herdsman—which are executed in a completely realistic style—stand out in bold relief. This combination of tonal values and precise draughtsmanship and the contrast between the general impression of transparency and the small patches of strong colour create an air of vitality, which suggests that this work may well have been painted from an actual scene. Adriaen van de Velde had the same poetic and sensitive approach to the landscape as Ruisdael, to whose generation he belonged. He received his initial artistic instruction from his older brother Willem van de Velde, who made his name in the highly specialized field of marine art. The *Warships in Quiet Waters* is a typical example of his work.

Adriaen van de Velde, *Summer Landscape with Cornfields,* page 124

Willem van de Velde, *Warships in Quiet Waters,* page 123

The discovery of marine painting was one of the most important innovations in seventeenth-century art. The fact that the discovery was made by the Dutch was due partly to Holland's geographical position as a coastal country but more especially to her dependence on seapower, for without an effective navy and merchant fleet the Dutch could never have maintained their economic and political status. Consequently everything to do with the sea was a matter of great public concern, and the Dutch artists, who studied their clients' interests very closely, were quick to seize upon this new motif. A large number of marine pictures were then produced showing merchantmen on the high seas, in stormy or quiet waters, in the harbour, taking on cargo or putting to sea. Fishing-boats and warships were also a favourite motif, the latter often being depicted in battle-scenes.

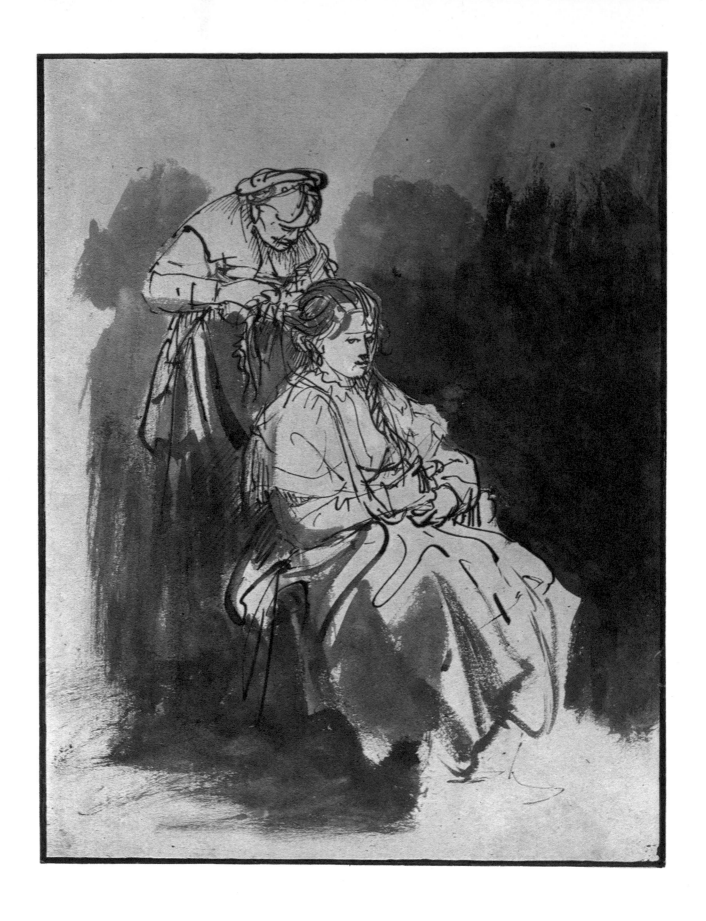

132 Rembrandt (1606—69), YOUNG WOMAN AT HER TOILETTE.

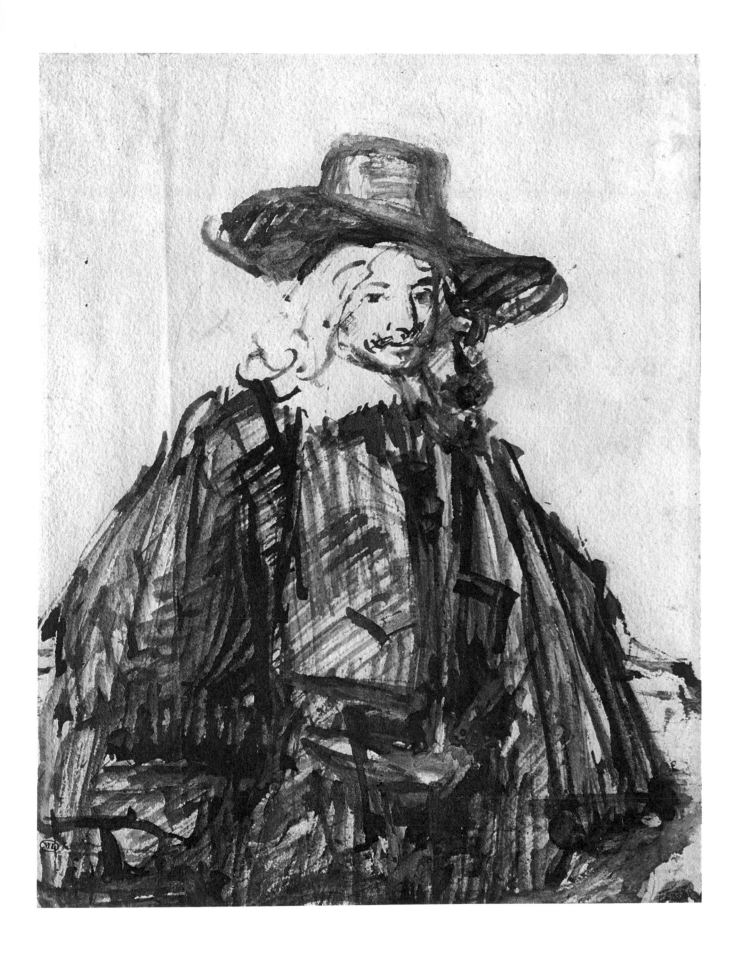

Rembrandt (1606—69), PORTRAIT OF A MAN.

As a fully fledged marine draughtsman Willem van de Velde had expert knowledge of ship construction. But despite this technical training, his marine pictures are not just technical exercises. On the contrary, they are genuine seascapes, in which the ships appear against a natural background. Van de Velde had a preference for calm seas and gentle swells and consequently he often used river estuaries, harbour entrances and the shallow waters close to land for his settings. In these surroundings, with small fishing-boats sailing alongside and low trees lining the shore, his ships gain visibly in stature, almost as if they had taken on a personality of their own. The reflections in the water, the high mist and the gentle movement of the flags and sails appear to have had a fascination for this artist, who was evidently more interested in the purely pictorial aspects of the seascape than in the harsh reality of seafaring itself.

The genre portrait, which shows people in scenes from everyday life, also originated in Holland, where the middle-class milieu was depicted by Pieter de Hooch and Gerard Terborch and the peasant milieu by Adriaen Brouwer, Jan Steen and Adriaen van Ostade. Unlike Steen, who tried to exert a moral influence, and Brouwer, who practised social criticism, Ostade was an uncommitted artist. He painted extremely lively scenes, which he set either in peasant cottages or in taverns. His *Peasant Tavern* is a highly imaginative work. Ostade felt his way into every single figure in this watercolour and created beautifully integrated groups of talkers, dancers, drinkers and musicians, who immediately engage the viewer's attention and draw him into their circle. The strong local colours in this work tend to overshadow its graphic quality, which is actually of a high order. But Ostade's draughtsmanship is clearly demonstrated by his *Backgammon Players*. The fully modelled figures in this pen drawing not only exist in their own right as individuals but are also welded into a living group. And all this is achieved with an absolute economy of line. This drawing was found in a folio together with a number of studies by Ostade, some of which bear a note to the effect that they were drawn from life, which would indicate that his peasant pictures were based on real people and real-life situations.

van Ostade,
Peasant Tavern,
page 125

van Ostade,
Backgammon Players,
page 126

Up to now we have been assessing the graphic work of the Netherlandish and Dutch artists in the light of their paintings, a method of procedure rendered necessary by the homogeneity of their *œuvres*, which made it impossible to break them down into specific categories. This does not mean to say, however, that their graphic works were essentially inferior or that they came into being simply as a by-product of their paintings. The truth of the matter is that although the two media were interdependent, each had its own intrinsic value. But when we come to Rembrandt the situation is quite different, for his graphic work was entirely independent. He himself always regarded his drawings—and even his studies—as fully autonomous products. For Rembrandt, drawing was not simply a question of reproducing visual experiences. On the contrary it was a completely authentic artistic process, in which he sought to translate external reality into a kind of spiritual reality. In view of its essentially abstract nature this process lent itself particularly well to graphic treatment, since spontaneity and inventiveness are more easily achieved in this medium than in oil-painting, which calls for much greater precision. An oil-painting depends for its success on careful planning, careful execution, and a great deal of patience. It is a slow process and one that is

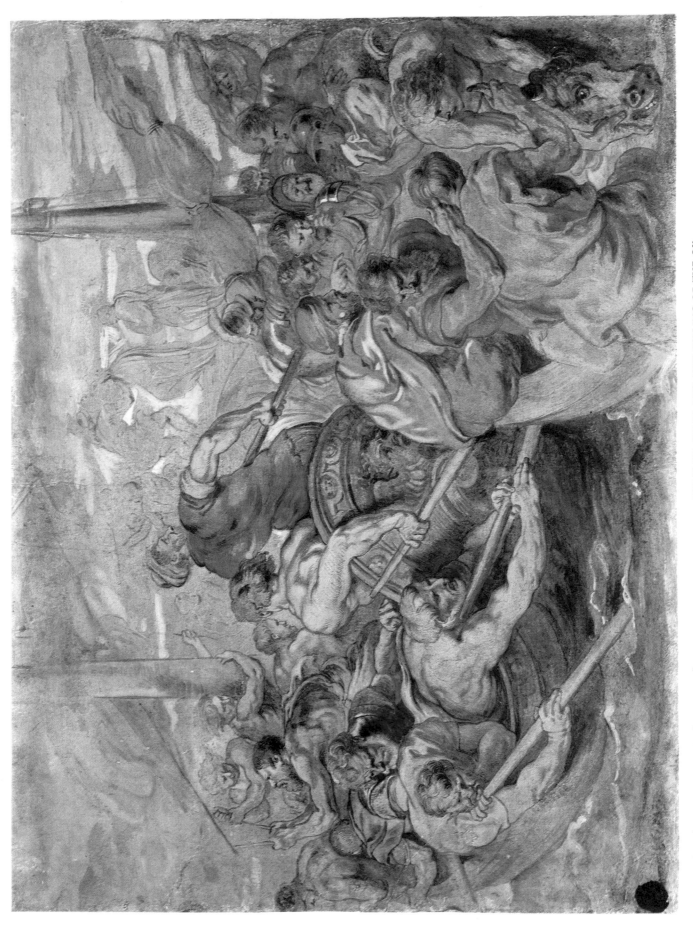

Peter Paul Rubens (1577–1640), ULYSSES' DESCENT INTO HADES, HIS RETURN TO CIRCE AND THE KILLING OF THE OX.

Peter Paul Rubens (1577—1640), YOUNG WOMAN.

Peter Paul Rubens (1577—1640), LADY-IN-WAITING TO THE INFANTA ISABELLA.

137

Peter Paul Rubens
(1577—1640),
STUDY FOR A CRUCIFIXION.

likely to act as a brake on intuition. For the traditional Dutch realists this
did not matter, for their strength lay precisely in the loving care with which
they attended to detail. But for Rembrandt, whose visionary art called for
a far more dramatic approach, the difficulties posed by the actual execution
of oil paintings were very great and although he eventually solved them,
they caused him a great deal of anguish throughout his lifetime.

In his drawings, of course, he faced no such difficulties and consequently he
tended to use this medium in order to work out his artistic ideas. It enabled
him to acquire self-control and above all to carry out technical and artistic
experiments. Because of this experimental bias his graphic technique under-
went repeated transformations, which reflect his artistic development and
the thinking behind it. This explains the immense variety of his graphic
œuvre, which reveals no constant features, either of technique, of form or of
content.

Every one of his drawings is a work of art in its own right, every one of them
testifies to his unique qualities as a draughtsman.

Although the small selection of Rembrandt drawings reproduced in this book
cannot possibly hope to be representative, they will perhaps give some idea

Rembrandt,
Female Nude,
page 128

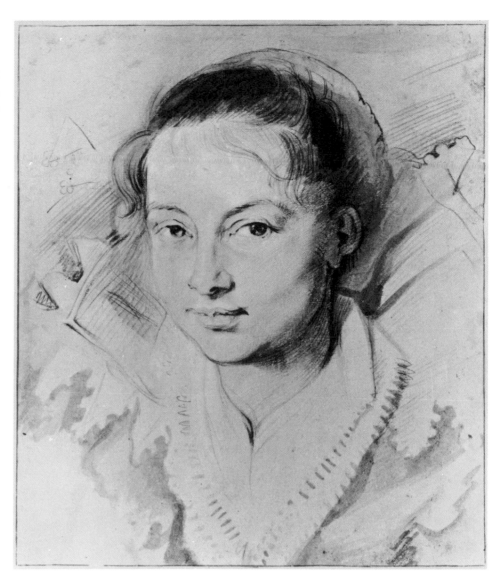

Peter Paul Rubens
(1577—1640),
PORTRAIT OF A YOUNG
LADY.

of the great diversity of his graphic work. In his *Female Nude seen from the Back* the outline of the figure was achieved with just a few strokes of the pen, the body shading being executed with a wet brush. The plasticity stems from the areas of dark shading on the left-hand side, which gives the whole figure a soft appearance. This is one of the rare works in which Rembrandt portrayed a female nude—or any human figure for that matter—as an object of sensual beauty. Most of his female nudes were old, sick or work-worn women, whom he showed in all their ugliness. Rembrandt also created many similar portraits of old men, for example his *Drunken Lot,* which is an absolutely shattering comment on human frailty and loneliness. In this work the old man's lack of inner stability has been translated into physical terms: his body is set in a void so that the viewer has no means of telling whether he is about to fall or has already fallen. The monotonous grey tones of the hatching on the shabby coat, which are continued over into the shadow cast by the body, create an overall impression of hopelessness. This is relieved only by the introduction—for example on the right leg—of a few bold and jagged strokes, which quickly peter out. By contrast the old man's head is executed in soft and gentle tones, which give it an air of quiet dignity. Rembrandt

Rembrandt, *Drunken Lot,* page 129

139

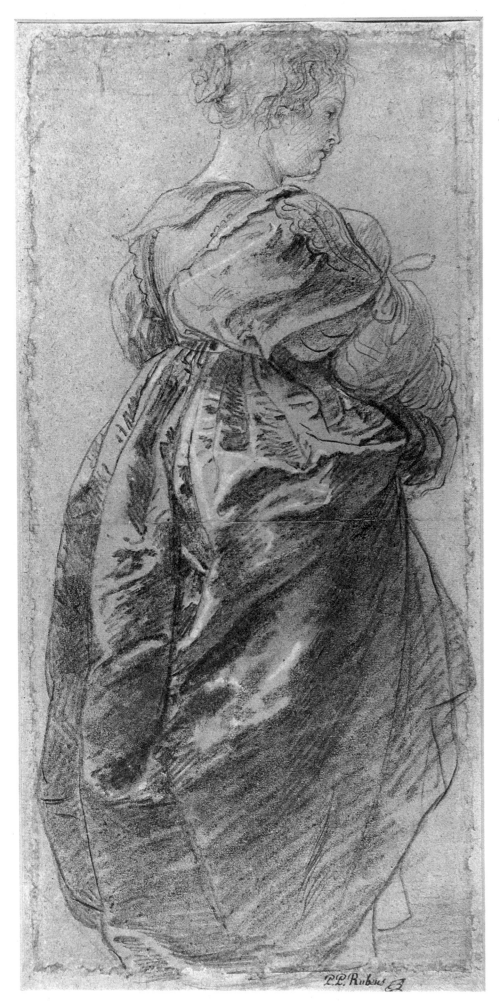

Opposite:
Anthony van Dyck
(1599—1641),
THE MOCKING OF CHRIST.

Peter Paul Rubens
(1577—1640),
STUDY FOR THE 'GARDEN
OF LOVE'.

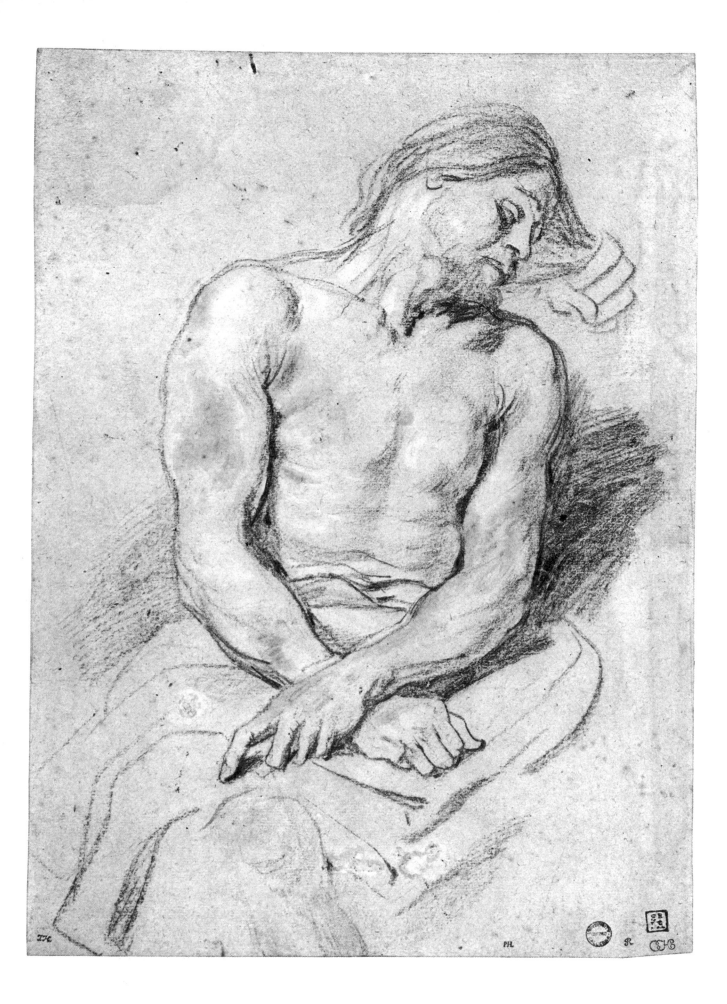

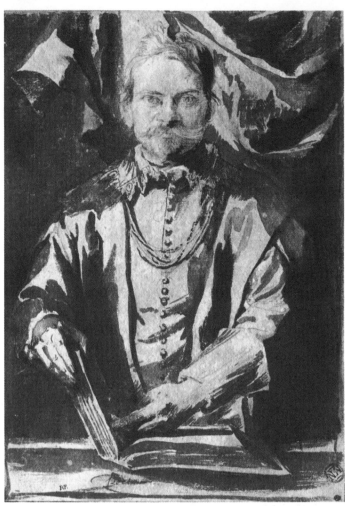

Anthony van Dyck (1599—1641),
PORTRAIT OF THÉODORE VAN THULDEN.

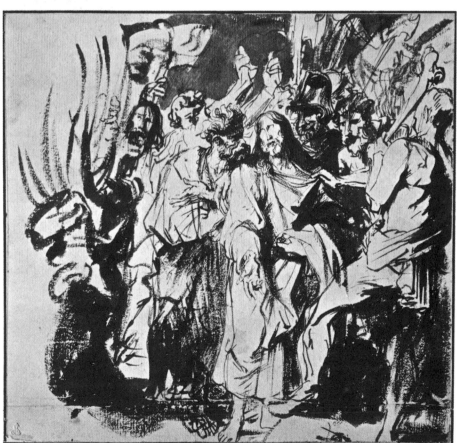

Anthony van Dyck (1599—1641),
THE SEIZURE OF CHRIST.

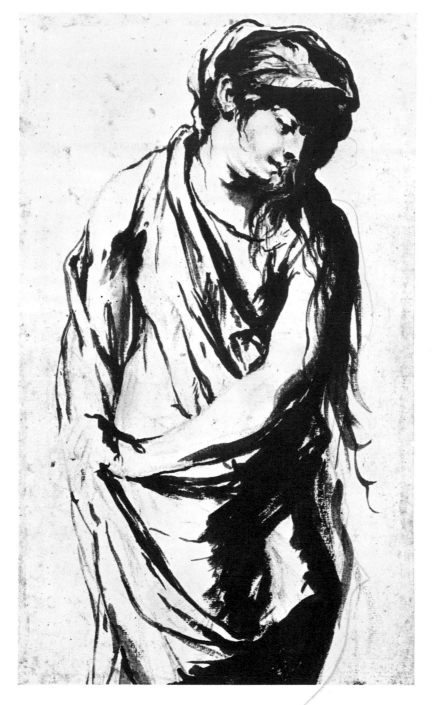

used an Impressionist technique in his *Young Woman at her Toilette*, which would seem to have been prompted by a real-life situation. The two figures were established with just a few strokes of the pen, and the dark shadows in the background—from which the two women are emerging— were painted in later with a bistre and Indian ink wash. The whole scene has a completely impromptu air, as if some visual impression had been immediately translated into an artistic composition. In his religious works Rembrandt created an impression of mystical power by his use of light. This technique in clearly demonstrated by his *Jesus and His Disciples*, where a refulgent Messiah brings light into the world of men, dazzling His disciples and making them stand out in sharp relief from the chaotic darkness which surrounds them. In this drawing inner enlightenment is expressed in pictorial terms.

Rembrandt,
Young Woman at her Toilette,
page 132

Jesus and His Disciples,
page 130

143

Rembrandt van Rijn was the greatest but also the least representative of the seventeenth-century Dutch artists. His work broke the bounds of contemporary thought because it was completely alienated from the political, sociological, economic and national currents of the period. It had its being in a universal sphere, in which the petty problems of the day were reduced to the level of farce, for Rembrandt was not interested in the spirit of his times or in the requirements of contemporary taste. His only commitment was to his own genius. And because he refused to acknowledge his times they failed to acknowledge him. Not until later did people realize that the importance of his work lay in its timelessness.

As an artist Peter Paul Rubens was the antithesis of Rembrandt. It was not just that he belonged to a different generation, he belonged to an entirely different world. Rembrandt was born in Leyden at the time when Holland became an independent Protestant republic and he spent the whole of his life as a member of this essentially bourgeois community. Rubens on the other hand, who was born in Siegen in Westphalia but was taken to Antwerp as a child, made his home in Catholic Europe, where he moved in high circles. Whereas Rembrandt's works were a direct product of his personal experiences and suffering, Rubens's art was firmly grounded in the European tradition; he made an intensive study of antiquity and the Italian Renaissance, and he placed his skills, his experience and his person at the service of the Catholic Baroque movement. Rembrandt was a painter, a draughtsman and an etcher whereas Rubens was essentially a painter. On the rare occasion when he made one of his perfect drawings he drew as a painter, forcing the linear composition to produce an essentially painterly effect. In his charming portrait of a *Lady-in-Waiting*, for example, Rubens used his charcoal with such delicacy of touch that he was able to bring out the airy texture of the lace collar, thus creating a perfect setting for this exquisite face. The soft glow of the skin, which was produced with a mixture of chalk and charcoal, acquires a sensual quality from the contrasting effect of the black pupils and the clearcut lines of the hair. In his *Study for the 'Garden of Love'* the artist also used his fertile imagination to reproduce in painterly terms the texture of a richly clad moving figure. But the finest example of Rubens's painterly use of graphic technique is provided by his drawing of a *Young Woman*, which was probably executed as a study for the Ildefonso altarpiece and not for a portrait. The plasticity and the painterly quality of this drawing are quite phenomenal. The play of light is created by just a few small areas of chalk, the soft flowing shadow is executed in charcoal whilst red chalk is used for the patches of living colour on the face and hands. The expression and gesture of this figure, the beautifully drawn hands, and the perfect plasticity of the head are quintessentially Baroque and place this drawing on the same level as Rubens's greatest paintings. In 1625 Rubens made a sketch based on the ceiling paintings carried out by Primaticcio, the virtuoso Italian interior decorator, in the Castle of Fontainebleau. This work, which shows Ulysses' descent into Hades, his return to Circe and the killing of the ox, was executed in oils on paper. But it was not just a copy of the Italian original, for Rubens took three separate scenes from Primaticcio's ceiling and condensed them into a single composition, which enabled him to treat the subject-matter in a much more dramatic form. His figures, colours and movement merge in a scene of concentrated fury, which confronts the viewer with the full force of Baroque pathos. The two principal groups are fused into

Rubens,
Lady-in-Wating,
page 137

Rubens,
Study for the 'Garden of Love'
page 140

Rubens,
Young Woman,
page 136

Rubens,
Ulysses' Descent into Hades, Return to Circe,
page 135

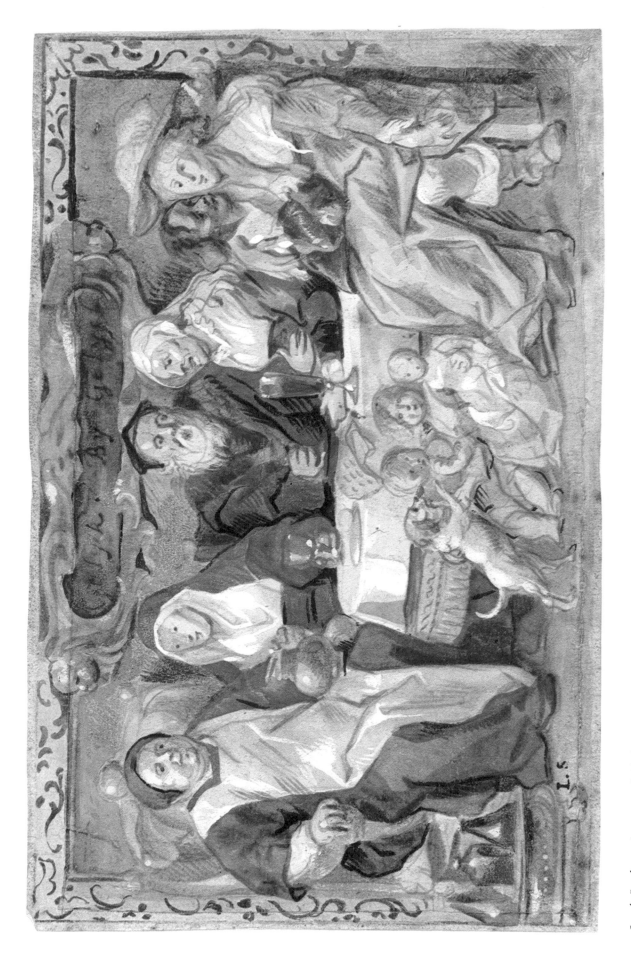

Jacob Jordaens (1593—1678), 'BIRDS OF A FEATHER FLOCK TOGETHER' ('GELYCK BY GELYCK').

a solid mass by the diagonal composition, which directs the viewer's gaze to the bottom of the picture, where the movement is taken up by the turbulent waters.

The passion and force which are such a marked feature of Rubens's art were also characteristic of his life. He loved splendour; he loved demonstrations of power, both terrestrial and heavenly; and he loved beauty in all its forms. This was why he had such little sympathy for the middle-class art of Holland. Rubens sought the irrational, the incommensurable and the miraculous—qualities which were not to be found in Protestant Holland but which abounded at the courts of the Catholic princes and in the transcendental vision of God proclaimed by the Roman Church in seventeenth-century Europe.

It was only natural that an artist of Rubens's stature should have found friends and admirers not only among his patrons, but also among his fellow artists. To be employed in his workshop was considered a high honour, one that was much sought after even by established artists. His most famous assistant was of course Anthony van Dyck, who worked for him during his apprenticeship and continued to do so after being registered as a master—at the early age of nineteen—even though he then had his own workshop and his own assistants. Rubens once described van Dyck as one of his best pupils. But in 1620, when van Dyck was twenty-one, the two men parted company. Nobody knows why, although in view of their markedly different temperaments it is not surprising that they should have done so. Van Dyck's reputation as a painter was not really established until he went to live in England, where his cool and elegant portrait style remained the model for all English portraiture until the end of the eighteenth century. His graphic works are basically Impressionist and specifically Baroque. The great emotional power of his *Mary Magdalene*, the expressive dynamism of his *Portrait of Théodore van Thulden* and the burning faith of his *Seizure of Christ* are achieved by means of extremely sensitive and varied ink hatching. In the *Magdalene* the graphic line is soft and clinging and in the *Seizure* it is full of fire, in keeping with the dramatic quality of the scene, while in his portrait of van Thulden the artist used chiaroscuro effects to capture the fascinating personality of his sitter. As for the chalk drawing of the *Mocking of Christ*, here van Dyck reveals a rare combination of anatomical precision and spiritual empathy, which is particularly marked in the turning of the head and the painful clutching of the hands.

The decline of Dutch seapower in the closing decades of the seventeenth century was accompanied by a decline in Dutch painting. By then the men who had freed the country from the Spanish had long since left the scene and the following generation of colonizers, who had turned Holland into a great trading nation, were due to depart. Their heirs saw their prime duty in the consolidation of personal and national wealth with predictable results for Dutch art, which soon came to reflect this new materialistic attitude. And so Dutch realism deteriorated into a rather mechanical and often affected form of decorative painting. A similar development took place in Flanders, although there it was brought about primarily as a result of the growing influence of the French Rococo and the Italian Late Baroque. The genre scenes of Cornelis Troost, a Dutch artist who was born in the closing years of the seventeenth century, also have a distinctly Rococo flavour. His *Comedy Scene* is an ironical comment on the elevation of the once-so-

van Dyck,
Mary Magdalene,
page 143

Théodore van Thulden,
page 142

The Seizure of Christ,
page 142

The Mocking of Christ,
page 141

Troost,
Comedy Scene,
page 149

146

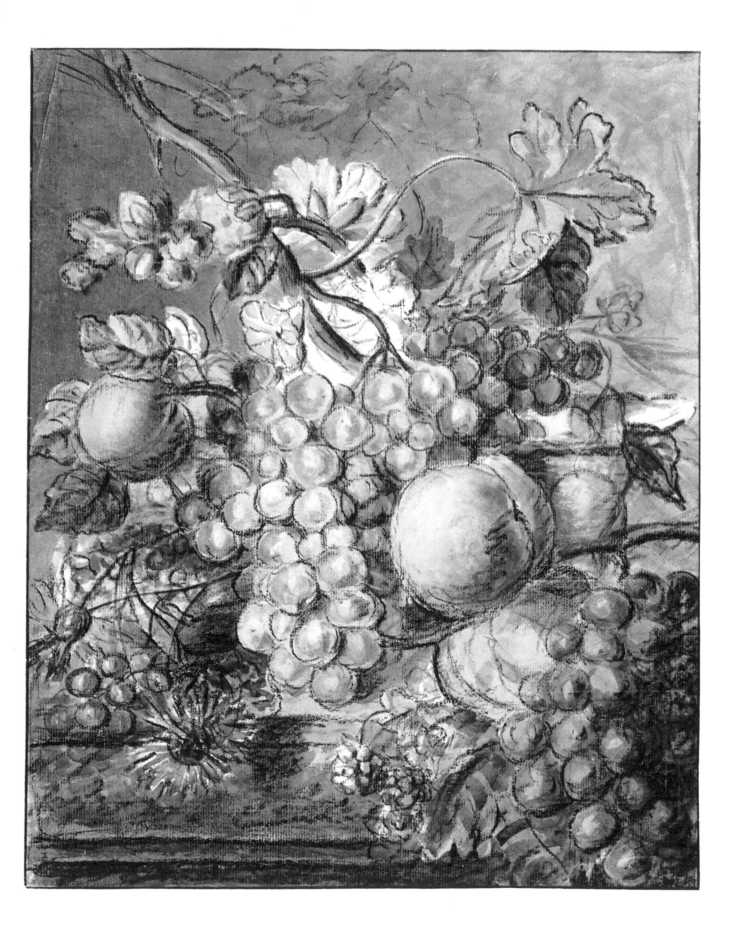

Jan van Huysum (1682—1749), STILL LIFE WITH FRUIT AND FLOWERS. 147

Cornelis Troost (1697—1750), THE LADY AND THE OLD CLOTHES' DEALERS.

Cornelis Troost (1697—1750), COMEDY SCENE.

Jakob de Wit (1695—1754), ALLEGORICAL COMPOSITION.

Opposite: Jan van Os (1744—1808), FLOWERS.

respectable middle-class wife, who is seen here in her new role as a coquettish lady of society. In this drawing an aging husband is leaving his home, apparently after a quarrel with his young wife, who is standing in front of the house shedding tears which look anything but heartfelt. The maid in the window tells us the reason for the quarrel: she impudently holds two fingers to her head to indicate that the husband has been cuckolded. In his watercolour of the *Lady and the Old Clothes' Dealers* Troost again indulged his irony at the expense of the *nouveaux riches*. The lady in this scene, who would clearly like to pass for a woman of the world, has been caught off guard by the offer of a bright new Gulden in exchange for her old gown. With exquisite humour Troost has laid bare her mercenary soul.

Troost,
The Lady and Old Clothes' Dealers,
page 148

In his *Allegorical Composition* Jakob de Wit—who was known as the 'Rubens of his time'—demonstrated his expert knowledge of Italian ceiling painting. The graceful and highly colourful figures seated on the wreath of clouds, whose movements carry the viewer's gaze onwards and upwards into the clear sky, have been organized with a sure instinct for decorative and spatial effects. This virtuoso watercolour, which de Wit executed as a study for a ceiling painting, is far removed from the mainstream of Dutch art. This is not the case with the still lifes of Jan van Os and Jan van Huysum, which are, both structurally and thematically, in the best Dutch tradition. In so far as they are essentially drawings and not oil paintings they naturally differ, in respect of texture and finish, from the great majority of Dutch still lifes, which were executed in oils. Whereas the latter were painted with immense attention to detail and so acquired an extremely smooth texture, these two compositions, which are really watercolour sketches, compensate for their lack of finish by their greater freshness and lightness.

de Wit,
Allegorical Composition,
page 150

van Os,
Flowers,
page 151

van Huysum,
Still Life with Fruit and Flowers,
page 147

Opposite: Aert Schouman (1710—92), THREE EXOTIC BIRDS.

François Clouet
(d. 1572),
PORTRAIT OF HENRY II.

FRANCE IN THE SEVENTEENTH
AND EIGHTEENTH CENTURIES

It was not until fairly late in the day that France began to take a really active part in the development of European art. During the Middle Ages the only really important contributions made by French artists had been in certain specialist fields. They had excelled, for example, in the painting of stained-glass windows. Strictly speaking, of course, this was not an autonomous branch of art since these windows were commissioned by Church architects and used by them as an integral part of their cathedrals. The whole object of medieval stained glass was to fill the great spaces between the buttresses and prevent the harsh light of day from penetrating into the cathedral. The transcendental effect of the High Gothic interiors depends in no small measure on the harmonious interplay of architecture and coloured light.

It was in the fourteenth century that the French made their initial contact

Robert Nanteuil (1630—78), LOUIS XIV.

with Western art, which was then entering upon its first great period in Italy. In 1309 the exiled papal court had established itself in Avignon, which soon became a lively centre of the arts. Many Italian artists were invited to work there, including Simone Martini of Siena and Matteo Giovanetti of Viterbo, whose frescoes in the papal fortress exerted a considerable influence on contemporary French painting. But the influence was not all one-sided, for the Italians also benefited from the highly inventive art of the French illuminators.

The illuminated manuscript was another specialized discipline in which the French excelled. Whereas elsewhere—in Italy, Bohemia and Germany, for instance—this traditional medium was still firmly in the hands of the monasteries and so continued to serve purely religious ends, in France it had become a secular art form, whose exponents dealt primarily with courtly themes. Most of their commissions came either from the French Court or from the Burgundian dukes, especially the Duke of Berry, who had no less than twenty Books of Hours executed by the most famous artists of his day. The gem of the ducal collection, which is also one of the truly great works of European illumination, is the *Très Riches Heures du Duc de Berry*, which is now in the Musée Condé in Chantilly and has been ascribed to the brothers Jean and Armand de Limbourg. Although the list of feast-days in this manuscript was still illustrated with scenes from the Bible the appendix contained more than a hundred and twenty miniatures depicting such secular themes as hunting scenes, banquets, stately processions, tournaments and dances. These motifs were placed in a natural setting which reflected the growing interest in landscape: the Duke's castle and citadels, painted in

Claude Lorraine
(1600—82),
CLUSTER OF TREES AT
THE SIDE OF A HILL.

luminous white, are seen rising up against a blue sky, green meadows dotted with realistic trees and bushes lie spread out in front of them, and farmers go about their work in fields and vineyards. Although the Burgundian miniatures exerted a lasting influence on the Early Renaissance painting of France, Germany, the Netherlands and Italy, they actually have far more in common with graphic art for in view of the small format of their works, the miniaturists were obliged to emphasize the linear composition at the expense of purely painterly elements. The close affinity between the ornamental figures and the typographical signs of the text also tended to underline this graphic quality. And finally there was the fact that the special brush used by the miniaturists—which had only a single bristle—was far more like a silver-point wire or an ink pen than the large brush used by the painter in oils. Seen in this light the miniature ought really to be classified as a graphic art form. Certainly these early fifteenth-century French miniaturists might justly claim to have laid the foundations, both thematically and structurally, for the subsequent development of graphic art in Europe.

For the time being, however, this was the only influence exerted by the French. In all other respects they themselves were influenced by others and the few well-known French artists of the day all imitated either the Italian masters of the *Quattrocento* or the early Flemish realists. In the sixteenth century this lack of native talent led to a situation in which the French Court found it preferable to employ foreign artists. Francis I, for example, brought Leonardo da Vinci from Italy and Jost van Cleve from the Netherlands. Judging by his name, Jean Clouet, who was 'valet de chambre' to Francis I, may well have been a Frenchman. But his work was unmistakably Flemish. His son François, who succeeded him as 'valet de chambre' in 1541, served first under Francis I and then under his successor Henry II. François Clouet's *Portrait of Henry II* is a very effective drawing. Using extremely delicate shading he created a fully modelled head which stands in marked contrast

François Clouet,
Portrait of Henry II,
page 154

Claude Lorraine
(1600—82),
LANDSCAPE WITH A
SETTING SUN.

Claude Lorraine
(1600—82),
PORT SCENE.

to the cap and robe, these having been sketched in with just a few faint strokes of the chalk. The narrow face with its cunning eyes and long nose—a legacy from his father Francis I—gives some idea of this extraordinary man, to whom the French are indebted for some of their most beautiful castles, but who was also responsible for the institution of the first anti-Huguenot measures. In 1533 Henry found himself obliged to marry Catherine de' Medici in order to replenish the state coffers. But although he had no

159

Claude Lorraine (1600—82), TWO WANDERERS IN THE CAMPAGNA.

Opposite: Claude Lorraine (1600—82), TIBER LANDSCAPE NEAR ROME.

Nicolas Poussin (1594—1665), TRIUMPH OF GALATEA.

personal interest in this rich heiress, he none the less stood by her, even when she offered him his freedom. On the other hand, of course, he may well have declined this offer of a divorce because he had already taken his freedom—without his wife's permission. Certainly his relationship to Diane de Poitiers, who was twenty years his senior, was more than a passing fancy. From the day he had mounted the throne Diane had governed his heart and guided his policies. The symbol of this royal attachment—two D's back to back and joined by a hyphen to form an H—can still be seen on Henry's coats-of-arms, on his furniture and on the cutlery in Chenonceaux, Amboise and the Louvre.

In his portrait of Henry II Clouet depicted an extraordinary man without recourse to external trappings. His drawing is, in fact, a typical product of the Renaissance period, in which men were assessed purely in terms of their personal stature. A hundred years later, with the advent of the absolute monarchy, the individual sought refuge behind his rank: all that mattered then was the splendour of his social position. The philosophy of Baroque man was fundamentally sensualist. He took great delight in posing before the public, as is quite evident from contemporary portraits, especially those of *Louis XIV*, who came to epitomize this period. The Sun King was twenty-five years old when he graciously permitted the engraver Robert Nanteuil to reproduce his image. The small inscription at the bottom left of this portrait states that it was executed 'ad vivum', which means that the king actually sat for it. Two years earlier, shortly after Louis had taken over the conduct of affairs from his ministers, Nanteuil had been appointed 'Dessinateur et graveur du Roi'. By the terms of this appointment he alone was allowed to make portraits of the king, and all prints of the monarch reproduced on proclamations and edicts had to be taken from his engravings. Later he lost his monopoly and once artists like Bernini, Lebrun and Rigaud had portrayed the king his reputation was soon undermined.

Nanteuil, *Louis XIV*, page 155

But at the time of this portrait Nanteuil still enjoyed his prerogative and he showed his gratitude by depicting his monarch surrounded by symbols of his greatness. 'Louis XIV, by God's Grace King of France and Navarre' is represented both as a great warrior and as a patron of scholarship and the fine arts. The military equipment on the right and the books, paintbrushes and musical instruments on the left of his portrait state this quite unequivocally, while the laurel wreath above his head testifies to his undying fame. By comparison with these impressive trappings the king himself seems positively unassuming, in spite of the enormous wig and the suit of armour. Nanteuil would no doubt have had little scope for interpretation, for the king would presumably have chosen this pose himself. But even so, he ought to have captured something of the majesty and grandeur of this man, who was to hold the whole of Europe in thrall for half a century.

Nobody can doubt the political importance of Louis XIV, but it is not such an easy matter to establish a reputation for him as a patron of the fine arts. We are indebted to Louis for Versailles, that symbol of absolutism and vainglory, for which the French people were bled to the tune of 300 million gold francs. But although it subsequently served as a model for every royal residence in Europe and is still generally regarded as the most impressive building in the Western world, from an artistic point of view Versailles is decidedly mediocre. The great Italian architect Lorenzo Bernini, who had long sought the king's patronage but was passed over in favour of the

163

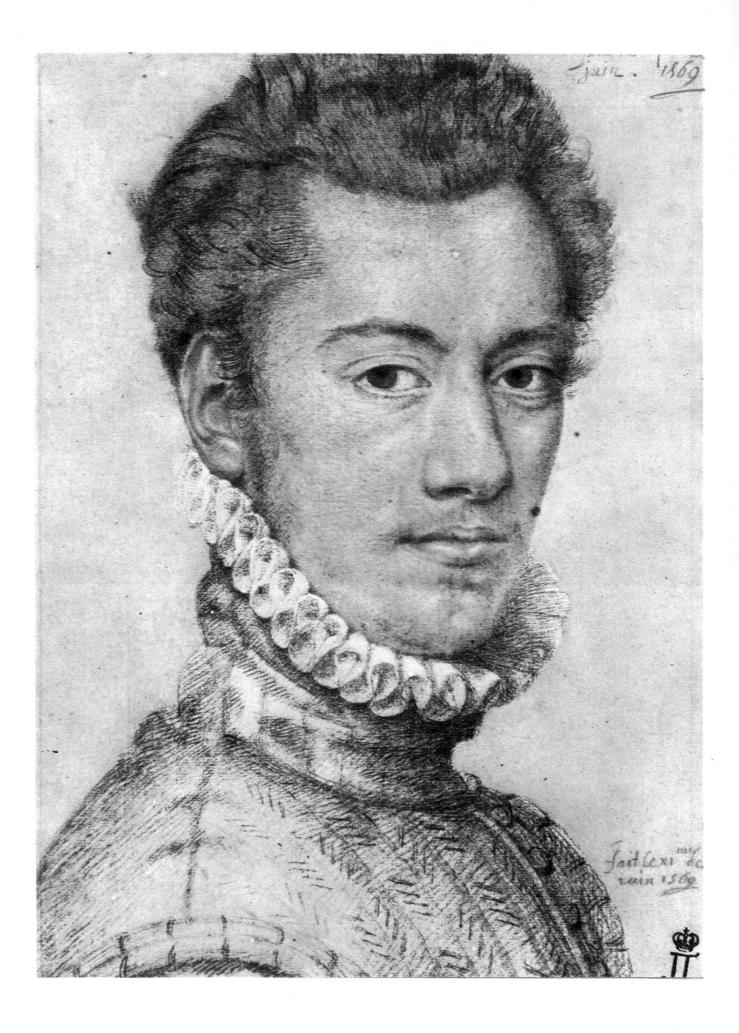

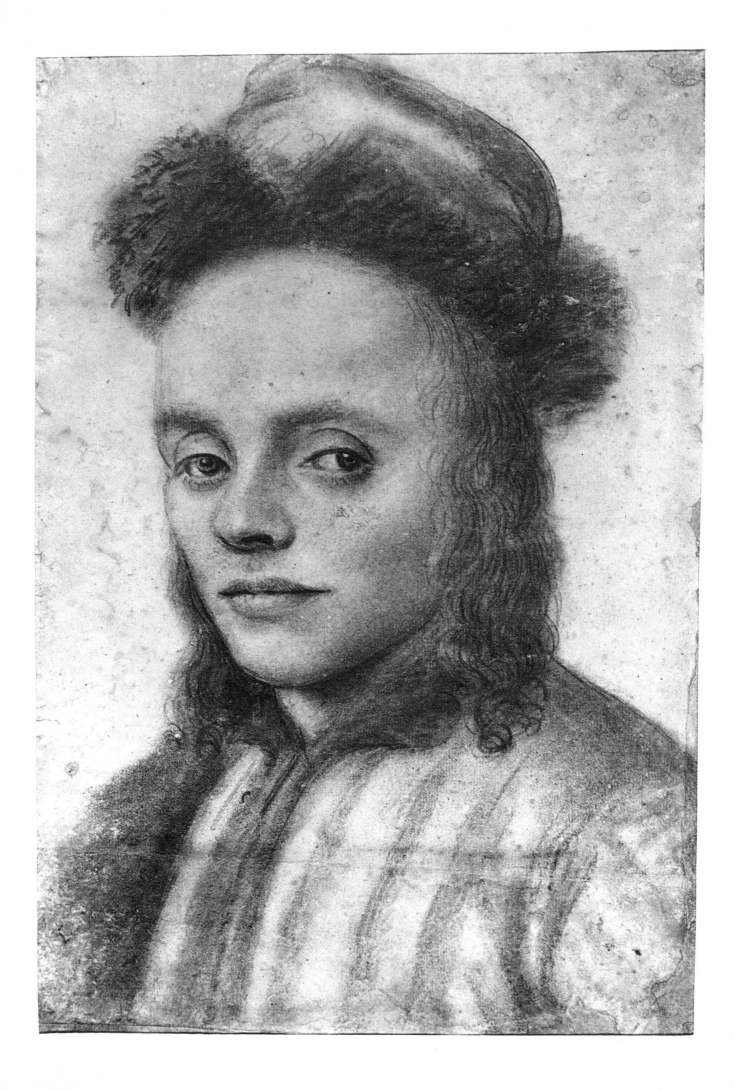

unimaginitive Frenchmen Levau and Mansart, would scarcely have produced a building of such uninspired magnificence.

The late seventeenth-century French painters were in a dilemma. If they wanted to find favour at court they had to abide by the monarch's wishes and conform to his artistic taste, which was far from impeccable. Because of this state of affairs Claude Lorraine and Nicolas Poussin, the two leading representatives of the French Baroque, were forced to spend the major part of their lives in Rome and although they maintained close contact with the French Court at all times, they were able to exert only a minimal influence on French art. The Sun King was only interested in art if it could be made to serve his political ends and helped to glorify the absolute monarchy. When Poussin—who had been appointed 'First Painter to the King' in 1627—suddenly left the country to escape from his monarch's authoritarian patronage, Louis found a willing instrument for his policies in the decorator Charles Lebrun. As head of the 'Académie royale de peinture et de sculpture' Lebrun exercised absolute control over the mainstream of French art, for no French painter received a court commission without his approval. Men of real talent, like Georges de La Tour and Matthieu Le Nain, who refused to conform to his requirements, took no part in the cultural activities of the court. They went their own way; and their paintings make a refreshing change from the uninspired and sentimental products of Lebrun and his followers.

Claude Gellée—who came to be known as Claude Lorraine after his place of birth—went to Rome in 1619 when he was only nineteen years old. In 1625 he returned to France, but two years later he was back in Rome and remained there for the rest of his life. His first biographer, the German Joachim Sandrart, has told of Claude's unhappy childhood and youth: Claude, the third of five children, was born into a poor family. At the age of ten he was apprenticed to a pastry-cook. Two years later, when his parents died, he went to live with his elder brother, who was then an intarsia worker, but left shortly afterwards and travelled to Italy with a lace merchant. In Naples he studied painting and drawing under Goffredi before going on to Rome, where he eked out a modest existence as a boy apprentice in the workshop of an insignificant decorator. He first began to make a name for himself after his return from France to Rome, when he painted a series of frescoes which met with the approval of his patrons. But by 1643, when he became a member of the Accademia di San Luca, he had probably given up frescoes in order to concentrate on panel paintings. He was a slow worker, producing about twelve pictures a year in his early period and seldom more than three in later years. However this did not detract in any way from his reputation, which was firmly established by 1640. His highly individual style was admired, not only by his purchasers, but also by his colleagues, who soon began to imitate him. This prompted Claude to compile his 'Liber Veritatis', a collection of 195 pen-and-ink studies which is now in the British Museum in London. Although the artist conceived this book simply as a means of protecting himself against copies and forgeries it also provides what is virtually a graphic catalogue of his *œuvre*.

Claude's principal sources were Adam Elsheimer, who shared his sensitive approach to nature, and Annibale Carracci, whose 'ideal landscape' served him as a model. But the influence exerted on him by these two masters of the Early Baroque should not be overestimated, for Claude was also the first

Poussin,
Triumph of Galatea,
page 162

166

Jacques Gautier-Dagoty (D'Agoty) (c. 1710—81), THE TAPESTRY WORKER.

Page 164: Pierre Dumonstier the Elder (active in the second half of the 16th century),
PORTRAIT OF ETIENNE DUMONSTIER.

Page 165: Nicolas Lagneau (active at the beginning of the 17th century), YOUNG MAN WITH FUR CAP.

Gabriel de Saint-Aubin (1724—80), SALON DE LA JEUNESSE ON THE PLACE DAUPHINE.

European painter who succeeded in coming to terms with Carracci's idealism. He did so by first acquiring a vivid visual impression of nature, which he then transmuted into a spiritual conception in the Classical mode. According to Goethe his paintings possessed 'supreme truth but not a trace of reality'. Goethe went on to elucidate this paradox by stating that 'Claude Lorraine knew the real world down to the smallest detail ... and used it as a means of depicting the world of his beautiful souls'. Sandrart has told us how he came to know the world so well: 'From long before daybreak until late at night he was in the fields learning to portray the red sky of the approaching dawn, the sunrise and sunset and the evening hours with complete naturalism; and when he had studied one or the other [of these phenomena] in the fields he mixed his colours accordingly, then took them home and used them on the work in hand, producing a greater impression of naturalism than any artist before him.' But it would be wrong to infer from this statement that Claude was an early *plein air* painter. He was just an extremely conscientious and methodical worker who was not prepared to leave anything to chance. He worked out his composition in minute detail and he made painstaking landscape studies in order to acquaint himself with the workings of nature. This methodical approach is best demonstrated by his drawings, almost a thousand of which have survived. They give a clearer picture than his paintings for they reveal, not only his impressions, but also the way in which he subjected these to the discipline of artistic form. His *Landscape with a Watchtower* is a case in point. This sketch, which shows a picturesque coulisse on the left, a few high trees in the foreground and a bright, distant view of a hilly coastline, is obviously a spontaneous impression of a natural scene. But, having got the impression down on paper, Claude then added the geometrical diagram as a structural guide. His *Port Scene* is a study in the use of reflected light, as revealed by the cloud formation, the harsh chiaroscuro, the wide areas of glittering water and even the illusion of space, which is produced simply by means of light. It is evident from the hurried brushwork, which

Claude Lorraine, *Landscape with a Watchtower*, page 156

Port Scene, page 159

168

blurs every detail, that the sketch was executed at great speed, doubtless in
an attempt to grasp the immediacy of the impression. But here too order is
imposed subsequently, with the result that the bright and dark sections, the
heavy and the light forms, the linear and flat areas, interrelate in a
reciprocating pattern of tension and harmony. The fact that the framework
of diagonals, verticals and horizontals was superimposed on to the drawing
indicates that the composition was not premeditated. On the contrary, Claude
obviously recreated, in the first instance, what he saw. It was only afterwards,
having put down his visual impression, that he subjected it to systematic analysis.

169

This highly unusual method is extremely revealing, for it shows that Claude regarded the landscape as something more than an artistic motif. For him the landscape came to represent the principle of change, which underlies the whole of nature, for it assumed a different form according to the light, the time of day and the vantage point from which it was observed. Having recognized the many-sidedness, the mutability and the essential formlessness of natural phenomena Claude Lorraine felt himself called upon to create a valid artistic structure which would give them permanence. Seen in these terms his landscapes really do possess 'supreme truth', in other words a supra-individual and natural truth, and 'not a trace of reality', in other words no insipid realism.

Claude Lorraine took the crucial step which led from the realistic landscape to a new form of pictorial landscape based on the representation of natural forms, and it is in this light that we must consider his drawings.

Antoine Watteau
(1684—1721),
STANDING PIERROT.

170

Antoine Watteau (1684—1721),
PORTRAIT OF AN OLD MAN.

His *Landscape with a Setting Sun* constitutes a marked departure from his normal style. Instead of using a vertical structure he built up his picture by placing transparent zones of chiaroscuro one above the other, fusing them into a composite work by his atmospheric handling. Nearly three hundred years later Cézanne and Lyonel Feininger evolved similar landscape structures. Claude also appears to have anticipated the late nineteenth-century Impressionists with his use of coloured light. In his *Two Wanderers in the Campagna* the deep blue of the southern sky is carried over into the sunlight which, instead of producing a white reflection, shines on the ground with a bluish glow and also reduces the intensity of the shaded areas to brownish tones. The *Tiber Landscape near Rome* reveals an almost total disregard for linear composition. The towers and mountains, for example, are indicated by just a few strokes of the pen. In fact the dominant feature of this work is the bistre wash, which has been applied with thick, full strokes of the brush to characterize the rocks, the clouds, the shadows and the scrub. The enormous rock coulisse on the left of the picture forms bizarre shapes against the low-hanging clouds, which are echoed by the hills, the reflections in the water and the wide shaded areas in the foreground. But on occasions Claude turned away from Classical composition and reverted to a Northern style. His *Temptation of Christ in the Wilderness* is a typical example. The highlights on the mountains and trees, which were created with white

Claude Lorraine,
*Landscape with
a Setting Sun,*
page 159

*Two Wanderers in
the Campagna,*
page 160

Tiber Landscape,
page 161

Temptation of Christ,
page 157

171

Antoine Watteau (1684—1721), STUDY OF FOUR WOMEN'S HEADS AND TWO SEATED WOMEN.

Antoine Watteau (1684—1721), LA COQUETTE.

heightening, and the painstaking execution of the branches and leaves are faintly reminiscent of the old German masters. Claude Lorraine exerted only a minor influence on the development of seventeenth-century art, even though his work was highly thought of by his contemporaries. But in the nineteenth century his landscapes created an impact, first on the Romantics, and subsequently on Corot and the Impressionists.

On 1 September 1715 Louis XIV died. The French provinces, which had been facing utter destitution, are said to have danced with joy at the news. France's 'great century' had come to an end—but only in the political sense. As far as French art was concerned the door was actually opening on a period of greatness, which has continued right down to our own day. After half a century of cultural dictatorship the French artists were at last able to emancipate themselves, not only from Louis's 'reasons of state', but also from their longstanding inferiority *vis-à-vis* the Dutch, the Flemish and the Italians. French art, which had always been committed, now severed its social and religious bonds and was therefore free to embark on the course which was to produce, some hundred and fifty years later, the new conception of 'art for art's sake'. But, although this idea was not actually formulated until the late nineteenth century, in point of fact it was already operative during the Rococo, especially in the sphere of painting.

More than any other artist of his time Antoine Watteau came to symbolize this new movement, which emerged as a reaction to the overpowering forms of the Baroque. He was closer to the love-lorn medieval troubadours than to his immediate predecessors, who had glorified their century with such ardour. Although Watteau was not actually a Frenchman—he was born in Flanders and was a countryman of the great Rubens—he none the less epitomized the new French Rococo style that was to sweep Europe after his death.

In 1699, when he was fifteen years old, Antoine defied his autocratic father by apprenticing himself to a reputable painter in Valenciennes. In 1702 he moved to Paris, where he eked out a meagre existence executing genre scenes for various hack painters. Some two years later he went to Gillot, an artist who specialized in theatrical scenes and who had painted many of the actors and actresses of the Commedia dell'Arte. This was a crucial move, for Watteau was completely captivated by the fantasy world of the theatre, which continued to fascinate him for the rest of his life. It was whilst he was with Gillot that he first began to draw figures in movement. He soon mastered this difficult technique and brought it to such perfection as to be virtually unrivalled in his ability to point a gesture or a pose. But this easy grace, which is one of the hall-marks of his work, was not so easily achieved. On the contrary it was the outcome of highly detailed studies and patient observation, which Watteau had to carry out whilst remaining unobserved himself, lest he should make his models self-conscious.

His *Study of Four Women's Heads and Two Seated Women* shows us the kind of woman revered in the Rococo period: slim, graceful, slightly coquettish, with a delicate face, a dainty upturned nose, a smooth matt complexion and a long slender neck. The woman in this study, whom Watteau has depicted executing various movements, seems extremely natural, certainly far more natural than the rather statuesque female figures featured in his paintings. Presumably this work—like the charming and entirely realistic *Study of Two Children's Heads and Two Hands*—was drawn from life. Thanks to his extremely sensitive draughtsmanship Watteau's realism never

Watteau,
*Four Women's Heads
and Two Seated Women,*
page 172

*Two Children's Heads
and Two Hands,*
page 176

174

Antoine Watteau
(1684—1721),
PROFILE PORTRAIT OF
STANDING WOMAN.

became academic. He liked to use coloured chalks, with which he was able to produce the most delicate shading as well as a firm line. In the children's heads he even exploited the coarse-grained texture of the paper in order to heighten the graphic effect: by applying the chalk very softly he confined his drawing to the embossed surface of the paper, which meant that the lower surface gleamed through the colour and provided a natural highlight. Although Watteau is best known as a painter of gallant society, he was also a keen observer of the workaday world and produced a whole series of drawings of poor people, whom he had doubtless encountered on the streets of Paris. In one of these drawings he portrayed an old *Savoyard* peasant, whose ragged

Watteau,
*Portrait of an
Old Man,*
page 171

The Old Savoyard,
page 177

clothes stand in marked contrast to the great dignity of the man himself. But, of course, this man was no beggar. The box hanging from his shoulder contained a marmot, with which he earned his meagre living as a busker.

These sober and realistic compositions are totally different from Watteau's *fêtes galantes* and his drawings of the Commedia dell'Arte, in which he depicted the magical and unproblematical world of beauty. His *La Coquette*, a watercolour which was probably a design for a fan painting, is typical of this branch of his art. Here reality and illusion are completely fused. A park-like landscape is set within a border of flowers and decorative devices, which include two veils that are faintly reminiscent of theatrical curtains. The figures are also theatrical: a coquette, an intriguant, a sad-faced pierrot and an old man, whose stooping body is a perfect symbol of human frailty. The profile busts of an ageing man with a pigtail and a matron in a lace bonnet,

Antoine Watteau (1684—1721), THE OLD SAVOYARD.

François Boucher (1703—70), LANDSCAPE NEAR BEAUVAIS.

which are set outside the actual scene and symbolize the bourgeois institution of marriage, are a sad reminder of the fate awaiting all young lovers. The antithesis between youth and age, between illusion and reality, is also reflected by the clothing, the old man's drab and uniform attire standing out in marked contrast to the shimmering silks of the young coquette. All these subtle allusions have been achieved within a very small format, for the original drawing is not much larger than the reproduction. The careful brushwork is coupled with a highly inventive and extremely graceful linear composition, whose fairy-tale quality is much enhanced by the pale pastel tones.

Antoine Watteau was the first French artist to turn away from the Baroque and pave the way for the Rococo. Because he was ahead of his time he was not understood by his early contemporaries and it was only after the death of the Sun King in 1715, when French society was able to relax and indulge its taste for more worldly pleasures, that he achieved popular success.

The *galanterie* and the sexual connotations in Watteau's work were extremely delicate and refined. This was not the case, however, with later Rococo painters, whose pastoral scenes provided the setting for highly ambiguous revels. Their shepherds and shepherdesses were meant to convey an image—partly ironical and partly romantic—of an ideal world of innocence that transcended the contemporary scene. By then, of course, the new French court had built farmhouses at Versailles with cowsheds and dairies, where Marie Antoinette offered her guests milk in cups shaped like her own breasts.

This sophisticated world of courtly frivolity is most clearly reflected in the work of François Boucher. The woman in his *Venus with Arrow and Quiver*, for example, is no mythological creature. This is quite evident from the way in which she nestles against the crumpled folds of the sheet, fully aware of her nakedness and with Cupid's arrow pointing at herself. The soft curves of the body and the sensual texture of the skin, which gleams like mother-of-pearl, are perfectly rendered by the pastel colours. The lascivious elegance of this nude figure is also greatly enhanced by the diagonal hatching of the background, which helps to bring out the principal contours.

Boucher, *Venus with Arrow and Quiver*, page 181

The *Young Lady Looking at her Ring* is in complete contrast. In this work, which is a study in innocence, Boucher used a technique which had been developed by Watteau: drawing *à trois crayons*, namely black, white and red. The combination of large areas of white with borders of black hatching creates a delicate silky sheen on the gown, which is reflected by the youthful face. This young girl, who is herself completely captivated by the beauty of her ring, is meant to captivate the viewer by her graceful appearance. In his *Landscape near Beauvais* Boucher also set out to enchant. Although the title shows that the work was based on a real landscape, this reality has been transmuted into a poetic vision. The idyllic panorama rises up rather like a stage set from the low mist clinging to the brook, whose shining surface serves as a fourth wall; and the distant scene acquires a magical aura from the white light, which renders it inaccessible to rational analysis.

Boucher, *Young Lady Looking at her Ring*, page 180

Boucher, *Landscape near Beauvais*, page 178

Boucher's most important pupil, Jean-Honoré Fragonard, also painted 'fairy-tale' landscapes. In his *Ponte di Santo Stefano in Sestri* the bridge, the buildings which flank it, and the various groups of figures are enveloped in a fine, atmospheric mist, almost as if a veil had been drawn across the scene. The fact that Fragonard made this sketch on a journey to Italy in 1773 might perhaps suggest that he was trying to create a *veduta*. In point of fact, however, he was simply using a real-life scene as the point of departure for

Fragonard, *Ponte di Santo Stefano*, page 183

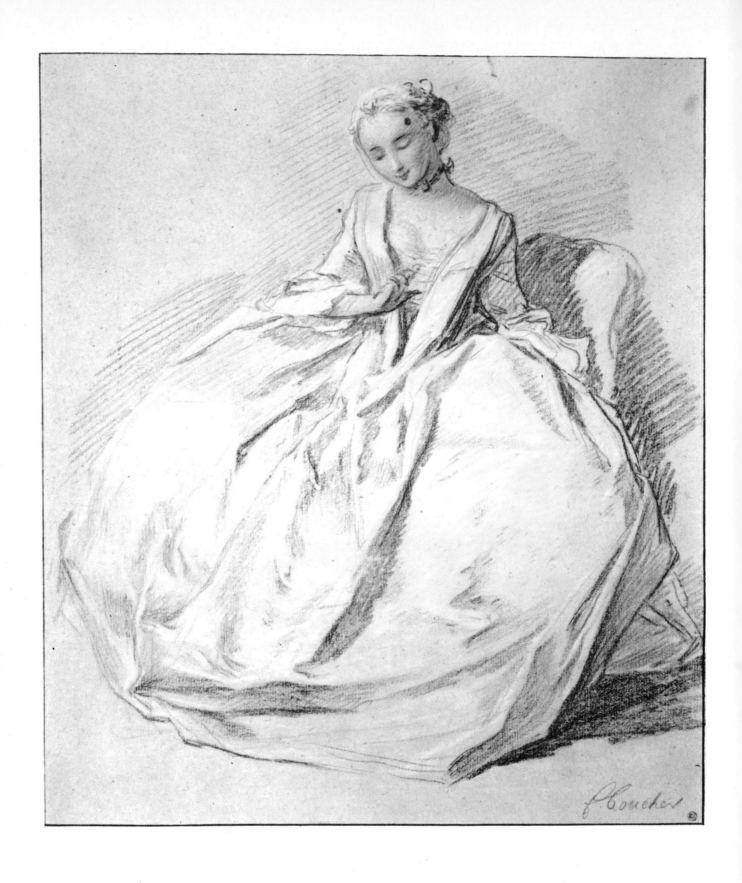

François Boucher (1703—70), YOUNG LADY LOOKING AT HER RING.

Opposite: François Boucher (1703—70), VENUS WITH ARROW AND QUIVER.

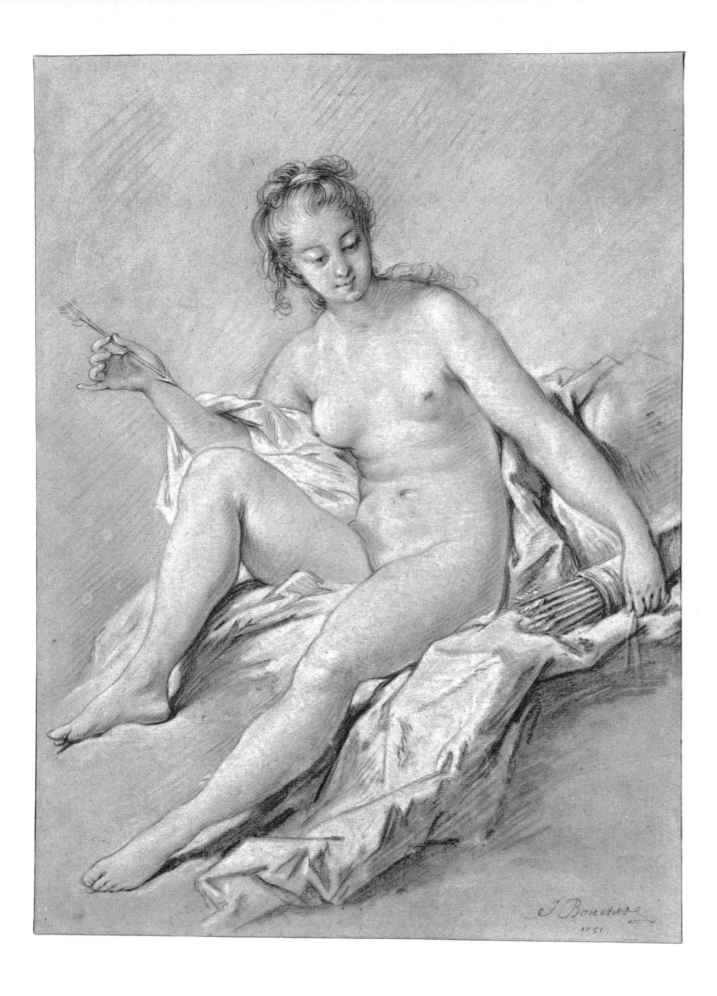

Hubert Robert (1733—1808), DANCE IN THE CAMPAGNA.

Opposite: Jean-Honoré Fragonard (1732—1806), PONTE DI SANTO STEFANO IN SESTRI.

an elegant and completely artificial visual poem. The charm of this sketch depends to a large extent on the extremely subtle effects which Fragonard obtained with his brown wash. Simply by varying the thickness of the colour he was able to differentiate between light and shade, between the vapour clouds in the sky and the dust clouds on the road and between the moving and stationary groups. He achieved similar effects in his watercolour of a *Children's Examination*. By using greenish tones throughout he was able to make the figures blend perfectly with the room, thus creating an impression of uniformity, and by skilfully varying the thickness of his brushwork he produced a complementary impression of great vivacity. The scene also acquires a distinctly painterly quality from the large areas of light and shade. Incidentally, there is a companion piece to this watercolour which is now in New York and which shows the same children receiving certificates and prizes.

Fragonard, *Children's Examination*, page 185

Like Fragonard, Hubert Robert appears to have been fascinated by the gayer aspects of eighteenth-century life. For many years he was attached to the French court as a stage designer and landscape gardener, whilst his commissions for paintings came from members of the aristocracy and leading financiers, who enabled him to live in princely style. In return for such generous patronage Robert provided his clients with pictures that lent dignity to their hedonistic pursuits, which were often quite unbridled. Although he doubtless conceived the idea for his *Dance in the Campagna* during his lengthy visit to Italy, this delicate drawing can scarcely have been prompted by a specific Italian scene. Had this been the case, the composition and the groupings would not have been so theatrical. The appeal of this drawing lies in its liveliness and its air of happy unconcern, which is brought out by the unconstrained outlines and the casual but charming use of bistre and watercolour.

Robert, *Dance in the Campagna*, page 182

Gabriel de Saint-Aubin scarcely painted a single picture, but he made thousands of drawings, which reveal a distinctly poetic talent. He might almost be called the first graphic reporter for he appeared at all public events with his sketchbook in his hand. But although the scenes which he depicted were very much part of the daily scene, his sketches were far from realistic. On the contrary, he always simplified his compositions, recording only those motifs which he considered to be of artistic interest. And so although his interior of the *Église des Invalides* takes account of the main architectural features, it is not an architectural drawing. What really fascinated Saint-Aubin in this subject was the contrast between the cold light descending from the dome and the warm tones of the entrance portal. Note too the way in which the Baroque architecture is reflected in the theatrical gestures of the groups of figures. This is a very intelligent device for, by identifying with these figures, the viewer is able to feel his way into the picture. The *Salon on the Place Dauphine* is even less realistic, due to the striking contrast between the monochrome architectural setting, which covers the whole of the picture surface, and the small but extremely colourful figures. Here too Saint-Aubin depicted a historical event, for this open-air exhibition was dedicated to the works of young and impecunious artists, who were unable to exhibit in the official *salon*, which was reserved for members of the Académie Française.

Saint-Aubin, *Église des Invalides*, page 169

Saint-Aubin *Place Dauphine*, page 168

One Parisian artist who had no difficulty in establishing himself, was Louis-Martin Bonnet, whose skill in the technique of crayon etching earned him the favour of the French court. In this process the grounded plate is

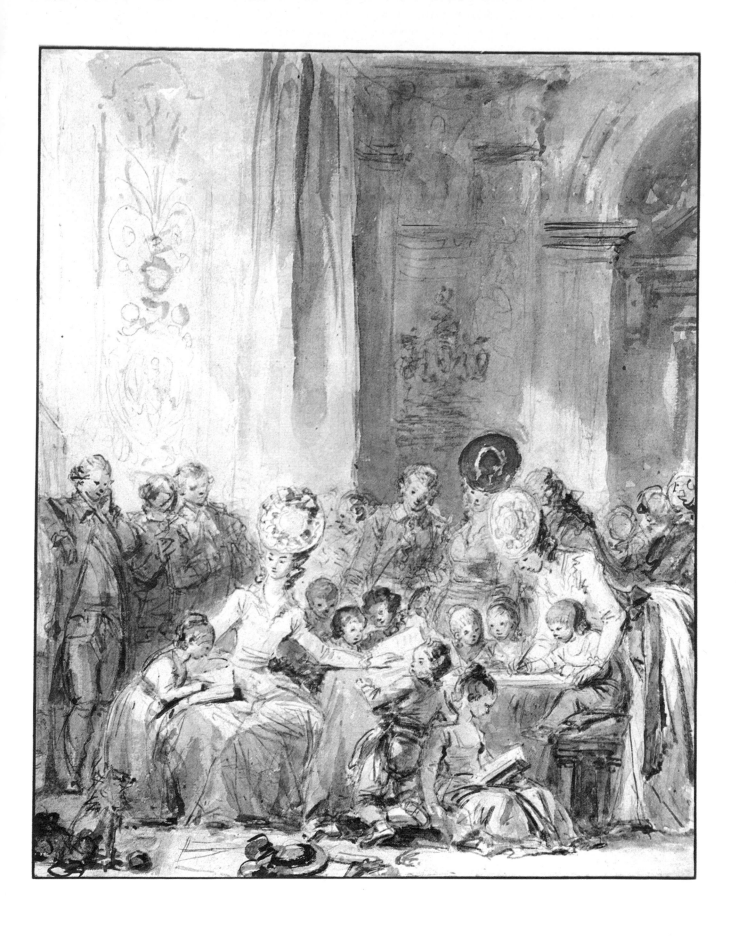

Jean-Honoré Fragonard (1732—1806), CHILDREN'S EXAMINATION IN THE HOUSE OF THE DUKE OF CHABOT. 185

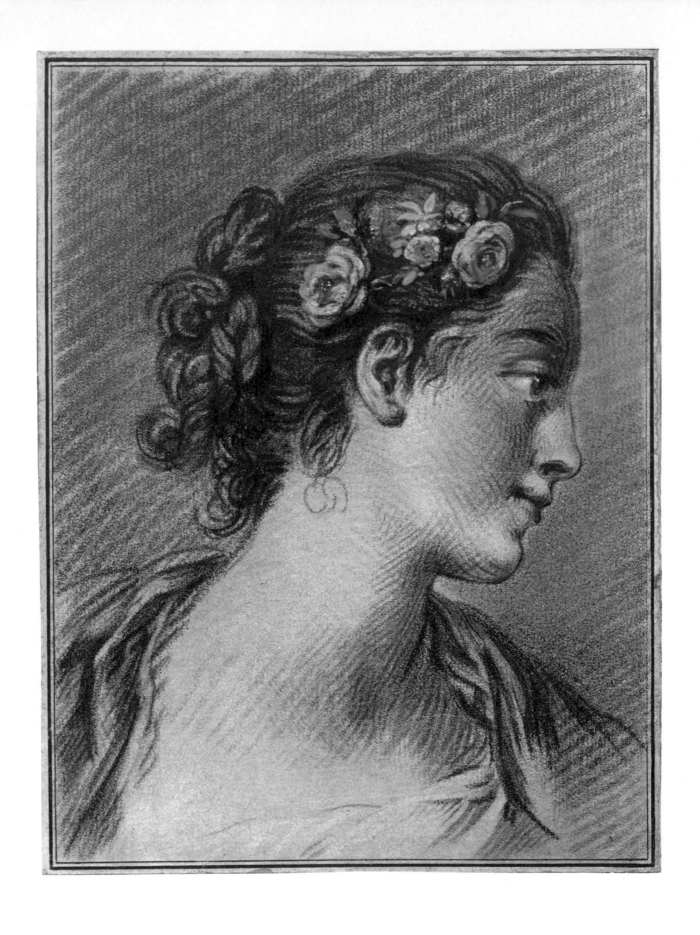

Louis-Marin Bonnet (1743—93), PORTRAIT OF A GIRL WITH ROSES IN HER HAIR.

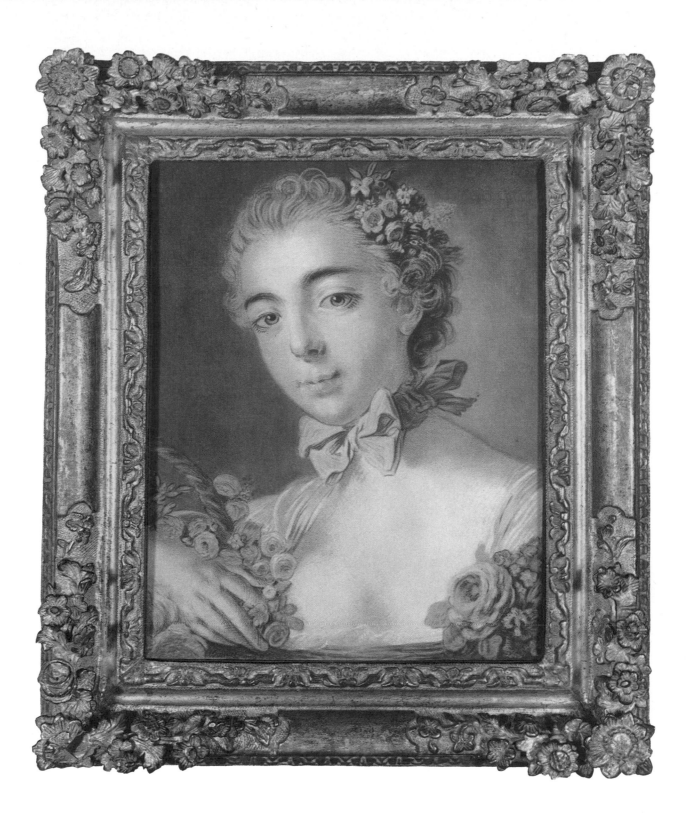

Louis-Marin Bonnet (1743—93), HEAD OF FLORA.

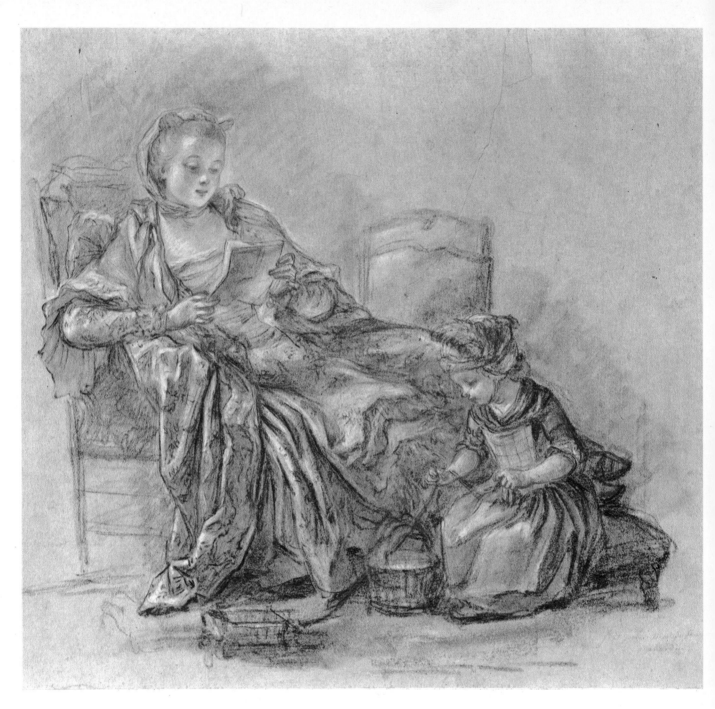

François Guérin
(1735—91),
LADY READING WITH
HER LITTLE GIRL.

Bonnet,
Head of Flora,
page 187

stippled either with an etching needle or, more customarily, with a roulette. This produces a linear structure on the finished print which looks remarkably like a chalk drawing. For colour prints, of course, a separate plate is needed for each colour, a procedure which calls for a high degree of technical precision, since each plate has to be printed exactly on top of the preceding plate so as to ensure that the colours are in register. It also calls for a precise knowledge of colour combinations. Bonnet's *Head of Flora* is a crayon etching of a pastel by Boucher, who was Bonnet's teacher. This print caused such a furore in Parisian society that Bonnet was commissioned to produce similar portraits of Louis XV, of his heir (Louis XVI), of Marie Antoinette and also of Madame du Barry. It was hoped that by disseminating these prints the royal family might gain the love of the populace. Bonnet sold his *Head of Flora* framed for between ten and fifteen *livres.* Our reproduction was taken from an original framed print.

Colour etchings are of course not nearly as old as colour engravings, which appeared in Italy at the turn of the fifteenth and sixteenth centuries and were used to popularize the works of the great Italian masters. They were bought primarily by the heads of large workshops, who gave them to their apprentices to use as models. But in the eighteenth century the coloured copper engraving entered into a new phase when Leblon invented first the three-colour, and subsequently the four-colour print. Leblon's most gifted pupil, Gautier-Dagoty, then greatly improved the four-colour system, and his colour engravings became so popular that he was even asked to produce a portrait print of Louis XV. Although his copper engraving of Chardin's *Tapestry Worker* is a faithful reproduction of the original painting, it is also a work of art in its own right for whereas Chardin obtained his spatial effects by means of colour, Gautier depended far more on the use of line. His engraving actually consists of a series of coloured areas, which are clearly demarcated by firm outlines, and although the colour certainly serves as a link mechanism, it is subordinated to the graphic structure, which is the principal feature of

Gautier-Dagoty, *The Tapestry Worker*, page 167

VUE DE LA PLACE D'HENRY QUATRE PRISE SUR L'EAU.

J. A. Le Campions (active in the 18th century in Paris),
VIEW OF THE 'PLACE D'HENRY QUATRE' (PONT NEUF) FROM THE RIVER.

190 Jean-Baptiste Greuze (1725—1805), HEAD OF A BOY.

this composition. Chardin's subject—which Gautier-Dagoty reproduced with such great artistry—seems strangely out of place in the gallant world of eighteenth-century France. The plain, simple room and the young girl completely absorbed in her work create a positively bourgeois impression. But of course Chardin had little in common with the spirit of his times, although he was far from being a revolutionary. Contemporary critics always spoke well of his work, the only thing they objected to being his failure to cater for the interests of the art collectors, in other words his refusal to make concessions to popular taste. This, however, was his only revolutionary trait. He made no attempt to produce painterly effects and he was not interested in erotic subjects. With great delicacy of touch and an extremely subtle use of colour he represented a view of reality that was both simple and true.

One of those influenced by this new bourgeois realism was François Guérin, whose idyllic chalk and pastel drawing of a *Lady Reading with her Little Girl* might almost be an early example of Biedermeier, even though the lady is in fact no lesser person than Madame de Pompadour. The warmth of this family scene, the intimacy between mother and daughter, has little in common with Guérin's typically Rococo painting, and it is not altogether surprising that this drawing, which is now in the Albertina in Vienna, was originally ascribed to Chardin.

Guérin,
Lady Reading with her Little Girl,
page 188

Like Guérin, Jean-Baptiste Greuze painted and drew in very different styles. As a painter he vacillated between Rococo and Neoclassical art and was rejected—with some justification—by the representatives of both movements. Sooner or later he was also rejected by most of his friends, who were not prepared to tolerate his arrogance and ruthlessness. The only one who stood by him was Diderot, who refused to allow these human weaknesses to colour his appreciation of Greuze's art. As a draughtsman, however, Greuze commanded the respect even of his enemies. In this sphere he was better able to follow the dictates of his own conscience, because graphic art did not really lend itself to the expression of grandiose ideas. Greuze's *Head of a Boy*, which he executed in red chalk, testifies to his outstanding skill as a draughtsman. The formal beauty of this child's face is completely captivating, although his troubled expression is most disturbing. The accusing and scornful eyes—which look right through the viewer—seem almost to anticipate the great event that was to put an abrupt end to Louis XVI's charming but frivolous age: the French Revolution, which brought great terror and confusion into the world but which also ushered in a whole new era.

Greuze,
Head of a Boy,
page 190

SPAIN IN THE SEVENTEENTH
AND EIGHTEENTH CENTURIES

Spanish art can only be understood within the context of Spanish history. Between 711 and 713 the Arabs conquered the southern half of the Iberian peninsula, thus dividing it into two separate territories, each of which developed its own cultural tradition: over the centuries the south became more and more subject to Islamic influence whilst the north strengthened its links with the Christian culture of the Western world in order to defend itself against the power of Islam.

But despite this basic opposition between the two territories, cultural exchanges were bound to take place, and by the early Middle Ages we find northern Spain playing the role of mediator between Arab art and the Franco-Italian art of Christian Europe. In Santiago de Compostela—a Christian shrine second in importance only to Rome and Jerusalem—the decorative forms of Islamic art were seen by pilgrims from every corner of the Western world and were soon propagated throughout the whole of Europe. This in turn tended to strengthen the links between northern Spain and its eastern neighbours.

Both the peculiarities and the qualities of early Spanish art are reflected in the numerous Castilian altarpieces and wall paintings, in which Islamic ornamentation is combined with an intensity of expression that we have come to regard as typically Spanish and that is to be found in the works of El Greco, Goya and even Salvador Dali and Picasso. But despite its passionate commitment, Spanish art was not really independent. For a long time to come it was conditioned by external factors. In the Late Middle Ages French and Italian influence actually increased and the Spanish wall paintings of this period owed much to the Florentine and Sienese schools. It seems likely that a number of anonymous artists were working in the north-east of Spain for a lengthy period in the fourteenth century. The medieval illuminators had been particularly active in this district ever since the tenth century and in the fourteenth century they received a new stimulus from the Burgundian miniatures. Following Jan van Eyck's protracted visit to Spain in 1427 close and lasting links were established with the Netherlands, which also proved extremely fruitful.

When the Arabs were finally driven from the peninsula in 1492 and Spain embarked on the expansionist policies that were to make her the leading European power, the stage was set for the development of a completely autonomous Spanish art form. Although initially there were no Spanish artists capable of creating a national style, the way in which men like Hernando de Llanos and Juan de Juanes took over the secular idealism of the Italians and the realism of the Dutch and adapted them both to meet the religious needs of the Spanish Counter-Reformational Church, shows that there was no basic lack of talent.

The most important representative of the sixteenth-century school of Spanish painting was Domenikos Theotocopoulos, better known as El Greco, who

El Greco
(1541—1614),
STUDY BASED ON A
MICHELANGELO
SCULPTURE.

studied in Rome and Venice before going to live in Toledo. Although a Greek by birth, El Greco fully understood the Spanish character, which he portrayed in a revolutionary style that ushered in the golden age of Spanish painting. His pictures do not glorify the sensual beauty of this world. On the contrary they are the visions of a fervent heart, products of religious ecstacy: no other painter of the time could rival El Greco in his ability to depict the religious zeal unleashed by the Spanish Jesuits. Although the transfigured world, which he portrayed in irrational colours and supernatural light, was understood by only a small circle of his contemporaries and although he had no disciples to continue his work after his death, El Greco established the whole of the subject-matter treated by the Spanish artists of the seventeenth century.

Unfortunately El Greco left no graphic *œuvre*, although we know that he made numerous drawings between 1566 and 1570 when he was in Italy. The only authenticated drawing of his to have survived is the chalk study which he based on Michelangelo's allegorical marble sculpture of a reclining figure from the tomb of Giuliano de' Medici in Florence. Strangely enough—although

El Greco,
*Study based on a
Michelangelo
Sculpture,*
page 193

193

Juan Carreño de
Miranda
(1614—85),
DISROBED CHRIST.

his fellow Mannerists regarded Michelangelo as a model—El Greco was not at all receptive to his art. 'Michelangelo', he said, 'was an honest man, but he could not paint.' This assessment, which is authenticated, caused considerable resentment in Rome and was one of the reasons why El Greco was obliged to leave the city. It should not surprise us to find, therefore, that far from being an act of homage to Michelangelo—El Greco's chalk study is a highly individual Mannerist version of the original sculpture. In producing it El Greco made three major alterations. In the first place he adopted a different and completely arbitrary viewpoint so that, instead of a reclining figure, we find ourselves confronted with an upright seated figure. In this way he was able to elongate the forms without changing their basic proportions. The second alteration which he effected concerns the disposition of the legs. In Michelangelo's sculpture the right leg of the statue is bent sharply backwards. By transferring this feature to the left leg of his figure El Greco created a virtually unimpeded flow of movement extending from the head all the way down to the right foot. Moreover—since the right foot is cut off by the picture frame—this movement, which is greatly enhanced by the flow of the drapery, appears to continue beyond the actual composition. El Greco's third major alteration was the introduction of a typically Mannerist chiaroscuro effect to replace the even distribution of light which Michelangelo had planned for his statue in the New Sacristy of San Lorenzo and which was meant to establish a condition of harmony between the statue and the surrounding space.

Juan Carreño de Miranda, one of the leading representatives of the Spanish Baroque, was strongly influenced by Italian sources. Apart from the many excellent portraits of the Spanish royal family, which he executed in his capacity as court painter to Charles II, he also produced a number of religious works, whose powerful forms and splendid colouring are specifically Baroque. His *Disrobed Christ* is a study for an altarpiece depicting Christ's baptism. (The altarpiece has not survived and may in fact never have been painted.) The precise definition of the body and the painterly use of light to produce plasticity show the influence of the Venetian school. But the area of cold light in which the figure is set and the almost abstract linear structure of the general background are typical features of Spanish religious art, which always stressed the supernatural component in such works.

Juan Carreño de Miranda, *Disrobed Christ*, page 194

But it was in Goya's work that this mystical and visionary view of the world was most fully realized. He is one of the greatest of Spanish painters and the only one to have achieved an international reputation as a draughtsman; his graphic work is comparable with that of Dürer and Rembrandt. Goya erupted on to the eighteenth-century Spanish scene with revolutionary force. By breaking the bounds of conventional propriety he shook the public out of its complacent acceptance of traditional forms, thus rescuing Spanish art from the intellectual sterility to which it had long been subject and restoring Spain to her former status as a rival of France and Italy. During this period of sterility, which had set in following the death of Velázquez and Murillo, Spanish painters were obliged to take their lead from the artistic activities being pursued in the major European centres. But the gaiety of the Rococo, which swept the continent in the first half of the eighteenth century, was too alien to the Spanish, whose sombre mysticism frustrated all attempts to establish the new movement in their country. Even when native French and Italian artists were invited to work in Spain the public remained unimpressed.

Francisco de Goya y Lucientes
(1746—1828),
THE COLOSSUS.

Luis Paret y Alcazar,
Sacrifice to Diana,
page 202

And so Spanish painting degenerated into a sort of academic formalism, which already revealed traces of incipient Neoclassicism. Paret y Alcazar's *Sacrifice to Diana* is typical of this development. The figures in this water-colour display a combination of Rococo grace and Neoclassical severity whilst the methodical structure of the mythological scene reveals the influence of Winckelmann.

Such evidence of academic zeal is not to be found in Goya's work. He named his mentors as 'nature, Velázquez and Rembrandt'. But this self-assessment should not be pressed too far, for it is really no more than a general statement of Goya's artistic allegiance. The figures and visions which he treated in his works are the product of his own personal experience, and the way in which he depicted them is entirely original and has no parallel either in his own or any earlier period. Goya was a complete outsider with an immensely fertile imagination, who established a new pictorial style that has retained its authenticity and its immense power right down to our own day.

Apart from a few hectic years as a student in Saragossa Goya led a completely conventional life. After completing his studies in Madrid he visited Italy for two years, returning to Spain in 1771. In 1775 he married the sister of the painter Francisco Bayeu, who was then employed as an assistant by Anton

Francisco de Goya y Lucientes (1746—1828),
DREAM: GROWTH AFTER DEATH.

Francisco de Goya y Lucientes (1746—1828), RAVING LUNACY.

Francisco de Goya y Lucientes (1746—1828), THE RAPACIOUS HORSE.

Francisco de Goya y Lucientes (1746—1828), DRESSED UP FOR A WALK.

Francisco de Goya y Lucientes
(1746—1828),
VISIONS: A SATIRICAL DRAWING.

Mengs, the German Neoclassical painter. On the recommendation of his brother-in-law Goya was commissioned to execute forty-five tapestry cartoons for the Escorial, which started him on his successful career. In 1780 he became a member of the Academy of San Fernando, which had twice rejected him prior to his Italian journey. In 1785 he became Deputy Director of the Academy and in the following year was appointed *Pintor del Rey*. He soon enjoyed the confidence of the *Infante* Don Luis and the protection of the whole royal family. But in 1792 this untroubled life came to an abrupt end when he suffered a severe stroke, which left him totally deaf. Overnight the pleasure-loving Bohemian became an embittered and introverted sceptic. But in this period Goya's art reached its full maturity.

Goya's society portraits remained as popular as ever despite the marked change which they underwent after his illness, when he saw people with different eyes. Behind their pleasing presentation he now recognized the lethargy, the arrogance, the viciousness and the lasciviousness of their inner nature, which were all reflected in his paintings. Instead of the beautiful aristocratic features which had graced his earlier portraits Goya began to paint brutish, moronic and hideously ugly faces, which stand in marked

Vicente Lopez y Portaña (1772—1850), PORTRAIT OF DOÑA SALVADORA JARA DA CAMARON.

Luis Paret y Alcazar (1746—99), SACRIFICE TO DIANA.

Opposite: Eugenio Lucas y Padillo (c. 1824—70), BULLFIGHT.

Eugenio Lucas

contrast to the splendid robes worn by his noble subjects, who thus appear as symbols of a bankrupt monarchy. Incredible though it may seem, this overt act of social criticism passed unnoticed. Far from losing his position at court Goya was inundated with commissions. It was not until much later that the authorities realized that the court painter Goya had become a revolutionary.

The collapse of the Spanish royal house was brought about by the war with France. In 1808 Charles IV was deposed by Napoleon, whose brother Joseph Buonaparte ascended the throne. This usurpation was followed by guerrilla warfare, in which the Spanish fought with fierce determination to overthrow the Corsian overlord. Goya followed their embittered struggle with intense interest and great sympathy. His contempt for the national and Church leaders now erupted into open hatred, which was accompanied by a marked increase in his graphic output: in his drawings and etchings he found a legitimate medium for his tormenting visions. His *Colossus* was conceived as a protest against the demonic exploitation of terrestrial power and not—as has sometimes been supposed—as a symbolic representation of Napoleon. This figure is the prototype of the political tyrant, in whose shadow all human institutions wither and die: the tiny houses and hamlets are completely at his mercy. Goya's *Raving Lunacy* was executed as a sketch for his *Proverbios*, the celebrated series of etchings which are among his best graphic works. Here the weapon in the hand of the demented man symbolizes the power wielded by the tyrant over defenceless people who have been deprived of the protection of the law. The red brush drawing of the *Rapacious Horse* was also executed as a study for the *Proverbios*. It is based on the legend of a bewitched man who kills his rival and abducts his wife. Goya interpreted this quite literally, but by painting the whole sketch in red he underlined the cruelty of the scene, thus giving it symbolic force. The underlying theme of the graphic series which he produced after 1810—*Desastres de la guerra, Disparates* and *Proverbios*—is *Existenzangst*. In this they differ from the satirical etchings and drawings of his early period, which were intended as acts of social criticism. In his *Visions,* which gave expression to the latent anti-clericalism of his day, he showed his contempt for the degenerate life of the Spanish religious, whilst in his *Dream,* in which an aristocrat dreams that he is transformed into a veritable giant after his death, he was evidently poking fun at the excessive praise which was frequently bestowed on politicians by posterity and which was out of all proportion to their true worth. Although at first sight Goya's exquisite watercolour *Dressed up for a Walk* appears entirely harmless, it is actually a vicious attack on the vanity of the Spanish aristocrat. By placing the central figures in this work in an almost total vacuum Goya demonstrated the essential unrelatedness of the vain man. And the two workaday figures lurking in the background make no secret of their contempt for this exalted world, which is here seen hovering 'on the brink'.

Although Eugenio Lucas y Padillo, the nineteenth-century Spanish artist, succeeded in developing an expressive from of draughtsmanship comparable to Goya's, in his case technical skill was not accompanied by profundity of thought. Lucas was at his best in the portrayal of dramatic scenes. His *Bullfight* is a typical example. Here the seething mass of spectators is represented by an almost abstract linear structure and even the figures in the ring are for the most part so blurred as to be indistinguishable. Only the two principals, the horseman and the bull, stand out clearly from the great whirl of colours and lines, thus establishing both the form and the meaning of the whole scene.

Tobias Stimmer
(1539—84),
ABRAHAM'S SACRIFICE.

GERMANY FROM THE RENAISSANCE
TO THE MODERN PERIOD

Dürer and Grünewald both died in 1528, followed by Hans Holbein in 1543 and Hans Baldung Grien in 1545. With this the period of German classicism —one of the most celebrated periods in the history of German painting and graphic art—came to an end. It was followed by an artistic vacuum that had its roots in religious and political strife and lasted for a full two hundred years. Of all the peoples of Europe the Germans suffered most from this pernicious confessional dispute. In 1546 Martin Luther died in Eisleben. Thus the end of the German classical period coincided with the end of the first phase of the Reformation, a movement that had roused such high hopes when it swept away the corrupt practices and intellectual dishonesty of the ancient order, an order which had sustained the Western world for over half a millennium.

But the Protestantism of the post-Lutheran period showed a very different face to the world, for it lacked conviction and it lacked unity. While the Catholic Church had the advantages of tradition and a central leadership the Protestant camp was split into warring factions: Lutherans, Calvinists, Anabaptists and Unitarians. The Lutherans were even divided among themselves into those who espoused and those who rejected the liberal views of Melanchthon. But on one point all Protestants—even the Lutherans and Calvinists—were agreed: they were all opposed to images of any kind in

205

Above:
Adam Elsheimer
(1578—1610),
STUDY FOR THE OIL-
PAINTING 'AURORA'.

connection with worship. The production of sacred art came to a complete standstill in all districts controlled by the Protestants. They made no attempt to decorate their churches and any works of art left in them from pre-Reformation days soon fell victim to the fanatical onslaughts of the iconoclasts, which reached their peak in the Calvinist outrages committed in the Netherlands. As a result of this doctrinaire attitude on the part of the Protestant Church the north German artists lost their traditional patron.

The principal reason for the sudden decline of Germain painting in the second half of the sixteenth century was the lack of a suitable ideological foundation. However conditions in the Catholic south were not quite so bad as they were in the Protestant north. The Counter-Reformation, which the Jesuits had introduced into the southern territories, furnished a link with Italian Mannerism whilst in Prague Rudolph II was following in the footsteps of his fourteenth-century predecessor Charles II and trying to establish this capital city as a centre of scholarship and the fine arts. The 'Rudolphine art' of Prague—an interesting variant of Italian Mannerism—made its influence felt as far afield as Frankfurt and the Upper Rhine, where it merged with elements of Netherlandish art.

Stimmer,
Abraham's Sacrifice,
page 205

By incorporating traditional German elements into his graphic work the Swiss artist Tobias Stimmer acquired a reputation among his contemporaries as one of the most gifted and versatile artists of his day. His *Abraham's Sacrifice* is typical of his work.

But the only artist who really stands out in this period of mediocrity is Adam Elsheimer. The high esteem which he enjoyed among the *élite* of the international art world during his lifetime is reflected in the obituary written to him by no less a personage than Peter Paul Rubens. 'The loss of such a man', Rubens said, 'must cast our whole guild into deep sorrow. It will not be easy to find a replacement for him, and in my opinion there is no one to equal him in the painting of figures, landscapes and much else besides.' We should not underestimate the influence exerted by Elsheimer on his contemporaries, primarily on Rubens, Claude Lorraine and Rembrandt's teacher Pieter Lastman. Unfortunately he made no real impact in Germany. Not that the German artists would not have responded to his work if they had had the

chance. But Elsheimer left his native town of Frankfurt when he was only twenty and travelled via Munich and Venice to Rome, where he died at the early age of thirty-two. His relatively small *œuvre* and the small format of his works may also have contributed to the fact that he was so little known in his native land.

According to the art biographer Joachim Sandrart, Elsheimer often spent whole days observing natural phenomena in order to perfect the detail of his landscapes. The small study which he executed for his oil-painting *Aurora* would certainly lend credence to this account. The distribution of light in this study—the bright morning sky and the small areas of reflected light on the otherwise dark earth—is clearly based on precise observation. And yet this drawing is not just a reproduction of a natural scene. The extremely subtle tonal values and the way in which the detail is organized into a bright and a dark diagonal zone raise it to an artistic level.

Elsheimer, *Study for 'Aurora'*, page 206

In 1618, just eight years after Elsheimer's death, religious strife broke out in Bohemia, which quickly spread throughout the Empire. And so, whilst painting entered a 'golden age' in Holland and reached one of its great climaxes in the Flemish, Italian and Spanish Baroque, in Germany it foundered in the chaos of the Thirty Years War. During this period only a few German artists, who were fortunate enough to escape the confusions of the times, continued to produce serious work. One of these was Matthäus Merian, who was a native of Basle. Merian was a highly skilled engraver and acquired considerable fame as an illustrator. His two best-known publications are the

Below:
Matthäus Merian the Elder (1593—1650), GOSLAR.

Merian the Elder, *Goslar*, page 207

Topographia (for which Martin Zeiller wrote the text) and the *Theatrum Europaeum*, a historical chronicle of events in Europe from 1617 onwards that contains many of the town views for which Merian is chiefly remembered and which possesses very considerable historical value. His *Goslar* is a typical example of his work. Merian's daughter Anna Maria Sibylla later acquired an international reputation as a painter of flowers and insects.

When the courtly and ecclesiastical Rococo style was developed at the beginning of the eighteenth century, painting was required to fulfil an entirely new role. The wall and ceiling decorations produced at that time were really an extension of architecture and as such made a crucial contribution to the illusionist spatiality of the Late Baroque castles, monasteries and churches. By their use of light and colour the early eighteenth-century Rococo painters deprived architecture of its structural definition and so gave it a supra-sensual dimension.

Anton Maulbertsch, *Allegory*, page 209

The patrons of those days demanded detailed studies demonstrating both the subject-matter and the style of any projected work. The *Allegory* by Franz Anton Maulbertsch—the foremost Austrian painter of his day—is one such study. The appeal of Maulbertsch's pen and ink drawing lies in its spontaneity. But, despite its general air of improvisation, the basic idea is perfectly clear: a group of allegorical figures—Historia, Veritas and Justitia—are being carried upwards into a clear sky on a cloud, whose lower surfaces—those facing the viewer—are kept in dark shadow, whilst its upper areas are brightened by the refulgent gleam of the heavens. Between these extremes of bright and dark lies a whole scale of subtle greys, which lend a painterly quality to the billowing composition.

Below: Daniel Chodowiecki (1726—1801), FAMILY OUTING.

In the Protestant north, where there were no Church commissions, the role of patron was taken over by the secular princes, who saw themselves as

Wallfahrt nach Frantzöst, Bucholz gezeichnet von D. Chodowiecki in Berlin 1775

Franz Anton Maulbertsch (1724—96), ALLEGORY.

the simple, honourable and paternalistic guardians of their people. This
fundamentally bourgeois attitude was faithfully reflected by the north
German artists, who transformed the subtlety and grace of the Rococo
into a pedantic form of realism. This transition from traditional Rococo
ornamentation to a highly objective art form led to a reappraisal of the
etching, which was particularly well suited to the representation of scenes
from bourgeois life. Daniel Chodowiecki is a typical representative of this
style. In his *Family Outing* he combined an extremely delicate etching
technique with an unerring sense of bourgeois reality. Chodowiecki also

Chodowiecki,
Family Outing,
page 208

Caspar Wolf (1735—83), THE LAUTERBRUNNEN GLACIER.

Carl Rottmann (1797—1850), THE ISLAND OF SANTORIN.

Wilhelm von Kobell (1766—1853), TERRACE NEAR FÖHRING.

produced countless etchings of scenes from contemporary plays, which have enabled modern scholars to reconstruct eighteenth-century theatrical methods with great accuracy.

The Neoclassical painting of the post-revolutionary period had no real champion in Germany. Whilst the revolutionary spirit of the 'Sturm und Drang' found an ideal outlet in the youthful dramas of Goethe and Schiller German painting vacillated between the bourgeois Rococo and a highly didactic form of Idealism. Winckelmann's theoretical writings and Goethe's *Italian Journey* aroused considerable interest in Roman and Greek Classicism, which was regarded as a counterpoise to the courtly culture of the Baroque and Rococo. In the event, however, German painting was renewed not by a revival of antique art forms but by a reawakening of interest in nature. Man was depicted as a creature of dignity in the naturalistic portrait and his new view of the world was represented in the naturalistic landscape, which embodied Rousseau's exhortation to go 'back to nature'. In Rococo art the landscape had been a mere adjunct, a backcloth that set the mood for games and fêtes. Now the German artists saw it with all the naïveté of the nature-lover. Instead of painting decorative landscapes from their imagination they painted wide open spaces with complete fidelity to the actual scene. These works were free from misguided pathos and free from the reverential ecstacy that was to become such a feature of the Romantic landscape.

Due partly to the enquiries of the natural scientists and partly to the poetic works which they inspired, a number of artists began to paint mountain landscapes. In 1773 the Bernese publisher Abraham Wagner commissioned the Swiss landscapist Caspar Wolf to draw a series of mountain motifs as designs for etchings. The *Lauterbrunnen Glacier* was one of these. Wolf is said to have executed this particular watercolour *in situ*, a most unusual practice in his day. The three pictorial levels in this picture—the snow-covered mountains, the glacier and the rock-strewn landscape—are cleverly distinguished from one another by the use of different structural and colour values: the contrasting colours and modelled structures of the foreground give way to a more uniform shade and a flatter composition in the middle distance, which are themselves superseded by the fading and near-amorphous forms of the distant peaks. The three tiny figures in the immediate foreground demonstrate the insignificance of man by comparison with the grandeur of nature.

Wolf, *The Lauterbrunnen Glacier*, page 210

With their pale, muted colours Wolf's landscapes are still distinctly reminiscent of the Rococo. This is not true of the mountain scenes executed by the Tyrolean painter Joseph Anton Koch, who did his utmost to break with tradition. In his *Schmadribach Waterfall* he used strong, luminous colours and condensed the natural forms into a monumental entity. Although the detail in this picture is certainly realistic, the overall conception is more than a straightforward reproduction of a natural scene. According to Koch, the mere imitation of nature is on a much lower level than art. He considered that, even when art appears natural, the naturalism should be a product of artistic creativity, which 'inevitably transforms nature'. Koch represented nature in the classical mode, depicting it as an essentially orderly and self-renewing system. He made no attempt to produce either a facsimile or a fantasy image of the world but rather a combination of both, in other words a completely authentic view involving both subjective and objective factors. Not surprisingly—in view of this total approach—he made no attempt to

Koch, *The Schmadribach Waterfall*, page 214

214 Joseph Anton Koch (1768—1839), THE SCHMADRIBACH WATERFALL.

exploit the watercolour medium by painting with a wet brush in order to blur the colours and so create painterly effects. Nor did he try to produce transparent colours. On the contrary he applied his watercolours very thickly over the whole of the paper ground. The gleam of the snow and the cascading water in the *Schmadribach Waterfall* were produced by the liberal application of white heightening and not by the paper ground shining through the colour. This particular watercolour, incidentally, served as a study for two large oil-paintings, in both of which nature is represented in even more idealized terms.

Koch exerted a considerable influence on the rising generation of German landscape painters including men like Preller, Fohr, Overbeck, Richter and Carl Rottmann. He met Rottmann in Rome, which was then a favourite haunt of German artists.

Karl Philipp Fohr (1795—1818), PROCESSION IN THE GRAVEYARD OF ST. PETERS IN SALZBURG.

215

Rottmann,
*The Island
of Santorin,*
page 211

Carl Rottmann was court painter to King Louis I of Bavaria, who commissioned him to paint a picture of Palermo and subsequently sent him to Greece in search of subjects for a series of frescoes for the Hofgarten arcade in Munich. It was on this journey that he painted his watercolour of the *Island of Santorin,* which emerged from the sea in 1540 B.C. as a result of volcanic activity. The column of smoke in Rottmann's study bears witness to the titanic forces which were responsible for the raising of the island and which constitute the underlying motif of the work. The bare rock, which is illuminated by a weird light, is backed by a dark ridge of storm-clouds that cast deep shadows on the water. The barrenness of the island is underlined by the tiny houses, which seem to be clinging to the rock for safety. The harshness of the general landscape is reflected in the systematic composition, which precludes all possibility of any poetic development. Even the reflections in the water are immobilized by the horizontal organization of the surface. The heroic mood of the work is heightened by the use of predominantly cool tones.

Carl Rottmann received his initial training from his father Friedrich. So too did Karl Philipp Fohr, who later attended the Academy in Munich. But in Munich Fohr soon fell out with his teacher for absenting himself from the classes on antique art, which formed part of the prescribed curriculum. He then left the Academy at the end of the year and set off on his travels at the early age of nineteen. Following in Dürer's footsteps he proceeded to Venice via the Tyrol and Verona. On this journey he produced numerous watercolours and drawings, which show that he was an ardent student of nature. But this enthusiasm was not entirely purged of a visionary form of idealism: for Fohr nature was the means whereby a man of pure heart might fulfil his innate longing for perfection. Being unable to find this man of pure heart in the present he turned to the past and sought him in the form of the noble and God-fearing knight of the Middle Ages. In his *Procession in the Graveyard of St. Peters in Salzburg* he combined these twin ideals of nature and purity in a single work of great vitality. The sky and the trees, which form the setting for the fortress of Salzburg in the background of the picture, leave us in no doubt as to Fohr's powers of observation. But the two knights riding along in front of the outer wall of the fortress give notice of his intention to translate an actual scene into a historical occasion with mystical overtones. This is then borne out by the action in the foreground, where the knight-errant, the Gentleman and his Lady and the solemn procession of monks represent the ideals of the medieval world. In 1816, when Karl Philipp Fohr made his second journey to Italy, he visited Rome, where he associated with the Nazarites, a group of expatriate German artists dedicated to the renewal of modern painting in the spirit of the old masters. In order to facilitate this process of identification a number of these artists became converted to Catholicism, wore long beards and flowing hair, donned cowls and led what was virtually a religious life in the monastery of San Isidoro near Rome. With their frog's eye view of Christianity these naïve brothers venerated the Saints and the saintly and so found a refuge from the misery of everyday reality. By practising self-denial the Nazarites hoped to inherit eternal bliss. They lived and worked in accordance with this precept, which they genuinely believed to have been the basis of medieval piety. Although Fohr found confirmation of many of his own ideals in San Isidoro he did not espouse the extreme pietism favoured by the Nazarites. At the age

Fohr,
*Procession in the
St. Peters Graveyard
in Salzburg,*
page 215

Moritz von Schwind (1804—71),
ST. GENEVIEVE IN THE FOREST.

of twenty-three Karl Philipp Fohr was drowned in the Tiber. His early death cut short the great hopes which had been placed in him.

Fohr's ecstatic view of nature found its most telling expression in the Romantic landscape. Many critics have tended to speak of the Romantics and the Nazarites as if they where identical, although practically every single item on the Romantic agenda was completely misunderstood by the German Roman artists. The Romantics had a far more comprehensive philosophy and their piety was never bound up with a particular confession. In their feeling for nature they strove after universal truth; even their individualism was grounded in universals. In art, as in life, they took the 'broad view'. Their expansive crystalline landscapes reflect a pantheistic view of the world, in which God, man and nature were fused into a corporate whole. In no other

Philipp Otto Runge
(1777—1810),
RECLINING CHILD:
A STUDY FOR
'THE MORNING'.

Caspar David Friedrich (1774—1840), THE WINTER.

epoch has the landscape been portrayed with such animation or such depth of feeling. But the Romantic landscapists were not concerned with the precise reproduction of nature. What interested them were the feelings that nature was capable of arousing in them. It was for this reason that they did not paint their landscapes in the open air. They took long walks in the mountains, the valleys and forests in order to acquire a general feeling of nature, stopping only to make an occasional rough sketch of some particular feature. Then, when they returned to their studios, they painted their landscapes on the basis of this overall impression, using the sketches merely as a very general guide line and attaching little importance to topographical accuracy or naturalistic colouring. Caspar David Friedrich's *The Winter* is a typical Romantic landscape. The melancholy mood of this introspective work is established in the first instance by the setting moon. The foreground scene—in which an old couple are contemplating a half-dug grave flanked by a pair of dead trees in the cemetery of a derelict church—demonstrates the essentially finite nature of human existence, which is contrasted with the eternal quality of the sea, the sky and the stars. The monochrome effect produced by the sepia wash reflects the universality of the theme.

Friedrich, *The Winter,* page 218

Only very few artists of this period succeeded in representing the Romantic *Lebensgefühl* as authentically as Friedrich. In the splendid portraits and highly sophisticated symbolical allegories of Philipp Otto Runge, a north German artist, Romantic yearning assumes a tragic dimension. His *Reclining Child* was executed as a study for the allegorical series *The Four Seasons.* In his paintings and drawings Moritz von Schwind, who was a native of Vienna, turned away from reality and sought refuge in a world of fable and legend. His highly imaginitive illustrations of German fairy-tales have retained their popularity for more than a hundred years. The Swiss artist Henry Fuseli painted numerous pictures based on antique legends, in which he combined the heroic forms of classical art with the poetic fantasy of the Romantics. His *Prometheus* is a typical example. After settling in London Fuseli translated Winckelmann's introductory writings on classical art. His illustrations to Shakespeare, Dante and Virgil were reproduced as engravings and enjoyed considerable popularity, especially in England.

Runge, *Reclining Child,* page 217

von Schwind, *St. Genevieve in the Forest,* page 217

Fuseli, *Prometheus,* page 258

The lofty ideals of the Romantics did not last long. Their universal feeling, which embraced every aspect of nature, was reduced to a form of sentimentality that was concerned only with the more intimate facets of life. In painting this development was reflected by the transition from the wide, open landscape to the contemplative idyll. Events in Europe during the early years of the nineteenth century had left the Germans very much subdued. By 1815 they had adopted an attitude of resignation and withdrawal. And so the country passed from Romanticism to the bourgeois style of the Biedermeier period.

Annibale Carracci
(1560—1609),
STUDY FOR ATLAS.

ITALY IN THE SEVENTEENTH
AND EIGHTEENTH CENTURIES

Baroque art had its origins in Rome, where it succeeded Mannerism, the ecstatic and highly schematic branch of Renaissance art which had been evolved by an earlier generation of Roman artists as a reaction to the naturalism and harmony of the High Renaissance. Mannerism signalled the end of a great epoch and not a new beginning. Although it gave able support to the Counter-Reformation in its struggle against the secular spirit of the Renaissance, it was too anaemic and too ethereal to be capable of further development. And so with the advent of the Baroque, when artists found themselves called upon to give sensual expression to supra-sensual phenomena, the old Mannerist style was rejected in favour of a new and, by comparison, brutal form of realism. The turning point was reached about 1590, when a

220

group of young Roman artists began to paint figures and objects with complete fidelity, using strong colours and powerful brushwork. Instead of idealized figures they depicted creatures of flesh and blood, instead of gracious poses they created dynamic movement.

The foremost exponent of the new style in its early phase was Michelangelo Caravaggio, who lived up to the great name which his father—the painter Fermio Merisi—had given him. He pointed the way for the whole of European art during the Baroque period, and the elemental force, which he brought into play, shaped a whole century. Caravaggio was made of far sterner stuff than the painters of the Late Renaissance, most of whom had led comfortable lives as court painters. He was often involved in brawls, he occasionally drew his knife and even his pistol, he had frequent fracas with the police and was eventually obliged to leave Italy after killing a rival in a duel. It is necessary to know all this if we are to understand the phenomenon of Caravaggio, for the whole character of his art was stamped by this revolutionary spirit. His work should be regarded as a protest against the existing order, against the traditional taste of his patrons, the arrogance of his scholarly colleagues, the whole artistic establishment of his day. Once, when he was advised to study antique statues, Caravaggio simply pointed to the people standing around him, thus giving his would-be mentor to understand that nature had already provided him with an abundance of models. This gesture of his says a great deal about Baroque painting. Baroque man was a man of the senses, who acquired knowledge through experience and not through the exercise of his mental powers. By the same token the Baroque artist turned to reality and not to tradition for his inspiration. Later he placed this inspiration in the

Giovanni Benedetto Castiglione (c. 1600—65), NOAH ENTERING THE ARK.

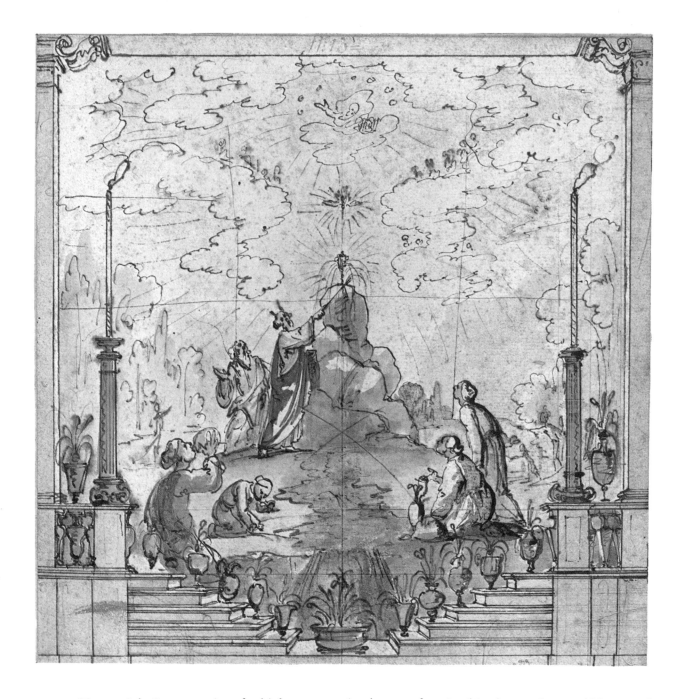

Giovanni da San
Giovanni,
(1592—1636),
MOSES SMITES WATER
FROM THE ROCK.

service of a higher conception by transforming his observations and his sensual impressions into supra-sensual motifs, into an act of homage to transcendental ideals. But the Baroque artist could only achieve true pathos if his figures and scenes were grounded in reality. Consequently in the Baroque period the study of nature became the corner-stone of art.

The artists of the Renaissance had also been well aware of the need to study nature. But they were pursuing an entirely different goal. By investigating individual natural pheomena they hoped to achieve an authentic formulation capable of universal application: for them the individual form was always subordinate to classical form. When asked where he found the models for his 'beautiful madonnas' Raphael is supposed to have replied: 'To paint a beautiful woman I would need to see many beautiful women, but since there are so few beautiful women I use a certain idea which enters my mind.'

The Baroque artists had no such ideal conception of beauty. They sought beauty in reality with all its conflicts and all its imperfections. The Renaissance

222

had banished spontaneity and discord, which lies at the very heart of the Baroque. The Baroque artists saw life as a completely dynamic process, a continuum based on constant change, and consequently they tried to solve all the intellectual problems of their day in terms of movement. Irrespective of whether they were treating secular or religious themes their spatial effects, their colouring and their composition were essentially dynamic. This new view of art was grounded in the observation of nature. The Baroque artists explored the effect of concentrated light and the interplay of light and shadow in great detail and by doing so achieved an unparalleled degree of plasticity. They used live models for movement studies and made countless landscape sketches to fix the diverse forms assumed by natural phenomena, paying great attention to lighting conditions, to cloud formation and to the changing state of the weather. Thus drawings acquired a new dimension: they became one of the means whereby artists apprehended reality. As such, they were far more than preliminary sketches for paintings, which is how the artists of the Renaissance had tended to regard them. In fact Baroque drawings were faithful reproductions of actual scenes, which were then 'conceptualized' or 'ideologized' in the subsequent painting. That is why most of the drawings of this period seem so sober and 'un-Baroque' by comparison with the highly emotional paintings which were based on them. The significance attached to linear composition during this period is demonstrated by the lively argument conducted by seventeenth-century artists as to whether line or colour should take precedence in painting. The 'linearists' took their stand by the great French painter Nicolas Poussin, who applied his colour with strict regard for the fundamental importance of the linear composition, thus lending it symbolic force. The 'colourists' were followers of Peter Paul Rubens.

Another Italian artist who exercised a lasting influence on the development of Baroque art was Annibale Carracci, who arrived in Rome a few years after Caravaggio. Carracci also painted extremely realistic pictures, for instance his *Street Life in Bologna*, but his realism was never as extreme as that of Caravaggio, whose work was frequently rejected by outraged patrons. The original altarpiece of *St. Matthew and the Angel*, for example, which Caravaggio executed for the church of San Luigi dei Francesi in Rome, was rejected on the grounds of indecency. In this painting the Evangelist was represented as a coarse, burly fellow dressed in ragged clothes with bare legs and dirty toenails. Carracci's realism was of a much more delicate order. Together with his brother Agostino, Annibale Carracci ran an academy in Bologna, where he gave life classes and instruction in aesthetic theory. In these courses for young artists special importance was attached to the study of the great works of the Renaissance. And so, by reviving the stylistic elements of the High Renaissance and invoking the vitality of that epoch, the Carracci brothers joined Caravaggio in opposing the Mannerist movement. But whereas Caravaggio chose the path of revolution, they proceeded by way of restoration. When he arrived in Rome Annibale Carracci—again aided by his brother— decorated a gallery in the Farnese palace with wall paintings of mythological subjects, which openly rejected the ascetic world of the Counter-Reformation and of Mannerism. In the Farnese Gallery earthly beauty was again made the subject of a work of art. These much admired frescoes of Carracci's proved a fertile source for the decorative painters of the Baroque. His drawing of Atlas was executed as a study for the figure of Atlas which appears on the frescoes to the right of the scene depicting Polyphem and Acis. This drawing, which

Annibale Carracci, *Study for Atlas*, page 220

223

Carracci used in order to clarify his ideas on the human body viewed from below, reveals interesting foreshortening of the upper body and the arms resulting from the slightly retrograde posture. The light, which falls on the body from the front, increases the plasticity and also strengthens the impression of unforced naturalism. Carracci must have drawn this figure from life, for it seems highly improbable that he could have produced such a lively effect without a model.

Carracci's *Accademica degli Incamminati* [Academy of those on the right path] proved extremely beneficial for the future development of Italian art, for it formed the basis of the 'Bolognese School', the focal point of the north Italian Baroque. The most important member of this school was probably Guercino, who produced a large body of graphic works, most of which were conceived independently of his paintings. Presumably he found it easier to set down his spontaneous ideas with a pen than with brush and oils. His drawings were executed without any attention to detail and in a highly volatile style, which preserves the full flow of the movement. In the *Raising of Tabitha* [from the Acts of the Apostles] he produced vigorous outlines, frequently raising his pen and not hesitating to correct his strokes, and then proceeded to create a living pattern of light and shade with his ink brush. His *Young Woman Holding up a Curtain* is of an entirely different order. Here the pen work is much more precise and much more varied. The linear composition of this extremely impressive drawing ranges from the almost abstract structures of the curtain to the firm hatching of the woman's body and the arabesque designs of the hair and sleeves.

Guercino,
The Raising of Tabitha,
page 225

*Young Woman holding
up a Curtain,*
page 224

224 Guercino (1591—1666), YOUNG WOMAN HOLDING UP A CURTAIN.

Guercino (1591—1666), THE RAISING OF TABITHA.

Giovanni Benedetto Castiglione, a native of Genoa, was another north Italian master who acquired a considerable reputation as a graphic artist. He was an engraver of genius and the expressive chiaroscuro effects which he achieved in this medium place some of his work almost on a level with Rembrandt's. Apart from a large number of line engravings and drawings, no less than seventy of his etchings have been preserved. Castiglione was especially interested in animal studies and many of his landscapes and religious paintings feature a wide variety of animals, which Castiglione portrayed in a realistic style. It is hardly surprising, therefore, that Noah's ark should have provided him with one of his favourite motifs. *Noah Entering the Ark* was executed as a study. In this particular composition Noah is seen turning sharply backwards so that his body assumes what is almost a *contrapposto* stance. The speed of the movement is clearly demonstrated by the swirling cloak. The animals shown in this study are portrayed with considerable skill; both their appearance and their movements are entirely characteristic. The general vitality of the scene derives in no small measure from Castiglione's highly original technique: coarsely ground pigment mixed with linseed oil and applied with rapid strokes of the brush.

Whilst the drawings of the Baroque panel painters were always highly realistic, those produced by the seventeenth-century Italian decorators were decidedly theatrical. In his *Moses Smites Water from the Rock* Giovanni da San Giovanni—probably the most talented of the decorative painters working

Castiglione, *Noah Entering the Ark,* page 221

Giovanni da San Giovanni, *Moses Smites Water from the Rock,* page 222

Rosalba Carriera (1675—1757), PORTRAIT OF ANTOINE WATTEAU.

Opposite:
Giovanni Battista Tiepolo (1696—1770) or Giovanni Domenico Tiepolo (1727—1804)
STUDY SHOWING VENUS, APOLLO AND TWO CYCLOPS.

227

Pietro da Cortona (1596—1669),
HEAD OF A YOUNG WOMAN.

in Florence in the early seventeenth century—employed a type of composition that is almost indistinguishable from a stage set. The only realistic element is the neatly drawn and strictly linear border, which simply provides the framework for the mystical action taking place in the background. There water is seen spurting from a chalice (a symbol for Christ) and running down the rocks to the ground, where it forms a stream that flows towards the viewer. The dove, which symbolizes the Holy Ghost, points to the mystical significance of water in baptism. For this transcendental scene San Giovanni employed a totally different technique from the one which he used for the realistic border. The line is much less forceful; the clouds and landscape dissolve into arabesque in the heavenly light. The charming combination of realistic and idealistic elements would suggest that this sketch may have been executed as a study for the kind of altar decoration commonly displayed in seventeenth-century churches on important feast days.

Baroque draughtsmanship was most realistic in the sphere of portraiture, which virtually precluded all possibility of idealization: if the artist was to gain the approval of his sitter he had to ensure that his portrait was a true likeness. Strangely enough, the most attractive portraits produced in Italy during the Baroque period were the work of a woman, although it could well be that, as a woman, she possessed greater intuitive powers then her male colleagues and was therefore better able to feel her way into her subjects. This woman was Rosalba Carriera, a pastellist who enjoyed great success in her native city of Venice with her society portraits and subsequently became

Giovanni Domenico Tiepolo (1727—1804), THE REST ON THE FLIGHT INTO EGYPT.

Giovanni Battista Tiepolo
(1696—1770),
JOHN THE EVANGELIST.

Giovanni Battista Tiepolo
(1696—1770),
PRUDENTIA AND A RIVER GOD.

portraitist to various European courts. In 1705 she was made a member of
the Accademia di San Luca in Rome, the first woman ever to receive this
distinction. In 1720, when she visited Paris at the invitation of a wealthy
banker, she was showered with honours and was elected to the French
Academy. Incidentally, it was due to her influence that pastel painting

230

became fashionable in Paris, especially amongst the lady artists of high society, who found oils rather too difficult. During her stay in the French capital, Rosalba Carriera met Antoine Watteau and on 11 February 1721— just five months before his death—she made a pastel sketch of the great Rococo artist. Like the sixteenth-century Venetian artists Carriera used blue paper, which gave a pale, transparent quality to her pastel colours. Although she clearly made no attempt at serious character analysis, neither did she indulge in empty ceremonial. Consequently, although her portrait is lacking in depth, the face is noble and extremely vivacious.

The Italian High Baroque reached its apogee in the work of the Tiepolos. Giovanni Battista was born in Venice in 1696 as the son of a ship-broker. Although he actually studied under Gregorio Lazzarini he always regarded Paolo Veronese, the great Venetian painter of the Late Renaissance, as his true mentor. He made numerous copies of works by Veronese, both in oils and in pen and ink. As early as 1717 Tiepolo was accepted into the Venetian artists' guild. Two years later he married the sister of Francesco Guardi, the Venetian *veduta* painter. In 1724 he was commissioned to paint a series of frescoes for the staircase of the Archbishop's Palace at Udine, a work which earned him the unofficial title of the 'celebre pittor Tiepolo'. Having thus established himself, he was soon overwhelmed with commissions, first in Venice and later in other parts of Italy as well. In Milan and Bergamo, for example, he produced frescoes which were greatly admired. His fame then spread beyond the frontiers of Italy, and King Frederick of Sweden, acting on the advice of his envoy in Venice, invited Tiepolo to visit the Swedish court and decorate the royal castle in Stockholm. But although he

Carriera,
*Portrait of
Antoine Watteau*,
page 227·

Giovanni Domenico
Tiepolo (1727—1804),
GROUP OF NOBLE
VENETIAN LADIES IN
CONVERSATION.

Giovanni Battista Tiepolo (1696—1770), HOUSES AND CAMPANILE.

was not yet forty years of age, Tiepolo could already afford to decline this offer (which carried great prestige but relatively little money). And so for the time being he remained in Italy, where amongst other things he painted a series of pictures for Augustus III of Saxony. It was not until 1750 that Tiepolo left Italy. He then proceeded to Würzburg, where one of his greatest tasks awaited him: the decoration of the newly built Archbishop's Residence. He was accompanied by both his sons, who assisted him on this great project. Within three years they had completed the enormous frescoes on the staircase and in the Kaisersaal, which subsequently served as a model for a whole generation of south German decorators. After his return to Venice Tiepolo became the first President of the Venetian Academy, which had been founded by the Republic in 1750. He then received commissions from many parts in Europe: Louis XV of France commissioned a large painting, George III of England bought a portrait of Frederick the Great, and Charles III of Spain invited him to decorate the royal palace in Madrid. It would seem that Tiepolo was none too pleased with these invitations to visit foreign capitals, which interrupted his work at home in Venice. He had already declined the offer made by the Swedish king and he now did his best to defer this Spanish journey. But, after resisting the persistent demands of the Spanish ambassador for the best part of a year, he at last set out for Madrid with the firm intention of returning to Venice as quickly as possible. However things were to turn out differently. After completing the frescoes in the royal palace he was detained in Madrid by further important commissions and eventually died there in 1770. Tiepolo's immediate influence on Spanish art was very slight. His mixture of Baroque fantasy and carefree sensuality appealed only to a small and sophisticated circle at the Spanish court and was completely rejected by the leaders of the Church, who considered that it lacked a true sense of religious commitment. The seven altarpieces which Charles III commissioned for Aranjuez were removed shortly after their installation due to the pressure brought to bear by the Church. When Tiepolo first arrived in Madrid he found the German Neoclassical artist Anton Raffael Mengs— who was then 'Court Painter to the King'—firmly established. But although Mengs maintained his position throughout the whole of the 1760s, Francisco Goya at least—who arrived in Madrid in 1775—recognized Tiepolo as the greater artist and his early decorative works were strongly influenced by Tiepolo's dramatic and highly expressive fresco style.

Tiepolo was very productive and above all a very fast painter. Because of this there were some who tended to regard him as a mere technician. In one of his letters to Stockholm the Swedish envoy, for example, informed his king that Tiepolo could paint a picture in less time than it took other painters to mix their colours. At the same time, however, he was forced to concede that the Italian was an unusually intelligent artist, whose brilliant palette and highly inventive ideas enabled him to produce works of great originality. This assessment of Tiepolo's working method is actually remarkably accurate. The fact of the matter is that, with his highly volatile style, Tiepolo simply had to work at high speed. The explosive dynamism of his work called, not only for great technical competence, but also for complete eclecticism in the matter of style: in order to achieve a particular effect in his paintings he would use colours whose luminosity is positively disturbing, while in his frescoes he did not hesitate to break the normal bounds of pictorial form by allowing his painting to blend in with the architecture. He also had recourse

to the most extreme foreshortening in order to heighten the impression of spatiality and employed visionary lighting effects to portray supra-sensual phenomena. In many of his pictures the light is so powerful that it leaves no shadows at all, and in such cases Tiepolo relied on the interplay of cool and warm tones for his chiaroscuro effects. In view of the unparalleled boldness and dynamism of Tiepolo's colouring and composition it is hardly surprising to find that, on occasions, he failed to pay adequate attention to detail in the execution of his paintings, although he certainly gave considerable thought to this aspect of the work during the preparatory stages. This is quite evident from the numerous drawings which he always kept in his studio for easy reference. His sketch of *Prudentia and a River God* probably dates from the 1740s, which would mean that it was executed long before he went to Würzburg. None the less, this composition—in which an extremely compact and fully modelled group of figures is seen ascending into a clear, bright sky—is entirely characteristic of the artist's mature style. Tiepolo created this impression of movement by placing the two figures in the immediate foreground and using extreme foreshortening. Powerful outlines are combined with deep shadow, which produces an impression of plasticity and makes the figures appear quite tangible. The background—which is filled with a pale haze—is in complete contrast: a vague, open expanse.

Giovanni Battista
Tiepolo,
*Prudentia and a
River God,*
page 230

The sepia drawing of *John the Evangelist* was executed as a study for the fresco on the cupola of the collegiate church of San Ildefonso, a court foundation belonging to the La Granja palace. It is therefore one of Tiepolo's late works, as is quite evident from the linear composition, which is far less clearly defined than it is in the earlier sketch. The cloud, on which the saint is seated, is established by delicate sepia shading while the great expanse of the heavens, from which the Evangelist receives the word of God, is indicated simply by his upturned eyes. There is a yet considerable uncertainty

Giovanni Battista
Tiepolo,
John the Evangelist,
page 230

as to whether the red chalk drawing of *Venus, Apollo and Two Cyclops* should be ascribed to Giovanni Battista or to his son Giovanni Domenico and although modern researchers tend by and large to favour Domenico, the father's influence is quite unmistakable. The soft blue tint of the paper, which shines through the chalk, lends added delicacy to the figures. The composition is in any case extremely fine, the intermittent line of the contours suddenly dissolving into areas of diaphonous shading. The lighting effects are produced by white heightening and although it might be felt that they lack definition —the fine white folds on the central figure may or may not be drapery folds—this very imprecision increases the charm of the drawing. The difficulty of ascribing this work definitively to Domenico is immediately apparent if we consider the latter's *The Rest on the Flight into Egypt.* For all the spontaneity of the brush and pen work, this bistre drawing creates a very compact impression. The action is not set against an open and indeterminate background, one that gives free rein to the imagination. On the contrary, it is cut short by the tree, which sets a natural limit to the scene. A particularly attractive feature is afforded by the powerful light, which produces an extremely vital chiaroscuro effect and lends great plasticity to the figures. In his *Houses and Campanile* Giovanni Battista employed a similar technique but to a very different end. With consummate skill the artist used the empty area in the foreground of this study both to heighten the impression of three-dimensional space and to capture the quality of the harsh sunlight. The contrast between the sunlit and the shaded areas is strengthened by the coating of white body colour which Tiepolo used as a general ground and which gives added depth to the thick brown wash used for the shadow. Although we

G. Battista or G. Domenico Tiepolo, *Venus, Apollo and Cyclops,* page 226

G. Domenico Tiepolo, *Rest on the Flight into Egypt,* page 229

Giovanni Battista Tiepolo, *Houses and Campanile,* page 232

Giovanni Battista Piranesi (1720—78), STREET WITH GRAVES IN POMPEII.

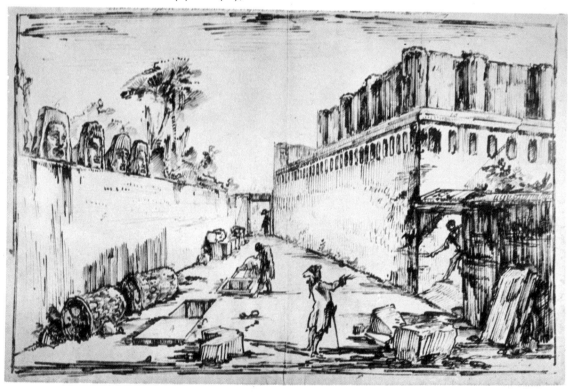

Lorenzo Tiepolo (1736—76), YOUNG MAN SMOKING A PIPE.

Giovanni Battista
Piranesi (1720—78),
ROMAN PRISONS.

possess only very few landscape sketches by Tiepolo, not one of these was
executed as a *veduta*. He was not really interested in the reproduction of
actual landscapes. What did interest him, however, was the specific quality
of particular situations, for example the quality of the bright noonday light
in this study. The indistinct forms in the background, incidentally, do not
really belong to this picture. They form part of a rough sketch made on the
back of the same sheet of paper.

Lorenzo Tiepolo's *Young Man Smoking a Pipe* was almost certainly not
conceived in terms of portraiture, but it is so personal and so individual that
it acquires much of the quality of a true portrait. Lorenzo had a predilection
for light-hearted and unconventional themes and it is quite possible that this
sketch was inspired by some unknown youth, whose fresh and untroubled
appearance struck a responsive chord in the artist. The vivacity of the facial
expression is skilfully rendered by means of chiaroscuro. The light which falls
on the figure acquires a painterly effect from the use of white heightening
whilst the broad rim of the hat throws his left ear and part of his right eye
into deep shadow. Lorenzo Tiepolo and his brother Domenico have both
suffered from the comparisons made between them and their illustrious father
Giovanni Battista Tiepolo. But in point of fact the situation is not quite so
straightforward. In the graphic sphere at least, Domenico revealed such
mastery that many of his drawings were originally ascribed to his father. And
there are many more drawings, which are known to have been produced by
one or the other of these two men but whose definitive ascription has yet to
be decided.

Lorenzo Tiepolo,
*Young Man
Smoking a Pipe*,
page 236

Giuseppe Zais (1709—84), RIVERSIDE VILLAGE WITH A FORTRESS.

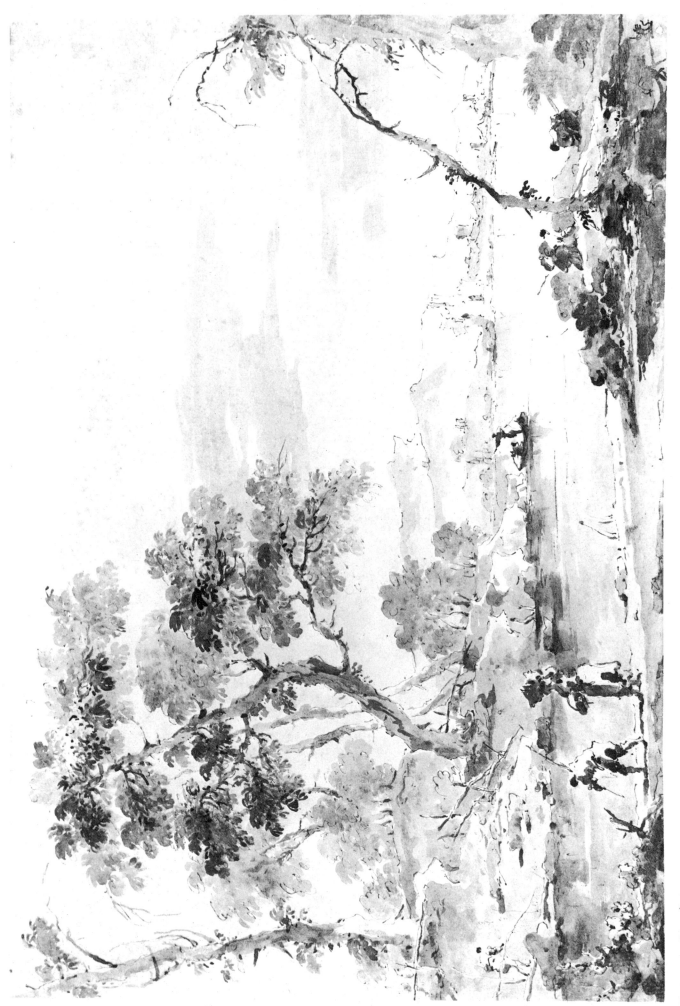

Francesco Guardi (1712—93), LANDSCAPE.

Though Tiepolo evinced only a passing interest in the landscape, this branch of art was to assume a dominant position in the *œuvre* of his brother-in-law Francesco Guardi. Indeed, Guardi was so successful as a *vedute* painter that, until quite recently, it was thought that he had concentrated exclusively on this genre, and his excellent religious paintings and histories, his portraits and flower paintings were ascribed to his less gifted brother Antonio. But although this misunderstanding has now been rectified, it would still be true to say that Francesco's impressionistic landscape and his picturesque views of his native Venice constitute the major part of his *œuvre*. Unlike his compatriot Canaletto, who always aimed at extreme realism based on precise observation of the laws of perspective, Guardi was more concerned with the purely painterly aspects of landscapes and townscapes, that is to say with atmospheric effects and with the fascinating interplay of colours and forms in real-life scenes. His *vedute* have been described by certain critics as *capricci,* and there is some justice in this classification, for the vivacity and playfulness of these works constitute one of their major features. Certainly, Guardi's drawings may be regarded as *capricci,* for he tended to use his ink brush and pen for the notation of spontaneous ideas, which were necessarily 'playful'. His *Landscape,* for example, is certainly not a precise representation of reality but a *veduta ideata*—a lyrical transformation of reality, in which the bright open expanse of the distant scene establishes a highly decorative contrast to the detailed

Francesco Guardi, *Landscape,* pag 239

Giovanni Antonio Canaletto (1697—1768), PORTICO WITH A LANTERN.

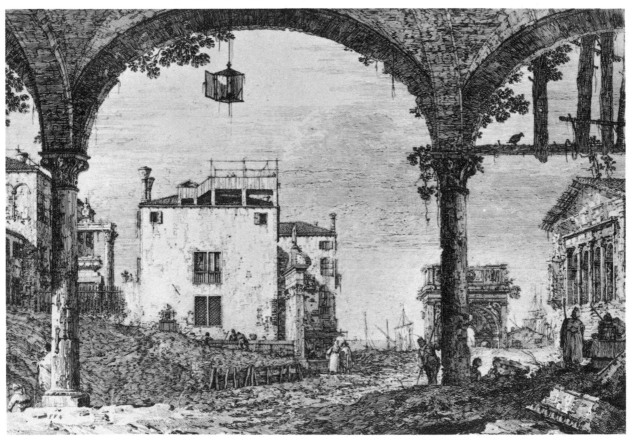

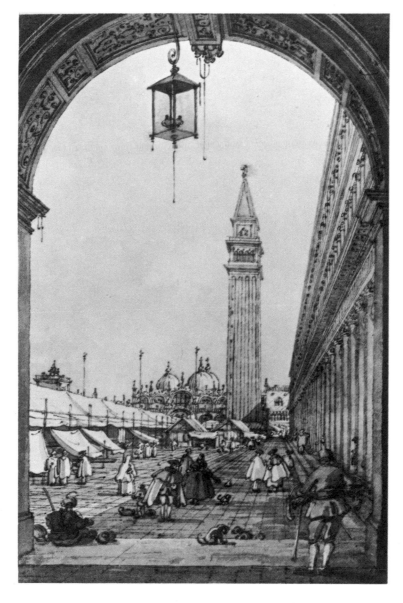

Giovanni Antonio Canaletto (1697—1768), PIAZZA SAN MARCO: VIEW FROM THE SOUTH-EAST CORNER.

and lively action portrayed in the foreground. His *Triumphal Arch at the Water's Edge* also defies topographical analysis. What excites our admiration in this drawing is the way in which Guardi was able to bring the individual buildings and figures to life. The detail on the arch (which is reminiscent of stenographic symbols), the hastily applied washes, the economy of colour, and the tonal values set up a pattern of vibrant movement but without destroying the overall impression of unity. This splendid drawing is quite on a par with Guardi's paintings.

Like all Baroque artists, Giovanni Battista Piranesi translated external reality into transcendent forms. Although he was trained as an architect and scholar he did not strive after academic objectivity. On the contrary, he placed a poetic and highly theatrical interpretation on real-life scenes. In his *Invenzione caprie de Carceri*, for example, he transformed the Roman prisons—which he had learnt about from his archaeological studies—into a series of terrifying visions that are completely divorced from reality. Far from trying to elucidate the actual architecture, he built up a complex system of arches and corridors, which seem to be quite unrelated to one another. It is almost as if he had been trying to show by means of the artistic structure that there was no way out

Francesco Guardi, *Triumphal Arch at the Water's Edge*, page 242

Piranesi, *Roman Prisons*, page 237

241

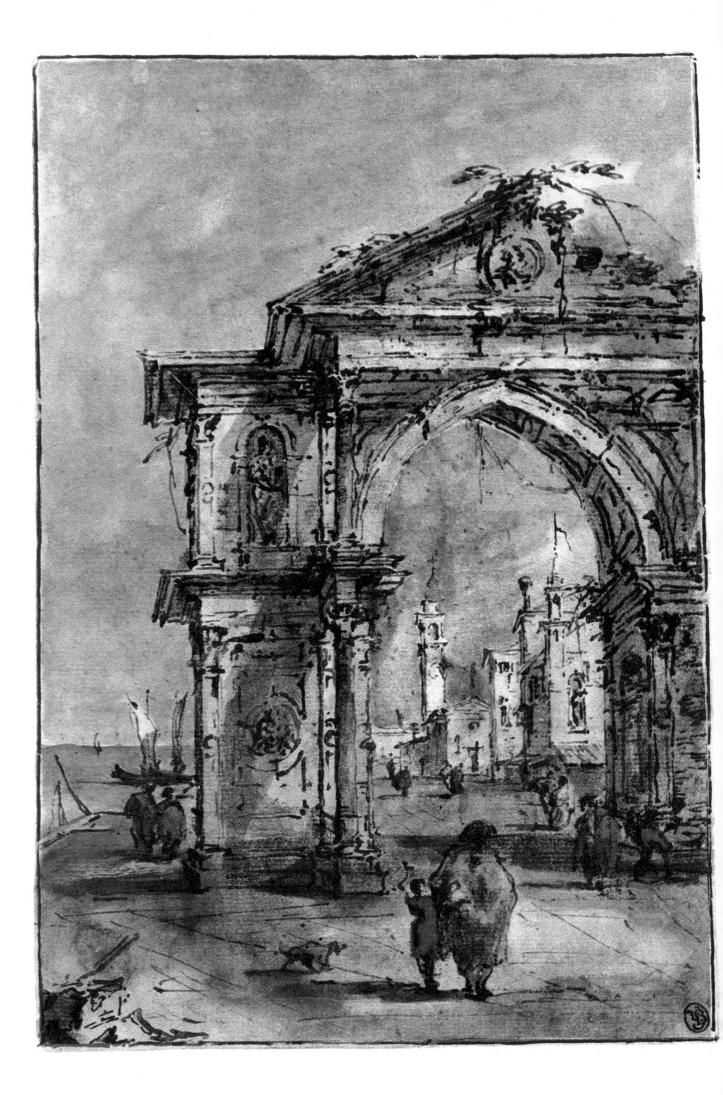

of these tortuous prisons. The nervous line and the blurred washes heighten the claustrophobic impression.

Venetian *veduta* painting reached its peak in the work of Antonio Canaletto. He too was closely connected with the theatre during his early years, for his father was a well-known scene painter and Antonio learnt his trade in the theatre. Later, on a journey to Rome, he tried his hand at landscape, producing works which betray his preoccupation with stage design. With its picturesque chiaroscuro and its general air of artificiality the etching of a *Portico with a Lantern*, which Canaletto created during this visit, is typical of this phase of his work. After spending a year in Rome Canaletto returned to Venice and, being unable to find work in the theatre, turned to *veduta* painting, which was then becoming extremely popular, especially with the English tourists.

Antonio Canaletto, *Portico with a Lantern*, page 240

The recent publication of Canaletto's *Venetian Sketchbook*—which had been virtually unknown before—enables us to gain an insight into his working method. All of the 138 sketches in this book which Canaletto used to refresh his memory when he came to paint his *vedute*, deal with the same subject: Venice. He drew palaces, palace windows and window-sills, terraces, turrets and façades. He concerned himself with every detail of the Venetian scene, with every peculiarity of light and shade, no matter how trivial. But despite this careful attention to detail, Canaletto always aimed at a general impression in his expansive and highly objective townscapes. Canaletto's objectivity is, of course, what distinguishes him from the Venetian Baroque artists. And yet we would be quite mistaken to look upon him as a revolutionary. It would be more to the point to remember that over a hundred years before, Caravaggio had set up new criteria for Western art by means of that same realism. The fact that Canaletto anticipated many aspects of nineteenth-century realistic painting should not blind us to his links with the past.

Antonio Canaletto, *Piazza San Marco*, page 241

Opposite: Francesco Guardi (1712—93), TRIUMPHAL ARCH AT THE WATER'S EDGE.

ENGLAND AND AMERICA IN THE EIGHTEENTH AND NINETEENTH CENTURIES

England's insular position and the isolation which this inevitably produced meant that few really vital contacts were established with the Continental art centres. The sea, which had proved so beneficial in preventing England from being attacked, tended to inhibit exchange in cultural matters. No country has ever succeeded in assuming the leadership of the art world entirely from its own resources: such developments have always been the result of an international communication of ideas.

Most of the ideas, therefore, which developed in English eighteenth-century art were brought about by its own stimulus. In some respects there was a reaction against what outside influence did exist, so that Hogarth, for instance, established himself in his own peculiar way and achieved fame and popularity. Later in the century, Gainsborough was another artist who followed no particular tradition, although he had in some respects to pander to fashionable society, whose members commissioned him to paint their portraits.

This same insularity showed itself even later in the work of such artists as Blake, Turner and Constable, all of whom were very individual in their outlook. But this lack of cultural exchange did not mean that England suffered, for the eighteenth and early nineteenth centuries represented the great period of English art.

It is true that earlier English art had always received more from outside sources than it gave in return. Its most important stimuli came from those Continental artists who were best able to accommodate themselves to the tastes and requirements of high society. The first European painter to make his mark and his home in England was Hans Holbein. It was due to him that English portraiture acquired an international reputation and that this medium dominated the English art scene for centuries to come. Holbein's woodcuts and line engravings were also well received in England and although this branch of his work was not taken up by contemporary English artists, it none the less prepared the ground for the subsequent development of the graphic arts in England.

Hans Holbein the Younger, *Charles de Solier, Sieur de Morette,* page 94

In the seventeenth century, English art was dominated by the great Flemish artist Anthony van Dyck, who was appointed 'principal printer in ordinary to their Majesties' after his return to England in 1632, during the reign of Charles I. His portrait style became a model for successive generations of English artists and a whole army of imitators, copyists and even forgers made a handsome living for themselves by exploiting van Dyck's popularity. Pieter van der Faes, a native of Soest near Utrecht, also made his mark in England and in 1661 became principal painter to the king. In 1679, when he was knighted, van der Faes changed his name to Sir Peter Lely, by which he is now generally known. As a painter Lely adhered closely to the style established by van Dyck, but in his drawings he was very much more original. The *Baldachin Bearer* forms part of a series of sixteen drawings, in which

van Dyck, *Théodore van Thulden,* page 142

Peter Lely (1618—80),
THE BALDACHIN BEARER.

Lely represented the participants in the festivities for St. George's Day. The harsh contrast between the black chalk and the white heightening is reminiscent of the work of Frans Hals, the great Haarlem master, who was a firm advocate of such powerful effects. The bold and rather coarse style of Lely's drawings, which would seem to point to a forceful and unaffected personality, makes a refreshing change from the cautious handling that is so characteristic of his paintings.

Lely,
Baldachin Bearer,
page 245

William Hogarth (1697—1764), STUDY FOR 'INDUSTRY AND IDLENESS'.

William Hogarth (1697—1764), THE INDUSTRIOUS 'PRENTICE.

The impact of van Dyck inhibited any further development in English art for over a hundred years. It was not until the middle of the eighteenth century that this period of stagnation was brought to an end. By then the elegant and artificial view of society established by Watteau and Fragonard in France was beginning to penetrate the English art scene, where it was very well received. True, the English painters of those days failed to grasp the essential *galanterie* of the French Rococo, but they did appreciate the rustic settings used by their French colleagues and, slowly but surely, the landscape was established as a branch of English art. Meanwhile, however, the great majority of English artists continued to curry favour with the members of the aristocracy and to glorify their lives in their paintings. One of the few who had the courage to opt out of this servile dependence and go his own way was William Hogarth. His whole *œuvre* is an open protest against traditional values, against the society of his day and against the uninspired products of the court and society painters. He knew the vanity of the aristocracy at first hand for during his early period, when he had also worked as a portrait painter, he had gained an insight into the private lives of the hereditary nobles; he had seen their intrigues, their arrogance and their depravity. In the end this reverse side of the aristocratic coin came to interest Hogarth more than the splendid façade with the result that he gave up society portraiture and became a satirist and moralist. He then pilloried the weaknesses of his contemporaries without mercy, although in doing so he was not motivated by a desire to pour scorn on society as such. On the contrary, he regarded himself as a true patriot and sincerely hoped that, by exposing vicious individuals to public ridicule, he might prevail on them to desist from their vices. Hogarth was a native of northern England. After producing some very gifted drawings while still a boy he was apprenticed to a goldsmith, from whom he acquired a sound working knowledge of engraving. Impressed by the design and execution of the heraldic motifs which his son produced during his apprenticeship, Hogarth's father then sent him to the St. Martin's Lane Academy of Art, where he studied until he was twenty-three. After leaving the academy he set up as a free-lance copper engraver, executing copies of popular paintings. By the 1720s reproductive engraving was a well-established trade and Hogarth quickly made his mark in it, for the quality of his prints was very high. Soon he began to produce original engravings as well, most of which dealt with satirical themes. These included his series *Industry and Idleness,* a cycle of twelve pictures showing various stages in the careers of two weaving apprentices. One of these acquires wealth and honour thanks to his industry, the other ends up on the gallows as a result of his idleness. There are two prints in this series which, between them, demonstrate the exceptionally wide range of Hogarth's graphic technique. In the pen, pencil and watercolour drawing we see the idle apprentice, who has now turned criminal and is living with a whore in a derelict attic. The cat, which has fallen down the chimney, has roused the couple from sleep. The cold light falling on their faces heightens the expression of terror and the wretchedness of their situation is underlined by the many signs of physical decay, which are also reflected in the graphic technique: imprecise contours which peter out abruptly; imprecise handling of the watercolours, which often overrun the contours and so give artistic expression to the disorderliness of the scene. The conscious improvisation of this sketch stands in marked contrast to the painstakingly

Hogarth,
Industry and Idleness,
page 246

detailed execution of *The Industrious 'Prentice*. This print is a perfect example of Hogarth's mature engraving technique. Using extremely delicate incisions he created a linear composition which provides infinite variations of light and shade whilst preserving absolute clarity in the representation of detail. Where the drawing relies on extreme boldness and simplification for its effects the engraving depends on absolute technical precision. The contrast between them is so great that it seems almost incredible that they should have been produced by one and the same artist.

Thomas Gainsborough's portraits were executed in complete accordance with the wishes of his aristocratic patrons. But although he has occasionally been apostrophized as a society painter pure and simple, he was in fact far more than this, as is quite evident from his numerous landscapes. In Gainsborough's day views of nature were considered to be in bad taste and though they might conceivably be used as decorations for a country house, in general the aristocratic art public expected paintings to be 'artificial', that is to say completely unnatural. And so the mere fact that Gainsborough painted so many landscapes in the course of his career shows that, in this respect at least, his art was quite independent of popular taste. In his watercolour *Landscape with a Bridge* he used only very few colours and was therefore able to avoid the heroic pathos so beloved of the eighteenth-century French and Italian landscapists. As a result this work remains extremely compact and intimate, the natural complexity of the scene being rendered with the utmost economy by the smooth combination of yellows, reds, browns, and greens, by the tight grouping of figures and objects, and by the occasional use of line as a link motif in the flat sections of the composition. In Gainsborough's *Horse and Cart on a Forest Road* the diagonal lighting combines with a host of small oblique brush-strokes, which bring the trees to glittering life. This virtually Impressionistic technique is also found in certain of Gainsborough's paintings. The chalk drawing of a *Seated Lady* is unusual in so far as it was not stumped in accordance with normal eighteenth-century practice. Quite the contrary, in fact. The lines—most of them diagonal—are quite definite. But they are broken up by the coarse-grained paper, which shines through the chalk in much the same way as in a screen-processed print. The white heightening creates an illusion of plasticity.

Although Gainsborough doubtless regarded such drawings and watercolours simply as studies, for us today they possess great intrinsic value, because they afford a far clearer insight into the artist's personality than we could ever hope to acquire from his paintings.

Unlike Gainsborough, who produced a large graphic œuvre, Sir Joshua Reynolds, the celebrated portraitist and court painter to George III, left only a few authenticated drawings. Although he made a prolonged study of the antique in Italy, Reynolds's portrait style was modelled on van Dyck's. Like him, he concentrated on the splendid appearance of his aristocratic sitters, which necessitated no tedious studies. In fact Reynolds most probably painted straight on to the canvas, filling in the detail between sittings. But the absence of a graphic œuvre should not be taken as an indication that Reynolds was a poor draughtsman.

Thomas Rowlandson began his career as a painter of histories and portraits but soon went over to social satire, a branch of art which had become particularly popular in England since the advent of Hogarth. Rowlandson

Hogarth,
*The Industrious
'Prentice,*
page 247

Gainsborough,
*Landscape with a
Bridge,*
page 251

*Horse and Cart on a
Forest Road,*
page 250

Seated Lady,
page 253

Thomas Gainsborough (1727—88), HORSE AND CART ON A FOREST ROAD.

Thomas Gainsborough (1727—88), LANDSCAPE WITH A BRIDGE.

was a prolific draughtsman, who used his considerable talents to ridicule the foibles of his contemporaries in drawings that are full of charm and robust humour. Despite the apparent innocuousness of the subject, his *In the Pantheon Theatre, London* is really a piece of social satire. In this etching Rowlandson shows a theatrical scene in reverse: the graceful dancers on the stage, who symbolize the world of illusion, are entirely credible, whilst the members of the audience, who are the representatives of the real world, are mere caricatures of humanity. Rowlandson was a close friend of the caricaturist Gillray. Once, when these two were in their cups, they are supposed to have described the world as one vast masquerade. Certainly this theatrical scene of Rowlandson's would bear out such a view of life. The original drawing which served as the model for this etching was executed largely in outline, the colour being added to the finished prints either by some impecunious artist or by a craftsman specially trained for such work.

James Gillray, who was the most important satirical artist working in England in the early nineteenth century, was much more acrid in his social criticism than either Hogarth or Rowlandson. Where they had been content to ridicule society in more or less general terms, he openly attacked the political personalities and institutions of his day. Gillray gave expression to the anti-clerical and anti-authoritarian trend of the post-revolutionary period. His *The Morning after Marriage* (1788) portrays the Prince of Wales and Mrs. Fitzherbert, whom the Prince of Wales married secretly in 1785, in a French hotel.

In the last two decades of the eighteenth century there were two artists working in London, whose *œuvres* reveal no immediate connections with contemporary political problems but who none the less grappled with the intellectual currents of the age: Henry Fuseli and William Blake. Fuseli, a native of Zürich, had started out in life as a scholar and poet but turned to painting in 1765, largely at Reynolds's instigation. In 1770 he went to Italy for eight years, where he studied the antique artists and developed a profound interest in the paintings of Michelangelo, which he copied in the Sistine Chapel. He took Michelangelo as his model because in his work he saw the force of genius bursting the bonds of traditional thought. In fact Fuseli regarded the High Renaissance as analagous to the 'Sturm und Drang' movement of his own time, whose adherents were then trying to move away from the rigidity of French rationalism. It was Fuseli who translated Winckelmann's introductory writings on classical art into English, and these did much to dispel the Late Baroque conception of pictorial form that was then in vogue in London. As a graphic artist Fuseli is best known for his illustrations to Shakespeare, Dante, Virgil and to ancient folk-lore and fairy-tales. His incipient Romanticism is reflected in his predilection for dark, demonic themes. His *Prometheus* is a typical example.

William Blake ressembled Fuseli in so far as he too was intent on creating pictorial symbols with which to express literary motifs. But Blake's poetic visions met with a far less sympathetic response on the part of the London art world than did Fuseli's, largely because his symbolism was so much more profound. Whereas Fuseli was content to depict physical forms in a purely descriptive manner, Blake represented the 'human form divine'. The frightening fantasy figures which fill his pictures are well exemplified by his illustration to Dante's *Divine Comedy*. In this watercolour the dead Beatrice appears to the poet in many forms: as a pure and shy young virgin, as a

Thomas Gainsborough (1727—88), SEATED LADY.

hetaera, as the queen of heaven and as a temptress. All these figures have come from the vortex on the left of the picture, which contains still more figures waiting to emerge: chimeras, spectres and phantoms. In his colouring Blake followed the description in Dante's poem (Purgatorio Cantos 29 & 30):

> After that the flowers,
> And the fresh herblets, on the opposite brink,
> Were free from that elected race; as light
> In heaven doth second light, came after them
> Four animals, each crown'd with verdurous leaf.
> With six wings each was plumed; the plumage full
> Of eyes; and the eyes of Argus would be such,
> Were they endued with life.

And again:

> Thus, in a cloud
> Of flowers, that from those hands angelic rose,
> And down within and outside of the car
> Fell showering, in white veil with olive wreathed,
> A virgin in my view appear'd, beneath
> Green mantle, robed in hue of living flame:
> And o'er my spirit, that so long a time
> Had from her presence felt no shuddering dread,
> Albeit mine eyes discern'd her not, there moved
> A hidden virtue from her, at whose touch
> The power of ancient love was strong within me.

Blake came from a well-to-do middle-class family, his father being a hosier in Soho. When he was ten he began to learn drawing at the Academy in the Strand. There he was introduced to reproductions of works by Raphael, Michelangelo and Dürer, whom he always regarded as his true mentors. Subsequently he received a thorough training in copper engraving at the Royal Academy, which enabled him to set up as an engraver on his own account. At first he executed illustrations for novels and magazines which reveal little of the originality of his later work. At the same time, however, he produced his splendid early poems—*Poetical Sketches* and *Songs of Innocence*—which he published himself, engraving the texts and embellishing them with hand-coloured illustrations. But from a commercial point of view Blake's illustrations and engravings were not a success. Although he and his wife worked furiously, his unorthodox works had little public appeal and Blake lived in dire poverty for many years until he found a faithful patron in Thomas Butt, a wealthy government official. Butt not only bought the major part of Blake's prints, but also commissioned a series of paintings, which greatly improved the artist's financial situation. But still Blake was denied public recognition. His paintings were not accepted by the Royal Academy and a comprehensive exhibition of his works, which he promoted at his own expense, ended as a complete fiasco: his watercolours, drawings, engravings and paintings were rejected by the public and critics alike. After these reversals Blake made no more attempts to win public favour and passed the remainder of his life in poverty. Three years before his death John Linnell

Above:
James Gillray
(1756—1815),
THE MORNING AFTER
MARRIAGE.

commissioned him to produce a series of illustrations to Dante's *Divine Comedy*. This work, which was probably the most important that Blake undertook, remained a fragment, for although he made over a hundred drawings—most of them finished in watercolours—only seven of these were actually engraved.

Blake exerted only a minimal influence on his contemporaries, but the impact which he made on later generations of artists was very considerable. In England the Pre-Raphaelites, an association of artists formed in 1848 under the leadership of Dante Gabriel Rossetti, adapted Blake's ideas for their own Late Romantic purposes, reducing his powerful and highly original figures to rather sickly and distinctly prosaic proportions. Like Blake, Rossetti produced a large number of illustrations—watercolours and drawings—which include some of his best work. His small and delicate pen drawing of *The Sleeper*, which he made as an illustration to Edgar Allan Poe, shows that Rossetti was an extremely subtle draughtsman. The delicate linear composition in this work produces alternating effects of plasticity and flatness which are most convincing. The woman on the window seat appears as a soft and fully modelled form thanks to the use of short, fluttering lines. The firm diagonal

Rossetti,
The Sleeper,
page 259

255

Thomas Rowlandson (1756—1827), IN THE PANTHEON THEATRE, LONDON.

Opposite: William Blake (1757—1827), BEATRICE SPEAKS TO DANTE.

P g Canto 29 x 30

hatching of the figures at the window, on the other hand, makes them look like creatures from some sinister nightmare world, an impression that is heightened still further by contrast with the townscape view in the background, which is drawn in great detail.

The *art nouveau* artists were also indebted to Blake for many of their ideas. The use of colour as a purely decorative device, the stylization of figures and vegetation, and the introduction of arabesques as a means of breaking up movement, which are such marked features of their work, all derive from him. The book illustrations of Aubrey Beardsley, who was one of the leading representatives of *art nouveau,* are very much in the Blake tradition.

Beardsley, *The Dancer's Reward,* page 397

Although Gainsborough's attempts to evolve a specifically English style of landscape painting had aroused little enthusiasm amongst his contemporaries it was not long before they began to bear fruit. Rousseau's exhortation to go 'back to nature' had not passed unheeded in England with the result that individual artists began to treat the landscape as a serious branch of art. Initially they found it extremely difficult to assert themselves in the face of the concerted opposition of the academic and historical painters, who were then in the ascendancy. But the future belonged to them and not to the French and Italian trained classicists. In 1802 John Constable, who always thought of himself as a 'natural painter', said that he was tired of studying the old masters and receiving his truth at second-hand. And yet Constable was not a revolutionary artist. Unlike Hogarth, he had no desire to criticize society or develop a new theory of art. All Constable wanted was the right to evolve his own personal style. But in order to achieve this aim—which we

Below:
Henry Fuseli
(1741—1825),
PROMETHEUS.

Dante Gabriel Rossetti
(1828—82),
THE SLEEPER.

today would consider perfectly reasonable— Constable had to renounce all
hope of public recognition and commercial success.

When he drew his *Village by the River* Constable noted down the date at the
foot of the sketch and in the case of other sketches he even added the time
of day and a brief description of the weather. This shows that, in his sketches,
he consciously strove after complete realism and always made allowance for
variations of light and changes in the weather. It is hardly surprising, therefore,
that he should have been discovered by the French Impressionists, many of
whom—especially Monet and Pissarro—cited his work in defence of their
own theories. Constable's drawings and watercolours are a very important
source of critical information for, unlike his oil-paintings, they were produced

259

Constable,
Village by the River,
page 262

Constable,
*Landscape with a
Windmill,*
page 263

out-of-doors. In these sketches, which he executed quickly and deftly, Constable dispensed with picturesque effects and was guided only by nature. In the *Village by the River* the trees and houses, whose main outlines are drawn with black chalk, form the basic framework for the interplay of the bright, fresh colours whilst the white ground which shines through them lends a transparent sheen to the sky and creates luminous reflections on the water. In his *Landscape with a Windmill* Constable was also guided by a direct impression of a natural scene. Here a completely ordinary but heavy sky filters the light so that the colours on the ground appear pale and arid and the edges of the individual objects become blurred, almost as if we were viewing them through half-closed eyes. These drawings call to mind the observation made by Fuseli, who said that Constable always made him ask for his coat and umbrella.

The English Romantic landscapist Joseph William Mallord Turner was the complete antithesis of the realistic and highly objective Constable. Many modern artists have been inspired by him: the Impressionists enthused over the misty atmosphere in his visionary landscapes, the Fauves justified their unrealistic colouring by reference to his decorative use of colour whilst the Expressionists found confirmation of their own highly emotional and simplified style in his hectic compositions with their dramatic chiaroscuro effects. But although these links undoubtedly exist and go a long way towards explaining Turner's widespread popularity during the first half of the twentieth century, they are in fact purely external. The ideas underlying Turner's art are quite different from those which inspired the painters of the modern period.

Turner was a dreamer, a sensitive visionary, whereas the Fauves, the Expressionists and the abstract artists of our own times have been systematic thinkers. Abstract art was the outcome of complex and long drawn out analytical processes and experiments; it was only after the theory had been established that changes were made in painting practice.

The key to Turner's artistic development lay in his eventful life. He received his initial tuition from an insignificant painter of flower studies. At a very youthful age he mastered the art of capturing a scene or situation with just a few strokes of his pen without becoming absorbed in the detail. During his early period he executed no oil-paintings, concentrating instead on watercolours, which were admirably suited to his 'sketching' style and were also far less time-consuming. But despite his natural facility, Turner none the less aimed at topographical accuracy in these early watercolour landscapes. In other words, he started on a completely realistic note. When this failed to gain him the support of the fastidious London public, which found itself out of sympathy with the impromptu style of his occasional works, Turner set out on a lengthy tour of the continent. He travelled quickly through France and Switzerland, then through Germany, the Netherlands and Italy, like a modern tourist doing the sights. The outcome was an enormous number of sketches, drawings and watercolours of town views and landscapes. Upon his return to London he had the best of these engraved and published them under the title *Liber Studiorum.* These prints sold extremely well and, encouraged by this, Turner set off on a further tour of France and Italy in 1829. By then he had completely eliminated the Romantic theatricality of much of his earlier work. He was no longer interested in cultural landscapes with their temples, fortresses and castles. Instead he focused his attention on the coloured light

which transformed the Italian landscape into a magical world. During this period his composition also became less exact, for the objects in his pictures, which no longer possessed any intrinsic value for him, are blurred by the wreaths of mist, in which the light is refracted. Not surprisingly, therefore, his view of *Florence* is not a topographical *veduta* seen in the cool, clear light of Tuscany but a tone poem set in a world of fable. In the pale light of the clouded sun even the figures and objects in the foreground lack precision whilst on the distant horizon the sky merges with the earth in an iridescent glow. The view of *Venice*, which Turner painted with a wet brush on a wet ground, is even more amorphous. Here the colour merges with the architectural forms, giving them an incorporeal and ghostly appearance while the elongated bell-tower of St. Marks is almost lost from sight in the pale luminous mist.

Turner,
Florence,
page 265

Turner,
Canale Grande, Venice,
page 264

In adopting this view of reality Turner was undoubtedly inspired by the great French landscape painter Claude Lorraine, who also produced distant views, in which reality is transfigured by atmospheric handling and the sun sets up a scintillating pattern of golden reflections. But Claude was still firmly rooted in the Classical cum Idealistic tradition of the Renaissance and the strict monumental structures of his paintings provided a powerful and orderly pendant to his visionary conception of light. With Turner there was no such compensatory force and consequently his colours and lighting effects were intensified to the point of ecstasy. It is this same ecstatic quality that distinguishes Turner's work from that of the French Impressionists. Although the Impressionists—as their name implies—were concerned with their own impressions, those impressions none the less enabled the viewer to experience the underlying reality by which they were prompted. The Impressionists were in fact highly naturalistic. Turner, on the other hand, was highly subjective, for he transformed reality into an inner vision. In his final period he carried this process to extreme lengths, producing paintings which do not appear to have any counterpart in nature. With these pure colour compositions he entered the sphere of abstract art. But these late works of his—which include many watercolours—do not mark the beginning of a new period of development. Unlike the abstract artists of the early twentieth century, who initiated an entirely new movement in art, Turner proclaimed the end of an epoch, one that had become completely engrossed in its own self-centred desires and illusions.

At the beginning of the nineteenth century a group of artists in Norwich formed the 'Norwich Society of Artists', which soon established itself as the most important regional school of painting in England. The most outstanding member of the school was John Crome, who was primarily responsible for the regular exhibitions staged by the Society between 1805 and 1825. Crome, the son of a weaver, did not develop his full potential until fairly late in life. After spending a long apprenticeship with an unimportant sign-painter he studied under two reputable portraitists, but did not himself become a portrait painter. Then, when he was thirty, he set up in his native city of Norwich as a teacher of drawing. He appears to have had extremely progressive ideas for we know that he sent his pupils out in the open air to paint direct from nature, a practice that was quite novel in those days. His own landscapes in oil reveal the influence of the seventeenth-century Dutch landscapists, especially Meindert Hobbema. Crome produced only a few watercolours, which are very much more original than his paintings. He used the watercolour technique to create highly sophisticated compositions, in which

Crome,
Forest Landscape,
page 267

261

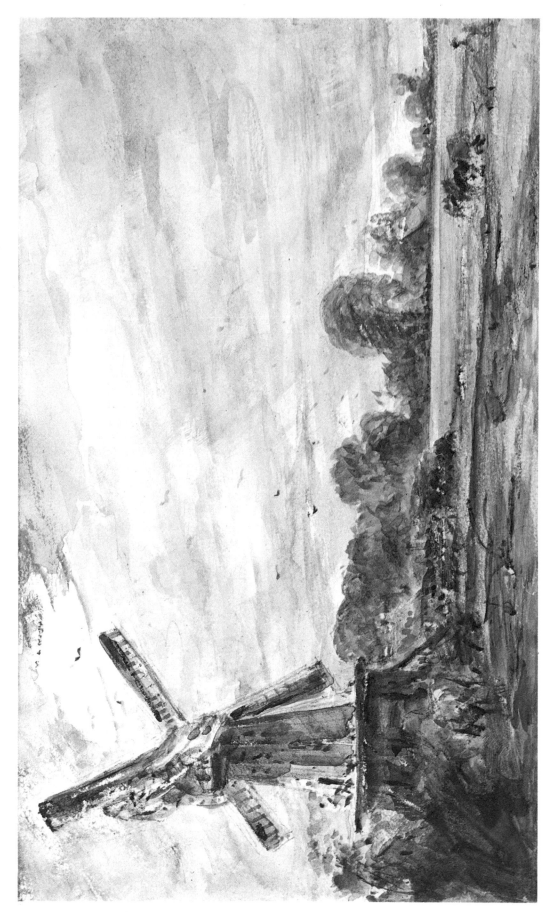

John Constable (1776—1837), LANDSCAPE WITH A WINDMILL.

Opposite: John Constable (1776—1837), VILLAGE BY THE RIVER.

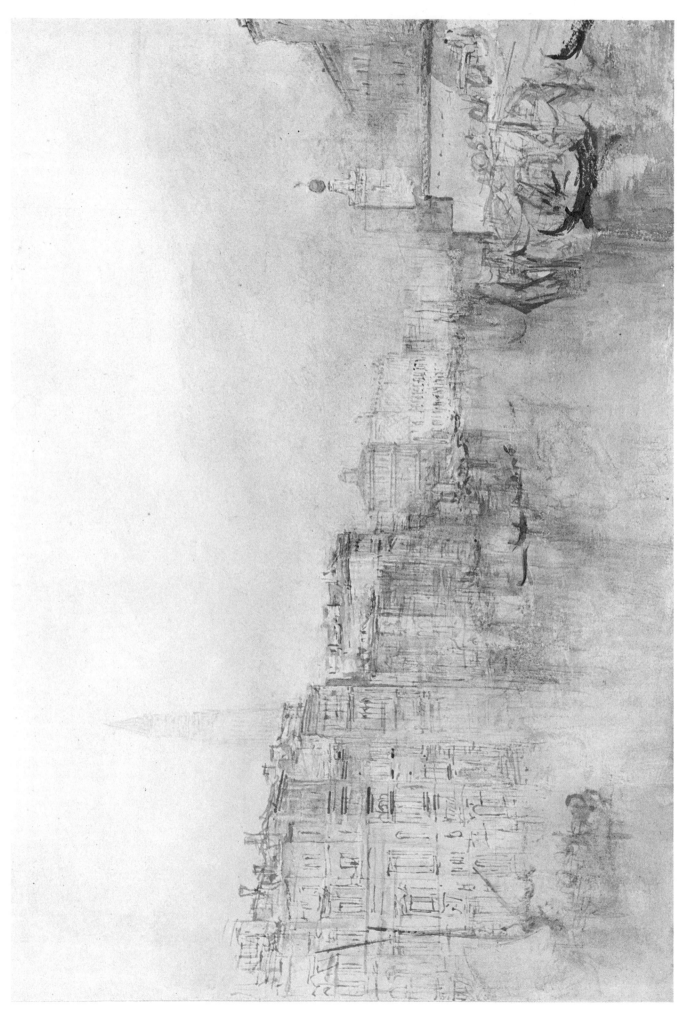

Joseph Mallord William Turner (1775—1851), CANALE GRANDE, VENICE.

Joseph Mallord William Turner (1775—1851), FLORENCE.

the natural forms are reduced to large and rather flat areas of colour. As a result Crome's trees and bushes are really little more than outlines. However, the lack of structural detail is compensated for by the extremely charming and basically pointillist use of colour, which sets up a slight vibration in the picture surface and also produces a distinctly luminous effect. Looking at Crome's watercolour it is not difficult to understand why both Constable and Turner should have been influenced by him.

In 1808 John Sell Cotman joined the Norwich school. Unlike Crome he produced only a few oil-paintings, concentrating instead on watercolours. His *Greta Bridge,* which he executed in 1805 in the wooded valley of the River Great, is one of his most beautiful works in this medium. Cotman went even further than Crome in the simplification of natural forms, subjecting the living landscape to a rigorous process of abstraction. He also differed from Crome in attaching far less importance to working in the open air. Although he made sketches of his landscapes on the spot, these were no more than *aides-mémoires* for his finished works, which were invariably produced in the studio. In his *Greta Bridge* this approach resulted in a highly abstract composition made up of large, clearly distinguished areas with relatively little structural definition, which are placed in juxtaposition to one another without any attempt being made to create transitional effects of tone or colour. In fact the colouring, far from having a unifying effect, is almost Surrealistic. The plasticity of the individual forms, which is very slight, is produced by flat washes which are also clearly distinguished from one another. This watercolour of Cotman's is strangely reminiscent of certain landscape compositions of Paul Gauguin's which the Frenchman executed during his Brittany period. Since Cotman died six years before Gauguin was born there can be no question of his having been influenced. Nor is there any evidence to suggest that Gauguin was acquainted with Cotman's work. It would seem therefore that these two artists were pursuing similar goals quite independently of one another.

Cotman, *Greta Bridge,* page 268

The development of American art was conditioned by a variety of factors, the most important being the multiplicity of the different racial groups living in the U.S.A., the relatively short history of the territory and the negative effects of Puritanism prior to the Declaration of Independence. North American art had been a purely colonial art form and even after the secession of their territory American artists were subject to European influences for some considerable time to come. In the graphic sphere they took their lead primarily from the English, producing a provincial, somewhat coarse but quite charming variant of the elegant and highly competent London style. The earliest American print is probably a woodcut that was produced in 1670 by John Foster, a New England artist. This rather primitive work is a study of the Reverend Richard Mather, the head of one of the most prominent families in Massachusetts, and like so many early portrait prints it reveals a remarkable sense of graphic style: by dispensing with plasticity and simplifying the linear composition Foster produced a portrait whose considerable expressive power is heightened still further by the use of harsh black and white contrasts. With their coarseness and refreshing naïveté portraits such as this

Foster, *Reverend Richard Mather,* page 270

John Crome (1768—1821), FOREST LANDSCAPE WITH FIGURES.

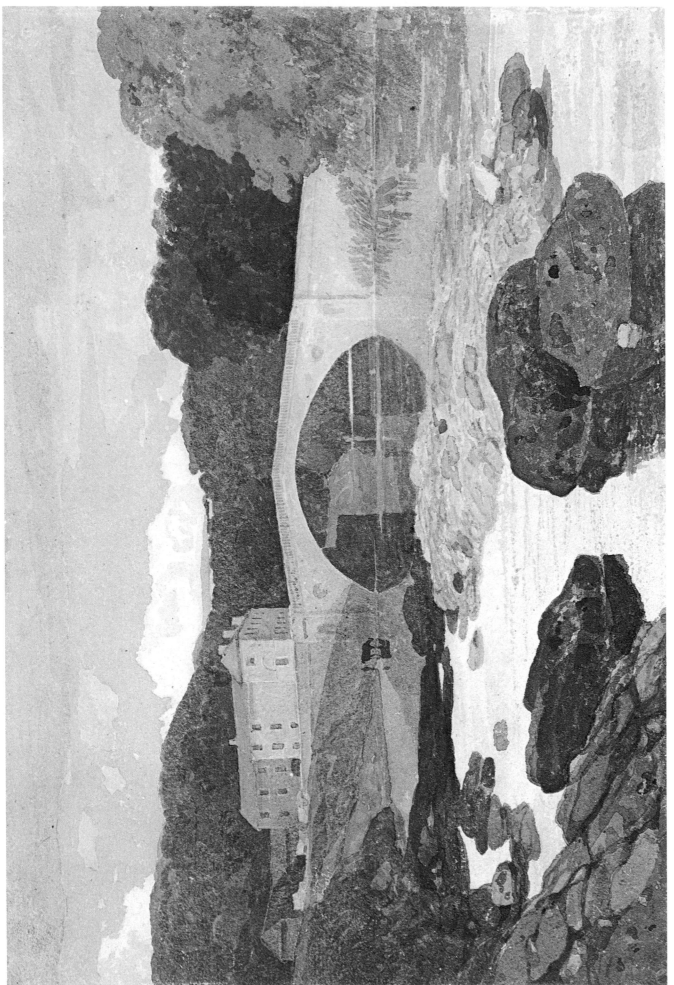

John Sell Cotman (1782—1842), GRETA BRIDGE.

reveal something of the determination of the early settlers, whose efforts to cultivate their territories involved them in a constant struggle with the elements.

During the eighteenth century the American graphic artists developed no genuinely artistic ambitions. They were quite content to provide a pictorial record of any significant events or personalities in the continuing history of their homeland. Consequently the great majority of prints and pictures produced in America from about 1675 to 1825 should not really be assessed as works of art but rather as historical documents. As such, they furnish us with a highly informative account of the exciting early period of American colonization and tell us a great deal about the dangers confronting the settlers, about their courage and fortitude, and about the simple pleasures of their daily lives.

The first half of the eighteenth century was a period of great activity in America. It was then that the ports of Boston, Philadelphia, New York and Charleston were opened up and it was then that the frontiersmen pushed forward into the virgin territories in the south and the west of the continent. But although the pioneers of those early days were essentially men of action, they included in their number a group of quite remarkable artists, who devoted themselves above all to the cultivation of the graphic media. The portraitists Peter and Henry Pelham, for example, ran a flourishing engraving workshop in Boston, where they introduced the mezzotint process following its successful development in England.

In the second half of the eighteenth century Paul Revere, the son of a French immigrant silversmith, was also working in Boston, where he founded a bell-foundry and a copper-works that is still standing. Revere was really more of a craftsman and a manufacturer than an artist and his graphic work reveals very few original ideas. For the most part he was quite content to copy or to engrave the works of other men. His line engraving of *The Boston Massacre*, for example, was based on a print of Henry Pelham's and the watercolouring was executed by Christian Remick. Despite the crudity of his engraving technique and the carelessness of his colouring Revere enjoys a considerable reputation today. Because of their rarity and their historical value his prints have become collectors' items. *The Boston Massacre*, which is his best-known engraving, exists in two forms: the '8 o'clock version' in which the hands of the clock point to 8.10, and the '10 o'clock version' in which they show the historically correct time of the massacre. The atrocity itself is portrayed in gory detail while the rhymed verse, which serves as a caption, points the moral in extremely high-flown language. This print was one of many in which the artists of North America protested against the tyranny of the English and, as such, it constitutes a piece of American history.

Revere,
The Boston Massacre,
page 272

These eighteenth-century American artists did not possess the technical skill of their English counterparts—men like William Hogarth and Thomas Rowlandson—but despite their essential crudity and lack of sophistication their prints, many of which dealt with humourous subjects, created a considerable impact and were well received by the American public. To some extent their popularity would have been due to the shortage of newspapers and books in America, since this meant that these primitive woodcuts and engravings of famous politicians and generals, of battles, revolts and natural catastrophes were able to fulfil a necessary social function

by providing the people with essential information. And in fact we find that Revere's *Boston Massacre* was followed by a large number of engravings, in which great army or naval battles were portrayed.

When the war was over and the United States of America had been founded the American artists turned their attention to the politicians, the men who were ultimately responsible for the Declaration of Independence and for the drafting of the constitution. These portraits of famous men reflected the sense of national identity which Americans were then acquiring.

Between 1790 and 1810 many European artists came to America. Fired by Rousseau's doctrine of the 'noble savage' these men wanted to see for themselves the virgin lands and the exotic Indian tribes which had long been the subject of travellers' tales. Painters like Charles St. Memin and John James Audubon, who, though born in the West Indies, had grown up in France, crossed the Atlantic in order to record both the people and the animals of the new world. St. Memin produced a series of remarkable watercolours and drawings of Indians from a wide variety of tribes, whom he encountered on his voyage along the eastern seaboard, and Audubon, who was both an artist and an ornithologist, made watercolour sketches of wild birds, which he then had reproduced by a gifted line engraver. These prints,

John Foster (1648—81),
REVEREND RICHARD MATHER.

William Pendleton (1795—1879) and John Pendleton (1798—1866), GEORGE WASHINGTON. 271

Paul Revere
(1735—1818),
THE BOSTON MASSACRE.

which were coloured by hand, were published in 1838 under the title *Birds of America,* one of the most interesting and comprehensive graphic collections in the whole of nineteenth-century art.

Lithography, which was invented by the German Alois Senefelder in 1798, was introduced into America some twenty years later, where it was popularized by William and John Pendleton of Boston. Although this process was more costly in terms of labour, the fact that almost any number of prints could be taken from the same stone more than made up for this. By using this method it was also possible to obtain more expressive and more

finely detailed prints, especially in colour. Countless original and reproductive lithographs came onto the American market at that time, where they enjoyed a great success amongst the settlers.

One of the most widely circulated lithographs was the Pendletons' *George Washington*, produced in 1828 and made after the famous portrait of George Washington which Gilbert Stuart painted in 1795/6. This lithograph appeared in the series, *The American Kings*. Stuart himself had painted the portrait fifteen times in order to meet the great demand for it.

W. and J. Pendleton, *George Washington*, page 271

Of the many art firms engaged in the production of lithographs in America in the nineteenth century one of the biggest and most successful was the firm of Currier and Ives, which at times employed as many as seven full-time painters, who turned out one original composition after the other for large-scale reproduction. In the 1860s Currier and Ives began to produce coloured lithographs. Previously, however, they had employed a large number of skilled craftsmen, who had coloured the individual prints by hand. For the best part of fifty years this firm produced a minimum of three new prints every week. All in all it marketed over 7,000 lithographs, which provide a perceptive commentary on the economic and political life of America in the nineteenth century. Nathaniel Currier and James Ives, who regarded themselves as publishers of inexpensive and popular art prints, were immensely successful, and the principal reason for their success was the growing interest of the American public in actualities. They also served a useful social function in so far as they enabled even the most isolated communities to form some conception of the progress in civilization and technology being made in the country at large. It was thanks to their prints that people all over America received a really tangible impression of the great East—West railroad, of the building of the American navy and merchant fleet, and of the strange incidents which were part and parcel of life on the new frontiers.

But these were not the only subjects treated by the artists working for Currier and Ives. They also produced humourous scenes of rural life illustrating the cares, the simple pleasures and the human frailties of the country-dweller. George Caleb Bingham made a name for himself as a painter, not only of political satires, but also of picturesque scenes of life on the Mississippi. Many of Bingham's pictures were reproduced by John Sartain, a mezzotint engraver who emigrated from England to America in 1830. One such picture was *The County Election*, which Sartain engraved in 1854 and which pilloried some of the malpractices encountered in the democratic processes of the Midwest. With his subtle chiaroscuro technique Sartain succeeded in reproducing the painterly quality of the original work while his close attention to detail enabled him to characterize the various Midwestern types with great accuracy. Prints of this kind became extremely popular and by the middle of the nineteenth century they were to be found in virtually every American home.

Sartain, *The County Election*, page 274

Many serious artists in America began their careers by working as free-lance commercial artists for newspapers and magazines. The most important of these was undoubtedly Winslow Homer. After serving a two-year apprenticeship in Boston, where he copied pictures for postcards, sheet-music scores and posters in a lithographic workshop, Homer was commissioned to illustrate Lincoln's inauguration for *Harper's Weekly* when he was only twenty-three. Shortly afterwards Harper's asked him to record the Civil War, which he did by joining the Confederate forces and producing a series of highly penetrating

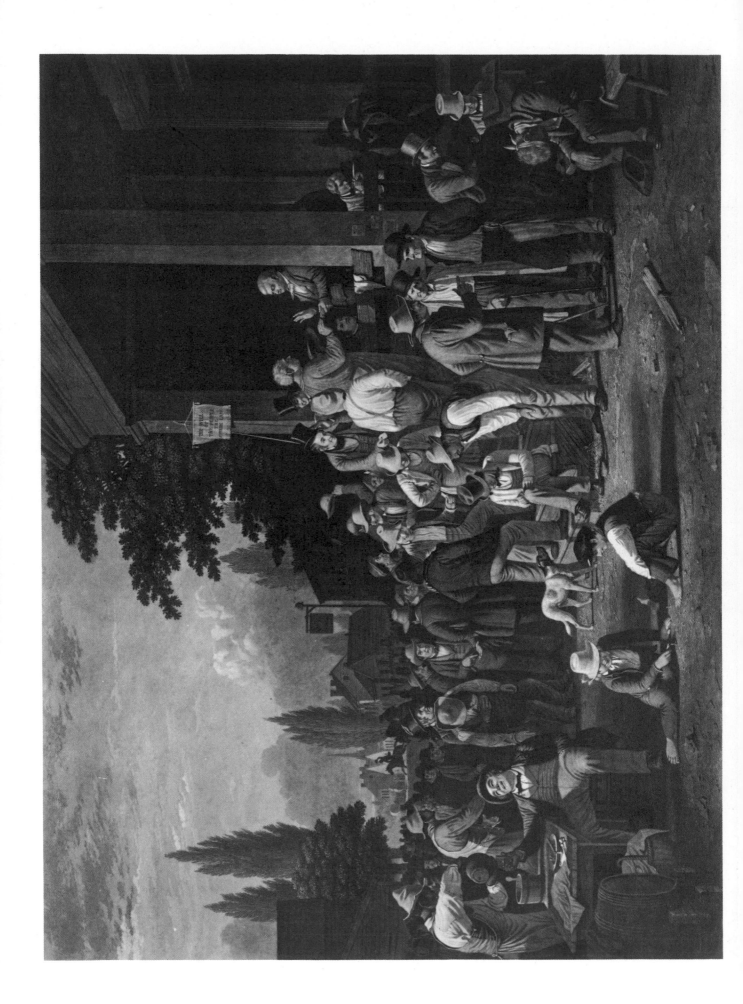

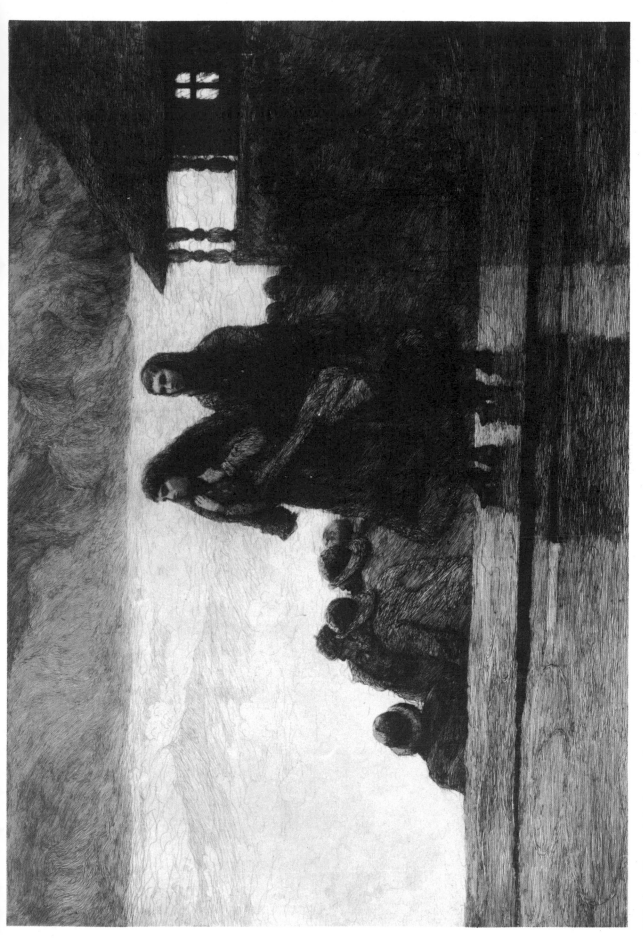

Winslow Homer (1836—1910), PERILS OF THE SEA.

Opposite: John Sartain (1808—97), THE COUNTY ELECTION.

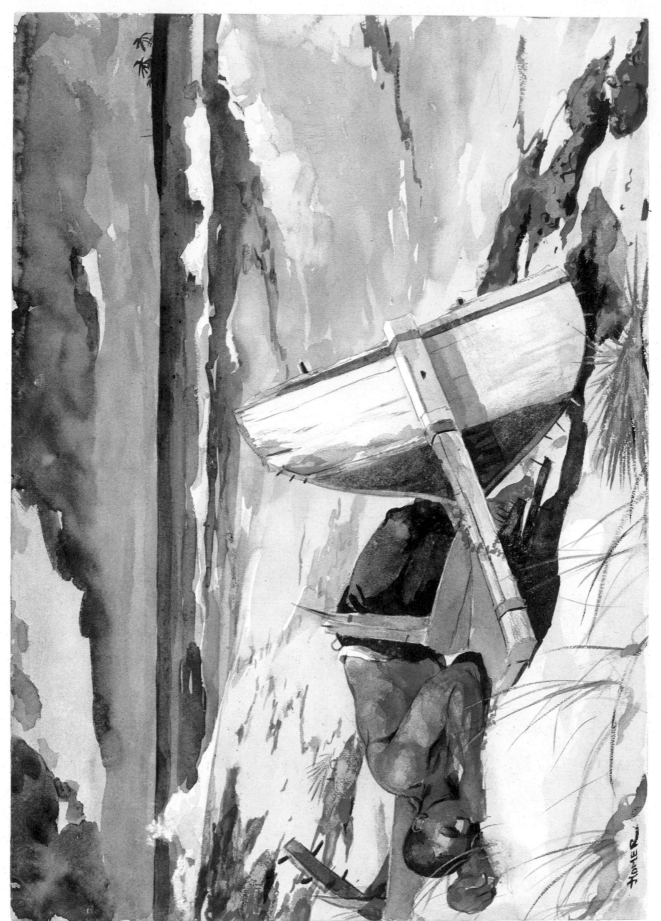

Winslow Homer (1836—1910), AFTER THE HURRICANE.

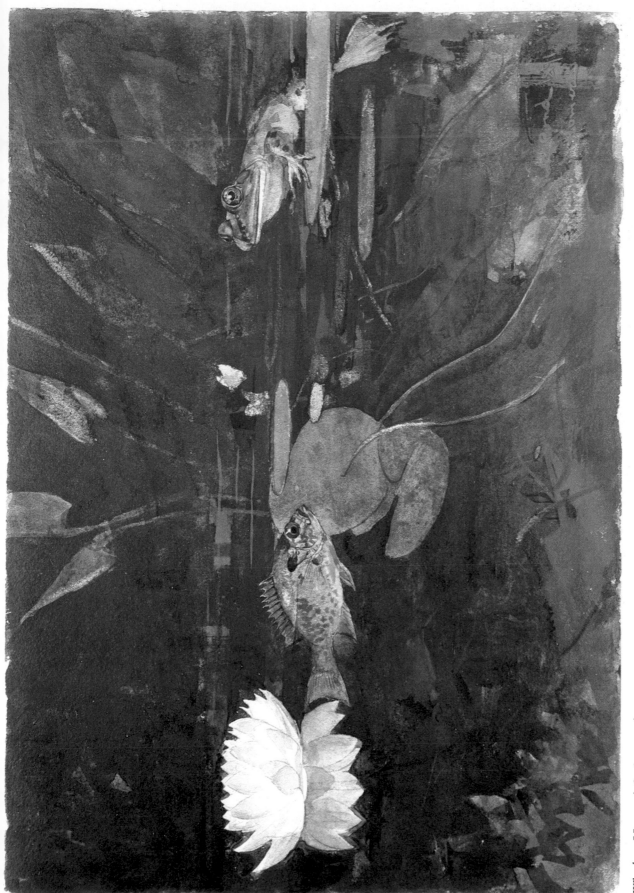

Winslow Homer (1836–1910), MINK POND.

pictures of camp life, which reveal a far greater interest in the human side of war than in its heroic or patriotic aspects. In these early illustrations we already find the simple, precise and completely unsentimental view of reality that is so characteristic of Homer's *œuvre*. Turning away from the idyllic *Biedermeier* style of his immediate predecessors, Homer produced works of monumental power, the high point of naturalistic painting in America.

The ten-month visit which Homer made to France in 1866 was undoubtedly one of the major influences in his artistic development. In Paris he came into contact with the early Impressionists and also saw the Japanese woodcuts which had just been introduced into Europe and which were to be an important element in the formation of his mature style. But although Homer was undoubtedly influenced by his trip to Paris, he was not swamped by it. When he returned to America his work was fundamentally the same as it had been prior to his departure, namely completely unsentimental and violently dramatic. His landscapes and seascapes, in which he depicted nature in its wild state, were described by one American critic in 1875 as 'barbarically simple'. Homer, he said, chose the least painterly aspects of the landscape and then proceeded to treat them in a painterly manner, as if they were views of Capri or Tangiers. In the etching *Perils of the Sea* Homer shows the dignity and patience of people living and suffering under very hard conditions.

Homer,
Perils of the Sea,
page 275

The predilection for watercolours which Homer acquired during his period as a war reporter remained with him throughout his life and enabled him to influence the development of a whole generation of American watercolourists. His best works in this medium date from the 1890s. In them the white paper, which provides the highest lights, also lends great luminosity to the colours, which are applied either in their moist state or, in some instances, in a partially dry condition. Like the Impressionists, Homer always tried to show the changing moods of nature and paid close attention to variations of light and weather. He once said that in watercolour painting the artist should paint objects precisely as he saw them. But he did not carry this precept to extreme lengths, despite the fact that the watercolour medium is particularly well suited to the representation of fleeting impressions. In his *After the Hurricane* Homer distinguished the various pictorial forms from one another by means of powerful outlines and clear colour contrasts. It was only within the individual forms—for instance in the clouds and waves—that he used transitional tones. Even in his *Mink Pond*, in which he portrayed a fantasy world, Homer remained completely realistic. The water-lily emerging from the shadowy depths of the pond and the luminous fish moving slowly through the water were conceived primarily as an experiment in the relationship between form and space. Although he felt himself to be very much a part of the natural scene Homer never romanticized his feelings.

Above:
James Abbott McNeill Whistler (1834—1903), BATTERSEA EARLY MORNING.

Homer, *After the Hurricane*, page 276

Mink Pond, page 277

279

Mary Cassatt (1844—1926), THE FITTING.

European art, which exerted only a relatively small influence on Homer, made such an impact on James Abbott McNeill Whistler that he spent the major part of his life in England and France. Whistler, a native of Massachusetts, attended West Point Military Academy from 1851 to 1854. After failing his course he worked as a Navy cartographer for a year, during which time he acquired a basic grounding in etching techniques. Then, at the age of twenty-one, he went to Paris to study painting. Three years later he published a series of thirteen etchings—generally referred to as the 'French series'—which brought him recognition. His early paintings, on the other hand, were unsuccessful and in 1858 one of his pictures was rejected by the Salon in Paris. When the same picture was accepted by the Royal Academy in the following year Whistler decided to move to London, where he played a major part in the revival of etching as a legitimate art form during the 1880s. But long before this—in 1859—he had published a series of etchings of life on the Thames. In Whistler's famous portrait of his mother, *Arrangement in Black and Grey*, we see his etching of the *Black Lion Wharf* hanging on the wall. Also from the Thames Set is *Battersea, Early Morning*. In this print the boats and their reflections in the water are built up from series of horizontal lines and the more static forms—the factories in the background and the bridge pillars and bollards in the foreground—are composed of vertical lines. The extremely impressive shadow effects are obtained by means of cross-hatching while the light clouds are indicated by serpentines and curls which are overlaid by groups of firm diagonals in the top right of the picture. The vivacity of the linear composition in this print had not been matched by any etcher since Rembrandt. Although the high assessment placed on Whistler's paintings by so many of his contemporaries has since had to be revised, his graphic *œuvre* is still considered to be of major importance.

Whistler, *Black Lion Wharf*, page 278

Whistler, *Battersea, Early Morning*, page 279

Mary Cassatt, a native of Philadelphia, was another late-nineteenth-century American artist who turned her attention to Europe. When she was still only twenty-two she defied her father, a rich banker from Pittsburgh, by crossing the Atlantic and making prolonged tours of France, Italy and Spain to study the old masters. In 1874 she worked in the atelier run by Chaplin, a strictly academic painter. Cassatt's rather conventional early paintings were fairly successful but later, when she veered towards the Impressionists in her search for a more personal style, public reaction was less favourable. After meeting Degas she began to exhibit with the Impressionists, although she did not by any means share all of their theories. Japanese art exerted a far stronger influence on her work, especially her drawings and etchings. The simplification and precision of her linear composition produced a degree of expressiveness comparable to that achieved by the great Japanese masters.

Cassatt, *The Fitting*, page 280

Paris was Mary Cassatt's real home, although she did return to America for a short while in order to plead the Impressionist cause and, while there, afforded crucial help to Durand-Ruel when he staged the great Impressionist exhibition in New York in 1886. It was thanks to this exhibition, incidentally, that the Impressionists were finally accepted by the international art world. After their New York success the galleries and private collectors no longer hesitated to buy their pictures with the result that the financial position of the Impressionist painters was greatly improved quite literally overnight. But although Mary Cassatt was largely responsible for this breakthrough, she herself did not receive wide public recognition during her lifetime. It was only after her death that her work was honoured in America.

Charles-François Daubigny (1817—78), NOTRE DAME ET L'ILE DE LA CITÉ.

FRANCE IN THE NINETEENTH CENTURY

The French Revolution sealed the fate of a society which, for centuries on end, had patronized the fine arts in France. Ever since the Middle Ages secular art had been promoted by the aristocracy and religious art by the Catholic Church. And now, without warning, the bourgeoisie was expected to assume this function. There was a precedent for such a development: two hundred years earlier the Dutch burghers had acted as patrons of the fine arts in the republican Netherlands following their secession from Spain. And a splendid job they had made of it. But the Dutch republicans of the late sixteenth and early seventeenth centuries had a very different attitude to life than the post-revolutionary republicans of France. In Holland the burghers were less preoccupied with abstract ideals: liberté, égalité, fraternité were not a consuming passion with them. On the contrary, they sought personal power and prestige through hard work, self-denial and thrift. And since, behind their republican mask, these commercial meritocrats aspired to emulate the aristocrats whom they had usurped, they naturally felt obliged to take a wider interest in the fine arts. At first they simply indulged themselves in the role of the generous patron but very soon these shrewd merchants realized that painting was a paying business. And so, after first serving as a symbol of affluence, the work of art came to be regarded as a safe investment. But this strange mixture of genuine appreciation and speculative flair actually provided a fertile ground for the production of works of art. True, these had to serve the requirements of society. But there was nothing new in that. The mixture was as before, save that instead of aristocratic masters the Dutch artists now had bourgeois masters.

The French republicans of the post-revolutionary period were far less receptive to art, which they tended to look upon as the traditional tool of the upper classes, whose leaders they had just delivered up to the guillotine. Consequently the initial reaction on the part of the Republican government was to withdraw all support, which meant that no more large-scale commissions were given to French artists. Instead of working for the state they now began to work for private individuals. But since the financial resources of these individuals were limited the large, corporate works of art which had flourished during the Baroque period were replaced by much smaller, individual works. As a result architecture, which had always been pre-eminent in the sphere of the fine arts, had to cede pride of place to painting. No other period in the whole of Western art has produced as little creative architecture as the nineteenth century. But painting also entered upon a new period of development. Previously painters had been able to take their orientation from the wishes and tastes of broad sections of the community, since they were employed by them or by their representatives. Consequently they had been carried along on a wave of general approbation. But now they lost contact with this wide and well-disposed public, for they were obliged

Jean-Auguste-Dominique
Ingres (1780—1867),
NUDE STUDY.

by their new working conditions to concentrate on the needs and wishes of
the individual. As a result they began to develop along far more personal
lines and to evolve ideas which often flew in the face of public opinion.
However, unless he was prepared to make concessions to the public, the artist
found that he was misunderstood and that, consequently, his work simply
would not sell. And so, whereas the eighteenth-century artist was promoted
and celebrated as the popular exponent of a common culture, his nineteenth-
century counterpart was forced to become an outsider, an object of pity or
scorn for his fellow men. Not every artist was prepared to take this difficult
path. Those who declined to do so had to subordinate their work to the
requirements of popular taste as formulated by the academies of art, which
became more and more important as the century progressed. Eventually a
point was reached where commercial success became the prerogative of the

professional daubster, whose sole object was to please and who did so by reducing beauty to smoothness, sentiment to sentimentality and genuine tragedy to empty sensationalism, thus producing the sort of works for which the late nineteenth-century word *Kitsch* was especially coined. Meanwhile the genuine artists went their own way, which involved them in conscious, if unintentional, opposition to society. This in turn opened up a great chasm between the artist and society, which has yet to be bridged and which has been the cause of endless misunderstandings, false assessments and bitter—and sometimes tragic—disputes. On the other hand, this rift has been extremely productive in so far as it has presented a constant challenge to all those prepared to search for new forms of expression capable of reflecting the reality of the post-revolutionary world.

The lack of a representative function, of a collective idea which they might have served, caused the nineteenth-century artists to proceed along highly individual paths of development. Every one of them had to seek out his own experiences, take his own decisions and establish his own style. The uncertainty to which this situation gave rise forced them to experiment, to try out every new technique and every new idea and investigate historical styles in search of pictorial forms which they could adapt to their own ends. Drawing, which was a relatively simple technique and one that allowed the artist to correct his work without difficulty, proved particularly suitable for such experimental purposes. The Romantic artist used drawings in order to impose an artistic and essentially unnatural form on his highly personal impressions of nature before proceeding to the actual painting, which had the reverse effect of heightening the links with nature. The French Romantics, it is true, revealed a preference for coloured drawings, but here too the

Jean-Auguste-Dominique Ingres (1780—1867), THE FAMILY OF LUCIEN BUONAPARTE.

285

Eugène Delacroix (1798—1863), REARING HORSE FRIGHTENED BY LIGHTNING.

Eugène Delacroix (1798—1863), SUNSET.

emphasis was on the linear composition, which enabled them to solve the specific problems posed by their paintings. For the Classical artist, on the other hand, drawings were a strictly formal exercise. They helped him to sublimate his ideal conception from a multiplicity of visual impressions. As for the Realists, they regarded drawings as an essential prerequisite to their finished paintings, for they used them as a means of exercising control over their artistic imagination. But however much they may have differed in their ultimate objectives, the members of these various schools had one thing in common. To a greater or lesser extent they all used the discipline of artistic form in order to develop a sense of genuine commitment to their own ideals. In this particular respect the French artists became a model for the whole of Europe. The revolutionaries of the turn of the century had rejected French art out of hand because of its total lack of conviction. But in the nineteenth century the French painters and graphic artists more than made good any past deficiencies in this respect.

Most of the French Classical artists of this period have been accused with some justification of being 'overcommitted'. Ever since Jacques-Louis David proclaimed the Classical manifesto by urging his compatriots to emulate the works of the Roman antique, French art was subject to considerable ideological pressure, which is never a very happy state of affairs. This manifesto, which was launched in order to oppose the artificial and outmoded ideals of the Rococo, set up a conflict in many Classical artists, who were torn between their sense of obligation towards the programmatic ideals of their movement and their own purely personal artistic desires. One great French Classical artist, whose work reveals clear indications of such a conflict, is Jean-Auguste-Dominique Ingres. As a loyal disciple of David he studied for many years in Italy, copied works by the masters of the Renaissance and based his style on antique sculptures. The great majority of his motifs were historical. As the Director of the Musée Napoléon (which later became the Musée du Louvre) Ingres was the most celebrated protagonist of the French Classical school of art.

But although his historical works, which were all executed with great technical verve, would certainly have earned him an honourable mention in the annals of art history, they are essentially insipid because entirely lacking in imagination. However, he also painted numerous portraits and a series of female nudes (such as *The Bather of Valpinçon*, *The Turkish Bath*, *The Great Odalisque*), which are of quite a different order. In these works Ingres took his lead from nature and, by doing so, was able to evolve a truly personal style. Although his portraits were based on Classical laws—the composition, the colouring and the expression are all completely harmonious—they are anything but insipid and they completely capture the sensuous quality of the sitter. His unique gift for portraiture was grounded in his splendid draughtsmanship, the product of long years of application. By simplifying his linear composition he succeeded in eliminating all purely contingent qualities and penetrating to an inner core of personality while still preserving the natural spontaneity of his model. *The Family of Lucien Buonaparte* creates such an intimate impression that the viewer is inclined to overlook the strict symmetry of the composition. Only the faint guide-line running from the statue in the background to the heads of the three standing figures gives us any firm indication of the artist's intention, namely to present a close-knit family scene by means of rhythmical grouping. The seated figure in the centre is

Ingres,
The Family of Lucien Buonaparte,
page 285

288

Alexandrine de Blechamps, Lucien's second wife. She is surrounded by her children, Charles-Lucien, Louis-Lucien and Paul-Marie. Lucien Buonaparte himself is not included in the group for, at the time, he was on his way to join his brother at Waterloo. His presence is none the less invoked by the portrait bust in the background whilst his mother, the head of the Buonaparte family, is represented by Canova's statue of Agrippina to the right.

In his *Dante's Barque,* an early work dating from 1822, the great Romantic artist Eugène Delacroix launched the first successful attack on French Classicism, which had found its ultimate expression in the cool approach of Ingres. Delacroix tried to introduce into painting the vivacity and expressiveness which had already made themselves felt in the spheres of music and literature. As he saw it the only way to overcome the rigidity of Classical composition was by staging a Baroque revival. In this respect, therefore, Delacroix's art was firmly rooted in traditional values. In respect of his drawing and painting technique, however, he was very much in advance of his times and his handling was later taken over by the Impressionists. With his soft, painterly brushwork Delacroix departed from the strictly linear composition of Classical art, thus emancipating French painting from the limitations of a purely realistic approach to nature. Unlike the Classicists, who used line as a means of defining pictorial forms, Delacroix employed it to indicate dynamic movement. For his lines were always lines of force, to which all detail had to be subordinated. For his sketches Delacroix

Eugène Delacroix
(1798—1863),
LANDSCAPE NEAR
TANGIERS.

289

Eugène Delacroix (1798—1863), TURKISH OFFICER ON HORSEBACK.

Opposite: Eugène Delacroix (1798—1863), PORTRAIT OF A YOUNG WOMAN.

normally used watercolours because in this medium he was better able to capture a spontaneous idea and preserve the vivacity of an original impression. Later, when he came to translate such impressions into oil-paintings, he frequently found difficulty in reproducing the power and fire of the original sketch. It was only in his mature period that he succeeded in developing a spontaneous style of oil-painting which did full justice to his rapid water-colour notations. The fact of the matter is that Delacroix's art achieved its highest expression in his watercolours; his oil-paintings are really no more than reproductions in a more durable form of insights and experiences established long before in his sketches.

The dissolution of linear form into areas of iridiscent colour, which is the most striking feature of Delacroix's early watercolour of a *Rearing Horse Frightened by Lightning*, did not appear in his oil-paintings until a good twenty years later. Although the horse's body, which is clearly illuminated by the lightning, stands out in bold relief from the swirling and threatening clouds in the background, its flying mane and tail are rendered indistinct by the violence of its movement and take on the colouring of the dark storm clouds whilst at the same time the glaring white of the horse's head runs over into the background.

Delacroix,
*Rearing Horse
Frightened by
Lightning,*
page 286

Jean-François Millet (1814—75), IN THE FARMYARD.

Théodore Géricault (1791—1824), SOLDIERS' BIVOUAC.

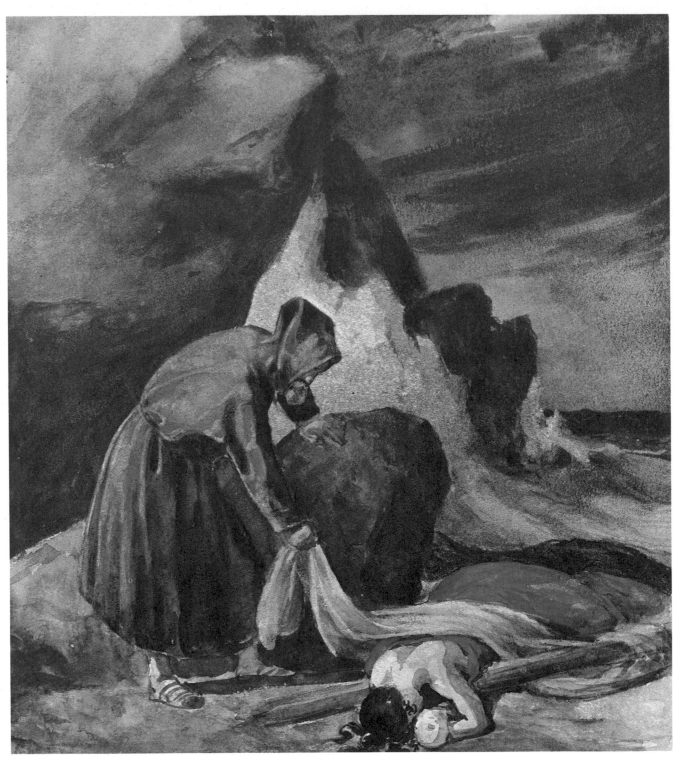

Théodore Géricault (1791—1824), A MONK FINDS A MOTHER AND HER CHILD DROWNED ON A ROCKY COAST.

Opposite: Constantin Guys (1802—92), LADY ON HORSEBACK.

Constantin Guys (1802—92), IN THE BOX.

Delacroix,
Sunset,
page 287

In his pastel study of a *Sunset* Delacroix created what is almost an abstract colour composition, for the sun itself is not visible and we see only its reflection on the clouds, the sky and the ground. Baudelaire was full of admiration for Delacroix's studies of sea and sky, which he saw in the Salon in 1859, and he spoke of these amazing works, which reproduce so faithfully the two most changeable things in the world: the waves and the clouds. He also mentioned that Delacroix had noted the date, the time of day and the strength of the wind in the margin of each sketch. None the less, Delacroix was no realist, as Cézanne correctly implied when he said: 'We all paint after the manner of Delacroix.' What he would have meant by this remark was that the art of painting consists of finding valid artistic forms and colours to represent the reality of nature, which is precisely what Delacroix did in his *Sunset.*

The power of light to change colour was something that Delacroix had learnt about in North Africa, which he visited in 1832. It was there, under the southern skies, that he painted his watercolour of a *Landscape near Tangiers,* in which the colouring is positively Surrealistic: pink sand, purple mountains and a yellow sky. An entry in the artist's diary casts light on this composition: 'In nature everything is reflection. If we look at the objects which surround us we sense a sort of affinity between them. This is established by the atmosphere which surrounds them and by their multiple reflections, which make them all interact in a certain way.' In this statement Delacriox clearly subscribes to a subjective view of reality and consequently of pictorial form. Seventy-five years later Emil-Othon Friesz, a leading representative of the Fauves,

Delacroix,
*Landscape near
Tangiers,*
page 289

Honoré Daumier
(1808—79),
DISTURBED NIGHT.

Honoré Daumier
(1808—79),
THE MUSE OF THE
ALE-HOUSE.

spoke in very similar terms when he said: 'We have to find an equivalent for sunlight by means of a technique based on colouristic orchestrations . . . But the point of departure is the artist's feeling for nature..'

The variety and the inconsistency of Delacroix's work reflect the transitional period in which he lived. In his choice of subjects he was Classical and historical, in his composition he combined Baroque dynanism with Romantic fantasy whilst in the boldness of his painterly style and his colouring he pointed the way to future developments. In this last respect he was equalled by only one of his contemporaries, Théodore Géricault. Born in Rouen in 1791 Géricault died in 1824 when Delacroix, who was seven years his junior, was just embarking on his long career. Of the two Géricault was the more radically anti-Classical. Although he acknowledged the great masters of the Baroque and the Renaissance and was influenced over a long period by Michelangelo's frescoes in the Sistine Chapel, he did not share their outlook and was really only attracted by the dynamism and expressiveness of their work. In his view of life and art Géricault was very much an individualist and he paid far greater attention to the real world in which he lived than to the ideals of the Baroque or the Renaissance. Consequently, when he returned to France from Italy, he brought with him a series of picturesque studies in which he had depicted the life of the Roman streets. He then produced a number of paintings and gouaches of horse-races before creating his major work, *The Raft of the Medusa.* This extremely realistic painting was prompted by a shipwreck and Géricault went to considerable lengths in his efforts to ensure authenticity. He obtained an exact reproduction of the actual raft, he travelled to Normandy to study the sea and he produced countless pen and pencil sketches of the individual figures in his painting, having first examined the decapitated heads of executed criminals and the corpses of people who had died, to which he was granted access by friendly doctors. In this painting of Géricault's, Romanticism acquired an entirely new dimension. Instead of transforming reality into a magical world of beauty he represented the fearful depths of human distress. He also confronted the viewer with this aspect of reality in his watercolour *A Monk Finds a Mother and her Child Drowned on a Rocky Coast.* The rigorously firm handling, the cold colours and Géricault's *formes désagréables* leave no room for sentimentality.

Géricault,
A Monk Finds a Mother and her Child Drowned,
page 294

But for all its authenticity, the realism of Delacroix and Géricault was still overlaid with emotional attitudes. From the mid-nineteenth century onwards, however, French realistic painting began to shed its Romantic attributes. This development was promoted by two important events: the revolutions of 1830 and 1848. The political changes to which these gave rise—freedom of the press, the right of assembly, the introduction of popular suffrage—were accompanied by a far-reaching sociological change for, with the growing industrialization of the country, the workers were acquiring greater power and beginning to enter the political arena alongside the nobles and the bourgeoisie. In this changing world the idealism of the early nineteenth century, which had sought to establish new social criteria by reference to the past, lost much of its power and was no longer a serious factor in the formation of artistic style. Instead both the writers and the artists of mid-nineteenth-century France began to turn their attention to the reality of their own times and to seek their inspiration there. Jean-François Millet was the first French artist to treat the worker and his *milieu* as a serious subject.

Honoré Daumier (1808—79), THE CONNOISSEUR.

Camille Corot (1796—1875), LANDSCAPE.

The titles of his best-known works—*The Winnower, The Sower, The Gleaners*—reveal his preference for peasant subjects. But Millet did not idealize rustic life. Nor did he use it as a pretext for social criticism. He wanted to portray the countryside as it really was: laborious and hard but rewarding for all that. His small drawing of a *Landscape* shows the quiet beauty that is one of the pleasures of the simple life. Looking at this gentle and completely unsentimental view of nature it is easy to understand why the Impressionists should have tried to promote his work.

Millet,
Landscape,
page 292

Constantin Guys, a relatively little-known French draughtsman and water-colourist, pursued a far more elegant form of realism than Millet. His favourite subjects were horses and beautiful women, which he portrayed as fleeting impressions. His *Lady on Horseback,* for example, is realistic only in terms of its general appearance, which would suggest that Guys was a keen observer of the passing scene. The detail is completely neglected. A few broad strokes of the brush suffice to indicate the background, and the lady's companion also remains a shadowy figure. In fact the only parts of the sketch which are at all defined are the front quarters of the horse and the lady herself, and her characterization derives largely from the elegance of her riding habit and her striking posture. Like the *Lady on Horseback* the same artist's *In the Box* is reminiscent in respect both of its subject-matter and its colouring of some of the best works of the Impressionists, although in point of fact Guys, who was a self-taught artist, had no close contact with this group. He lived in England for a long time, where he was greatly impressed by Turner's work. In the Crimean War (1854-56) he worked as a correspondent for the

Guys,
Lady on Horseback,
page 295

Guys,
In the Box,
page 296

Edouard Manet (1832—83), BERTHE MORISOT WITH A FAN.

Illustrated London News. Then, in 1860, he moved to Paris, where he become friendly with Baudelaire, Daumier and the photographer Nadar, who all recognized the great significance of his work.

Romantic, idealist, realist, satirist and pamphleteer—Honoré Daumier was all of these things and much more besides. He took the Romantic irony, which Heinrich Heine had made famous in the field of literature, and transformed it into malicious satire. The social corruption of the day provided the young Daumier with the subject-matter for the sarcastic drawings and woodcuts which he produced for *La Caricature* and *Le Charivari*, two contemporary French magazines. With the growth of democratic institutions he pinpointed their weaknesses and abuses, drawing attention to the cowardice and hypocrisy, the greed and ambition of the new citizen class. Daumier was an idealist, but neither in the Romantic nor in the Classical sense. He felt himself called upon to rouse the French citizens from their lethargy so that, like him, they might learn to distinguish between true and false ideals. But he was soon forced to realize that his idealism was not going to change the course of events and that society was not prepared to let his vilifications pass unpunished. In 1831 he was sent to prison for six months and in 1835 a new law was passed which greatly curtailed the freedom of the press and made political caricature an indictable offence. From then onwards Daumier directed his ridicule at the anomalies which he discovered in the everyday life of Parisian society, although occasionally he also entered the sphere of the working classes, producing realistic, genre-like scenes such as *The Washerwoman, The Third-class Carriage* and *The Smith,* which contain seeds of genuine social criticism. In his paintings, drawings and lithographs he restricted himself to simple, characteristic forms and revealed a preference

Edouard Manet (1832—83), THE RACES AT LONGCHAMP.

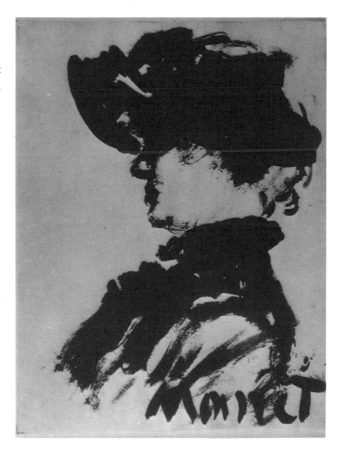

Edouard Manet
(1832—83),
FEMALE HEAD.

for harsh chiaroscuro effects, which he combined with an economical use of colour. These essentially graphic techniques lend a degree of force to his Parisian scenes that raises them far above the episodic level of straightforward caricature. In his *Muse of the Ale-house,* for example, the woman's natural grace and the prominence which she acquires both from her central position and from the light that falls directly on to her figure, enables her to dominate the seething mass of Philistines who occupy the main section of the room. Only three of these men have been clearly characterized, but their hypocritical faces are enough to suggest that the rest of the company is not so very different. In his *Disturbed Night* Daumier transformed a simple family scene, in which a father is roused from his sleep by his recalcitrant child, into a macabre allegory of entrenched authority doing battle with a subservient creature. This drawing dates from 1847, the year immediately preceding the revolution, and clearly contains a veiled allusion to the political events of the day. Daumier's *Connoisseur* is a work of quite a different order. Here a gaunt old man is totally engrossed in a small reproduction of the *Venus of Milo.* The discarded portfolio of drawings at the side of his chair and the paintings on the wall are quite forgotten as he ponders on the imperishable beauty and youthfulness of the carved figure. In this watercolour Daumier reveals a melancholy trait that is somewhat surprising in this master of mordant satire.

When Daumier died on 10 February 1879 he was totally blind and completely destitute. Following Louis-Napoléon's *coup d'état* of 1851, which brought to a sudden end the freedoms granted to the French people after the revolution of 1848, Daumier withdrew from public life. Later—in 1865—he left Paris for the provinces, where he spent the rest of his days in great poverty, which was relieved only by the occasional generosity of a few faithful friends, one

Daumier,
The Muse of the Ale-house,
page 297

Disturbed Night,
page 297

The Connoisseur,
page 299

303

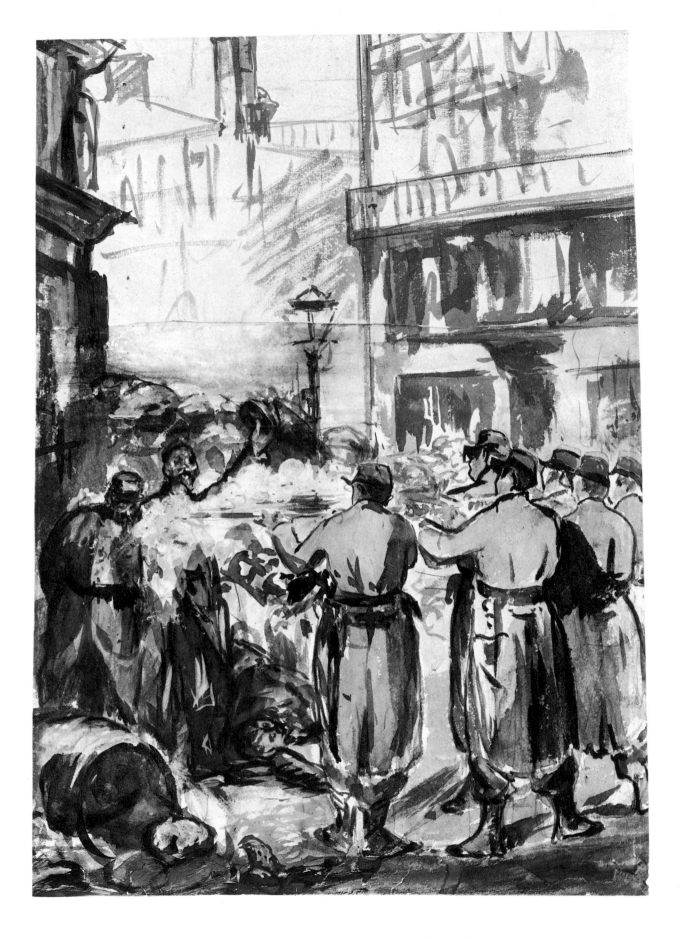

Edouard Manet (1832—83), BARRICADE.

of whom was Camille Corot. During his early period Corot painted historical subjects, but after visiting Italy in 1825–7 he turned to landscapes. His large works in this genre were all executed in the studio, but in order to ensure maximum authenticity in these finished works Corot made numerous drawings, sketches and *pochades* in the open air. As a result of sketching and painting *in situ* he acquired a completely unconventional view of landscape which prepared the ground for a whole new phase of landscape painting. At the time he was quite unaware of the revolutionary implications of this approach and was not at all pleased with the praise showered on him by the younger generation of French artists for having broken with the 'Classical' view of landscape painting embodied in the work of the academicians. In fact he did all he could to keep his distance from such anti-establishment groups. But despite his protests, Corot's new way of looking at nature was destined to have far-reaching effects. Meanwhile—in the small village of Barbizon in the forest of Fontainebleau—he continued to commune with the landscape, which he saw through the eyes of a poet. Reality, he once said, is a part of art, the artist's sensitivity merely complements it. This humility *vis-à-vis* nature carried over into his style, which is best demonstrated by his drawings, where the simple but extremely sensitive draughtsmanship draws the landscape together into a corporate entity. 'I never hurry to get down to the detail', he said. 'I am only interested in the general character of a picture.' Some twenty years later Claude Monet expressed similar ideas: 'I have simply painted from nature by trying to reproduce my impression of the fleeting moment.'

Corot, *Landscape*, page 300

From then onwards *plein air* painting became one of the most important branches of pictorial art. Those who practised it did so, not in order to reassure themselves about the living structure of actual landscapes or to discover patterns of movement which would give greater validity to their pictorial conception, but simply as a means of capturing the fleeting appearance of a particular scene. It was not until much later that a malicious art critic called these young artists 'Impressionists' because—in his view—all that they were capable of was representing their own personal impressions in a totally inadequate form. In doing so he coined the name of a whole epoch and also accurately described the aims of the new group. In the programme which they published in connection with their second exhibition the Impressionists stated that they wished to portray objects, not for their own sake, but purely for the sake of the colours in which they appeared. And so they began to observe the play of light on objects or landscapes, which gives them a different appearance according to the time of day and the state of the weather, they observed the interrelationship between light and shade, the peculiar effect of rapid movement, the languorous mood of a summer's afternoon, the iridescent gleam on the surface of water and the ghostly swirling of early morning mist. While the Realists tried to portray the world with photographic precision, the Impressionists were content to reproduce their subjective impressions of the world. This was the fundamental difference between these two groups, both of whom claimed that their approach was entirely 'realistic'.

By no means all of the Impressionists set out to create a revolution. Edouard Manet, one of the earliest members of this movement, merely wanted to inject new life into the academic painting of his day, which had become utterly sterile. When he did so, however, he found that he had offended the bourgeoisie, an outcome which he had certainly not intended and which caused him great distress, since his social loyalties lay with this class, of which he was a member.

Claude Monet (1840—1926), HAYSTACKS.

Claude Monet (1840—1926), ROCKS BY THE SEA.

Auguste Renoir
(1841—1919),
MOTHER AND CHILD.

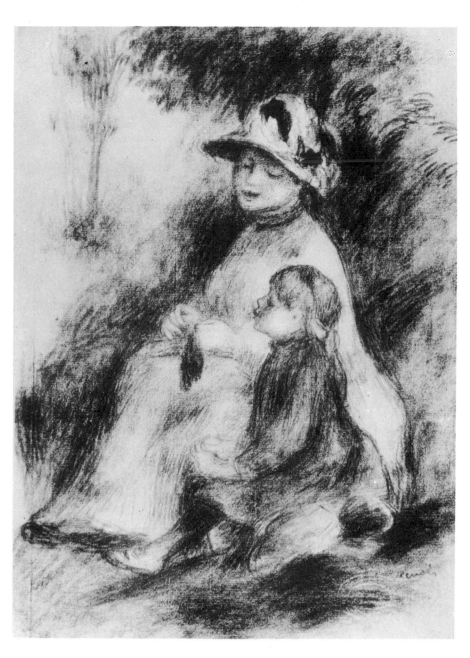

At the same time he aroused the admiration of the more activist elements of the Parisian art world, who openly opposed the establishment in their endeavours to establish new paths of development. As a result Manet found himself in a highly unenviable position midway between the revolutionaries and the traditionalists. This conflict remained a source of distress throughout the whole of his life. Bright, clear colouring and flat composition were the principal features of his work, which is well illustrated by his *Berthe Morisot with a Fan*. In this watercolour a beige, amorphous sofa and a light blue wash form the background to the female figure, whose pale, shadowless face and hands stand in glaring contrast to the dark colouring of her hair, her gown and her fan. When he saw Manet's *Olympia* the arch-realist Courbet said: 'That is flat, it has no plasticity whatsoever, she's the Queen of Spades.' Although this comment, which could be applied equally well to *Berthe Morisot,* was of course intended as a censure, it actually puts the case for Manet extremely well. The flatness of his composition and the unnaturalness

Page 308:
Auguste Renoir
(1841—1919),
TWO WOMEN.

Manet,
Berthe Morisot with a Fan,
page 301

307

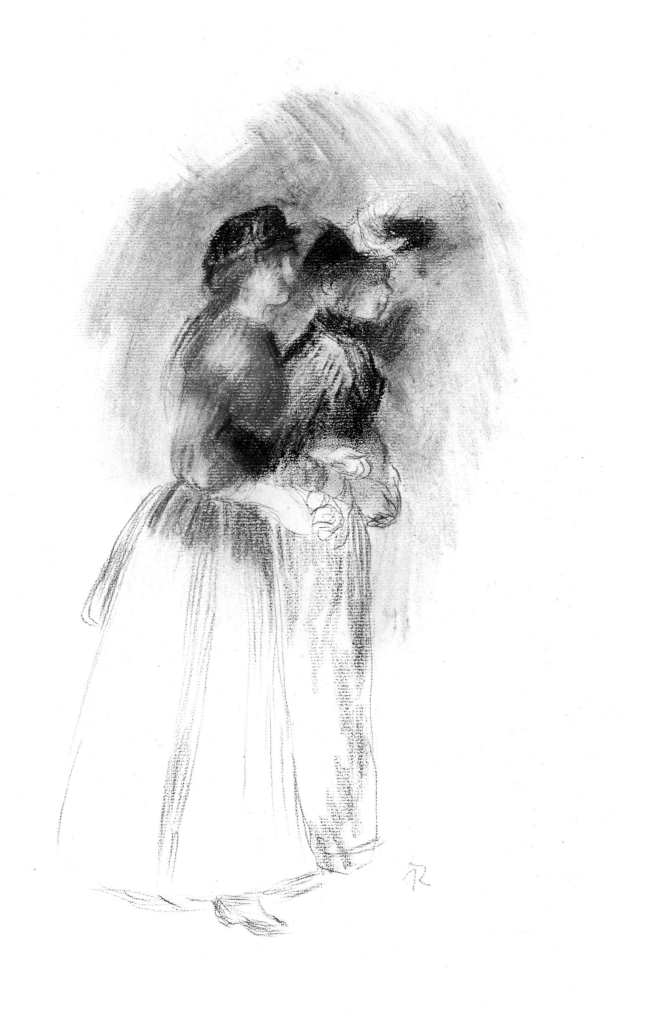

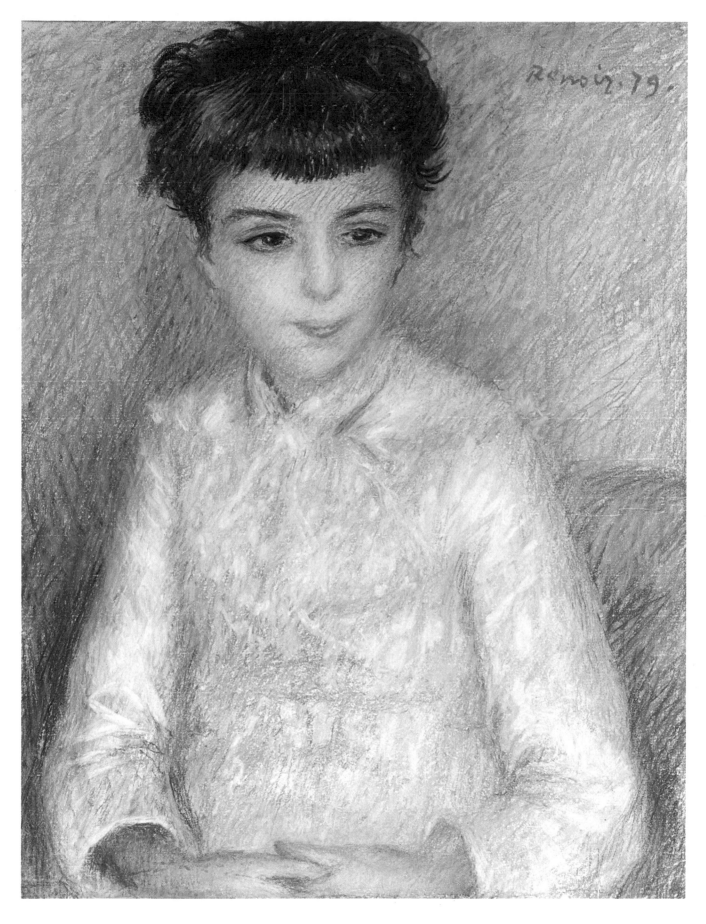

Auguste Renoir (1841—1919), PORTRAIT OF A YOUNG GIRL WITH BROWN HAIR.

Camille Pissarro (1830—1903), HAY HARVEST IN ERAGNY.

Manet,
Barricade,
page 304

of his colouring are the whole point of this work. They are also the reason why he was able to exert such an enduring influence on European art, for he proved that it was just as easy to create a valid and convincing painting with these new methods as with traditional techniques. In fact he went further than this. In his *Barricade* he showed that, by dispensing with the naturalist approach, it was possible to produce a far greater impact on the viewer. The horror of this scene is made manifest by the violent contrast between the bright sunlight which shines on the execution squad and the smoke-laden world of shadows in which their victims are enclosed. Although the work was doubtless inspired in the first instance by the rising of the Paris Commune in 1871, it is also reminiscent of Goya's execution scene in his *Disasters of War*. But whereas in Goya's etching the inhumanity of war is expressed by each individual figure, in Manet's drawing this inhumanity emerges as a general impression, due to the highly individual colouring and composition.

The process of reducing pictorial form to areas of pure light and colour, which was cautiously initiated by Manet, was carried to its logical conclusion by his slightly younger contemporary Claude Monet. Objects as such meant

310

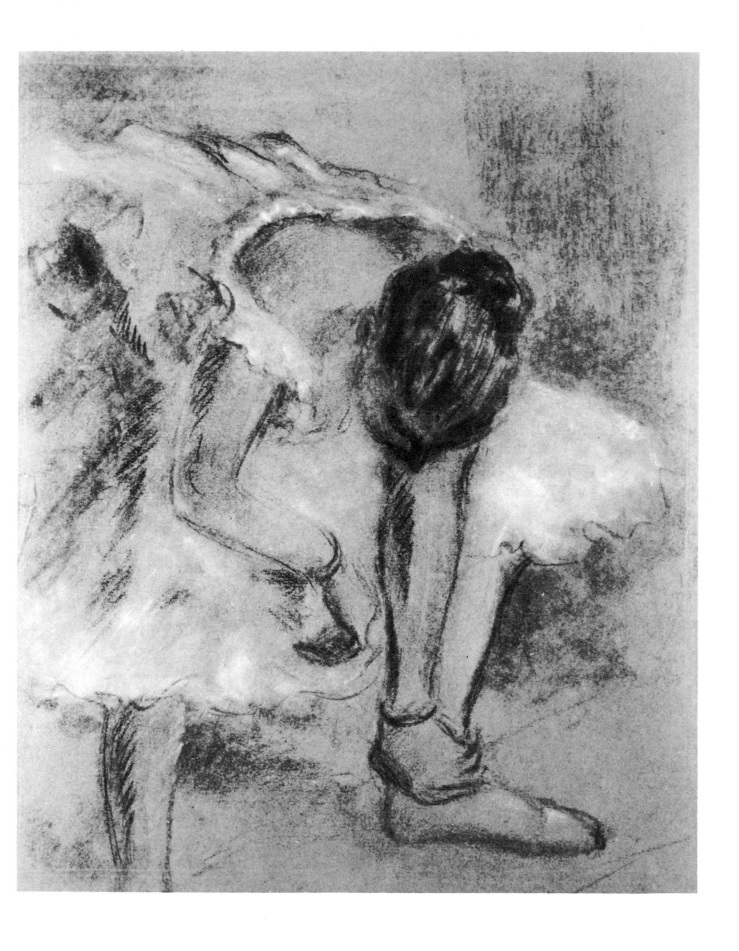

Edgar Degas (1834—1917), DANCER TYING HER SHOE.

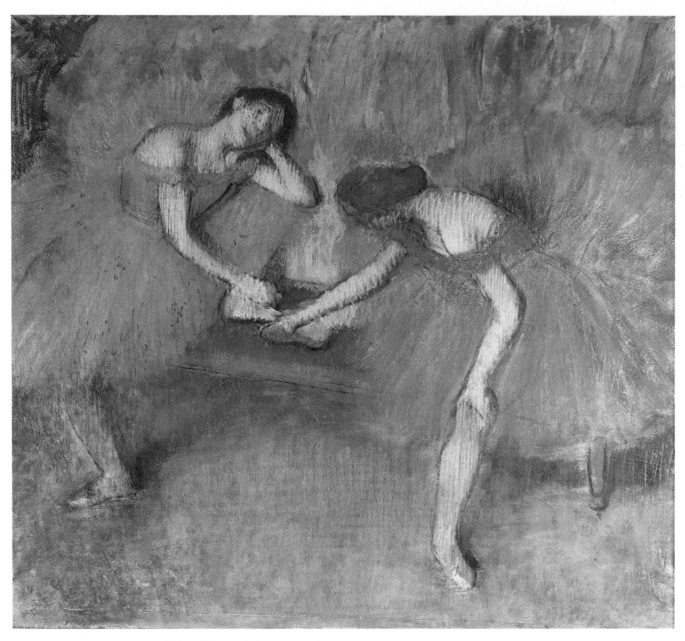

Edgar Degas (1834—1917), TWO DANCERS RESTING.

Monet,
Haystacks,
page 306

nothing to Monet. All that interested him was the impression which they created in certain lighting and weather conditions and at certain times of the day and year. Both his attitude to objects and his approach to his work are well illustrated by the circumstances in which he painted a series of fifteen pictures, all of which represent one and the same haystack. When he started this series he had with him two canvases, 'one for dull and one for bright light'. But soon the light changed and was neither dull nor bright and so he sent for a third canvas. By the time this arrived he realized that three canvases would not be enough either. In the end he stood surrounded by no less than eight canvases, which he worked on in turns according to the condition of the light 'in order to grasp a genuine impression of a certain aspect of nature and not an image compounded from a number of different impressions'. In order to convey the immediacy of his impressions of nature as genuinely as possible he also had frequent recourse to chalks, exploiting the powdery quality of this medium to produce the effect of filtered light.

Monet, who had started out in life as a caricaturist, was largely responsible for the fact that many of his Impressionist friends came to regard drawing as an independent medium. Auguste Renoir, for example, carried the pastel drawing to new heights during his Impressionist period. In his *Portrait of a Young Girl with Brown Hair* he dispensed with firm contours, replacing them with extremely sophisticated coloured hatching, which produces what is virtually a stumped effect. As a result the greenish-yellow tones of the background run over into the luminous white of the dress while, to a lesser degree, the white also appears as part of the background. Similar transitions of tone are to be found in Renoir's rapid sketch of *Two Women*, where the grey of the background turns to deep black in the women's hats and blouses, only to reappear in its original form on their long skirts. The distribution of the reds and yellows is essentially the same.

Renoir, *Young Girl with Brown Hair*, page 309

Renoir, *Two Women*, page 308

Renoir represented what is probably the most agreeable aspect of Impressionism. 'As far as I am concerned', he once said, 'a picture must be likeable, pretty and pleasing. Above all pretty! There are enough disagreeable things in life; it is not necessary to add to them.' With this outlook on life Renoir was able to create a world of total enchantment, in which the most mundane situations are charged with vivacity and grace. He was a painter who excelled in the portrayal of human beauty, which he discovered in the movements of a dancing couple, in the faces of youths, but above all in women. He paid tribute to the charms of women in countless works. We encounter them in his landscapes, in his pictures of coffee-houses, of gardens and fields. He painted them in portraits and in nude studies, alone and in groups. But, whatever their setting, these women—who range from the sophisticated to the simple— all radiate an air of sweet and tender sensuousness. Renoir's pictures were revolutionary in so far as they posed no intellectual problems whatsoever. For centuries on end artists had been serving a 'higher conception' and by and large it would be true to say that the more committed their art became, the more important it was considered to be. Although Renoir did not introduce the idea of 'art for art's sake', it was he who gave it enduring form.

Renoir, *Mother and Child,* page 307

The most consistent of the French Impressionist painters was Camille Pissarro. In all the crises which endangered the group he never once wavered in his allegiance. He also set an example to its younger members and was tireless in his efforts to compose the many quarrels which threatened the very existence of the Impressionist movement. Moreover, he was a splendid pedagogue. A kindly and affable man by nature, Pissarro became extremely argumentative whenever he was called upon to defend Impressionism against the attacks of the pro-establishment critics or the ignorance of the general public, and it was thanks mainly to this initiative that the eight great Impressionist exhibitions were staged between 1874 and 1886. Although he was the only member of the movement whose pictures were regularly hung in the official Salon he associated himself from the outset with the 'Société anonyme des artistes, peintres, sculpteurs et graveurs' that was founded by the artists whose works were rejected by the Salon.

The first Impressionist exhibition took place in 1874 in the studio of the photographer Nadar. The contributors included Berthe Morisot (Manet's sister-in-law and model), Renoir, Sisley, Cézanne, Degas, Guillaumin, Pissarro and Monet, whose 'Impression, soleil levant' prompted the art critic Leroy to coin the derogatory title 'Impressionism' with which to describe the works of this new movement. Two years later a second Impressionist exhibition was put

on by the art dealer Durand-Ruel, the first member of the French art world to recognize the significance of the group. Subsequently he succeeded in selling a number of Impressionist works, but the Parisian establishment—and especially the critics—remained adamant in their opposition. The reaction of *Le Figaro* to the 1876 exhibition was typical: 'An exhibition of so-called paintings has just been opened at Durand-Ruel's', the critic wrote. 'The unsuspecting passer-by, who is tempted to enter the gallery by the transparencies [in the entrance] is subjected to a fearful spectacle. Five or six demented people, including one woman, have joined forces to exhibit their works, which were greeted with loud laughter by a number of viewers. These "artists" call themselves Impressionists: they smear a few wild daubs of paint on to a canvas and present it to us as art. It is just as if a madman were to pick up pebbles in the street and tell us he had found diamonds.' The critic then went on to deliver a lecture to each of the artists in turn. Pissarro was told that trees are not purple and that the sky does not look like fresh butter.

Now that Impressionist paintings have become entirely acceptable it is important that we should know about this early public reaction, for it shows how revolutionary they were once thought to be. Never before had any artistic movement been so bitterly opposed by artists, critics, dealers and so-called connoisseurs. Never before had a group of artists been exposed to such ridicule or been forced to fight so passionately for public recognition. Few have had to make such harsh sacrifices in defence of their principles as the Impressionists. Long years of deprivation were paid for with fearful illnesses: for fifteen years Renoir suffered from arthritis and in the end was so crippled that he was confined to his wheelchair and had to have his brush tied to his fingers in order to paint; Manet was bedridden during the closing years of his life and died following an operation in which one of his legs was amputated; Pissarro suffered for years on end from a chronic eye complaint; and Cézanne was a diabetic. They all went without food, they seldom had sufficient money to consult a doctor and only a few of them were recognized during their lifetime. This development was symptomatic of a deep-rooted process of change which was then taking place: by ceasing to concern themselves with the representation of extra-artistic ideas and by refusing to seek their inspiration in the realm of nature the artists of the nineteenth century had broken with a tradition which their forbears had served for half a millennium; and in acquiring their independence they had lost contact with society, which was still bound up with that tradition. The crisis of confidence between the artist and his public, which had been present in latent form ever since the French Revolution, was brought to a head by the Impressionists.

In this, as in previous periods of change, great importance was attached to linear composition as a means of establishing new pictorial structures. The majority of Impressionists, it is true, still tended to use the graphic medium simply as an alternative to painting. But the more the nineteenth-century artists sought to overcome nature, the more they turned to drawings or engravings in a conscious attempt to give greater force to their highly personal artistic ideas.

This move away from nature found its most forcible expression in the work of Edgar Degas. Because he was on friendly terms with the Impressionists and sometimes exhibited with them he has been wrongly classified by some critics as a member of this group. 'My work', Degas said, 'is the outcome of ceaseless reflection and study of the old masters—of spontaneity, inspiration and

Pissarro,
Hay Harvest in Eragny,
page 310

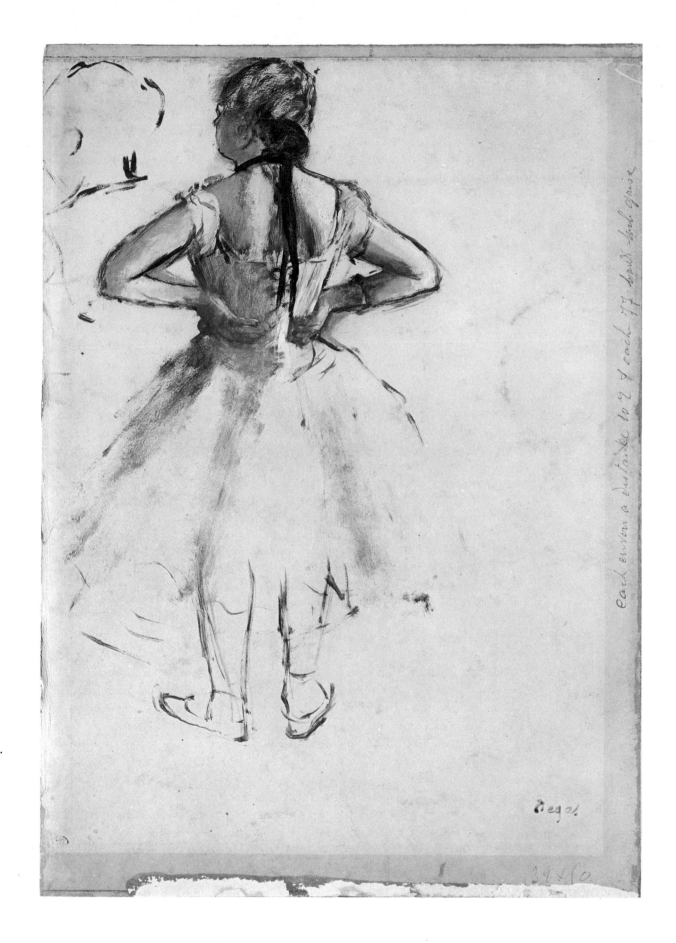

Edgar Degas (1834—1917), DANCER.

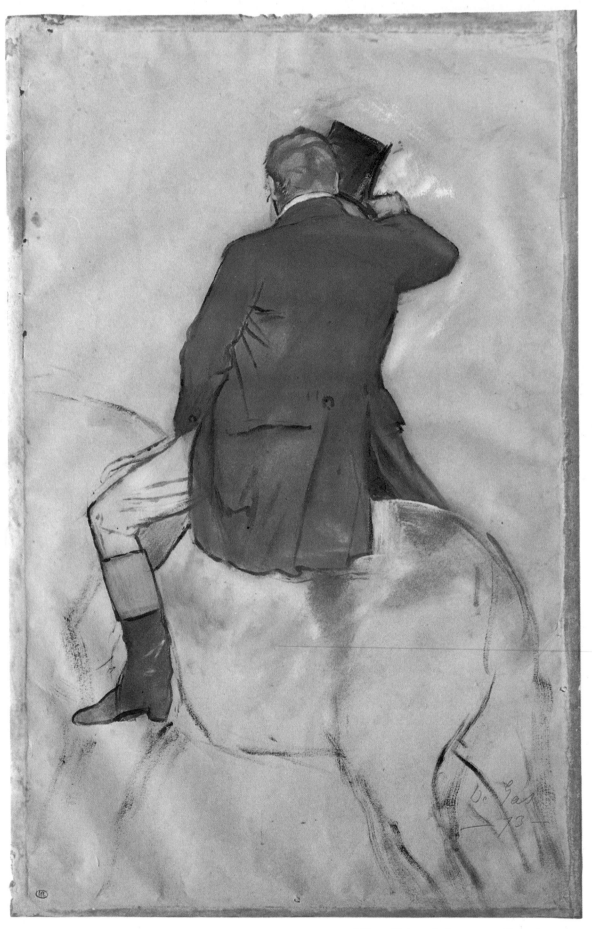

Edgar Degas (1834—1917), HORSEMAN.

Edgar Degas
(1834—1917),
RIDERS ON THE
SEASHORE.

temperament I know nothing.' Whilst the Impressionists sought to eliminate reflection from their work in order to capture the fleeting impression, Degas gave his preference to the methodical pursuit of formal structures and in doing so he had frequent recourse to graphic works. As a young man Degas was introduced to Ingres, who said to him: 'Faites de lignes, beaucoup de lignes—soit d'après le souvenir, soit d'après la nature' (Draw lines, lots of lines—be they from memory or from nature). This piece of advice might well stand as a motto for a large part of Degas's œuvre. He observed, he thought and he worked as a draughtsman, even in his paintings. He once described himself as a 'colourist of line' and for a long time linear composition meant more to him than colour. It was only in his late work, when he went over from oils to pastels, that he was able to strike a balance between line and colour, although even then he continued to produce painterly effects by linear means. By creating areas of colour rich in tonal values and then distinguishing

317

these from one another by the use of bold contours he achieved a painterly intensity that was surpassed by none of the Impressionists with the single exception of Monet in his late period. Because of his marked preference for the world of the ballet and the world of horses, Degas was accused by his colleagues of trying to create a market for his work amongst race-horse owners and balletomanes, although in actual fact his pictures were rejected by both of these groups. The truth of the matter was that horse-riding and the ballet provided him with ideal subjects. The horseman and the dancer combined absolute discipline with a maximum of poise and grace, which is precisely what Degas himself set out to do. In his pastel drawing of *Two Dancers Resting* he created a highly stylized arabesque by the arrangement of the dancers' limbs and the juxtaposition of their blue skirts but without destroying their natural grace. Degas's *Dancer Tying her Shoe* and his *Dancer* are typical of a large number of works, in which he consciously set out to create a highly objective portrait without allowing his own personality to intrude in any way. In order to capture the impression of complete spontaneity which is the very essence of such works he often observed his models without letting them know that he was doing so. His pictures of horsemen also have this snapshot quality, although they too were anything but unpremeditated, for he made literally hundreds of preliminary drawings for his simplified and monumental pictures of horsemen and horses. Sometimes he even studied photographs taken by friends on race-courses in order to acquaint himself with the more detailed aspects of the horses' movements. Degas did not think very highly of *plein air* painting. When he used a landscape background he always gave it an unnatural appearance by using unrealistic colours. His *Riders on the Seashore* acquires its magical effect from the contrast between the dark but articulate equestrian group and the diffused glow of the setting.

In later life Auguste Rodin, the great pioneer of modern sculpture, produced a series of drawings which were not intended as studies for specific sculptures but which provide a sort of résumé of his experiences as a sculptor. Like Degas, Rodin used linear composition as a means of clarifying his formal structures. In his *Seated Girl,* in which the nude figure appears against an almost neutral background, the outlines are all executed in pencil whilst the plasticity— which is kept to a minimum—is produced by a thin coating of gouache.

Degas's and Rodin's attempts to introduce formal discipline into their pictorial works amounted to a clear rejection of Impressionism, which was already beginning to lose its impetus in the 1880s. The sheer technical brilliance of this new school and its preoccupation with the purely decorative aspects of painting encouraged intellectual stagnation, and it gradually became apparent that Impressionism as such was incapable of further development. Soon everybody was looking for a way out of the dilemma. Renoir studied the old masters in search of greater formal clarity, Cézanne began to concern himself with the structural aspects of composition whilst Pissarro went over to 'Pointillism' in 1884 and continued to paint in this style for the next five years. The Pointillist technique was evolved by Georges Seurat, who had been deeply interested in the theory of colour ever since his student days at the École des Beaux-Arts. He was one of the first to realize that Impressionism was a declining force and he developed his scientifically based conception of Pointillism, or Divisionism, in order to hasten the end of the essentially intuitive approach adopted by the Impressionists. He argued that, instead of

Degas,
Two Dancers Resting,
page 312

Dancer,
pages 311 and 315

Horseman,
page 316

Riders on the Seashore,
page 317

Rodin,
Seated Girl,
page 320

Alfred Sisley (1839—99), EARLY FALL OF SNOW IN A FRENCH VILLAGE.

46

mixing their colours on the palette, artists should rely for their colour effects on the optical mixtures produced in the retina of the human eye, since this was more in line with the workings of nature, where colour was produced by the interaction, or mixing, of coloured light. What this came down to in practical terms was a 'confetti technique', in which series of tiny blobs of two different primary colours were placed in close proximity on the canvas in order to produce a more powerful secondary colour in the eye of the viewer. Before evolving this theory of colour, however, Seurat had concentrated on black-and-white drawings, in which he dispensed with linear composition as such and defined his pictorial objects simply by the use of light and shade. There is nothing extempore about these flat forms of Seurat's. Quite the reverse! The whole import of these works depends on the rhythmical relationship between the different structures and the careful gradations of tone. Commenting on Seurat's drawings, Paul Signac once said that, although they were only simple sketches, the contrasts and gradations were so precisely worked out that it would be entirely possible to paint a picture from them without even looking at the model.

Nineteenth-century linear art reached its apogee in the work of Henri de Toulouse-Lautrec. Turning his back on the theories and programmatic ideas subscribed to by the vast majority of his contemporaries he created intensely expressive works simply by his use of line. Although he was certainly realistic in his subject-matter his drawings acquired a distinctly personal quality from his exploitation of exaggerated movement and unconventional colour and, above all, from his highly simplified use of line. Toulouse-Lautrec, whom the chansonette Yvette Gilbert affectionately referred to as her 'little monster', came from one of the oldest families in France. The Counts of Toulouse-Lautrec-Monfa are said to have played a glorious part in the Crusades. There are various reasons why Henri, who was born in Albi in 1864, should have added to his family's fame as an artist rather than in some aristocratic pursuit. In the first place he had the misfortune to break both his legs as a child with the result that his growth was stunted and he was unable to take a normal part in social life. And then there was the fact that his education was completely unconventional. Finally, there was his unusual graphic talent, which developed at an early age and convinced his family that he should be encouraged to pursue an artistic career. They sent him to Paris, where he received a thorough training in various ateliers. But in the end he tired of the unimaginative and sterile painting of the academies and opted for the throbbing life of the city in preference to the bloodless atmosphere of the ateliers. In the cafés and cabarets of Montmartre, in dives and even brothels Toulouse-Lautrec soon became a familiar figure. There, in addition to alcohol, he found an inexhaustible supply of subjects for his drawings. The Can-Can dancers, the coquettes, the *souteneurs* and the dance hostesses became his models. He would sit for nights on end at a table in a café-dansant unobserved by the milling crowd about him, whose pulsating life he recorded with incredible speed. He hated the studied poses of the professional models and far preferred to take his sketching-pad to Montmartre, where he was able to study the unforced movements of the local girls. Toulouse-Lautrec did not indulge in social criticism; he attacked nobody and he never gave offence. What fascinated him about Montmartre was its unreal atmosphere, its completely false milieu: the made-up faces, the harsh footlights, the cheap decorations, the glittering baubles, the coquettish smiles of the girls and the

Opposite:
Auguste Rodin
(1840—1917),
SEATED GIRL.

Seurat,
Study,
page 324

Study for 'La Grande Jatte',
page 325

Toulouse-Lautrec,
A Drive in the Country,
page 327

Yvette Gilbert,
page 328

La Clownesse,
page 329

Jean-Louis Forain (1852—1931), PORTRAIT OF THE CABARET ARTIST VALÉRIE (VALÉRY) ROUMY.

Paul Signac (1863—1935), FISHING VESSEL AT THE HEAD OF A JETTY WITH A LIGHTHOUSE.

Georges Seurat
(1859—91),
STUDY FOR 'LA GRANDE
JATTE'.

airs and graces of the young men about town. And for this unreal world he found suitable artistic equivalents, or rather in this unreal world he found suitable material for his own way of looking at the world, which was itself alienated from reality. His chalk drawing *At the Circus: The Clown Footit with a Poodle and Elephant* is based on an almost Surrealist structure. The circular ramp surrounding the circus ring links the group in the foreground with the elephant, which is disproportionately small, whilst the completely neutral beige-coloured floor of the ring reduces the plasticity of all the pictorial forms, so that only the linear composition and the flat, shadowy figures remain. The inverted world, which the artist has indicated in the formal composition of his drawing, is underlined by the contrast between the gigantic clown and the tiny, emaciated dog. This work was dedicated to Arsène Alexandre, doubtless as a token of gratitude for his article in *Le Figaro*, in which he invalidated the rumours about Toulouse-Lautrec's health which were then circulating in Paris. In the spring of 1899 Henri was admitted to a clinic for alcoholics, where he worked with great concentration in order to convince both his doctors and himself that his illness was of no account. He was released at the end of three months but soon returned to his excessive

Toulouse-Lautrec,
The Clown Footit with a Poodle and Elephant,
page 326

325

Henri de Toulouse-Lautrec (1864—1901), AT THE CIRCUS: THE CLOWN FOOTIT WITH A POODLE AND ELEPHANT.

Henri de Toulouse-Lautrec (1864—1901), A DRIVE IN THE COUNTRY.

Henri de Toulouse-
Lautrec (1864—1901),
YVETTE GILBERT.

drinking habits. His early death was undoubtedly due to his uninhibited zest
for living, to which his enormous *œuvre* bears witness. At the age of thirty-
seven Toulouse-Lautrec left no less than 500 paintings, 3,000 drawings and
countless lithographs.

His simplified use of line, which enabled him to produce what are virtually
abstract structures in his drawings, also benefited his graphic work. His major
achievement in this sphere was his posters, which are unique. Many of them
are publicity posters, in which he immortalized a number of the cabaret and
café artists of his day. Yvette Gilbert, for example, is now remembered as the
figure created by Toulouse-Lautrec whilst Jane Avril and May Belfort were
both greatly indebted to him for the help he afforded them in their careers.
But it was Toulouse-Lautrec's coloured lithographs that were to exert such a
lasting influence on the development of graphic art in the twentieth century.
In these he created spatial effects by placing unshaded areas of colour either

Toulouse-Lautrec,
Yvette Gilbert,
page 328

Henri de Toulouse-Lautrec (1864—1901), LA CLOWNESSE.

Page 330: Henri de Toulouse-Lautrec (1864—1901), ELSA, THE 'VIENNESE WOMAN'.

side by side or in juxtaposition to completely blank areas, thus setting up a structural tension based purely on colour contrast. In his later works in this medium he enlivened the monochrome areas with blobs of colour which he sprinkled on to the stone with a toothbrush.

Toulouse-Lautrec, *Elsa, the Viennese Woman,* page 330

Although he had no disciples Toulouse-Lautrec exerted considerable influence on posterity. The abstract ornamentation of *art nouveau* owed much to his simplified use of line; his large areas of pure colour were later taken up by the Fauves and used by them as an element in the formation of a new style; and the youthful works of Picasso—who came to Paris in 1900, just one year before Toulouse-Lautrec's death—bear witness to the impact which he made on the art of the present century.

In their quest for new and unnaturalistic forms of expression the European artists of the late nineteenth century discovered Japanese art. Degas, Toulouse-Lautrec, van Gogh and the young Gauguin all found a new lead in the flat composition and the sensitive colour rhythms of Japanese woodcuts and pen drawings. As far as Gauguin was concerned, the discovery was to have far-reaching effects, for it made him aware of the existence of art forms which up till then had commanded little interest in Europe: the art forms of primitive tribes. He then spent the rest of his days trying to satisfy his longing for the primitive life. It was this that made him give up his career as a stockbroker when he was thirty-four. Soon afterwards he walked out on his family and sought refuge in Pont-Aven, where the austere beauty of the Breton countryside with its low, thatched houses and the originality of the local population completely fascinated him and inspired a series of pictures which are remarkable for their simplicity of line and colour. During his four-year stay at Pont-Aven he visited Panama and Martinique and also spent two disastrous months with van Gogh in Arles. Then in 1891 he undertook his long-planned journey to the South Sea islands. There, in Tahiti, he finally found what he had long been seeking: the unself-consciousness and the innocence of a truly primitive people. '... with its burning, luminous colours the landscape dazzled and blinded me ... and yet it seemed so simple to paint the things just as I saw them, to apply reds and blues to my canvas without stopping to think ... Why then did I hesitate to allow all the golden light and all the joy of the sun to flow over on to my canvas? The long accustomed routine of Europe, the timidity of expression of degenerate races ... our great error is the "Greek", no matter how beautiful it may be.'

These words reveal Gauguin's quest for the original conditions underlying all artistic activity, which he eventually found in the South Seas. Inspired by the folk art of the islanders he created a series of woodcarvings and also discovered the great potential of the woodcut as a means of simplifying and stylizing natural forms. This medium enabled him to dispense with many features of traditional European art which he considered superfluous: perspective, relief, chiaroscuro and sensuousness of expression. Instead he concentrated on the creation of a bold and highly simplified linear composition and large monochrome areas. In 1888, three years before his departure for the South Seas, he had outlined his future programme: massive, simplified forms, flat colours, clear definition of the individual forms by means of dark contours, light without shade, abstraction of both colours and linear composition, freedom from nature.

Gauguin, *Nave Nave Fenua,* page 333

The *Tahitian Landscape* forms part of the Noa-Noa album, in which Gauguin recorded his impressions of the South Seas following his first visit to Tahiti.

Tahitian Landscape, page 332

Paul Gauguin (1848—1903), TAHITIAN LANDSCAPE.

Opposite: Paul Gauguin (1848—1903), NAVE NAVE FENUA.

This 345-page folio volume contains fifty-nine watercolours and woodcuts, a selection of photographs, poems by Charles Morice and simple texts by Gauguin. Later Morice claimed that he had conceived the idea for this book, a claim violently opposed by Gauguin: 'I had the idea of comparing the qualities and characteristics of the islanders with our own. And I discovered enough originality (I myself live like a savage) to be able to write about it and to compare it with the writings of a civilized man, namely Morice. That was how I envisaged our collaboration and that was how I arranged it. Although I am not a "professional", I know which one of us is more important, the one who records the life of the primitives or the one who represents the corrupt world of civilization.'

The two works of Gauguin's reproduced in this book show why it was that he had such an enormous influence on the development of twentieth-century art. The luminosity of the watercolour points unmistakably to the Fauves whilst the symbolic force of the woodcut is reminiscent of both *art nouveau* and Expressionism.

EUROPE IN THE TWENTIETH CENTURY

Although we might be tempted to think, when we compare modern works with those of earlier periods, that the break with traditional art was a sudden and revolutionary act, this was far from the case. The first indication that a fundamental change was soon to take place was given by Delacroix, whose spontaneous and expressive handling constituted an important prerequisite for the development of a new and purely painterly style. However, in so far as Delacroix was still firmly rooted in traditional thought, it is not really possible to regard him as a pioneer of modern art. The nineteenth-century realists such as Courbet, Millet and Daumier fall into a similar category. By turning away from history painting and concentrating on the world around them, by avoiding anything that might conceivably be regarded as sentimental, they infused a new and refreshing spirit of naturalism into the sterile art of their times. But, although works like Millet's *Gleaners* and Courbet's *Stone Breakers* created quite a sensation in their day, they were not the first of their kind. The Dutch had already produced works that were equally unsentimental and equally realistic two years before. Courbet and his compatriots certainly introduced a new range of subjects but not a new conception.

The French realists of the Barbizon School, however, did introduce a new conception. They were the first landscapists to work in the open air and by doing so they replaced the traditional view of nature with a far more authentic view based on direct observation. In a sense, therefore, they were also the first artists to dispense with preconceived motifs and, if we are prepared to accept that modern art has come about as a result of a growing movement towards abstraction, then the realists of the Barbizon School must be regarded as the first modern artists.

Although the Impressionists were decidedly unconventional, both in their handling and in their colouring, their approach was essentially the same as that of the Barbizon School. True, they set up the artist's subjective and dynamic impression of nature as a counterpoise to the static view of nature espoused by academics, but they remained realists for all that, since they used this subjective approach simply in order to create adequate pictorial forms for the portrayal of real phenomena. But there were other late-nineteenth-century artists who consciously set out to subordinate external reality to their own artistic conceptions. Although it is always possible to identify the figures and objects in their works, their pictorial forms are often highly distorted so much that these artists cannot be regarded as realists in any real sense of the word. It is a point to be noted that these men—among them, Degas, Toulouse-Lautrec and Gauguin—attached special importance to line and plane in the composition of their pictures and either neglected or completely dispensed with plasticity and tonal values.

The next attack on traditional values, which was far more sustained, was launched by the Cubists at the turn of the century. Cézanne had already

Cézanne,
House in Provence,
page 337

paved the way for this new development by basing his compositions on geometric forms and treating nature simply as a point of departure for his constructional experiments. He was followed by the Cubists and their logical approach further undermined the illusionist conceptions of traditional art, which had first been established by the masters of the Italian Renaissance following the discovery of linear perspective in the early fifteenth century. The Cubists' view of art was essentially two dimensional. Consequently they did not interpret reality in purely visual terms. On the contrary, they created a highly subjective and artificial view of reality, one which involved them in a process of 'abstraction'. By reducing all pictorial objects and figures to stereometric forms they sought to eliminate any sense of physical volume. They also dispensed with all techniques calculated to produce an impression of depth. Consequently we find no converging lines in Cubism. Side and aerial views of objects are presented as if they were frontal views, which means that all lines run in parallel. Nor is there any painterly shading in Cubist works. The individual arears of colour, which are clearly outlined, are almost invariably monochrome, the only exception to this general rule occuring where one area of colour overlaps another and is permeated by it.

Whilst the Cubists sought to produce two-dimensional compositions by the use of strictly linear structures and geometric forms, the Fauves tried to achieve a similar result by means of pure bright colours, which they exploited far more than the Impressionists had ever done. To this extent, therefore, Fauvism and Cubism represent two opposite poles. A similar polarity existed during the early part of the Renaissance between the linear style of the Florentines and the painterly style of the Venetians. And, just as the interaction of these two early Italian schools led to the emergence of the High Renaissance, so too the Fauves and the Cubists were responsible for the evolution—immediately prior to the First World War—of late or synthetic Cubism, in which colour and handling were combined with Cubist structures, thus providing a sound and undogmatic basis for future developments. By now art had been virtually removed from the illusionist tradition to which it had been subject for nearly half a millennium: the Barbizon School had dispensed with preconceived motifs, the Cubists had disposed of the third dimension whilst the Fauves had finally established the autonomy of colour. Only one step remained to be taken: the elimation of recognizable objects and figures. The basis for this development had long since been established. If we disregard the figurative scene and concentrate on the background, we find in a large number of Degas's works examples of pure colour composition which anticipated the absolute painting of our own day. Gauguin's abstract ornamentation carried this process still further while, by rejecting the illusionist practices of traditional art, the *art nouveau* of the turn of the century also gave its assent to a purely aesthetic conception. *Art nouveau* has often been reviled by later critics, who have regarded it as a typical product of the *fin de siècle*. In point of fact, however, this movement, which spread across the whole of Europe, signalled a new departure. Although they failed to produce a clear-cut solution to the artistic problems of their day, the adherents of *art nouveau* none the less pointed the way forwards in every single sphere of the fine arts: painting, architecture, sculpture and craftwork. Their real significance lies in the influence which they exerted on the works produced in these fields by their immediate successors. For example, Wassily Kandinsky—the founder of non-objective painting—was closely tied up with

Kandinsky,
The Mirror,
page 401

Paul Cézanne (1839—1906), HOUSE IN PROVENCE.

art nouveau. It was in 1910 that Kandinsky took the final step in the development of abstract art by eliminating all recognizable objects and figures and replacing them with pictorial signs derived not from nature or history, but from his own creative imagination. With these signs he created compositions which depended for their effect solely on the rhythmical interplay of lines and forms and the harmonious integration of colour nuances.

In view of this general movement towards non-naturalistic forms of expression it is scarcely surprising to find that graphic works came to play a significant role in the art of the period. After all, linear composition had always reflected the artists ability to abstract from reality. But whereas graphic works had previously seldom been produced on their own account, now they were generally accepted as a completely autonomous branch of art. In fact it soon became apparent that certain pictorial ideas could only be expressed in this medium.

And so the graphic arts came to be regarded as a genuine alternative—and not a mere adjunct—to painting. In earlier days drawings had been used primarily as preliminary studies for paintings whilst by and large the various engraving processes had been exploited for reproductive purposes. It was only very rarely that the European artists of previous centuries realized the full potential of the graphic media, although on those occasions when they did so they invariably produced work of an exceptionally high quality. We need only recall Dürer's line engravings and woodcuts, Rembrandt's etchings, Goya's etchings and aquatints and Daumier's lithographs to realize just how great their achievements were. But in treating the graphic arts as a serious medium these men all went against the tide of contemporary opinion and,

337

Paul Cézanne (1839—1906), LE CHATEAU NOIR (c. 1895/1900).

with the single exception of Dürer, graphic artists were generally ostracized by society.

In the early twentieth century things were very different. By then the graphic arts had been fully accepted by the vast majority of artists and were used for a wide variety of purposes. In France the Cubists, who were concerned with the reduction of pictorial objects and figures to stereometric forms, were able to heighten the constructive quality of their work by concentrating on charcoal drawings and black and white lithographs whilst the Fauves succeeded in producing flat patterns of colour by using watercolour and Indian ink. Meanwhile in Germany the Expressionists—especially the members of 'Die Brücke'—turned to the woodcut, which lent itself particularly well to the radical simplification of objects and figures. The fact that Kandinsky's first abstract composition was a watercolour underlines the importance attached to the graphic media in the early years of the century. But it was not just a case of upgrading traditional graphic techniques. Other completely novel techniques were tested and immediately pressed into service at that time. Initially, at least, the collage—which was much favoured by the Cubists—was conceived as a purely graphic process. Heliogravures were produced and serigraphy, which had become widely known as a commercial printing process, was employed as a means of breaking down graphic forms. Moreover, different traditional techniques were used in combination (chalk and watercolour, watercolour over pencil, gouache and watercolour, etc.), and this also extended the graphic range. Throughout the whole of the twentieth century line drawings and graphic prints have played a leading role in the development of art. There is scarcely a painter of rank who has not been attracted to these media and even sculptors like Maillol and Barlach have produced drawings of intrinsic value.

Following the development of photographic and stereotype printing, art prints were no longer strictly necessary for the reproduction of original paintings. None the less, artists have continued to produce them which would bear out the thesis that these media offered them scope for new modes of expression. Nor have they entirely lost their original function. On the contrary, they are still highly valued for reproductive purposes. Moreover today art prints are no longer copies of an original work, they are themselves originals. For the most part these original prints are signed by the artist and issued in numbered series and since they are also reasonably priced, they have afforded many art lovers direct access to modern art. This is an important facet of contemporary graphic art, which has helped to ensure that the gulf between the artist and society has not grown even wider.

Although he looked anything but a prophet, Paul Cézanne was in fact one of the most prophetic figures in the history of modern art. Rainer Maria Rilke, who knew Cézanne personally, gave an extremely observant pen-portrait of him both as an artist and as a man: '... he claimed to have lived as a Bohemian for the first forty years of his life. It was only then, as a result of his association with Pissarro, that he acquired a taste for work. But this taste was so strong that during the remaining thirty years of his life he did nothing but work. Without joy, apparently, in a state of fury, in conflict with every single one of his works, none of which appeared to him to achieve what he considered to be essential. He called this achievement "la réalisation" and he found it in the Venetian paintings which he had seen and unreservedly acknowledged in the Louvre ... Old, sick and utterly exhausted by his

Paul Cézanne (1839—1906), THREE SKULLS.

Paul Cézanne (1839—1906), THE VIADUCT IN THE VALLEY OF THE ARC.

Paul Cézanne (1839—1906), LANDSCAPE IN PROVENCE.

ceaseless labours; mocked, jeered at and even mishandled on his way to his studio—but keeping the Sabbath, attending Mass and the vespers like a child and politely asking his housekeeper Madame Bremond for better food—he still hoped from day to day that he might yet achieve what he felt to be his essential purpose.'

During his 'Bohemian' period Cézanne was extremely restless, and this coloured both his personal life and his work. He took part in the first Impressionist Exhibition in Paris in 1874, but his pictures provoked a particularly violent reaction from the critics and even prompted disparaging remarks from his fellow Impressionists, whose references to his 'coarse and unfinished' works made Cézanne particularly bitter. Personal difficulties with his father, who refused to continue his allowance, were accompanied by quarrels with Monet, Renoir and even the philanthropic Pissarro with the result that Cézanne lost all confidence in himself.

And so, when his father died in 1886, he retired in a state of despondency to the parental home in Aix-en-Provence. It was there that he produced the numerous masterpieces which were to exert such a crucial influence on the development of twentieth-century painting. Even the small-format drawings and watercolours which he produced from 1886 onwards reveal all the characteristics of his new and revolutionary conception of art: the firm structures which lend an 'appearance of permanence' to his landscapes, the total rejection of chiaroscuro, the juxtaposition of warm tones, the flatness of the composition, the breaking down of natural objects into geometric forms and the harmonious interplay of colours.

The basically Cubist composition of Cézanne's pencil and watercolour sketch of *Le Chateau Noir*, a house he himself lived in for a number of years, is heightened by the clearly defined windows and the transparent arrangement of trees in the foreground, which are set out in a strictly geometrical pattern.

Cézanne, *Le Chateau Noir*, page 338

In his *Landscape in Provence* the various strata of the actual landscape are represented as large, simple pictorial forms, whose completely harmonious structural and tonal values soon make even the most observant viewer forget that he is looking at a landscape. The Mont Sainte-Victoire and the viaduct in the valley of the Arc is a subject that Cézanne treated on numerous occasions. This particular version is one of the first. In it Cézanne still used modelled forms, notably for the pine-tree in the foreground. But even at this early stage he had begun to use flat, abstract forms, for the strange shapes on the gently tinted ground beneath the tree are far from realistic. Although Cézanne's still life of *Three Skulls* probably dates from the closing years of his life it would be wrong to regard it as a melancholy reflection on mortality. Here too his sole object was to integrate the individual pictorial objects into a corporate whole by creating harmonious patterns of forms and colour. Thus the structure of the skulls reappears in the cloth patterns whilst their colouring is repeated in the ceiling.

Landscape in Provence, page 342

Viaduct in the Valley of the Arc, page 341

Three Skulls, page 340

Cézanne carried the alienation of natural forms and colours as far as was humanly possible without rendering them completely unrecognizable. It was left to the Cubists to do this. The leading representatives of this movement—Braque, Picasso and Léger—set out to destroy the traditional three-dimensional view of pictorial space by dispensing with all illusionist techniques. But they very soon realized that this could only be done if the pictorial objects themselves were transformed beyond recognition, for only then could they be sure that their conception of space was not being influenced by the traditional

Fernand Léger (1881—1955), TWO FIGURES (1918).

view. Consequently, the deformation of pictorial objects undertaken by the Cubists was not an end in itself but merely a technique whereby they hoped to establish entirely new artistic criteria. In their view the reality of a picture should be assessed purely in terms of the picture, that is to say without reference to external reality. In other words, the viewer should react to what he sees without even thinking about it and, above all, without drawing comparisons between the artist's representation of an object and his own recollections of that object in real-life situations. 'Composition', according to Matisse, 'is the art of arranging in a decorative manner the various elements at the painter's disposal for the expression of his own feelings'.

Braque, *Still Life Composition*, page 354
In Braque's *Still Life Composition* elements of this kind, which reflect different levels of reality, are welded together into an artistic whole. A crystalline structure of lines and forms executed in charcoal creates a distinctly non-spatial and purely artistic setting for a group of familar objects: fragments of advertising copy, which are also executed in charcoal, a brown rectangle, which seems at first sight to be a purely graphic element but which the yellow gummed label shows to be a cigarette packet, and finally—on a completely different level of reality—a strip of grained wood, which has been painted in. Because their significance is not immediately apparent these random symbols perfectly reflect the modern world, which is charged with such a welter of phenomena that man can only record them and is quite unable to organize them into a meaningful pattern. This organization has been achieved by Braque in a work which combines an extremely tight composition with complete individuality of the component forms.

From about 1918 onwards Braque moved away from the strict Cubism of his early period and adopted a much freer and less doctrinaire style. After having conducted such a determined fight against the naturalistic painting he returned to objective forms, albeit without betraying the stylistic principles which he had set up for himself. He used his new-found freedom, which was grounded in a wider experience of life, in order to subject his visual impressions of reality to the requirements of artistic form. During his late period Braque still retained the flat composition of his Cubist work, but he discarded his rigid geometric forms, hard, brittle colours and severe structures, developing instead a highly imaginative linear style with extremely decorative colouring that is almost classical in its harmony.

Braque,
Helios VI,
Mauve Hera,
page 355

Although Fernand Léger was not a Cubist in the strict sense of the word he played a major part in the evolution of the movement. By preserving his independence he was able to draw on Cubism throughout the whole of his late period whilst others, who had embraced it unreservedly, were forced to abandon it, once they had exhausted its experimental potential. After the war, when so many artists became pessimistic about the state of civilization, Léger actually took pleasure in the new world of the machine. In creating his compositions from mechanical components, such as cogwheels, crankshafts and pistons, Léger was not trying to attack civilization. On the contrary he was expressing his approval of the technological age. His pen and ink drawing of *Two Figures,* which later served as a study for his *Éléments Mécaniques,* is a typical example. Here Léger used mechanical components to create a self-

Léger,
Two Figures,
page 344

Below:
Pablo Picasso (b. 1881),
STILL LIFE WITH
PLAYING-CARDS.

Pablo Picasso (b. 1881), HALF-LENGTH FEMALE PORTRAIT (1958).

Opposite: Pablo Picasso (b. 1881), THE EMBRACE (1900).

Pablo Picasso (b. 1881), MOTHER AND CHILD (c. 1920).

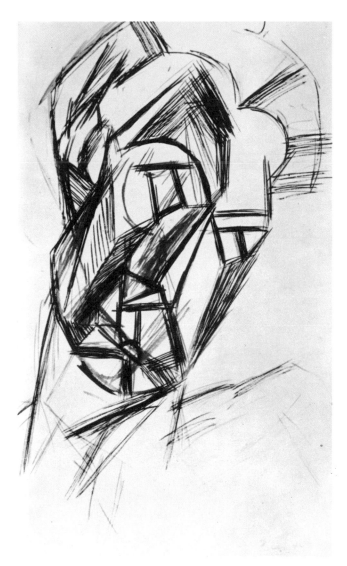

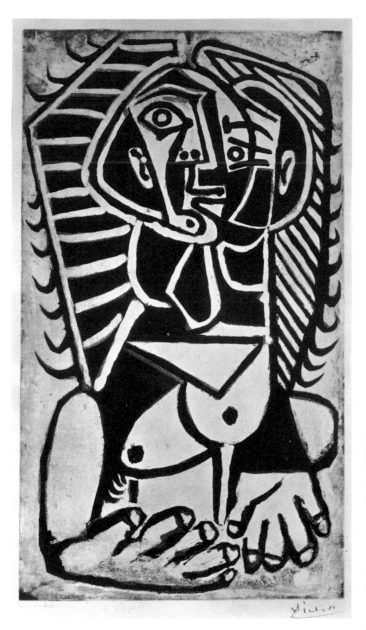

Pablo Picasso (b. 1881), STUDY FOR A HEAD.

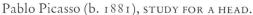

Above:
Pablo Picasso
(b. 1881),
FEMALE TORSO (1953).

contained structure which, although Cubist in its general layout, contains fully modelled forms that distinguish it from the modish sophistication of so much of the Cubist work of that period. The firm outlines and the precision of even the smallest forms show Léger's willingness to come to terms with the reality of the machine age.

No twentieth-century artist has made greater use of the graphic media than Pablo Picasso. The concept of freedom, for which he has fought so passionately the whole of his life, found what is probably its most perfect expression in his graphic works, which he used for formal experiments in every phase of his artistic development. Picasso has such a complete technical mastery of the various graphic techniques that he is able to employ them successfully even in apparently unpropitious circumstances. He is, for example, perfectly happy to use a linoleum cut in cases where every other artist would have opted for a lithograph—and the results invariably justify his choice. Picasso has never regarded lithographic prints as finished products. If he thinks it necessary, he is quite prepared to go over the print with Indian ink or watercolour. He was also the first artist with the temerity to stick pieces of newspaper or part of a matchbox on to a graphic work. This new technique was soon taken up

349

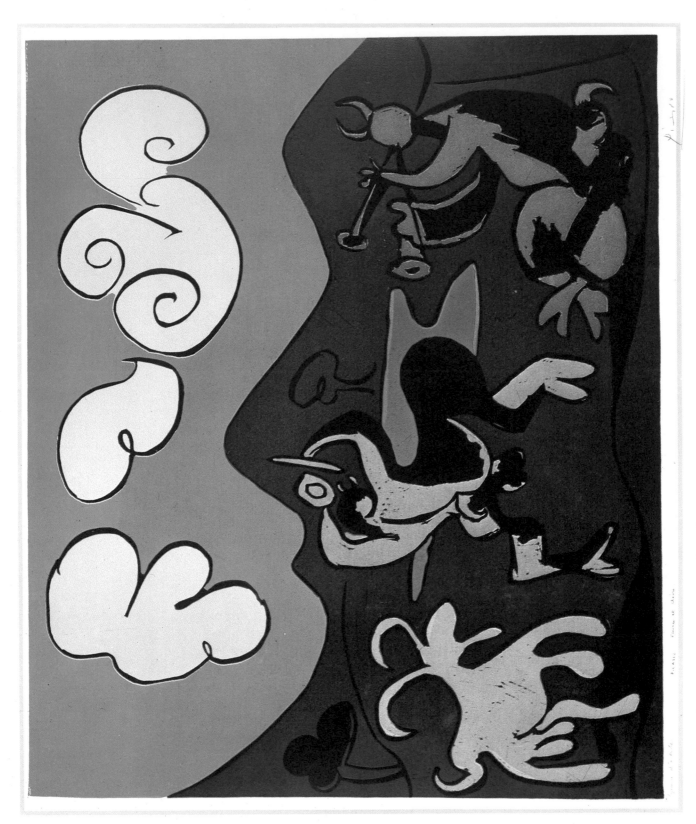

Pablo Picasso (b. 1881), FAUNS AND GOAT (1959).

André Derain (1880—1954), TWO DANCERS (c. 1906).

by his admiring followers, who were greatly perturbed when he suddenly dropped his 'papiers collés' to go off on a new tack. Picasso has never tied himself down. He has often given offence, often attracted attention and always provoked astonishment. This explains the apparent inconsistency of his artistic development, which many have found disconcerting. In the case of Picasso we cannot speak of an early or a late style, for everything he ever put his hand to was a new departure. Moreover he was not inclined to rest on his laurels, to produce even more elaborate variations on an established theme. His creative urge was so strong that he followed up every new idea that looked at all promising, fearlessly taking and—on occasions it seems— positively welcoming the risk of error and confusion. For Picasso the experiment was always more important than the outcome, even when this was ingenious and even when he was its author. He was usually so irritated by such solutions that he immediately turned his back on them and poured scorn on all those who tried to use them as the basis for some delectable theory. Because of his inconstancy he has frequently been represented as a charlatan. In point of fact, however, this desultory approach merely testifies to his inventiveness and mental agility.

Picasso received his initial training from his father. Then, when he was fifteen years old, he became a student at the School of Art in Barcelona before going on to the long established Academia de San Fernando in Madrid, where his youthful talent benefited little from the sterile tuition. In 1901 Picasso settled in Paris and within two years had his first exhibition, at which he showed a series of extremely individual pastels including *The Embrace*. The highly

Above:
André Derain
(1880—1954),
STREET SCENE.

Opposite:
André Derain
(1880—1954),
BATHERS.

Picasso,
The Embrace,
page 346

Georges Braque (1882—1963), STILL LIFE COMPOSITION (c. 1912).

simplified forms in this work, which Picasso painted in 1900, are filled out with just a few luminous colours whilst the poetic and melancholy mood is heightened by the diffuse linear composition. The isolation of the two figures, who are placed in the middle of the greyish-brown square, and their search for refuge in the comfort of an embrace anticipate Picasso's 'Blue Period', which lasted from 1901 to 1904 and in which he dealt almost exclusively with such themes as loneliness, sadness and distress. His models during this period were the poor and the sick, men and women whose bodies were wasted by hunger and suffering.

Georges Braque (1882—1963), HELIOS VI, MAUVE HERA (1948).

Henri Matisse (1869—1954), NUDE REFLECTED IN A MIRROR (1936).

Henri Matisse (1869—1954), HARBOUR OF COLLIOURE.

Henri Matisse (1869—1954), RECLINING NUDE.

358 Edouard Vuillard (1868—1940), THE FIREPLACE (1899).

Edouard Vuillard (1868—1940), THE PATISSERIE (1899).

In his 'Pink Period', which followed, Picasso brightened his palette, due in no small measure to the influence of the Fauves. He did not, however, adopt their harsh and strident colouring, for which he had little sympathy. The social criticism of his 'Blue Period' was superseded by the gentle melancholy of his circus scenes, harlequins, wandering players and female nudes, which not only provided him with his principal themes during this phase of his development, but also began to bring him public recognition. It was in 1907, when he saw the commemorative exhibition of Cézanne's work, that Picasso made a definitive break with the past. Just one month after visiting the exhibition he created the first genuinely Cubist composition, *Les demoiselles d'Avignon,* which launched a whole new epoch of European art.

In the years that followed he concerned himself intensively with the organization of two-dimensional surfaces, the breaking down of pictorial objects into stereometric forms and similar Cubist problems. With its austere and carefully thought-out linear composition his *Still Life with Playing Cards* is a typical early Cubist work. But Picasso soon tired of such methodical simplification and while his fellow Cubists continued to concentrate on still-life subjects, he turned his attention to other motifs and became the first artist to paint portraits, landscapes and figure compositions in the Cubist mode. His approach remained completely undogmatic and because of this he was able to draw on Cubism throughout the whole of his career. Thus in his *Half-length Female Portrait,* a linoleum cut dating from 1958, Cubist elements—the simultaneous use of profile and full-face views, the constructive juxtaposition of line and plane, the reduction of natural forms to geometric motifs—are used in conjuction with luminous colour combinations and contrasts between highly detailed and completely plain areas, which impart immense vivacity to what is essentially a static composition. In his *Female Torso,* a work of equal power, Picasso subordinated elements of the human figure to the requirements of graphic composition. The component forms in this aquatint are fused together to form a labyrinthine structure. By constantly shifting from objective to non-objective features, by interspersing recognizable forms with fantastic arabesques Picasso gave this figure something of the mysterious power of a sphinx.

Picasso's actual Cubist period came to an end in 1917 when he went to Rome to design costumes and décors for Diaghilev's Russian Ballet. There, under the influence of antique art, he began to paint in a completely realistic and almost classical idiom, using light and shade to create fully modelled figures. His *Mother and Child* is a typical example of the 'Neoclassical' work which he produced in the early 1920s. But classical motifs and forms also appear in Picasso's later work. His exquisite *Fauns and Goat* which dates from 1959, is a case in point. In this linoleum cut the landscape and the figures are closely linked with one another by the use of linear arabesques. Like the bold outlines which separate the different areas of colour—a necessary feature of the linoleum cut, where the softness of the material precludes all possibility of fine incisions—these contribute greatly to the gaiety and freshness of the scene.

The small selection of Picasso's graphic works reproduced in this book can only hint at his enormous range. No matter which medium he turned to, he was always able to bend it to his artistic will and he has never used any graphic process in a routine manner. Picasso, who used virtually every twentieth-century style for the expression of his artistic ideas, also exploited

Pierre Bonnard (1867—1947), PLACE CLICHY (1923).

the whole range of the graphic media and probably contributed more than any other artist of our day to the promotion of this branch of the fine arts.

At the historical Salon d'Automne in Paris in 1905 a group of French artists tried to overcome the traditional and completely naturalistic colouring of academic painting by using pure, bright, luminous colours, which were so violent that a critic called these painters 'Les Fauves' (the wild beasts). The precursors of this movement—who are now household names—were then little known outsiders: Van Gogh, Gauguin and Cézanne. Gauguin once said that by combining line and colour he tried to create harmonious works which would make people think in exactly the same way as music made them think, that is to say without preconceived ideas or images. Later Henri Matisse, the principal representative of the Fauves, drew a similar parallel between the harmonious effects of colour and musical composition.

When the Parisian art critic dubbed Matisse and his colleagues 'Les Fauves' at the 1905 exhibition he was very wide of the mark, for every one of

Marc Chagall (b. 1887),
THE RABBI.

these artists attached considerable importance to graphic works, which call for a high degree of formal discipline—the exact opposite, in fact, of 'wildness'. André Derain's watercolour of *Two Dancers* reveals a definite movement towards abstract forms and complementary colours. The principal features of this work are the purely decorative colour composition, which stands in marked contrast to the explosive colouring of Derain's paintings, and the rhythmical interplay of the compact pictorial forms. Derain's etching *Bathers* is an even more compact picture. Here the artist constructed a whole network of hatching and cross-hatching and, by frequently changing the direction of his strokes, produced an impression of sensuous vibration, albeit without prejudicing the close-knit structure of the scene. By giving equal prominence to the colouring of the foreground and background in his coloured lithographs, Edouard Vuillard was able to produce extremely well-balanced pictures. His flat patterns enabled him to neglect the detail and concentrate instead on harmonious colour composition. In his five-colour lithograph of *The Fireplace*, the right side of the picture is largely taken up by the brighter colours, the most prominent of which is the luminous yellow, while the left-hand side is dominated by the dark green. In fact, though, the two sets of colours completely permeate one another, thus setting up a lively and dramatic relationship between the various pictorial elements. Vuillard's *Fireplace* and his seven-colour lithograph *The Patisserie*, both come from an album of lithographs which the artist produced in 1899. Vuillard was really at the height of his powers between 1900 and 1920. He worked on a variety of

Derain,
Two Dancers,
page 351

Bathers,
page 352

Vuillard,
The Fireplace,
page 358

The Patisserie,
page 359

Marc Chagall (b. 1887), THE CHURCH AT CHAMBON (1926).

Opposite: Odilon Redon (1840—1916), ST. SEBASTIAN BOUND TO A TREE (1910).

scales, from the large decorative schemes for the interior of a room to small paintings which can be held comfortably in the hand. The best of these smaller pictures are among the most exquisite productions of French art. Delicate, subtle and tender, they belong, like the paintings of Watteau, to a world of chamber music.

Although the works of the Fauves invariably look as if they had been dashed off on the spur of the moment, this was in fact seldom the case. For the most part they were the outcome of careful thought and long experiment. This is particularly true of the soothing, harmonious and apparently unproblematical colour compositions of Henri Matisse, an extremely methodical artist, who went to infinite pains to create an impression of spontaneity. In his watercolours and pen drawings Matisse achieved this impression by his use of contour, by enveloping his figures and objects in arabesques, by the juxtaposition of completely blank and highly detailed areas, by means of distance (as in the *Harbour of Collioure*), or by stressing the solidity of his figures (as in the *Nude Reflected in a Mirror* and in the *Reclining Nude*).

Albert Marquet, who was born in Bordeaux in 1875, is usually classified as one of the Fauves, although he was anything but a revolutionary. The flat, furious colours of Vlaminck and Derain were entirely alien to him and he even remained impervious to the more moderate and highly decorative colouring of his friend Matisse. Marquet went his own way. He regarded colour as a means of reproducing external reality and not as a means of abstracting from reality, which was how the majority of the Fauves regarded it. At heart he was a realist. He was interested in the world as it was or, to be more precise, as it presented itself to him. It is hardly surprising to find, therefore, that he was a tireless draughtsman and always carried his sketchbook with him to note down any sudden movements, special details or particularly striking figures that he happened to observe. He had a special gift for rapid notation, as is evident from the two pen drawings reproduced in this book.

Fauvism was to have a far more lasting effect on Raoul Dufy who, like Marquet, painted a large number of town and harbour views and 'coastscapes'. Dufy also started out as a realist but changed his style completely after seeing Matisse's *Luxe, calme et volupté* at the 1905 Fauvist exhibition. He then abandoned his naturalistic palette and began to chose his colours according to purely decorative criteria but without losing sight of external reality. His works of this period are extremely strong in colour, and are close to those of his Fauve contemporaries. But like Derain, he was gradually to lose the pioneering instinct. Dufy's most characteristic works are charming in subject, vivacious in handling, and highly decorative in effect. In his own way he sums up an aspect of the 1920s in his oils and watercolours, in many cases of the French Riviera, which have an elegance and light-heartedness that bring to mind the paintings of Venice *en fête* by Canaletto, who had precisely the same feeling for buoyant, rhythmic brushstrokes and who was able to depict crowds in a similar kind of way. Dufy, like Canaletto, also painted the social life of London. Some of his finest works are concerned with music-making: the *Homage to Mozart* series is among his most lyrical works. He preferred watercolours to oils because in this medium he was better able to produce the transparent, luminous effects which are such an important facet of his work. In order to strengthen the linear structure of his watercolours Dufy went over them with pen and ink, adding short calligraphic strokes to the diffuse areas of colour, thus heightening the definition of his work but

Matisse,
Harbour of Collioure,
page 357

Nude Reflected in a Mirror,
page 356

Reclining Nude,
page 357

Marquet,
Lamplighter,
page 370

Raoul Dufy,
Polo,
page 368

Nice,
page 369

Maurice Utrillo (1883—1955), STREET IN PARIS.

Raoul Dufy 1940
Nice

in no way detracting from its poetic quality. This practice was soon adopted by many other artists, none of whom, however, was able to equal Dufy in his ability to combine painterly and graphic elements.

It was Pierre Bonnard, the close associate of Vuillard and co-founder with him of *Intimisme*, who established the pastel drawing as a twentieth-century art form. In his pastel technique, which was derived in the first instance from Edgar Degas, Bonnard finally resolved the dichotomy between colour and line. His *Place Clichy*, which is a typical work, is a colour composition in the precise sense of the word, for in it the linear composition also provides the colour. Renoir had painted the Place Clichy forty years earlier, using a similar type of composition, with the figure of a young girl prominently placed in the foreground and cut off by the edge of the picture in a similar way. The differences, however, are extremely revealing and tell us a great deal about the developments of painting in those crucial decades. Bonnard is much less interested in descriptive detail and in perspective. The figures and the traffic are discernible but, as in a late Turner, they are representational elements that are subordinate to an interest in the surface properties of texture and pigment.

Bonnard's work is, in its way, a more self-conscious work of art than the Renoir painting. As with so much twentieth-century art, the creation of an objective and descriptive illusion is considerably less important than the personal angle, the private point of view.

Above:
Raoul Dufy
(1877—1953),
NICE.

Bonnard,
Place Clichy,
page 361

Opposite:
Raoul Dufy
(1877—1953),
POLO (detail).

Albert Marquet (1875—1947), LAMPLIGHTER.

Redon,
*St. Sebastian Bound
to a Tree,*
page 365

Odilon Redon is really one of the most remarkable artists of his time and his true stature is perhaps only now being fully appreciated. Like Gauguin, with whose works of a more symbolic kind his own can often be compared, he raised the quality of mysteriousness from the level of affectation and trickery to the status of poetic necessity. His strange figures and pungent colour strike the eye not as bizarre, but as the necessary expression of an unusual and delicate imagination. In his *St. Sebastian Bound to a Tree* he employed unrealistic colours, not as a means of abstracting from reality in the Fauvist mode, but in order to create a mystical symbol that would transcend reality. In this work Redon effectively combines watercolour with pencil.

Marc Chagall, who was born almost fifty years after Redon, pursued similar ends in his pictures, in which he conjured up a world of dreams and fantasy based on childhood memories. Chagall came to Paris in 1910 and was immediately captivated by the achievements of the Cubists and the Fauves. But he adopted only those features of their work which could be made to serve his own highly poetic purposes: the deformation of objective forms and the use of luminous colours. Unlike the Cubists, Chagall did not set out to destroy the traditional conception of three-dimensional space. What he did was to create an imaginary conception of space, one in which his figures and objects were able to move at will, irrespective of the laws of gravity. His gouache of *The Church at Chambon* is typical of his work. Here Chagall

Chagall,
*The Church
at Chambon,*
page 364

depicted the idyllic beauty of peasant life, in which man and nature are still in complete harmony with one another. The touchingly ramshackle houses, which are completely in keeping with the puppet-like peasants and the little girl with her clutch of hens, are symbols of rustic simplicity and not of a chaotic world.

Maurice Utrillo was another early twentieth-century artist who succeeded in lending a magical quality to banal, everyday situations. But whereas Chagall looked at the world through the naïve eyes of a dreamer, Utrillo saw it in completely realistic terms. His pictures are nearly all town views—of gloomy backyards, small and ugly suburban squares, shabby tenements with the stucco peeling from their walls, bare, stunted trees set against a grey and chilling sky.

Jean Dubuffet
(b. 1901),
PORTRAIT OF
HENRI MICHAUX (1947).

Somehow Utrillo contrived to transform these unpromising subjects into highly personal visions. Even in his lithographs the drab city scene acquires an aura of freshness and vivacity from the long roads, the varied line of the rooftops and the high, open sky. Utrillo's *Street in Paris* illustrates his feeling for the atmosphere of a particular locale. It also shows his signature in reverse, which proves that this was an original lithograph.

Utrillo, *Street in Paris*, page 367

In this work Utrillo drew his design on the stone in reverse but was unable to add his signature in the same way with the result that this appeared as a mirror image.

Jean Dubuffet, who was born in Le Havre in 1901, resembles Utrillo in many ways. He too has tended to concentrate on unusual subjects, including psychotics and convicts, and he also attaches supreme importance to spontaneity of expression. In fact Dubuffet's *art brut*, his 'raw art', is intended as a protest against the aesthetic school of twentieth-century art. But, despite its undeniable 'rawness', his *Portrait of Henri Michaux* reveals a sensitive appreciation of the essential relationship between line and plane. In this work, in which the design is scratched out of a black paper ground, the dark areas are firmly established by means of bold outlines whilst the background is organized into a lively pattern by means of interlacing scratch marks. His work is a good example of that interest in all aspects of primitive expression and feeling which has been so important to twentieth-century artists, and which includes everything from primitive works of art to the activities of children. It would be a mistake, however, to equate Dubuffet's work with children's art. His sense of design, his colour and his handling reveal great sophistication. His work, of which his *Portrait of Henri Michaux* is a typical example, belongs to the *svelte* tradition of the School of Paris.

Dubuffet, *Portrait of Henri Michaux*, page 371

Bernard Buffet, born in 1928, won the attention of critics and the public at large at a very early age. He had his first one-man show in 1947. He was strongly influenced by the *Misérabilisme* movement of the 1940s. His thin, elongated figures and forms, which are set against a background of faint, delicate lines, create an impression of hopelessness in keeping with this movement. His later works include painted views of Paris, London and New York and a series on the *Life of Joan of Arc* (1957-8). He also executed a series of dry points on the theme of the *Passion* (1954). In recent years his works have become extremely mannered and have lost much of their original force.

Buffet, *The Painter and his Model*, page 374

Jacques Villon, who was born Gaston Duchamp-Villon, was both a painter and graphic artist. He went to Paris in 1895, where he became a friend of Toulouse-Lautrec, and made satirical illustrations for various papers. He later joined the Cubist movement and organized the 'Section d'Or' exhibition in 1912. He did not turn to original book illustration until later in life. His etching *The Three Magi* is one of six illustrations by Villon for André Frénaud's *Poemes de Brandebourg* (1947). In these poems of Frenchmen held captive in Germany, the journey of the three Magi symbolizes the Frenchmen's hope and yearning for freedom. This etching is a good example of Villon's later graphic style. He has created a linear framework of closely etched straight lines and the three figures are built up by a series of planes against a continuous ground of blue lines. The space between the lines softens their colours and gives a transparency to the figure group. Movement is suggested by the angular, Cubist treatment of drapery formed by overlapping diagonal planes.

Jacques Villon, real name Gaston Duchamp-Villon (1875—1963), THE THREE MAGI.

Opposite:
Bernard Buffet
(b. 1928)
THE PAINTER AND HIS
MODEL.

Vincent van Gogh
(1853—90),
PEASANT WOMAN
RETURNING HOME.

As a result of the new developments which set in at the turn of the century
Paris was finally established beyond dispute as a major art centre. Montmartre
became a Mecca for painters and sculptors, not only from the French provinces,
but also from other parts of Europe and even from overseas. Picasso came
from Spain, Chagall from Russia, Feininger from New York, Modigliani from
Italy, August Macke from Germany and Van Gogh from the Netherlands.
Some—like Chagall and Picasso—settled in Paris for good, others moved on
or returned home, where they transmitted their Parisian impressions and
experiences to their compatriots and so set up new movements in their native
lands. As a result Paris became something of a catalyst for the rest of Europe,
not because these foreign artists slavishly copied the Paris fashions but because

they received from them powerful stimuli, which enabled them to develop their own creative potential.

Vincent van Gogh arrived in Paris in 1884. In his native Netherlands, which had once played such an important part in the evolution of European art, his dark pictures of peasant life with their heavy overtones of social criticism had been flatly rejected by his countrymen. Once in Paris he found it possible to follow his brother Theo's advice, which was echoed by many of the Impressionist painters whom he met there, and abandon the gloomy, pessimistic style of his Dutch period in favour of the Impressionist technique. But after twenty months, after receiving some small measure of recognition, van Gogh left Paris for the south of France, where he began to use startlingly vivid colours and replaced the dissolved contours of his Impressionist period

Vincent van Gogh (1853—90),
CYPRESSES IN ST. RÉMY (1899).

by firm outlines, which enabled him to define his pictorial objects in precise terms. During this late period he used linear composition as a means of heightening the expressiveness of his work. Van Gogh's visions of a tormented world, which found their final expression in the frenzied brushwork of his paintings, were first set down *in situ* in the form of drawings made with a reed pen. His *Roulin the Postman, Sailing-boats* and *Cypresses,* which were all executed as preliminary studies for paintings, are highly wrought works, in which the original real-life subject has been raised to a higher, artistic level of reality. The cypress has been transformed into a flame-like form, the waves breaking against the shore in front of the sailing-boats have been whipped up into a frenzy by the force of the linear composition, whilst the contrasting shading of the postman's beard and jacket and the large blank areas of his trouser-legs correspond exactly to the design of the finished painting. Van

van Gogh,
Roulin the Postman,
page 376

Sailing-boats,
page 378

Cypresses,
page 377

Peasant Woman,
page 375

377

Gogh's numerous drawings, which were all executed with the same conscious precision, effectively give the lie to the once popular view of his work as the product of a psychopathic personality. He was of course a completely serious artist working under conditions of immense difficulty.

Van Gogh's compatriot, Piet Mondrian, also regarded drawings as an indispensable means of coming to grips with reality and bending it to his artistic purposes. After seeing Cubist works by Picasso and Braque at an exhibition in Amsterdam Mondrian abandoned the realistic landscapes of his early period and, from 1912 onwards, carried out countless experiments, in which he simplified his pictorial objects virtually beyond recognition. In these abstract experiments he restricted himself to just three motifs: church façades, trees and dunes. His *Church in Domburg* shows the façade in its natural state whilst his *Church Façade in Domburg* shows the same façade reduced to a system of intersecting lines, which are rhythmically organized and fill the whole of the picture space. But for the Gothic window-forms this composition would have more in common with a brick wall than with a church front. The two reproductions of trees by Mondrian show a similar process of simplification. In the first of these the tree is completely realistic whilst in the second it is transformed into a weird, unnaturalistic and almost calligraphic structure. The abstract colour tableaux which Mondrian produced later in his career were the outcome of these graphic experiments.

Mondrian, *Church in Domburg*, pages 380 and 381

Tree, page 379

Below: Vincent van Gogh (1853—90), SAILING-BOATS.

Piet Mondrian (1872—1944), TREE (c. 1909/10).

Piet Mondrian (1872—1944), TREE (c. 1910/11).

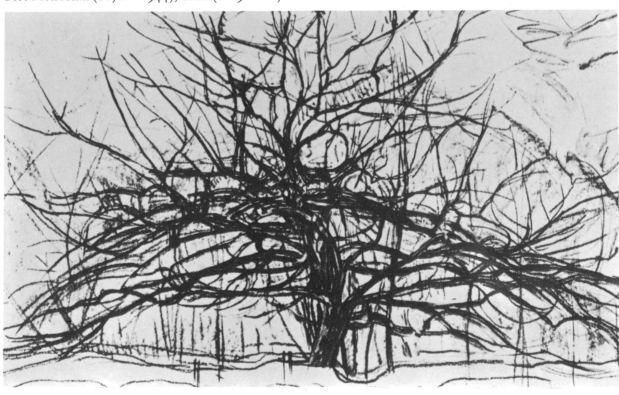

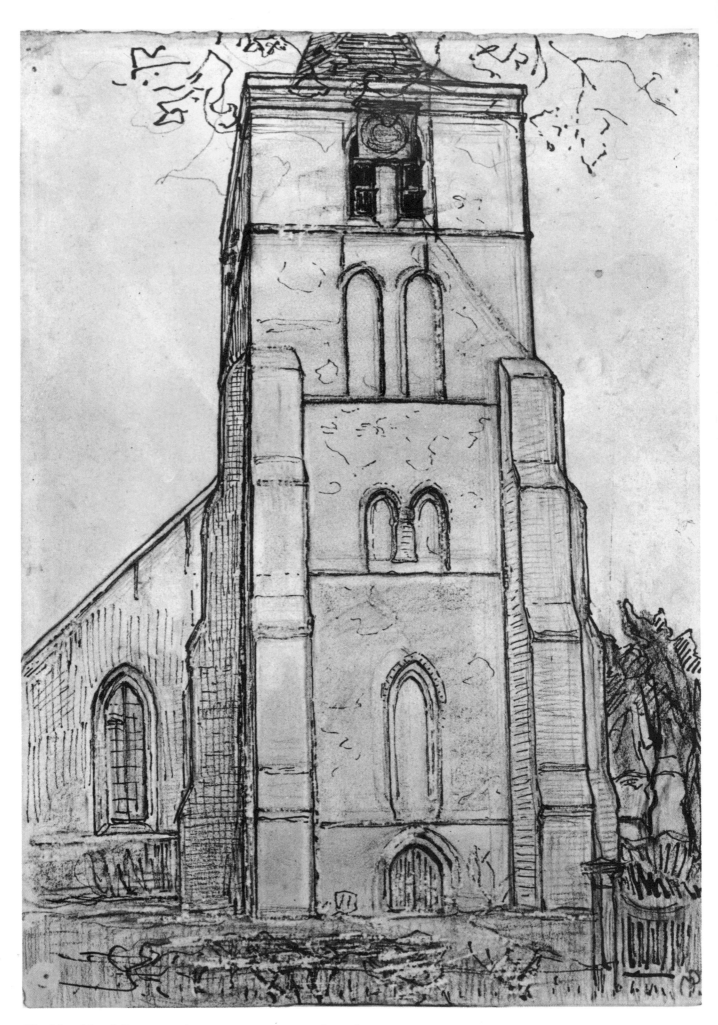

Piet Mondrian (1872—1944), CHURCH IN DOMBURG (1909).

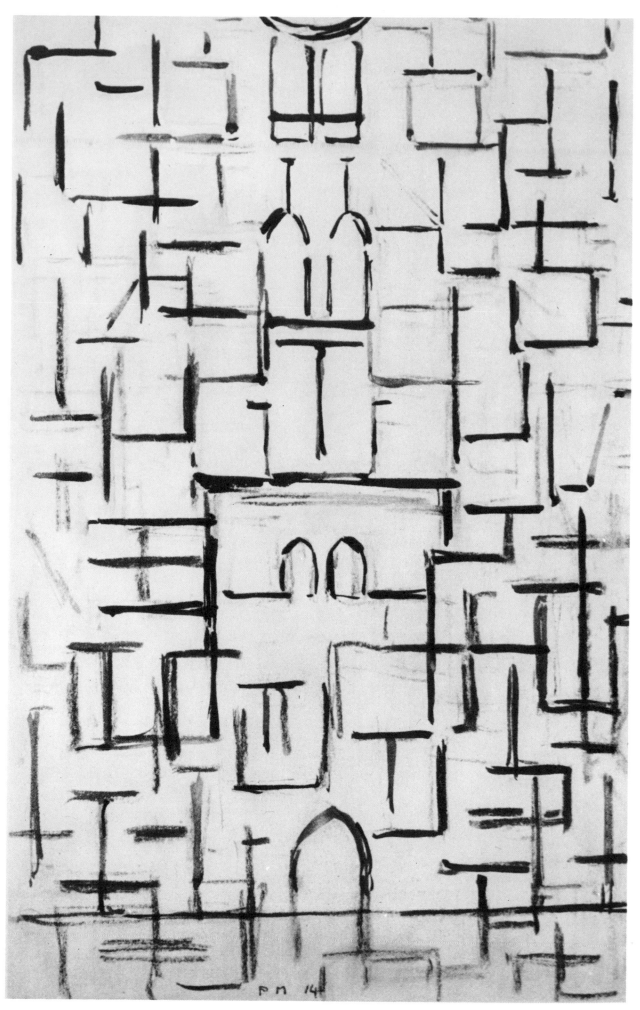

Piet Mondrian (1872—1944), CHURCH FACADE IN DOMBURG (1914).

The pressing social problems created by the industrial expansion of the late nineteenth century made practically no impact on French art. Van Gogh's passionate commitment to the cause of the dispossessed and suffering Dutch peasants met with little sympathy in Paris whilst the ecstatic visions of world-wide disruption which he conjured up in Arles were treated simply as works of art and assessed from a purely formal point of view. And so it was left to the artists of other European countries to explore the path opened up by van Gogh. One of these was the Belgian James Ensor. Before the turn of the century he had abandoned the Impressionist style of his early period and begun to expose the spiritual barrenness of his fellow men in works of insidious and aggressive intent. The masks and disguises which he used in his paintings are meant to symbolize the prevarication and deception in contemporary society. His *Entry of Christ into Brussels*, in which he used his own features for the figure of Christ, was set against the background of the Brussels Carnival. His object in this work was to demonstrate the helplessness of the individual when exposed to the masses.

Ensor, *Entry of Christ into Brussels*, page 383

Later both Carl Hofer and Max Beckmann used clowns and harlequins as vehicles for their social criticism, a technique which clearly derived from Ensor, whose expressive art exerted a considerable influence, not only on north German Expressionism, but also on Edvard Munch, who was one of its major forerunners. Munch, a Norwegian, came to Paris in 1885, where he had his first encounter with the Impressionists. But their works made less impact on him than those of van Gogh and Gauguin and he left the French capital after only three weeks to join a group of young revolutionary artists in Oslo. From then onwards his principal themes were existential alienation of contemporary man and the chaotic world in which he was forced to live. In 1894 Munch produced his first etchings and lithographs. A few years later he also began to make woodcuts. In these works he consciously exploited the specific character of graphic art and gradually fashioned an extremely powerful vehicle for his artistic ideas. His *Young Woman on the Shore*, in which a heavily contoured female figure is depicted in the midst of a deserted landscape, acquires symbolic force from the highly simplified areas, whose flowing rhythmical forms anticipate the *Jugendstil* of the late 1890s. In his *Female Nude with Red Hair* Munch portrayed a modern Mary Magdalene, a demonic and sinful creature with searching, frightened eyes, for whom there would appear to be no salvation. This work is interesting as an example of the ambivalent relationship between religion and sin that so fascinated the late nineteenth century, and which found expression in works as diverse as Moreau's paintings and Oscar Wilde's play, *Salome*. Munch's lithograph *Lady with a Brooch* also shows many of his characteristic features as an artist. The face is beautiful but the expression melancholy. The way in which the figure emerges from the dark background serves not only to emphasize her presence as the main feature in the pictorial composition, but also to suggest that mood of loneliness and solitude which so interested Munch.

Munch, *Young Woman on the Shore,* page 386

Female Nude with Red Hair, page 385

Lady with a Brooch, page 384

Munch's graphic work is an important part of his *œuvre*. He produced 750 plates, from which between 70,000 and 100,000 prints were taken. He himself favoured this medium, in which his ideas are expressed with great clarity, because it enabled him to reach a wide public. Munch's importance was first recognized in Germany. As early as 1892 he was invited by the Artists' Association in Berlin to exhibit his works in the German capital. This he did and sparked off a major controversy. After a storm of protest from the Berlin

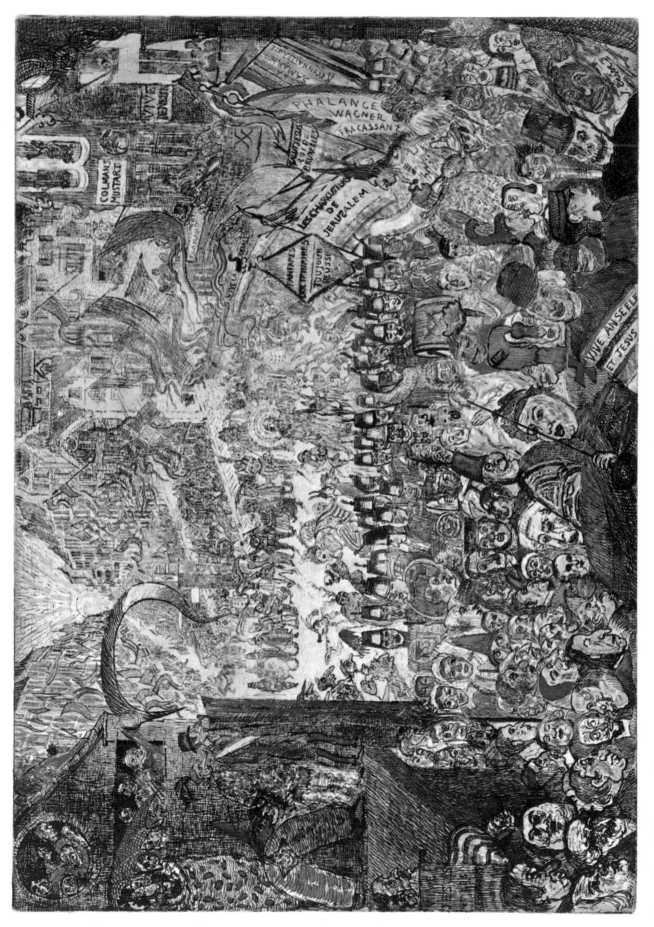

James Ensor (1860—1949), ENTRY OF CHRIST INTO BRUSSELS (1898).

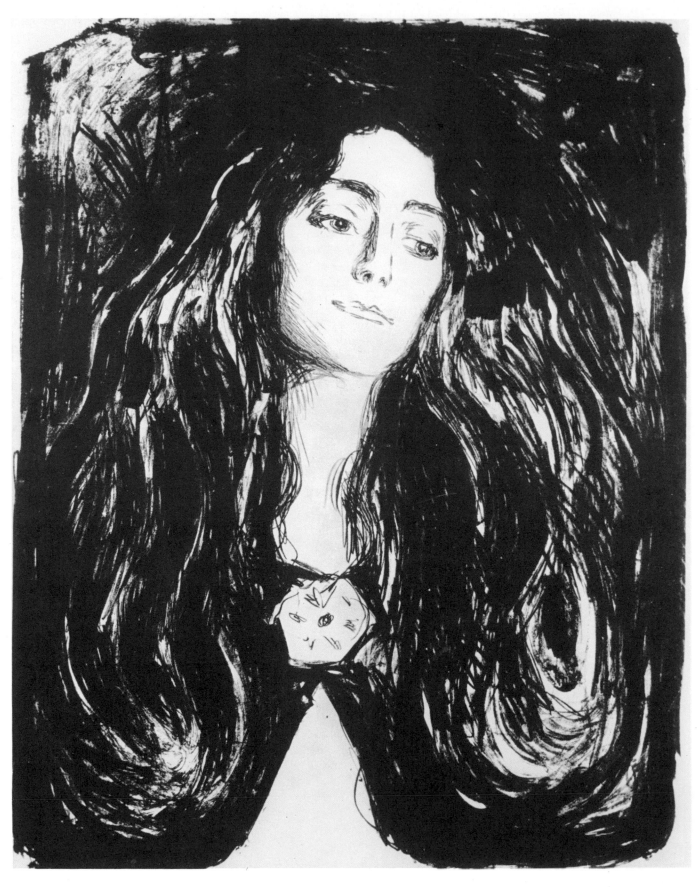

Edvard Munch (1863—1944), LADY WITH A BROOCH.

Opposite: Edvard Munch (1863—1944), FEMALE NUDE WITH RED HAIR (SIN) (1901).

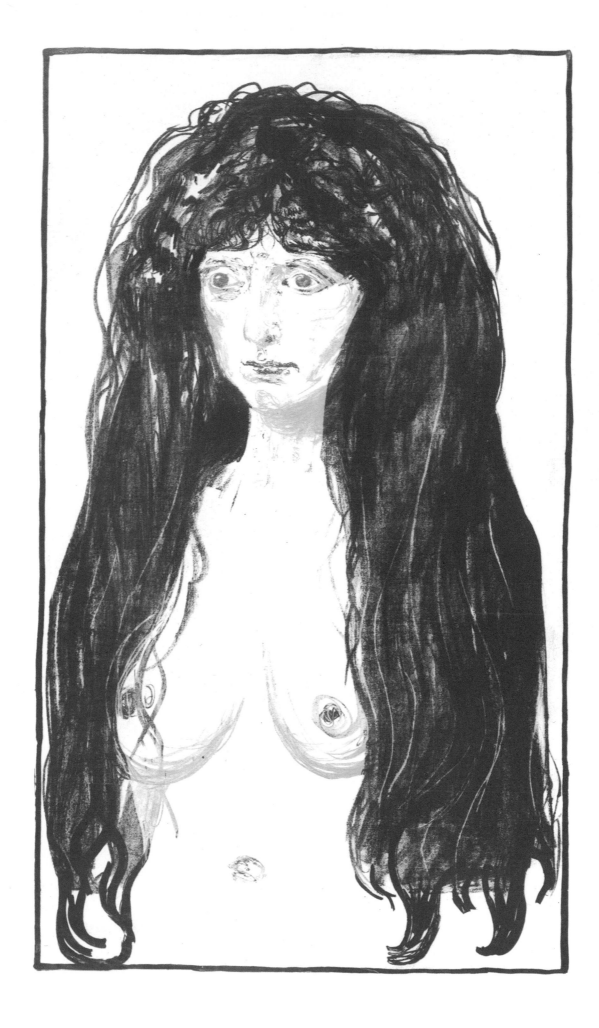

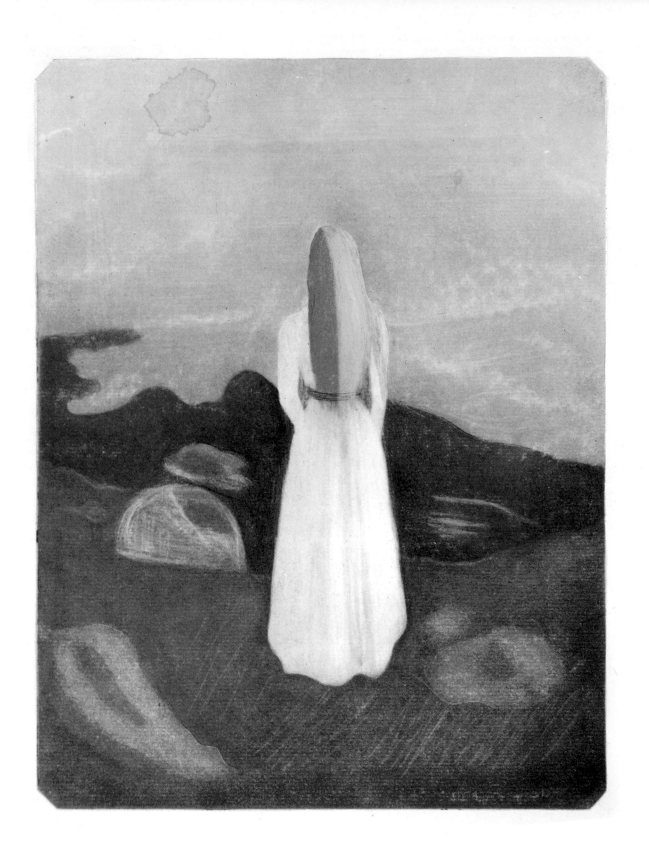

Edvard Munch (1863—1944), YOUNG WOMAN ON THE SHORE (1896).

Asger Jorn (b. 1914),
Two watercolours
from the series
'DIE DIDASKER'. (1944).

critics the exhibition was closed down with the result that a number of young artists left the Association, whose leaders were distinctly conservative, and formed the Berlin Secession under the leadership of Max Liebermann. From this body Munch received the recognition that had been denied him by the Berlin Association. As a result he came to exert a crucial influence on the development of art and, more particularly, graphic art in Germany.

Asger Jorn, born in Denmark in 1914, played a leading role in the Danish Abstract Surrealist group during the Second World War. His motifs were often borrowed from Viking themes. His brutally expressive works, character-ized by raw colour, convey the violence of the mid-twentieth century.

Jorn,
Die Didasker,
page 387

Henry Moore (b. 1898), STUDY FOR THE NORTHAMPTON MADONNA (1942).

English art at the beginning of the twentieth century was largely French-oriented. Impressionism had made a deep and lasting impression in England and both Cubism and Futurism had been enthusiastically received there especially by the younger generation of artists. Wyndham Lewis, a highly talented writer and painter, who was a member of the London Group, founded a new movement in 1914, which was known as 'Vorticism'. Aided by many of the leading writers of the day, including T. S. Eliot, James Joyce and Ezra Pound, Lewis and his associates succeeded in adapting the new non-naturalistic ideas evolved in France for their own purposes. The Vorticist paper *Blast,* which was edited by Lewis, was for many years the mouthpiece of the English *avant-garde,* who sought to establish new forms of English art in the face of embittered resistance on the part of the entrenched forces of conservatism.

Initially, however, England lacked artists of real stature, who might have gained wide popular support for the new movement, and it was not until Henry Moore entered the scene that modern English art acquired an international reputation. After studying in France and Italy Moore joined the London Group but was actually more attracted to the French Surrealists, with whom he frequently exhibited. In 1934 he published a manifesto, in which he formulated his view of art: 'Beauty, in the later Greek or Renaissance sense, is not the aim of my sculpture. Between beauty of expression and power of expression there is a difference of function. The first aims at pleasing the senses, the second has a spiritual quality which for me is more moving and goes deeper than the senses.' Although his paintings and graphic works are closely linked with his sculptures, it would be wrong to look upon them simply as preliminary studies. Even his *Study for the Northampton Madonna* owes its intrinsic vitality—which Moore regards as the *sine qua non* of art— to his masterly handling of purely graphic techniques. In this work Moore created a powerful linear composition in orange and black with wax marking pencils and then applied ink and Indian-ink washes, which were repelled by the wax outlines so that these stand out in bold relief. The respect which Moore showed here for the essential quality of the marking pencils is typical of his general approach. In his sculptures he always preserves the intrinsic quality of his material—be it stone, clay, bronze or wood—in order to enrich and heighten the purely formal aspect of his work.

Moore, *Study for the Northampton Madonna,* page 388

Inspired by the fantastic creations of his great predecessor William Blake, Graham Sutherland produced a series of etchings in the 1920s, in which he transformed the landscape into hallucinatory visions with distinctly Surrealistic overtones. In the 1930s he gave up etchings and eliminated the landscape as such from his pictures. But he still retained a number of individual natural forms—roots, thorns, dead branches—which he used more or less as ciphers, placing them in unnatural settings, where they appear as weird, threatening creatures. During this period Sutherland often turned to watercolours and gouaches because these media enabled him to achieve the almost calligraphic clarity which is one of the hallmarks of his style. This penchant for graphic effects has also made itself felt in Sutherland's oil-paintings.

The Irishman Francis Bacon is another artist who has employed graphic techniques to create threatening, Surrealistic pictures, in which the human beings are so distorted that they look more like phantoms. Bacon uses deformation as a means of unmasking his subjects and also for purposes of irony, which in his case assumes the form of insidious social criticism.

David Hockney
(b. 1937),
'THE ARRIVAL' (1963)
FROM A RAKE'S
PROGRESS.

One of the most important developments in the post-war situation has been the growing internationalism of styles, which have passed from country to country with increasing rapidity. American Pop Art, for example, has had a major influence on many young British artists, such as Peter Blake and David Hockney. In Hockney's work this is revealed in his taste for everyday subject-matter, surprising juxtapositions and a light, humourous tone. But there is, too, in his work a note of fantasy. It is very evident in the most brilliant of his most recent prints, the illustrations to Grimms' *Fairy Tales,* and is also clear in the earlier series of designs for *A Rake's Progress.* The *Arrival,* from *A Rake's Progress,* is a good example of his style, with its strong feeling for the relation of shapes and its clever use of line. The deliberately child-like quality that runs throughout his work is also evident in the way he reduces all the elements in the subject—the arrival of the young man in New York—to symbols that are not only clear and obvious (a skyscraper as a symbol of America, the wings as a symbol of flying) but which are also represented in a deliberately naïve manner. But Hockney is, of course, an extremely sophisticated artist, who is interested—and allows his interest to show as a part of the subject of the painting or print—in all the devices with which an artist works. The influence of children's comics, for example, with their clear graphic style, have been a potent source of new ideas for Hockney.

French Impressionism elicited comparatively little response from German artists, who were far more concerned with the social problems which emerged during the closing years of the century. Käthe Kollwitz, a native of Königsberg, produced a series of etchings and lithographs, which illustrate and comment on Gerhart Hauptmann's naturalistic drama *Die Weber* (The Weavers), whilst in other graphic cycles she depicted the misery of the German proletariat which she saw every day of her life in Berlin. A similar concern for the joys and sorrows of the ordinary man is to be found in the woodcuts and lithographs of the sculptor Ernst Barlach. Both Kollwitz and Barlach, like the Bohemian artist Alfred Kubin, were extremely expert in the use of black and white contrasts and bold outlines to produce emotional effects. They were less concerned with aesthetic considerations than with the need to present a truthful and personal record of events. Even Lovis Corinth, who inclined strongly to Impressionism during his early period and painted many colour compositions of great delicacy, produced a number of drawings that are quite astonishing. His *Self-Portrait* is a work of almost frightening power. The piercing eyes, the pursed lips and the determined chin are anything but Impressionist and provide a perfect illustration of Corinth's late style, in which he portrayed the world about him at a far deeper level. Max Liebermann, on the other hand, adopted a much less problematical attitude towards

Above:
Käthe Kollwitz
(1867—1945),
THE WEAVERS, NO. 6:
THE END (1898).

Barlach,
Women Mourners,
page 393

Kubin,
Fear Not,
page 392

Corinth,
Self-Portrait,
page 394

Alfred Kubin (1877—1959), FEAR NOT (1936).

Liebermann,
Girl Reading,
page 395

the deficiencies of contemporary society, which he portrayed in his graphic work during the 1870s. Although the moneyed classes, to which he originally belonged, accused him of espousing the cause of poverty and squalor, he was in fact the one German artist of note who managed to discover cheerful and, on occasions, distinctly lovable traits amongst the German proletariat. In his *Girl Reading* the harshness of the black charcoal is mitigated by the soothing effect of the white shading, which gives an air of warmth and restfulness to the scene. But, of course, Liebermann was far less provocative than artists like Barlach and Kollwitz, who tried to shock, not only by their choice of subjects, but also by their harsh use of line.

Another late nineteenth-century movement with militant aims was the German and Austrian *Jugendstil,* which reached its climax in Vienna and then spread across the whole of Europe. Of course the *Jugendstil* artists were not concerned with social injustice. What they took exception to was the extreme traditionalism of contemporary architecture and painting, which they wanted to see replaced by a completely new and essentially ornamental style. By

using highly artificial forms they hoped to provide a viable alternative to the imitative art which had been dominant in Europe ever since the Renaissance. But they were also opposed to Impressionism for although this had been extremely fertile in its day, by the 1890s it had degenerated into a somewhat insipid form of decorative art. And so the *Jugendstil* artists abandoned the soft, flowing colour compositions of Impressionist art in favour of a flat, unnaturalistic style based on bold outlines. At the same time, like the Impressionists, they moved away from historical or narrative themes in favour of intimate figure studies, landscapes and still lifes, concentrating on purely aesthetic problems.

The graphic media were of course particularly suitable for this type of flat, ornamental composition and the *Jugendstil* artists made frequent use of them. In his watercolour of *The Artist's Mother Sleeping* Egon Schiele, one of the leading representatives of the Viennese School and an artist who was greatly influenced by Gustav Klimt, created a completely two-dimensional ground composed of differently structured areas of colour, from which the female

Schiele,
The Artist's Mother Sleeping,
page 398

Ernst Barlach (1870—1938)
WOMEN MOURNERS.

Selbstporträt
Lovis Corinth
3 Januar 19—
1921

Opposite:
Lovis Corinth
(1858—1925),
SELF-PORTRAIT
(1921).

Max Liebermann
(1847—1935),
GIRL READING
(c. 1893).

head emerges as a fully modelled form. This picture was doubtless inspired by a personal view of the world, in which man appears surrounded by the dark forces of fate, and in this respect—but not in respect of technique—it is closely allied to the work of Edvard Munch. *Jugendstil* ideas are particularly prominent in the mature work of the Swiss artist Ferdinand Hodler. During his late period he used extremely bold outlines both in his landscapes and in his figure compositions, which enabled him to develop a highly ornamental style.

Hodler,
Study for 'View of Eternity',
page 396

395

Oskar Kokoschka (b. 1886),
PORTRAIT OF A WOMAN (1916).

Ferdinand Hodler (1853—1918), STUDY FOR 'VIEW OF ETERNITY' (1914).

Aubrey Beardsley
(1872—98),
THE DANCER'S REWARD.
Illustration to Wilde's
Salome (1894).

Aubrey Beardsley, the leading representative of the 'Modern Style' in England, was even more radical in his approach to ornamentation, for he allowed both the figurative and the vegetable forms in his works to merge into the decorative linear structures. In his drawings he completely dispensed with shading and made no attempt to effect painterly transitions. Instead he placed black forms against a white ground after the manner of the eighteenth-century silhouette. Beardsley illustrated numerous books in this way, including Oscar Wilde's *Salome*, and exerted a considerable influence on European book illustration from about 1900 onwards.

Beardsley,
The Dancer's Reward,
page 397

The all too prevalent idea that the *Jugendstil* was simply a modish curiosity, a freak development of the *fin de siècle*, becomes quite untenable if we consider that no lesser person than Wassily Kandinsky was an enthusiastic member of this movement during his early period and that it was partly through his preoccupation with *Jugendstil* ideas that he was able to produce the first abstract painting. Kandinsky came to Munich in 1896 after abandoning a legal career in Moscow. In Munich he studied under Anton

397

Egon Schiele (1890—1918), THE ARTIST'S MOTHER SLEEPING (1911).

Azbe and Franz von Stuck but was not influenced by them. However, he was influenced by the *Jugendstil,* which established itself in Munich at the turn of the century, and in the pictures which Kandinsky produced at that time he combined elements of the new style with fantasy motifs from traditional Russian art. Before leaving Russia Kandinsky had run a printing shop for a brief period and so had a sound working knowledge of the various reproductive processes, which enabled him to print most of his graphic works himself. This applies especially to the numerous linoleum cuts which he made during his early period. As a rule Kandinsky took his prints from two separate plates, one black, the other coloured (with watercolours), a technique that may well have been inspired by the coloured woodcuts from Japan, which were then enjoying great popularity in Europe. With its highly stylized forms Kandinsky's coloured linoleum cut *The Mirror* is typical of the work that he produced at this time: the drapery folds are almost pure graphic structures, the pink clouds are broken down into smaller ornamental areas by means of internal contours whilst the flowers on the dress appear to merge with the flowers on the ground. This fusion of real and ornamental elements was not new, of course. Gauguin had already used this technique for the coloured woodcuts which he had executed in Tahiti a good ten years before. However, as far as Kandinsky was concerned, the *Jugendstil* was only one stage in a personal development that was to lead him to the production of the first completely non-objective painting. The Impressionists had subjected pictorial forms to a process of partial abstraction, the Cubists had disposed of three-dimensional space and the Fauves had developed the abstract use of colour. But it was left to Kandinsky to take the final step: the total abstraction of natural forms. What was it that drove him to make such a radical break with tradition?

Kandinsky, *The Mirror,* page 401

Kandinsky himself described the background to these events in his memoirs. He tells us, for example, that when he first looked through a microscope and examined the strange forms and structures of natural phenomena, he discovered an entirely new world that was in no way analogous to the tangible world about him. His acute powers of observation were also an important factor. So too was chance. It seems that one evening, when he arrived home after having completed a study, which still completely occupied his thoughts, his gaze chanced upon a picture that was leaning against the wall in his studio. In the gathering dusk he was unable to make out the subject-matter of the picture but was quite overcome by its component forms and colours, which he found 'indescribably beautiful'. Upon closer examination he discovered that this work was one of his own paintings which he had stood against the wall on its side. The following day he looked at the painting again in the daylight and tried to recreate the purely formal impression which he had received the previous evening. But even when he placed the picture on its side, the pictorial objects continued to impose themselves on his mind so that he was only partially successful. It was then, Kandinsky said, that he realized that objects detracted from his pictures.

And so Kandinsky painted the first abstract picture in 1910, thus launching a new artistic movement that was soon to dominate the whole of Western art. Later he tried to evolve a precise system of abstract art and in his *Point and Line to Plane,* which first appeared in 1926, he analysed the different graphic elements of abstract composition. In this book we are told that verticals are warm and horizontals cold, that the upper part of a picture

399

should be light and relaxing while the lower part should be compact, that the forces on the left must be extroverted and those on the right introverted. Kandinsky also laid down rules for the relationship between form and colour. For example: red corresponds to a right angle, blue to an obtuse angle and yellow to an angle of sixty degrees. Not surprisingly, the abstract compositions which Kandinsky produced in the 1920s are distinctly constructive while his earlier works have a far more painterly, flowing line. His *Head*, a watercolour which he painted before the First World War, is typical of his early, spontaneous style. In this work the abstract signs are joined together by bold lines and areas of transparent colour to form a highly dynamic, swirling design. The immediacy of this watercolour clearly distinguishes it from the far cooler, almost geometric products of the 1920s, which are well illustrated by Kandinsky's *Composition with a Blue Spot*. Here the component elements remain spatially isolated and the unity of the work derives from the use of complementary colours and the short, delicately drawn lines, which not only create an impression of movement but also serve to consolidate the overall structure.

Kandinsky, *Head*, page 403

Kandinsky, *Composition with a Blue Spot*, page 402

Kandinsky's significance for the development of modern art in Germany was not due solely to his courageous advance into the sphere of abstract art. His outstanding qualities of leadership and his great pedagogical gifts were also important factors. As early as 1901 he founded the 'Phalanx' artists' association in Munich in a valiant attempt to break with traditional teaching methods. By uniting all the progressive forces in the city he hoped to set up a community whose members would both teach, and learn from, one another and so provide mutual encouragement. But this association made no real impact on the artistic life of the city, partly because its members were too little known, partly because it lacked a clear-cut and convincing programme. Eventually, however, its ideological needs were supplied by the French. Both on visits to Paris and at public exhibitions these young Munich artists became acquainted with the flat compositions of Cézanne and Gauguin and with the new and powerful colouring of the Fauves, which they then took as a model for their own work. This common interest led in 1909 to the formation of the 'New Artists' Association', which was also headed by Kandinsky and included, amongst others, Alexej Jawlensky, Alfred Kubin, Gabriele Münter and Marianne von Werefkin. In the following year Paul Klee, Franz Marc and August Macke also joined. Shortly afterwards, however, friction arose between the conservative and progressive factions and in 1911 the progressives— Kandinsky, Marc, Macke, Kubin and Münter—broke away from the Association to form the 'Blaue Reiter' group, which remained in existence until the outbreak of war in 1914. Heinrich Campendonk, impressed with the work of Marc, also joined the group in Munich.

Campendonk, *Female Nude*, page 407

Franz Marc visited France as early as 1903. In one month there, he said, he learnt more than in the five years he had spent at the Munich Academy. In Munich he had come into contact with the *Jugendstil* and, after seeing works by modern French artists, he developed the various *Jugendstil* techniques, evolving an extremely personal and powerful two-dimensional style, which lent itself particularly well to graphic works. His marked preference for the woodcut—which was by no means the most popular of the graphic processes in his day—is in keeping with the monumental nature of his art. Marc's *Tiger*, a woodcut which he executed in 1912, shows his great love of ornament. In this work the component forms interlace in perfect harmony: the animal and

Wassily Kandinsky (1866—1944), HEAD. 403

Above:
Franz Marc
(1880—1916),
TIGER (1912).

Marc,
Miranda,
page 406

plants are closely interwoven, the stripes on the skin are reflected in the pointed leaves and the whole of the picture area is filled with matching shapes. And yet this woodcut is not merely decorative. It is also charged with movement and concentrated power. Marc was doubtless greatly influenced by the French Cubist technique of reducing natural forms to flat, geometric shapes. But where the Cubists proceeded soberly and systematically in pursuit of a strictly intellectual art form, he introduced an emotional quality by stressing the lyrical element in his work. His *Miranda* is a romantic nature-spirit, who is completely at one with her fantastic surroundings. In this watercolour Marc conjured up a world of light and purity, a world uncontaminated by man and accessible to him only in his dreams. This is the garden of Eden, from which man was expelled and which is now inhabited by animals and fairies, the only innocent creatures left on earth. Marc also portrayed this same world in his splendid animal pictures, using luminous colours and crystalline forms which, in his late works, became virtually abstract.

August Macke—who was a close friend of Marc's and, like him, one of the leading representatives of the 'Blaue Reiter'—was also a metaphysical painter

in the sense that he was profoundly interested in the workings of secret forces and the inscrutable ways of the invisible God. But whereas Marc was a fundamentally pessimistic and melancholy person, Macke was decidedly cheerful and quite unproblematical. This optimistic outlook found suitable expression in his extremely colourful and unsentimental compositions. His *Children and Goats on the Bank of a Lake,* which he executed in coloured chalks and watercolour, reveals the influence of various French schools. Macke took from the French Impressionists their general conception of a world transformed by light and sunshine, from the Fauves he learnt the use of pure colour, whilst from the Cubists he acquired his two-dimensional view of pictorial space. In this work he created a mosaic of different colours, some of which overlap one another, and then inserted animals, trees and figures in a completely random pattern, leaving the viewer to pick them out from the rhythmical play of light and colour, which ranges from luminous blue on the left to glittering yellow on the right of the picture.

Macke, *Children and Goats on the Bank of a Lake,* page 408

Paul Klee, the Swiss artist, evolved a completely individual style that is quite devoid of metaphysical overtones or extra-arstistic intellectual ballast. Where Kandinsky is often cramped and unnecessarily complex, where Marc is symbolic and cryptic, Klee is unbelievably imaginative and eminently artistic. By the time he joined the 'Blaue Reiter' group in 1911 he had already come to terms with all traditional values. The drawings and etchings which he produced during that early period reveal a delightful sense of humour and an unashamed penchant for the absurd. But he had not yet developed a sense of colour. It was only as a result of his extremely close friendship with Kandinsky and Macke, whose highly colourful pictures excited his admiration, that he began to make cautious experiments with watercolour. In 1912 he visited Paris, where he met Picasso and the Fauvist Delaunay and also saw works by van Gogh and Cézanne. But it was when he visited Tunis with Macke in 1914 that Klee made the transition from draughtsmanship to painting. The colourful world of the south, the light and the exotic vegetable forms, the strange noises and smells stimulated his senses and gave wings to his imagination. 'At first an overwhelming tumult', he wrote in his diary, 'culminating at night with the "marriage arabe". No single thing, but the total effect. And what a totality it was! The essence of "A Thousand and One Nights", with a ninety-nine per cent reality content.' And in the following entry he said: 'It penetrates so deeply and so gently into me, I feel it and it gives me confidence in myself without effort. Colour possesses me. I don't have to pursue it. It will posses me always, I know it. That is the meaning of this happy hour. Colour and I are one. I am a painter.'

Klee executed his watercolour *Motif from Hamammet* during this visit to Tunis—just one year after Macke had created his watercolour and coloured chalk design, to which it bears a superficial ressemblance. But, if we compare these two works in detail, we soon see how different they are. Macke used complex, overlapping structures and contrasting colours; and he also disrupted his pictorial motifs, often—it would seem—without reason, for he immediately proceeded to reconstitute them. Klee, on the other hand, produced a completely harmonious work, in which nature is transformed into an autonomous, musical and abstract composition of great simplicity. The solid houses of Hamammet have been reduced to two-dimensional structures, their tiles and windows have become independent forms, whilst the bright colours of this southern world have been transposed from a natural to an artistic order. And the finished

Klee, *Motif from Hamammet,* page 411

405

work is so simple and so harmonious that the whole process acquires an air of inevitability. When he was in Hamammet Klee wrote in his diary: 'I did a watercolour here, transposing a great deal but remaining completely faithful to nature.'

We also find this fidelity to nature in Klee's *Landscape in Red with White Sun,* which he painted in 1917. An entry in his diary for July 1917 casts some light on this work: 'The diffused clarity of overcast weather is richer in

Klee,
Landscape in Red
with White Sun,
page 409

406

phenomena than a sunny day. A thin stratum of cloud just before the sun breaks through. It is difficult to catch and represent this, because the movement is so fleeting. It has to penetrate into our soul. The formal has to fuse with the *Weltanschauung*.' The red sky above the horizon, which is broken up by patches of cloud, is reflected in the landscape and the houses. It is this which effects the strange transposition from a natural to an artistic order of reality. The abstraction in this picture is very gentle: the houses are almost three-dimensional whilst the beautifully structured landscape, whose macabre chiaroscuro is relieved by the bright, flat colours of the border, actually does create an impression of depth.

The 'Blaue Reiter' came to an abrupt end in 1914 with the outbreak of the First World War. Kandinsky and Gabriele Münter then moved to Switzerland and Marc and Macke were both killed on active service. After the war some of the members of this group were reunited in Weimar, where the German architect Walter Gropius tried to revive the medieval conception of the 'total work of art' in his *Bauhaus*, a multi-disciplinary institute modelled on the old German '*Bauhütte*' or masonic guild, whose members built the great German

Opposite:
Franz Marc
(1880—1916),
MIRANDA: FIGURE FROM SHAKESPEARE'S TEMPEST
(c. 1914).

Below:
Heinrich Campendonk
(1889—1957),
FEMALE NUDE IN FRONT OF A FARMYARD.

Paul Klee (1879—1940), LANDSCAPE IN RED WITH WHITE SUN (1917).

Opposite: August Macke (1887—1914), CHILDREN AND GOATS ON THE BANK OF A LAKE, THUNERSEE (1913).

cathedrals. This romantic association with the past was strangely out of place, for the *Bauhaus* was an essentially progressive institute. Thanks largely to the personality of its director and the energy and dedication of his colleagues it did not degenerate into an unworldly and introverted colony. The artistic élite of Germany worked under Gropius both in Weimar and in Dessau. Wassily Kandinsky spent ten years at the *Bauhaus* and Paul Klee nine while the German-American artist Lyonel Feininger, who was a founder member, stayed with the institute until it was closed down by the National Socialists in 1933. Like Klee, Feininger was a musician. He was also a romantic with a revolutionary conception of artistic form. After adopting Cubist-type deformation he proceeded to use crystalline forms in order to evoke a highly individual dream-world with lyrical overtones. In his paintings he created fascinating and extremely subtle effects by superimposing transparent areas of light and colour one upon the other. This technique had of course already been used by the French Impressionists and had been largely responsible for

Paul Klee
(1879—1940),
SLIGHT DETERIORATION
(1927).

Paul Klee (1879—1940), MOTIF FROM HAMAMMET (1914).

411

Lyonel Feininger (1871—1956), THE CATHEDRAL OF SOCIALISM (1919).

the formlessness of much of their work, a danger which Feininger avoided by introducing a firm linear structure into his work. As a graphic artist Feininger revealed a preference for the black and white woodcut, with which he succeeded in producing distinctly painterly effects. His *Cathedral of Socialism* acquires an air of light and grace from the flow of the verticals, whose inherent harshness is relieved by the diagonal rays of the stars. Although the powerful forms of the cathedral run counter to the movement of these rays they are none the less perfectly integrated into the brilliant linear framework. In his *Ships at the Quayside* Feininger was also intent on reducing the power of the black and white contrasts, which he did by introducing black stipples into the white areas and vivid white structures into the black areas. Although this woodcut is by no means provocative—either in an artistic or in an intellectual sense—it is a very exciting piece of work, in which Feininger represented a purely personal conception with great virtuosity.

But other artists of this period certainly were provocative, not only in political and social matters, but in the artistic sphere as well. They were usually referred to as 'the Expressionists', although in actual fact they were essentially individualists and seldom joined together in specific associations. One exception to this general rule was provided by the 'Brücke' group, which was formed in Dresden in 1905 by Erich Heckel, Karl Schmidt-Rottluff and Ernst Ludwig Kirchner. Apart from Kirchner, the members of the 'Brücke' were all self-taught artists and, although ultimately they attached greater importance to social criticism, the immediate aim of the group was to renew contemporary art by ridding it of the ballast of academic training. The

Above:
Lyonel Feininger
(1871—1956),
SHIPS AT THE QUAYSIDE
(1918).

Feininger,
*Cathedral of
Socialism*,
page 412

Ships at the Quayside,
page 413

413

Ernst Ludwig Kirchner (1880—1938), BERLIN STREET SCENE (c. 1913).

'Brücke' artists used violent colours, deformation and—occasionally—distortion in their quest for extreme expressiveness. They regarded works of art as a vehicle for elemental experiences and not as a means of providing aesthetic satisfaction. Consequently they evinced little interest in their contemporaries, apart from Munch and van Gogh. Instead they sought their inspiration in the unrealistic figuration and colouring of the medieval masters, in the coarse works of primitive peoples and in the extremely colourful and

Ernst Ludwig Kirchner (1880—1938), PORTRAIT OF OTTO MUELLER (1914/15).

Ernst Ludwig Kirchner (1880—1938), SUNBATHING.

Ernst Ludwig Kirchner (1880—1938), VALLEY NEAR DAVOS-FRAUENKIRCH (TREES ON THE SERTIGWEG) (1926).

Otto Mueller (1874—1930), GIPSY WOMAN AND CHILD (1927).

individual products of folk art. Not surprisingly, this group played an important part in the revival of the graphic arts, especially the wood and linoleum cut. Kirchner's *Portrait of Otto Mueller* gives a good idea of the positively archaic woodcut style evolved by the 'Brücke' artists. Beauty in the classical sense of the word has no place in this print. By a combination of hard, jagged lines and large, monochrome areas Kirchner created an impression of extreme psychological tension, almost as if his sitter were possessed by demonic powers. In his *Berlin Street Scene*, a pastel drawing executed in 1913, the two men about town and their lady companion are distorted into caricatures of human beings. With their bloodless, cruel faces these macabre and sinister figures seem to anticipate the cruelty of war, which was then imminent. Even Kirchner's landscapes, which were painted much later, are profoundly pessimistic. His *Valley near Davos-Frauenkirch* is no rustic idyll. On the contrary, it is an exalted vision of nature, in which Kirchner portrayed the elemental forces that pose a constant threat to man. In his final period this pessimism was transformed into a tragic form of melancholy which reflected his state of mind at that time and finally caused him to commit suicide.

Although he was fully versed in the harsh techniques of the 'Brücke', Otto Mueller—who joined the group some years after its inception— was a far more decorative artist than most of his colleagues. It was often said of him that he had the mind of an aristocrat and the blood of a gipsy. But Mueller's

Above:
Otto Mueller
(1874—1930),
GIRL IN THE GRASS
(1918/19).

Kirchner,
*Portrait of
Otto Mueller*,
page 415

Berlin Street Scene,
page 414

*Valley near
Davos—Frauenkirch*,
page 417

419

Mueller,
Gipsy Woman and Child,
page 418

Girl in the Grass,
page 419

Below:
Karl Schmidt-Rottluff
(b. 1884), CATS.

mother—a gipsy child who grew up in civilized surroundings—gave him not only her blood but also her deep affection for the world of the gipsies. These mysterious creatures with their gaunt frames, their ragged clothes and their unmistakable air of dignity were a source of constant fascination to him and appear in different guises in many of his pictures. For Mueller the gipsies were symbols of freedom, natural beings untouched by civilization, who lived their lives beneath the stars without conflict. As a result many of his female figures—and not just his gipsy women—have a sort of vegetative quality: they look like fragile plants and merge with the landscape as if they were part of it.

Karl Schmidt-Rottluff, born in 1884, was one of the foremost German Expressionists, especially in the graphic arts. He exhibited with the 'Brücke' until the group was dissolved in 1913. During the 1920s his art became more naturalistic although he was still influenced by Cubism and continued to stress outline. He was one of the artists most persecuted by the Nazis, who

Emil Nolde (1867—1956), POPPIES AND IRISES.

Emil Nolde (1867—1956), SURF.

in 1937 confiscated 608 of his works and in 1941 forbade him to paint and put him under SS supervision.

Emil Nolde, the German Expressionist from the Baltic, also belonged to the 'Brücke' for a few years. His preference for luminous colours, which he liked to apply very rapidly, and his disregard of linear structures placed him on a par with the Fauves so that he too was accused by contemporary critics of painting 'meaningless and wild' pictures. Nolde was not unduly perturbed by such criticism. He was essentially a lone wolf and, apart from a protracted journey through Russia, China, Japan and Polynesia which he undertook in 1913–14, he lived in complete seclusion in a fisherman's hut on the Baltic coast. Like his great German predecessor Caspar David Friedrich, who was also inspired by the flat and lonely Baltic coast, Nolde created a series of masterpieces that are, in their own way, hymns to solitude and silence. At the time when so many artists, including the members of the 'Brücke', were concentrating on urban imagery, and finding there a source of loneliness too, Nolde stands apart. His work can be regarded as a development, albeit a late one, of the Romantic Movement to which Friedrich had belonged. Nolde is among the most remarkable of twentieth-century German artists, the true heir to that particular combination of throbbing colour and 'primitive' imagery which had been the unforgettable creation of Gauguin. He was able to overcome the twin dangers of Romanticism and Expressionism; his imagery is often exotic but never merely picturesque, while his colour and handling achieve power without becoming either brutal or hysterical. What is equally remarkable about Nolde is that he was able to maintain the quality of his achievement into his old age. Nolde liked watercolours because with them he was better able to capture a momentary mood than with the more cumbersome and time-consuming oil technique. Nolde applied his watercolours with bold, flowing strokes of the brush to long-grained, absorbent Japanese paper, parts of which he often wetted beforehand in order to produce blotches of faded colour and runs. This technique can be seen in his *Surf*. But Nolde discovered elemental beauty and archetypal forms, not only in the distant seascapes and landscapes of the flat, north German coastal area, but also in the flower-beds of cottage gardens. 'Flowers bloom for man's delight. I paint them in the summer to bring joy to the winter.' These words of Nolde's reveal his deep attachment to flowers, which is well illustrated by his *Poppies and Irises*. As a 'cultural Bolshevist' Nolde was forbidden to paint by the National Socialists and during this period of persecution was forced to content himself with watercolours which he always referred to as 'unpainted pictures'. By 1945 he had produced a large number of these, some of which he subsequently reworked in oils.

The historian Paul Sethe once observed that artists invariably make better prophets than politicians or publicists. This is certainly true of the Expressionists of the 1920s, who conjured up the horror of forthcoming events with almost visionary insight. George Grosz was showing Hitler in his true colours as early as 1925. In a series of caricatures which he produced then he depicted Hitler as the butcher and blood-thirsty dictator that he later turned out to be. Grosz, who was essentially a satirical artist, also mounted caustic attacks on the social evils of his day. In his *Gold-diggers* and *Café* he invoked a terrifying image of a post-war society completely given over to the pursuit of pleasure and profits and quite unaware of the catastrophe for which it was heading. What is interesting about Grosz's caricatures is that

Nolde, *Surf*, page 422

Poppies and Irises, page 421

George Grosz (1893—1959), CAFÉ.

they represent an attitude of life that was to find an outlet in many art forms in the 1920s and 1930s. In their mixture of satire and acid social criticism, and in their creation of a world with hardly a redeeming feature, they can be paralleled—to take but one example—in the films made in America by Erich von Stroheim. Grosz remains undoubtedly one of the most remarkable satirists of the twentieth century, although it is fair to say that he is sometimes apt to weaken his case through exaggeration. But the best of his drawings are still among the most striking examples of social satire since Hogarth.

Another German artist who attacked the cruelty of war with equal vigour and with savage irony was Otto Dix. Drawing in the trenches with charcoal or chalk, he created extremely bold effects with rapid, powerful strokes. His

Otto Dix (1891—1969), SHOT-UP HOUSE (c. 1916).

Otto Dix (1891—1969),
DEAD SOLDIER (1922).

Shot-up House of 1916, which he executed in body colour on brownish paper, is virtually an abstract composition. But this does not mean that Dix was turning away from reality. On the contrary, he was using an abstract structure to symbolize the total destruction wrought by war, which is anything but unreal.

Carl Hofer was far less provocative in his record of contemporary society. Instead of probing into the underlying causes of fear and dissension he tried to depict its helpless victims. The men and women in his pictures are faceless creatures and are frequently represented as harlequins, fools or dupes. Max Beckmann also employed a muted form of social criticism, expressing his disapproval of the contemporary scene by means of symbolic figures: cabaret or circus artists chained together and performing as a group and men and women with mask-like faces and bodies racked with ungratified desires. The look of resignation, revulsion and cynicism, which is a constant feature of his numerous self-portraits, faithfully reflects the corrupt world in which he lived. Oskar Kokoschka is another twentieth-century artist who used the portrait as a means of expressing the inner reality of his subject and it was

Carl Hofer
(1878—1955),
GIRL WITH HARLEQUIN
(1921).

through him that Freud's psycho-analytical discoveries found legitimate expression in this sphere. In his *Portrait of a Woman* Kokoschka depicted the psychic instability of his subject with great perspicuity. The wide, staring eyes, the tight-lipped mouth, the bulbous and arched nose and the heavily lined face all point to insecurity and severe mental distress. The idea of probing beneath the surface was not, of course, Kokoschka's own pictorial discovery. Van Gogh, to quote one predecessor whose work Kokoschka would have known, creates through an arrangement of brilliantly coloured and agitated strokes, a strong sense of tension; his sitters often suggest a state of nerves. This is, of course, an attribute not of their personalities so much as of the artist's style. It is interesting to see, in the case of Kokoschka's pre-1914 portraits, how the pictorial mood remains the same from picture to picture. It would be absurd to suppose that all the sitters were preoccupied

Kokoschka,
Portrait of a Woman,
page 396

Max Beckmann (1884—1950), NAKED DANCE.

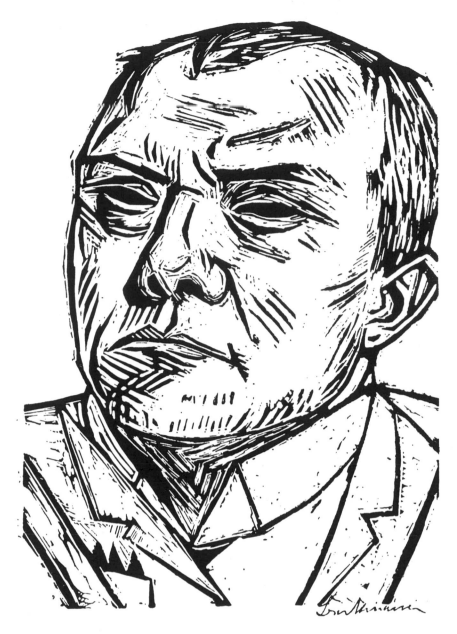

Max Beckmann
(1884—1950),
SELF-PORTRAIT

by the same psychological problems; or even to suppose that they all had problems in the first place. Kokoschka's portraits were certainly influenced by that mood of psychological investigation which was so prevalent in Germany and Austria at the time. But they also depend, to an even greater extent, on the pictorial development of ideas inherent in Expressionism—the distortion of conventional anatomy and three-dimensional space, the emphasis on strong linear rhythms and the use of colour in an emotive rather than a descriptive role.

Twentieth-century Italian art has been much less problematical. Futurism, which is of Italian origin, is essentially optimistic, for it presupposes a belief in the future. The Surrealism of Chirico and Carrà was also far less tormented and brooding than that of the German Max Ernst or, for much

429

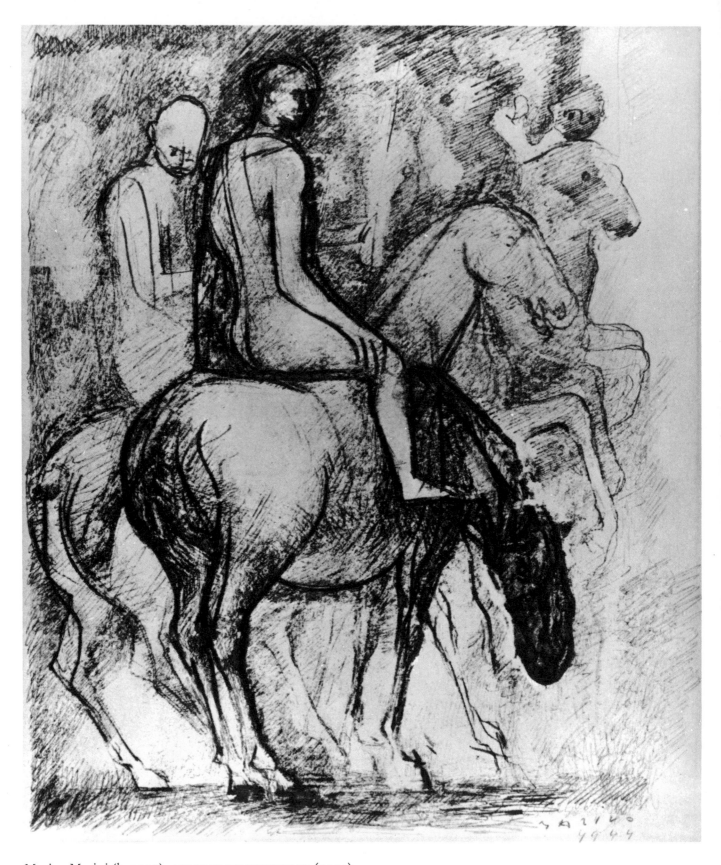

Marino Marini (b. 1901), ACROBAT ON HORSEBACK (1944).

Opposite: Giorgio de Chirico (b. 1888), IL CONDOTTIERE (1917).

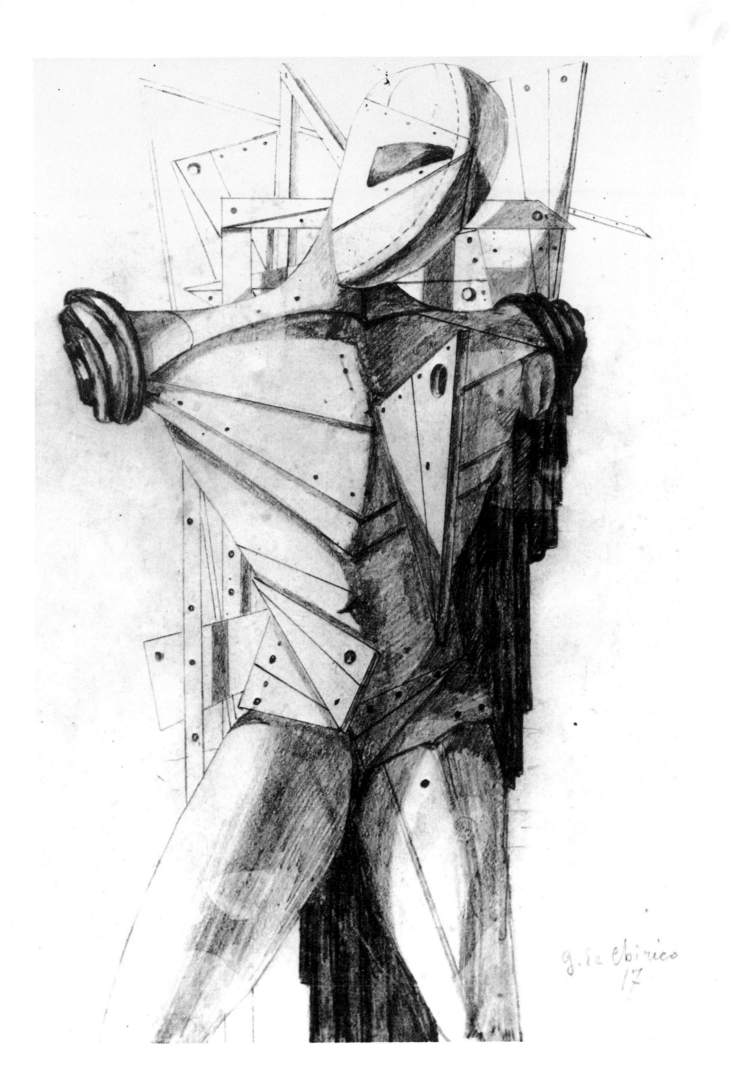

Giorgio de Chirico,
Il Condottiere,
page 431

of the time, of the Spaniard Salvador Dali. In his *Condottiere* Chirico combined in one and the same figure an allusion to Italy's great past with a symbolic representation of the new technological age. True, the main emphasis is on the material composition of this figure, for the rivets joining the wooden components are clearly visible. But even though its human aspect is far removed from the humanity of Classical art, this 'manichino' is certainly not a technical demon. On the contrary, it is a creature that can help modern man to come to terms with his new reality, which was of course the role played by the *condottiere* in the Renaissance.

Amedeo Modigliani took no interest in such sociological questions. Nor was he influenced by the great stylistic experiments of his day. He concentrated throughout the whole of his career on just two themes: the female nude and the portrait. But although Modigliani painted or drew the same slim female figure time and again, this self-imposed restriction was more of a strength than a weakness, especially in his graphic work, which is well illustrated by his *Nude Girl.* Using long, almost continuous lines Modigliani described the body-forms in this drawing gently but succinctly and also created an impression of soft plasticity without having recourse to shading. Modigliani's line is completely individual and is far more than a simple contour. With the most minute variations in the intensity of his stroke he is able to set up rhythmical modulations which give his figures a lyrical and highly sensuous quality.

Modigliani,
Nude Girl,
page 433

Marino Marini is another Italian artist who has severely restricted his range of subjects. In his sculptures, his paintings and his graphic works he has concentrated almost exclusively on the horse-and-rider theme, which he sees in completely and genuinely primitive terms as an encounter between the rational and the natural being. In this encounter man tries to subjugate the horse, which represents the forces of nature, whilst the horse, for its part, is intent on resisting this encroachment on its liberty. And so, far from acting in concord as in traditional equestrian works, Marini's horse and rider are in a state of constant strife. Although Marini's paintings and graphic works are closely related to his sculptures, they are none the less works of art in their own right. The fact that Marini has dispensed with perspective and plasticity in his pictures shows that he regards them as autonomous products. In his *Acrobat on Horseback* he combines powerful contours with lively shading, which frequently overruns the borders of the component forms and so helps to co-ordinate the various pictorial areas into a complete whole. Today Marini is already regarded as one of the old masters of modern art.

Marini,
Acrobat on Horseback,
page 430

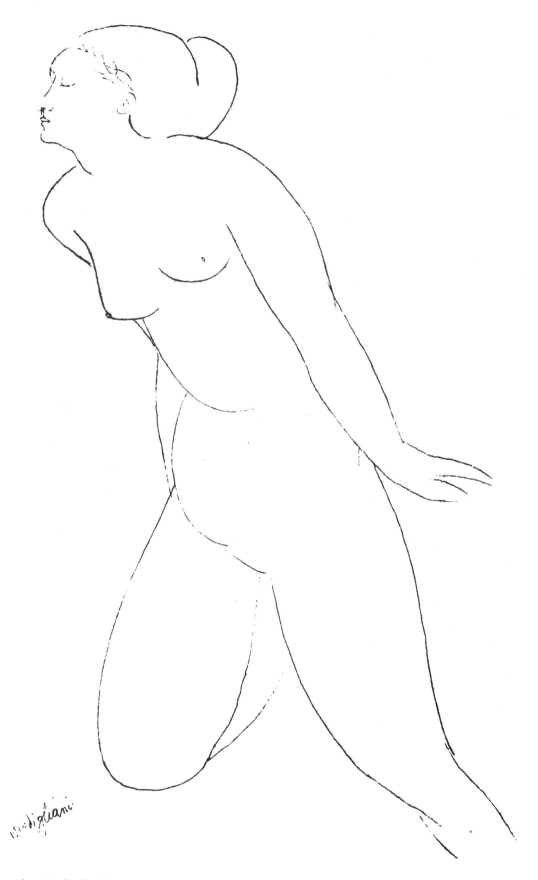

Amedeo Modigliani (1884—1920), NUDE GIRL.

433

AMERICA IN THE TWENTIETH CENTURY

By and large the new and revolutionary art forms, which were developed in Europe in the early part of the twentieth century, met with a far more favourable response in America than in Europe. Ideas which were rejected out of hand by the European establishment were discussed in all seriousness and, not infrequently, endorsed by the American art public. Unencumbered by traditionalist considerations, the Americans were able to welcome the 'moderns' as the harbingers of a new epoch, to which they pledged their whole-hearted support. Even before the turn of the century the Impressionists had made their mark in America, where they had been far more successful than in Paris, Rome or Berlin. Later the Cubists, the Fauves and the Expressionists were also well received with the result that America became a kind of promised land, where many European artists went in search of recognition and patronage. This development was particularly pronounced in the 1920s when large numbers of artists left Europe for America, larger even than in the 1930s, when political oppression swelled the ranks of the émigrés. True, not all of those who sought their fortune as artists in America were successful. None the less, they paved the way for future artistic exchanges, which have proved particularly fruitful. Ever since the 1920s American artists have been turning to Europe in order to learn whilst European artists have been active in America both as teachers and as innovators.

These lively exchanges between the old and the new world have had far-reaching effects on the development of the graphic media in America. During the early years of the twentieth century this branch of art had passed through what was virtually a renaissance due to the impact of Cubism and, more particularly, Expressionism. The extremely powerful lithographs and woodcuts executed by the Expressionists, who concentrated on harsh black and white effects in their graphic art, aroused the interest of American artists and prompted many of them to study the great masters of this medium. John Sloan's graphic works, for example, reveal the influence of Daumier. Sloan, who started his career as a graphic reporter for the *Philadelphia Inquirer*, was a self-taught artist, who began to portray grim scenes of big-city life early on in his career. Many of Sloan's prints were conceived as exercises in social and political satire. Here too he showed his close affinity with Daumier, some of whose prints he possessed. Sloan's etching *Roofs, Summer Night* is no 'summer idyll'. On the contrary, it is an extremely depressing picture of a scene from city life, in which the artist's delicate use of line enabled him to create an oppressive atmosphere that appears to engulf his characters and render them quite incapable of positive action. Like Zille and Kollwitz and many other graphic artists who chose to depict the grey milieu of the big city, Sloan used a harsh and, in many cases, positively primitive technique in pursuit of his social and political aims.

Sloan,
Roofs, Summer Night,
page 436

Maurice Prendergast
(1859—1924),
ORANGE MARKET (1900).

George W. Bellows also portrayed scenes from city life in his realistic graphic works, but he did so without any sense of social commitment. What interested him were the painterly aspects of this frenzied world. In his lithograph *A Stag at Sharkey's*, which was produced as a study for a painting of the same name, he created an exciting and highly dramatic portrait of a group of boxers, whose white bodies stand out in luminous relief from the dark background and the dim forms of the remaining figures.

Bellows,
A Stag at Sharkey's,
page 441

Joseph Pennell was an artist with a far more positive attitude to the industrial life of the big city. Without pathos and without sentimentality but with a highly developed sense for the strange beauties of the urban scene he produced a number of quite remarkable townscapes. His line engraving *The Stockyards* is a particularly interesting example of his work. Although at first sight it might be thought that Pennell was trying to create a confrontation between townscape and landscape, between industry and nature, in this print he was actually intent on effecting a reconciliation between these two opposing spheres. The strictly linear structures of the stockyards blend perfectly with the rectilinear forms of the telegraph poles, the factory chimneys and the buildings, thus producing a completely composite picture. In this charming

Pennell,
The Stockyards,
page 437

John Sloan (1871—1951), ROOFS, SUMMER NIGHT (1906).

Hassam,
Fifth Avenue,
page 440

Prendergast,
Orange Market,
page 435

engraving Pennell portrayed, with complete honesty but without any sense of rancour, the contradictory features which came to the fore with the onset of the industrial age.

Childe Hassam's friendly townscapes, on the other hand, are virtually Impressionistic. The multiplicity of the pictorial forms and the wealth of narrative detail in his *Fifth Avenue* are reminiscent of townscapes by Pissarro. The contrast between animated and deserted pictorial areas—which Hassam used in order to heighten the mood of this work—is particularly effective. Thus the blank wall in the foreground stands out against the complex structures of the houses in the background whilst the isolated figure standing in front of the bare house wall is juxtaposed, first with a few groups of figures, and eventually with the great crowd on the street.

Maurice Prendergast was even more strongly influenced by the French Impressionists than Childe Hassam, for he borrowed not only their general style but specific techniques as well. For example, he took over the coloured monotype invented by Degas and then proceeded to refine it. Later he described this process in the followings words: 'Paint on copper in oils, wiping

Above:
Joseph Pennell
(1858—1926),
THE STOCKYARDS
(c. 1910).

parts to be white. When picture suits you, place it on Japanese paper and either press in a press or rub with a spoon till it pleases you. Sometimes the second or third plate is the best.'

Apart from Realists like Sloan, Bellows and Pennell and Impressionists like Hassam and Prendergast there were other artists, like John Marin, B. Davies and Lyonel Feininger, who set out to introduce the new European trends into America. John Marin, possibly the most important of the pioneers of modern art in America, studied in Pennsylvania and, subsequently, New York. In 1905 he went to Europe, where he stayed for six years, mostly in Paris. Initially he was influenced by Whistler and remained so even after making contact with the Fauves and the Cubists in Paris. It was not until 1908 that he really responded to modern art but, having done so, he became an enthusiastic exponent of the new method. After returning to America in 1911 he etched a remarkable group of town views, in which the big-city scene is portrayed with explosive force. These include a whole series of prints of the Woolworth Building. This massive skyscraper, which rises up into the storm-tossed sky like some great Gothic cathedral, is evidently built on shifting ground, for every single structure in this scene—the skyscraper itself and the smaller buildings which surround it—has been caught up in the whirling movement. Marin's pulsating vision of big-city life was matched by a

Marin,
Woolworth Building,
page 442

John Marin (1870—1953), BOAT BEFORE DEER ISLE (1926).

correspondingly forceful graphic style based on short, jagged lines which sometimes assume objective shapes and sometimes describe bizarre forms of Cubist provenance. Apart from these remarkable townscapes Marin also produced seascapes and landscapes, in which he tended to concentrate on the monumental aspect of nature. The natural forms in his *Boat before Deer Isle* are so simplified as to be almost abstract. But, although Marin used the sea, the boat, the sky and the land simply as pictorial elements, relating them to one another in purely artistic terms, he was none the less able to preserve the specific atmosphere of a seascape by employing diaphonous, transparent colours and an open background composition. Even in this watercolour Marin demonstrated his graphic talent: line takes precedence over painterly values and improvisation is always subject to the requirements of the pictorial structure. But, despite his insistence on linear values, Marin was always able to portray his conceptions of elemental forms completely spontaneously.

Marin, *Boat before Deer Isle*, page 438

Marin and Feininger were both strongly influenced by European Cubism and Futurism. So too was Charles Sheeler. But whereas Marin and Feininger both practised deformation—albeit in very different ways—in order to establish their subjective view of reality, Sheeler's strange pictorial conceptions were derived directly from the environment. The world of technology provided him with the motifs for his cool spatial compositions and by carefully choosing his vantage point he was able to obtain significant pictorial effects without recourse to deformation. Thus in his lithograph *The Delmonico Building*, by using a low vantage point he sets up a kind of spatial dynamism similar to that produced by Marin in his *Woolworth Building* by means of conscious deformation. Sheeler's highly sophisticated use of chiaroscuro—a technique particular well suited to the lithographic medium—also enabled him to create quite remarkable pictorial effects in what were essentially mundane motifs. The deep shadows cast on the heavily foreshortened, left-hand house wall produce fascinating and almost abstract patterns, the Cubist structures in the foreground form an effective contrast to the pure, unshaded surface of the skyscraper whilst the contrasting window forms and projecting wall sections produce a marked rhythmical organization of the surfaces. In his architectural studies Sheeler was continuing in the Realist tradition of American art. With his fundamentally Cubist view of the world he probed the forms and structures of external reality until he discovered aspects worthy of pictorial representation.

Feininger, *Cathedral of Socialism*, page 412

Sheeler, *Delmonico Building*, page 444

The economic crisis of the early 1930s had a profound effect on the character of American art. In view of the terrifying social and financial difficulties which shook Amercia to its foundations and reduced a large number of its people, including many artists, to extreme poverty, it is hardly surprising that the aesthetic and formal aspects of art should have been pushed into the background. At that time a number of American artists received support in the form of modest commissions from the 'Works Progress Administration'. Painters such as Raphael Soyer, Rockwell Kent and Adolf Dehn contributed to this government-sponsored programme by producing lithographs which were highly critical of the existing social conditions. Others, such as Thomas Hart Benton and Grant Wood, turned to social satire. Reginald Marsh and John Sloan both used etchings in order to portray and comment on the lower-class life of the American cities. But whereas Marsh had occasional recourse to pathos and bitter irony, Sloan invariably incorporated humorous motifs into his work.

Due to the great influx of European artists following the outbreak of the Second World War the graphic arts in America underwent a marked revival. In 1939 the English artist S. W. Hayter transferred his 'Atelier 17' from Paris to New York. Hayter had developed his graphic techniques in the company of the French Surrealists and consequently his art was diametrically opposed to the powerful and, in many cases, highly unsophisticated realism of the American school, which had been completely preoccupied with political and social themes during the 1930s. With his subtle and flexible incising techniques Hayter made a considerable impact on the technical aspects of the graphic arts in America. Moreover, with his Surrealist background he was also able to influence their stylistic development by introducing American artists to the possibilities of abstraction which until then they had studiously avoided. Artists like Kurt Seligmann, Max Ernst, Arshile Gorky and Hans Hofmann were paving the way for non-objective art in America in about 1940, but it was Joseph Albers who provided the major impetus for this development. Albers had worked at the Bauhaus in Weimar and Dessau for a full ten years. Later, when the Nazis came to power and closed the institute down, he emigrated to America, where he taught at Black Mountain College in North Carolina, becoming an exemplar and a mentor to a whole generation of

441

John Marin (1870—1953), WOOLWORTH BUILDING, No. 3 (1913).

American artists. Albers was perhaps the most consistent exponent of the sober, constructive Bauhaus style, in which inspiration was rigorously subordinated to the requirements of technical precision. Of recent years he has been constantly preoccupied with constructional problems and the square has held a particular fascination for him. He himself has commented on his *Homage to the Square:* 'Although technically the paint is completely flat and is spread evenly from one contour to the other, it none the less produces an impression of depth. For the colours are actually formed in or on the underlying screen. According to whether they naturally attract or repel one another they combine or separate—in respect of both tone and light—to form many different kinds of groups. The stress placed on the borders influences the order in which we take in the colours: concentrically or eccentrically, inwards or outwards, or backwards and forwards. And so, again and again, the intended interaction of the colours presents three-dimensional effects of a new or different kind. And yet the two-dimensionality [of the work] can never be overlooked. Quite apart from the interaction (which the artist consciously tried to produce by reciprocal inflection or intensification) he also pursued a further and completely independent goal: an attempt was made to preserve as far as was possible the "true face" of each individual colour despite its cooperation with other colours—a process similar to that involved in the Pompeian colour system.'

During the 1940s, when so many American painters were coming to terms with the problems of abstract art, their colleagues in the graphic sphere—men like Leonard Baskin, Mauricio Lasansky and Ben Shahn—continued to concentrate on social and political problems. Baskin, who has also achieved prominence as a sculptor, is one of America's leading woodcut artists. The monumental character of his prints—most of them are large-format works and some stand over six feet high—gives them an extraordinary power. Mauricio Lasansky came to the United States from Argentina in the 1940s to teach at the University of Iowa, where he built up an important graphic workshop. Like Baskin, Lasansky has recently produced a number of extremely impressive prints. Both technically and thematically his work is breaking new ground. In his *Nazi Drawings,* which may well have been inspired by Goya's *Disasters of War,* he has tried to come to grips with the horrors and atrocities of recent history. In our reproduction the evil-doer and his victim merge to form a single entity: the human face and the death's head are inextricably bound up with one another. The victim's mouth is twisted in pain and the monstrous skull exudes an aura of brutality. The background of this pencil drawing is taken up by letters and numbers which have been stuck on to the picture by means of a collage technique and which, because of their completely impersonal character, afford perfect symbols of the inhumanity of the evil-doers and the anonymity of their victims.

Ben Shahn's work is also stamped by a profound sense of social commitment. Shahn, who was born in Lithuania in 1898, came to America with his parents when he was eight years old. As a young man he obtained work with a lithographer, who was impressed by his great promise as a draughtsman. This early training, which doubtless played a crucial part in shaping his subsequent career as a graphic artist, was followed by a course of study at the National Academy of Design. But neither this period as a student nor the protracted visit to Europe which he undertook after leaving the Academy made a really powerful impact on Shahn. The decisive factor was the social

Albers, *White Line Square* page 452

Lasansky, *Nazi Drawings,* page 447

Page 444: Charles Sheeler (b. 1883), DELMONICO BUILDING (1926).

Page 445: Ben Shahn (b. 1898), GOLDWATER (1965).

HE SAYS NO TO CIVILIZATION AND SURVIVAL

"I CAN TELL YOU ONE THING

Ben Shahn

Willem de Kooning
(b. 1904),
UNTITLED (1960).

distress which he was obliged to witness in America in the early 1930s and which made such a profound impression on him both as an artist and as a human being. From then onwards he concentrated exclusively on themes from daily life and dispensed with all purely formal experiments. Public recognition came when he painted his *Funeral of Sacco and Vanzetti*, a silent but moving impeachment of American justice for the wrongful execution on a charge of murder of two Italian anarchists. Since then Shahn has continued to grasp political nettles. For example, between 1960 and 1962 he painted a series of pictures entitled *Lucky Dragon*, in which he pursued the fate of the Japanese fishing-boat that found itself within the fall-out area of an American atomic explosion in the Pacific. Apart from his paintings and large-format murals Shahn has also produced a large number of posters, in which he has given

Mauricio Lasansky (b. 1914), NAZI DRAWINGS (1965).

free rein to his sense of social criticism. His serigraph of Senator Goldwater, which was conceived as an 'anti-election poster', is a case in point. The 1964 Republican candidate for the American presidential election is seen in this print as an infantile monster looking at the world through the spectacles of a man who 'says no to civilization and survival'.

In the 1950s more and more American artists turned to non-objective art, to Op and Pop Art and to so-called minimal art. As a result Europe lost its traditional role as the arbiter of American artistic fashion. Indeed, American Pop Art may be regarded as a protest against the established aesthetic systems of European thought. Although we are constantly being told that many of

Shahn, *Goldwater*, page 445

the basic tenets of Pop Art were anticipated by the Dadaism of the early 1920s, in point of fact the resemblance between these two movements is purely superficial. Essentially Dadaism was a blatantly destructive attempt to overthrow established bourgeois values. In Pop Art, on the other hand, the commonplace has been exalted. Popular forms, popular images, consumer articles and spare parts have been incorporated into artistic compositions. Thus, although the Pop artists have opposed traditional aesthetics, they have done so without undermining the traditional conception of reality.

American graphic art also underwent a marked change in the course of the 1950s. Until then the work produced in this medium had been completely realistic but, with the advent of the new decade, non-objective art also made its presence felt in the graphic sphere. This innovation was due in no small measure to the growing popularity of lithography for, whereas line engravings and etchings were precise techniques which necessitated extremely accurate studies, the lithographic process allowed the artist far more freedom and so enabled him to reproduce the sort of spontaneous ideas encountered in non-objective art. The first important American lithographic workshop was set up in New York in 1957 by Tatyana Grosman, who had settled there in the early 1940s after fleeing from Germany with her husband, a painter of note. In order to convince her American colleagues of the advantages of the lithographic method Grosman procured a printing press and installed it in a garage. Initially she worked with three New York artists: Fritz Glarner (a non-objective painter who was born in Switzerland), Grace Hartigan and Larry Rivers (who subsequently collaborated with Frank O'Hara, the poet and curator of the Museum of Modern Art). Together they published a portfolio of lithographs under the title *Stones,* which received widespread recognition. Meanwhile Tatyana Grosman has been producing her *Universal Art Editions,* to which numerous well-known American artists have contributed, including Robert Rauschenberg, Helen Frankenthaler, Robert Motherwell, James Rosenquist, Jasper Johns, Barnett Newman and Lee Bontecou. Apart from prints and series by individual artists she has also published collections of lithographs in portfolio form, all of which have been acclaimed far beyond the frontiers of the United States. With the support of the 'National Council of the Arts' Mrs. Grosman founded a workshop for experimental etching in 1967. The products of this workshop to date include: a portfolio of prints by Jasper Johns, in which the artist treated themes allied to those dealt with in his paintings and sculptures, and a book of etched texts by the sculptor Lee Bontecou.

Motherwell, *Gauloises,* page 449

Three of the most important contributors to Grosman's *Universal Art Editions* are Robert Motherwell, James Rosenquist and Jasper Johns. Robert Motherwell's collage *Gauloises* bears a formal resemblance to the *papiers collés* produced by Picasso and Braque in 1912 during the synthetic phase of Cubism. But whereas the bits of newspaper, the cigarette packets and the snippets of rag which the Cubists stuck on to their pictures were meant to produce pictorial associations of a metaphorical nature, Motherwell's cigarette packet is not. What he has done is to place a real element, namely a cigarette packet, in an unreal, namely an artistic, context, thus raising an ordinary consumer object to the level of a pictorial object. Motherwell's cigarette packet is in fact the sole theme of his picture. The print and emblems on the packet, the folds, the tears in the paper and the colours combine to produce graphic and textural qualities similar to those found in a drawing or a paint-

Roy Lichtenstein
(b. 1923),
LANDSCAPE (1967).

Robert Motherwell
(b. 1915),
GAULOISES (1967).

Opposite:
Claes Oldenburg
(b. 1929),
TEABAG (1966).

Jasper Johns
(b. 1930),
WHITE TARGET (1968).

ing. The only difference is the element of surprise, which the viewer senses when he discovers that these familiar signs and forms actually constitute an artistic structure.

James Rosenquist's lithograph *Firepole* also contains specifically naturalistic elements. The aggressive vitality of this print derives partly from its unusual colouring, which is reminiscent of the glaring colours used on advertising posters, and partly from its provocative layout. The infinitely detailed, modelled forms of the pole, the boots and the trousers almost offend the eye of the viewer accustomed to the values of traditional art. But then these fresh and vital forms were not prompted by cultural or intellectual considerations. All they are meant to convey is a purely sensual impression.

Roy Lichtenstein has been pursuing similar ends, using pictorial motifs derived from advertisements and the comic strip. He is trying to bridge the

Rosenquist,
Firepole,
page 453

451

Joseph Albers (b. 1888), WHITE LINE SQUARE (1966).

Lichtenstein,
Landscape,
page 449

Johns,
White Target,
page 451

gap between the pictorial object and the real object, to restore the close relationship which once existed between them. The communications media of our much maligned modern civilization—from television to advertising—are constant features of his work. Lichtenstein treats such themes in a slightly ironical, slightly critical but always extremely effective way. In his hands they have proved a rich and eminently suitable source of pictorial motifs.

Jasper Johns has also contributed to the de-mystification of art by reproducing commonplace objects without creating metaphysical associations. These objects, which constantly recur in his work, include targets, flags, thermometers, books, maps, figures and letters. As models for his bronze sculptures he uses electric light bulbs, food tins and beer bottles whilst his lithographs are mostly graphic reproductions of existing pictures. In his *White Target* Johns painted a white motif against a dark ground so that his signature and the title exercise a similar function to that fulfilled by the linear structure of the target, namely pictorial animation. This apart, the picture depends for its effect on the monumental isolation of the target from its natural setting, which lends a special significance to its rectilinear and concentric forms.

James Rosenquist
(b. 1933),
FIREPOLE (1967).

Oldenburg,
Teabag,
page 450

In their endeavours to find pictorial equivalents for the objects in their natural environment, contemporary American artists have discovered new materials and new graphic techniques which lend themselves particularly well to the realization of their *avant-garde* conceptions. Claes Oldenburg and Roy Lichtenstein, two of the leading exponents of Pop Art, have turned to serigraphy and printed on to new materials such as plastic, plexiglass and felt. But their works are so original that it is scarcely possible to classify them as graphic prints in the old, classical sense of the word. They are really experiments, which these artists have carried out in order to further their painting and sculpture.

de Kooning,
Untitled
page 446

Willem de Kooning, who was born in Rotterdam in 1904 but has lived in the United States since 1926, has maintained a slightly more traditional style. His interest in representation, concentrated on a long series of female nudes, is matched by his fascination with the paint surface. He is a master of a rich, juicy texture.

By now America's artists—certainly her painters and graphic artists—have completely emancipated themselves from their European mentors. Ever since 1950 American art has been developing its own forms of expression, which are likely to influence Europe to an ever increasing extent. After playing a dependent role for so long the Americans have suddenly become the leaders of artistic fashion. Convincing proof of this change in the hierarchy of contemporary art was furnished by the recent great 'documenta' exhibition in Cassel, where more than one third of the exhibits were American. This spectacular success story has been due in no small measure to the development of the graphic arts in America over the past twenty years, for it was largely thanks to the reproductive potential of the art print that the world was made aware of the existence of a specifically American art form.

Aquatint. An etching technique developed by Le Prince about 1768. The plate is first covered with grains of resin and then heated so that the resin melts. Next the pure whites are stopped out and the plate is prepared in the normal way, after which it is placed in acid, which bites through the resin to produce a network of fine lines, giving the effect of tone. The depth of tone of the finished print depends on the degree of exposure to the acid. The resinous ground is of course removed prior to printing.

Bistre. A brown pigment originally produced from vegetable fibres and used by the old masters in the form of ink. Later, bistre was produced from soot or burnt umbre and used as chalk.

Block-book. A form of illustrated book in vogue about 1430 and printed from hand-cut wooden blocks containing both text and illustrations. The earlist examples pre-date the invention of movable type by some twenty years.

Calligraphy. In general terms this concept refers to any written characters which serve a decorative as well as a communicative purpose. In the more restricted sphere of graphic art a calligraphic work is one that is 'freely and rhythmically treated, with pen squiggles like handwriting'.

Charcoal. Charcoal is particularly useful for making rapid sketches. Since they are easily smudged charcoal drawings have to be fixed immediately and the fixative most commonly used today is shellac dissolved in alcohol. Charcoal sticks are made from twigs of willow or vine which are charred away from the air. Charcoal drawing is not a recent development. It was in common use in Dürer's day, but the majority of the drawings produced at that time have failed to survive because no satisfactory fixative was then available.

Chiaroscuro woodcut. The prints produced by this process, which was evolved in about 1500, resemble drawings executed in Indian ink and heightened with tone. Two blocks are used: a key-block, which prints black and produces the actual drawing, and a tone-block, in which lines are cut out so as to print white. These two blocks are printed in register so that the forms do not overlap, thus creating a black design heightened with tone.

Cloth print. The earliest cloth prints were made by hand from wooden blocks carved by professional wood engravers. Following the introduction of paper into northern Europe in the mid-fourteenth century similar prints were made, using paper instead of cloth. These constitute the earliest form of woodcut.

Copper engraving. See *Line engraving.*

Crayon engraving. This technique, which was developed in the late sixteenth century and is used both in etching and in line engraving, gives an effect similar to that of a chalk drawing. By means of a roulette—a small wheel fitted with tiny spikes—delicate dotted lines are made in the etching ground or engraving plate. These roulettes can also be used to produce granular effects.

Dotted print. In this special form of engraving small shallow impressions were made in the metal plate which printed as white dots. Lines were made by punching series of dots whilst shading was produced by increasing the density of the dots in a given area. This technique, which was in vogue in the fifteenth and sixteenth centuries, was eventually superseded by the line engraving.

Drypoint. In this particular engraving technique, instead of using a sharp burin to produce deep furrows, the artist simply scratches the surface of the plate with a special 'pencil' made

of hard steel. Drypoint is a much quicker and more spontaneous process than line engraving and lends itself particularly well to the reproduction of painterly effects. Its one disadvantage is the fact that the plate wears out very quickly. The process has been in use since the early sixteenth century. In the nineteenth it was modified for use in etching.

Etching. Like line and drypoint engraving, etching is an intaglio process. But instead of being incised with a burin, the plate is bitten by either nitric or hydrochloric acid. In this process the plate is first covered with a ground, consisting of a layer of wax or asphalt, both of which are impervious to acid. The etcher then draws on the plate with a needle, reproducing his design in the ground and exposing the metal in the process. Next his plate is immersed in an acid bath, where the acid bites into the bared metal, producing impressions similar to the incised furrows of the line engraving. After the plate has been removed from the bath and the ground cleaned off the prints are taken in the normal intaglio manner. But although etched and engraved prints are produced by basically similar methods, they have a totally different character. An engraved line is hard and clear-cut, in keeping with the precision and self-control demanded of the engraver in its execution. An etched line, on the other hand, is smooth and flowing. It also has a granular texture due to the fact that the acid invariably seeps underneath the edges of the ground, thus producing a slightly ragged line. It is possible to obtain distinctly painterly effects by etching in stages. If the plate is removed from the acid bath after the faintest lines have been bitten, these can be stopped out with varnish, after which the plate may be returned to the bath to produce darker lines. The process can be repeated any number of times, which means that the etcher has at his command a complete range of lines of varying strength. Etching is often reinforced by drypoint, which heightens the painterly quality of the finished print. The earliest etchings date from the Dürer period.

Gouache. A special kind of watercolour paint made by mixing white or gum arabic with ordinary watercolours. These additives render the colour opaque. Gouache is often known as poster paint.

Hatching. Hatching is shading executed in parallel lines and is used to produce an impression of plasticity by purely linear means. Cross-hatching is shading executed in two sets of parallel lines which cross one another; it has been in use since the fifteenth century and produces a deeper shade than ordinary hatching.

Incunabula. Early books printed before 1500, many of which were illustrated with woodcuts or engravings.

Line engraving. Line engraving is an intaglio process, which means that the artist's design is reproduced on the steel or copper plate by means of incisions, made with a graver or a burin. Once this stage has been completed the whole plate is covered with a thin kind of printer's ink, which is then rubbed off from the level surfaces but left in the incised furrows. Next a piece of damped, absorbent paper is laid on top of the plate, whereupon both are passed through a heavy press. As a result of the pressure the paper is forced into the furrows, where it absorbs the ink and so receives the print. The burin, whose tip is lozenge-shaped, is pushed forwards into the copper, ploughing a V-shaped furrow and throwing up small shavings on either side, which are then removed with a scraper. In order to strengthen his line the engraver has to make a deeper incision, which automatically produces a wider furrow. Consequently, by varying the pressure on the burin it is possible to produce a line of variable strength, which means that the linear composition is largely determined by the engraver. For this reason most artists prefer to do their own engraving rather than leave this aspect of the work to a craftsman, which is quite a common practice with woodcuts. In cutting curves and arcs the engraver has to use both hands, turning the plate—which lies on a leather cushion filled with sand—with one hand whilst cutting with the other. In this way it is possible to produce even concentric curves with great precision.

Linocut. The linocut is exactly the same as the woodcut, from which it was developed, save that linoleum is used instead of a woodblock. Because this material is relatively fragile only coarse forms can be reproduced in linocuts, a fact which has recommended the material to contemporary artists and art teachers.

Lithograph. The lithograph is a surface printing technique in which the artist's design is drawn with a greasy chalk on to a thick slab of Solnhofen limestone or (of more recent years)

synthetic stone. This stone has the characteristic of absorbing both grease and water, two materials which naturally repel one another. After the drawing has been completed the stone is wetted, the water penetrating only those parts of the stone which are free from grease. Subsequently, when greasy ink is rolled on the stone, it is repelled by the wet surfaces but adheres to the greasy chalk, from which it is transferred to the paper during the printing process. This technique, which was invented by Alois Senefelder in 1796, was quickly adopted by artists throughout Europe because it enabled them to use the traditional draughtsman's tools, namely pen, pencil and chalk. The first artist to produce coloured lithographs, using a different stone for each colour, was Toulouse-Lautrec. Today zinc or aluminium is normally used instead of stone, which had always proved cumbersome. These metals posses the same characteristics as Solnhofen limestone.

Manière de lavis. See *Aquatint.*

Mezzotint. The mezzotint engraving was extremely popular in the eighteenth century, especially in England. In this process the plate is first worked on with a 'rocker', a curved instrument somewhat like a chisel but with a toothed blade, which produces a mesh of burred dots that cover the entire surface. At this stage the plate would produce a completely uniform, rich black print. Some of the burr is then removed with a scraper in order to produce greys whilst the lighter tones are obtained by polishing the appropriate areas with a burnisher. The mezzotint is not a linear technique but a tone process, which is chiefly remarkable for its delicate painterly transitions.

Monotype. A monotype is a print made from an unengraved copper plate. The design is painted directly on to the copper and then printed in the normal way. This gives an effect which differs slightly from that which would be obtained by painting on to the paper direct. A faint image is left behind on the plate after printing and this can serve as a guide for a repeat of the process.

Niello. Niellos are small metal plates, usually made of silver or gold and with a design engraved on them, which were originally used as decorations for the lids of small boxes, book bindings and the claps of reliquaries. In order to heighten the contrast between the intaglio and surface areas and so give greater prominence to the design the early goldsmiths, who made these plates, used to fill out the incised lines with niello enamel, which was compounded of lead, silver, copper and sulphur. The first niello print was the result of an accident: a damp cloth was inadvertently laid on a niello plate, in which the enamel had not yet dried, with the result that the design was transferred from the plate to the cloth. The implications of this new technique were eventually recognized and the niello print was incorporated into the graphic repertoire, where it played an important part in the development of line engraving.

Pastel. Sticks of pastel are made of dry powdered chalk bound with small quantities of water-soluble gum. These sticks are used for drawing, the colour being rubbed on to coarse-grained soft paper, cardboard or vellum. Because of their softness and because it is possible to build up layers of colour one on top of the other, pastels are virtually indistinguishable from paintings. The one great disadvantage of this medium is the ease with which the powder smudges or is dislodged from the paper, which means that fixing is imperative.

Proof. Unlike the woodcut, both the etching and the line engraving can be tested at any stage of the incising process by taking specimen prints. It is not uncommon for several such prints to be taken to enable the artist to correct his plate and reassure himself on the progress of the work in hand. These proofs are highly valued by collectors because they provide an insight into the working method of the artist concerned. They are commonly referred to as 'proofs before the letter' because they are taken before the engraving or etching is handed over to the letterist.

Red chalk. Red chalk was first used in the fifteenth century and was originally made from natural red ochre. Today it is normally made from synthetic materials.

Rocker. A tool with a curved and toothed blade used in the mezzotint process.

Sepia. A brown pigment made from the 'ink' of the cuttlefish which is often confused with bistre. It is used mostly for pen drawings.

Silver point. The silver point was used by the old masters for sketches executed in the open

air and on journeys. It consisted of a piece of silver wire held in wood, rather like the modern lead pencil, by which it was superseded. These silver-point sketches were made on paper coated with opaque white, to which a slight tint of colour was added. The sketches themselves appeared as a delicate shade of silver-gray.

Soft-ground etching. In this special type of etching process the etcher lays a sheet of paper on a soft thin ground and then draws his design on the paper with a pencil, which presses down into the ground and exposes the metal. The prints produced in this way are remarkable for the delicacy of their linear composition, and look rather like a pencil or chalk drawing.

Steel engraving. See *Line engraving.*

Tempera. In the Middle Ages all paintings were executed in tempera colours, that is to say, in powder colours bound with a mixture of raw eggs and water with various additives such as varnish, balsam, glue, starch and rye flour. The chief characteristics of tempera paintings are their precise, firm brushwork and their highly luminous colours. Following the discovery of oil-painting in the fifteenth century this medium went out of favour, although it has never been completely abandoned. The texture of a tempera painting is entirely matt and lacks the rich gloss of an oil-painting. But, if desired, this gloss can be supplied by coating the tempera with varnish.

Wash. A wet brush charged with Indian ink, sepia or watercolour can be used to heighten the plasticity of the figures in a pen drawing. This process is called a wash.

Woodcut. The woodcut is the oldest and the best known form of relief printing. After the artist's drawing has been transferred to the woodblock the blank areas are cut away with special knives and gouges, thus leaving the drawing in relief. Consequently, when the print is taken, the drawing will print black and the blank areas

white. It is not possible to vary the depth of colour since the relief surfaces are all of equal height. Nor is it possible to produce delicate linear structures similar to those created in etchings and line engravings, for the raised strips of wood have to be of a certain thickness, since otherwise they would break when pressure is applied during the printing process.

Wood engraver. In the fourteenth and fifteenth centuries artists produced only the preparatory drawings for their woodcuts and left it to the professional wood engravers to complete the processing. But although the majority of these craftsmen were highly skilled, the artists were not always satisfied with their work. This was especially true of men like Dürer, whose woodcut compositions were extremely intricate. Today artists are less inclined to allow a craftsman to carve their blocks, for it is now generally appreciated that the technical process plays a crucial part in the realization of the original conception.

Wood engraving. This technique was revived by the English artist Thomas Bewick (1753 – 1828) at the end of the eighteenth century. In this process the design is cut into the wood by means of a burin or graver, the tool used in copper engraving. Consequently, it is possible to create extremely delicate linear structures and tonal values similar to those produced by the line engraver or etcher. The principal difference between the woodcut and the wood engraving lies in the block. In the woodcut the artist uses soft wood cut with the grain whilst in the wood engraving he employs boxwood cut against the grain. Boxwood, a much harder material, is necessary because of the greatly increased pressure to which the wood engraving is subjected during the printing process.
Unlike the line engraving on metal, where the ink is forced into the lines, the ink lies on the surface of a wood engraving. The resulting print thus gives the effect of white lines on a black ground.

INDEX OF ILLUSTRATIONS

459

461

464

INDEX OF ARTISTS

*Numbers in bold type refer to pages
on which the artists' works are reproduced*

Illustrations Credit:
The majority of the illustrations have already appeared in *Das Große Buch der Graphik*, © 1968 Georg Westermann Verlag, Brunswick. Photographs by Hermann Buresch.
Grateful acknowledgement is extended to all museums, collections and private owners for their help and for their permission to reproduce works in their collections.
SPADEM, Paris/Cosmopress, Geneva and ADAGP, Paris/Cosmopress, Geneva have given permission to reproduce the works illustrated on the following pages: 280, 306, 307, 308, 309, 311, 312, 315, 316, 317, 320, 322, 323, 344, 345, 346, 347, 348, 349, 350, 351, 352, 353, 354, 355, 356, 357, 358, 359, 361, 362, 363, 364, 365, 367, 368, 369, 370, 371, 373, 374, 401, 402, 403, 433 and 409, 410, 411.
Courtesy of the Estate of Lyonel Feininger represented by Marlborough Gallery, New York: pages 412, 413.